VANESSA PLACE

3: Argument

about

the

strange distortions of language that serve the legal system.

readers will find

themselves longing to escape the text,

frail the fabric of justice is.

—Ken Gonzales-Day

defense documents

benefit from further

elucidation which only grow more disturbing presented in their purest
form.

in effect saying

in essence

'A whore is a whore is a whore'—

—Kim Rosenfield

cold, philosophical, and

relentless, this volume is an analytical double-

time, legal language trying (and

failing) to secure meanings ; and poetic language

procedurally measuring

the legitimation of a legal edifice from which no one

can escape.

a treatise ; a discourse

; and an institution of aesthetics and ethics of

juridical administration.

—Simon Leung

scribing

appellate briefs, rendering

"neutral" language presented before a court.

by

reframing, turn them into what is arguably
today.

—Kenneth Goldsmith

VANESSA PLACE

Tragodía
3: Argument

Blanc
Press
Los Angeles, California

TRAGODÍA 3: ARGUMENT
Blanc Press September, 2011
Los Angeles, California
© 2011 Vanessa Place
ISBN: 978-1-934254-27-1

A portion of *Argument* appeared in *P-Queue, vol. 7 : Polemic*, September 2010.

Vanessa Place would like to thank Kenneth Goldsmith, Marjorie Perloff, Robert Fitterman, Kim Rosenfield, Teresa Carmody and Mathew Timmons.

Blanc Press Los Angeles
Freedom of the press is limited to those who own one.
When the rim is bent it will press against the works and
impede the proper action of the currents.
blancpress.com

TABLE OF CONTENTS

ARGUMENT

APPELLANT'S CONVICTIONS MUST BE REVERSED FOR THE VIOLATION OF HIS RIGHT TO SPEEDY TRIAL

Introduction

The charged events occurred on February 21, 1989; a complaint was filed on March 6, 1989; the information filed on April 6, 2004; and appellant convicted on October 26, 2004. As noted, appellant fled the scene, first going to Costa Rica to see his family, then moving to Texas. In 1994, Texas police stopped him for a traffic violation, briefly detaining him on a California arrest warrant, in 1996, appellant was again stopped and detained; at that point, he asked an attorney to find out his legal status in California. By all accounts, appellant was told he was not wanted. In 2003, the Los Angeles Police Department reconstituted appellant's warrant file, and appellant was arrested in 2004. Appellant's convictions must be reversed as the delay here—whether measured from 1989, 1990, 1994, or 1996—constituted an impermissible violation of his State speedy trial right. (*People v. Horning* (2004) 34 Cal.4th 871, 892-893, 895, cert. den. 126 S.Ct. 45; *Klopfer v. North Carolina* (1967) 386 U.S. 213, 223.)

A. Federal and State speedy trial rights: overview

Both federal and state constitutions protect the right of an accused to a speedy trial. While each right so secured sets forth different points of activation, and different standards for establishing a violation, the fundamental guarantee of both is to prevent oppressive pretrial incarceration, minimize the accused's anxiety and concern, and limit impairment of the defense; the latter interest is paramount because:

> ... the inability of a defendant adequately to prepare his case skews the fairness of the entire system. If witnesses die or disappear during a delay, the prejudice is obvious. There is also prejudice if defense witnesses are unable to recall accurately events of the distant past. Loss of memory, however, is not always reflected in the record because what has been forgotten can rarely be shown.

(*Barker v. Wingo* (1972) 407 U.S. 514, 532.) In *Horning*, the California Supreme Court surveyed the parameters of the Sixth Amendment right to a speedy trial:

the federal right does not attach until either a formal indictment or information has issued, or an actual restraint imposed via arrest and holding *(People v. Horning, supra,* 34 Cal.4th at p. 891, citing *United States v. Marion* (1971) 404 U.S. 307, 320), subsequent delay deemed unconstitutional upon consideration of the "four 'Barker' factors: 'whether delay before trial was uncommonly long, whether the government or the criminal defendant is more to blame for that delay, whether, in due course, the defendant asserted his right to a speedy trial, and whether he suffered prejudice as the delay's result.'" *(People v. Horning, supra,* 34 Cal.4th at p. 892, quoting *Doggett v. United States* (1992) 505 U.S. 647, 651.) For a delay to be found to be of "uncommon" length involves a determination that the interval between the filing of the information and trial "has crossed the threshold dividing ordinary from 'presumptively prejudicial' delay." This presumption "intensifies over time": postaccusation delay is presumptively prejudicial "at least as it approaches one year."[1] *(Doggett v. United States, supra,* 505 U.S. at pp. 651-652, 658; *People v. Horning, supra,* 34 Cal.4th at p. 892.)

The speedy trial right established by article I, section 15 of the California Constitution is triggered by the filing of a felony complaint: unlike the federal standard, the State constitutional inquiry is concerned with actual prejudice, and the defendant must affirmatively demonstrate he was disadvantaged by the delay. For its part, the Government must justify the delay, and the court weigh this justification against that prejudice. *(People v. Martinez* (2000) 22 Cal.4th 750, 754, cert. den. 531 U.S. 880; *People v. Horning, supra,* 34 Cal.4th at p. 895 [no prejudice shown]; *Serna v. Superior Court* (1985) 40 Cal.3d 239, 262-263, cert. den. 475 U.S. 1096; *People v. Egbert* (1997) 59 Cal.App.4th 503, 510-511.)

In *People v. Horning,* the California Supreme Court found no federal or State violation where the Stockton murder occurred in September 1990, the defendant was questioned by police on October 26th, absconded the next day, was arrested for bank robbery in Arizona in March 1991, and sentenced to four

1 Though the presumption of prejudice cannot alone sustain a federal speedy trial claim, "its importance increases with the length of delay." *(Doggett v. United States, supra,* 505 U.S. at pp. 655-656; *Ogle v. Superior Court* (1992) 4 Cal.App.4th 1007, 1020 [prejudice presumed "when it is reasonable to assume sufficient time elapsed to affect adversely one or more of the interests protected by the speedy trial clause."].) This is simply because the longer the delay, the more the integrity of the trial is compromised "in ways that neither party can prove, or, for that matter, identify": negligence absent "particularized" prejudice must have lasted longer than that which is demonstrably prejudicial. *(Doggett v. United States, supra,* 505 U.S. at pp. 651-652, 655-656; *People v. Horning, supra,* 34 Cal.4th at p. 892-893.)

life terms, stated while in prison that he knew he was wanted in California for murder, escaped from prison in May 1992, abducted a family at gunpoint on June 25, 1992, consequently engaging in a high-speed chase with authorities, shot at those authorities, escaped on foot, tried to abduct some other people the following day, stole their car, then carjacked another vehicle on July 4th, engaged in another chase/shoot-out, escaping again on foot, was rearrested in July 1992, and arraigned on the amended murder complaint on May 20, 1993. (*People v. Horning, supra,* 34 Cal.4th at pp. 880-891.) In dismissing the claims, the Court essentially found the federal right had not been triggered; in any event, some of the delay was "fully justified," whether because the defendant was in hiding or unavailable due to his Arizona prosecution. The Court also found the California prosecutor's decision not to extradite and prosecute "practical," given the length of the defendant's Arizona sentence: only after the defendant's escape and subsequent criminality, did the expenditure of State resources become appropriate, neutralizing the attendant delay. Though the reasons for the delay between the July 1992 arrest and the May 1993 filing of the complaint were "unclear," it was a shorter time than that needed to spark a Barker inquiry, and, overall, the defendant was more to blame for any procrastination than was the Government. As the delay was nominal, and there was no particularized prejudice shown, both state and federal claims fell.[2] (Id., at pp. 893-895.) But under either test, appellant's convictions must be reversed:

B. Appellant's speedy trial motions

Appellant made two motions to dismiss for violation of his rights to a speedy trial, one by his first attorney,[3] and the second by trial counsel. Trial counsel also later made a post-trial motion to dismiss on the same grounds. The first motion was denied by one court, the second by the trial court.

1. The June 16, 2004 motion.

At the hearing on the motion, Pardo, appellant's sister, testified appellant lived in Burbank with their aunt, Inez Quirot, in 1989. Pardo could not recall the exact address; Quirot died in 2001. (RT B-3-B-5) Adalberto Luper had been a Los Angeles Police officer for twenty-seven years, retiring in 1999;

2 The Court also dismissed the defendant's federal due process claim as such a claim would entail proof of demonstrable prejudice and proof the delay was intentionally devised to gain a tactical advantage over the defense, neither of which had been established. (*People v. Horning, supra,* 34 Cal.4th at p. 895.)

3 Though couched as a speedy trial/due process motion, this first motion is considered here as its prejudice and justification analysis was built upon by the subsequent motion, and the facts and arguments therein used in ruling on the state right.

from 1994 through 1996, Luper worked as a robbery/homicide detective. It would have been "rather easy" to trace Concepcion at that time using her Social Security Number. Detectives could have run the number through TRW, in addition to checking the CLETS system, local data banks for previous arrests, previous housing locations, change of addresses with the postal service and utility companies. If the victim were in Los Angeles County, she would have probably been located "within a few hours after making a few phone calls." If she'd moved out of state, it would have taken "one or two days longer," in any event, "probably within five days we would have had something." It might have been a little more difficult to find the victim if she did not have a SSN. (RT B-11-B-16)

Appellant testified he was stopped for speeding near Dallas in 1994; at that time, he was arrested, and told there he had a California warrant for "something about a kidnaping." This was the first appellant heard of a warrant: one of the Texas detectives said he would be held until they contacted someone in California. The next day, the detective said "they" had called him back, "they" didn't want appellant, and appellant was released with his ticket. Appellant's Texas driver's license had his correct address. (RT B-17-B-21, B-27-B-28) In 1996, appellant was stopped in Houston for an expired inspection sticker, and again taken in on a California warrant. At the station, appellant was detained for about twenty hours, and told the California warrant was void, as it had "expired." Appellant was fingerprinted, photographed, and released after paying his ticket. (RT B-21-B-23, B-28-B-30)

Appellant subsequently contacted an attorney to find out what was happening; the attorney made some telephone calls on appellant's behalf, then told appellant "not to worry about it," because that's what the California authorities had said. Nine years later, appellant was re-arrested. In the fifteen years since appellant lived in Burbank, his memory of the details of the charged events has faded. (RT B-23-B-25, B-28, B-30-B-31)

Peter Bakotich is a LAPD detective assigned to the Fugitive Warrant Unit for fifteen years; Bakotich, testifying for the prosecution, said the Department did not have access to credit information in 1995: the Department's current information technology is far superior than what it was in years past.[4] Appellant's arrest warrant was issued on March 6, 1989. The "due diligence" notes in appellant's file include a notation from September 14, 1993 that

4 According to Bakotich, the LAPD still does not have access to TRW information because the City Attorney does not want to pay the requisite fees. (RT B-42-B-43)

appellant's driver's license had expired, and that no other information had been found regarding appellant's whereabouts. There was another computer search done in 1994, with no results. In 1994, extradition was denied by the District Attorney's Office because the victim could not be located; notes in the file dated July 10 and 12, 1996 indicate telephone calls were received by an attorney representing appellant, who asked appellant's warrants be pulled. The attorney was told police were unable to locate the victim and the District Attorney would not bring appellant back. (RT B-32-B-37, B-40, B-42) The function of the Fugitive Warrant Unit is to locate suspects, not victims or witnesses; the LAPD is to locate witnesses. (RT B-36, B-40-B-41)

There are no file notes from 1989, 1990, 1991, or 1992; this might mean either the Fugitive Warrant Unit or the North Hollywood file was lost during that time, though there is no indication either file was actually lost. There is no way of telling what any officers did relative to the case during the dataless years. (RT B-37-B-40)

Margaret Moss is a LAPD detective; in 1994, she was a detective at the North Hollywood station, supervising the Major Assaults Crimes Table. Moss became involved in the case on July 12, 1996, when a detective from the Fugitive Section asked her about an "old warrant case." Moss could not find the case, which had been initiated in 1989: she checked the warrant package area, the computer area, checked the computers for past reports and all names previously given. She ordered the police reports from the Record and Identification Section, and checked the status of the warrant. On July 18, 1996, she spoke to the Texas attorney, telling him they were working up the case and she would contact him about the current status. She did not say the warrant was void. On July 25, 1996, Moss noted in the file that she was unable to find Concepcion. (RT B-44-B-47, B-51)

Moss had attempted to locate Concepcion by checking to see if she had any tickets/warrants, or other police reports. She rescrambled her name for alternative spellings. She went to Concepcion's residence, spoke to the neighbors, called her old telephone numbers, asking how long the new holders had the old numbers, and talked to the investigating detective. It is common for sexual assault victims to "put things behind them" and avoid contact with police, so Moss did not know if Concepcion wanted to be located. (RT B-47-B-48) By September 1996, she had approved a new warrant package; between July 12th and September 1996, she learned the District Attorney's Office did not want to

extradite. At some point, she told the Texas attorney the warrant was still valid. (RT B-48-B-5)

Steven Bishop is a LAPD detective; in 1996, he was assigned to North Hollywood detectives, supervised by Detective Moss.[5] On August 9, 1996, Bishop tried to find Concepcion via the LAPD computer system, which checks for tickets, and national criminal histories. He went to her stated residence, and spoke to the manager, who had never heard of Concepcion. He spoke to the neighbors. He went through the telephone book, calling a number of Concepcion M's, including those listed with Menem or M's. He found cars registered to various Concepcions, and contacted those registration holders. Bishop created a replacement warrant package on September 10, 1996, which involved retrieving reports from Records and Identification, redoing computer run ups and compiling notes; on September 11th, an entry indicates that Deputy District Attorney Phil Wynn said there would be no extradition because the witness could not be found. No one got a photograph of appellant from Texas, or copies of his fingerprints, though a copy of his driver's license was obtained. (RT B-54-B-57-B-59)

Detective Sean Mahoney is at the North Hollywood Division, working night detail; on September 13, 2003, he found an address for Concepcion via the auto track system, utilized by the LAPD within approximately five years of the hearing date. He mailed Concepcion a contact card, and on October 27th, she called. On October 31, Mahoney's request for extradition from the District Attorney's Office was approved. As far as Mahoney knew, there was no reason someone could not have located Concepcion using the auto track system five years ago. (RT B-60-B-66)

Counsel argued the police negligence here included loss of appellant's file, the failure to locate Concepcion and/or appellant for fifteen years, and, after appellant contacted authorities in 1996, telling him not to be concerned with the case. There was no valid police purpose for the delay: even relieving the LAPD of the initial responsibility to locate appellant after he left California, they were notified of appellant's presence in Texas in 1994, and again in 1996, twice given the opportunity to extradite. They chose not to do so. Counsel also argued the LAPD could not be absolved of its obligation to expend a minimal effort to find Concepcion based on the City's disinclination to fund credit report searches; the defense investigator was able to reconstruct every address, telephone

5 Neither Moss nor Bishop knew whether anything had been done on the case from 1990 to 1996. (RT B-52, B-57)

number, and car that the victim had in the twenty years before trial. Moreover, the police loss of appellant's file from 1990 to 1994 was indicative of a sub-minimum standard of diligence. (RT B-66-B-70) In terms of prejudice, counsel noted appellant's aunt died in 2001, other corroborating witnesses were not locatable, and the memories of the current witnesses were degraded to the point that the case was just "him versus her." The court interjected that even if the case had gone forward in a timely fashion, it "would probably still come down to him versus her." (RT B-68-B-69)

The State argued a fifteen-year delay alone would not justify dismissal, absent a showing of specific and substantial prejudice: according to the Government, the question was whether if appellant was arrested in 1989, would there be any difference in his position at trial. The prosecutor admitted "we don't know" what, if any, efforts were made to find appellant from 1989 to 1993, arguing the loss of the file made that period of time irrelevant.[6] The decision not to extradite in 1994 was based on the practical expedient that the victim could not be found, which changed in 2003. (RT B-70-B-75) The court denied the motion, finding the "mere age" of the case not automatically prejudicial, and the defense had not demonstrated sufficient prejudice.[7] (RT B-75-B-76)

2. The September 8, 2004 motion

A subsequent motion was filed by trial counsel, along with copies of various police reports, including a copy of the reconstituted Fugitive Warrant Section Due Diligence report, Concepcion's physical examination report, and declarations by a number of new witnesses, including appellant, Evelyn Kunze, Jakob Halfrod, Pardo, Steven J. Johnson, and new counsel. (CT 163-281; RT D-2-D-5) Appellant's declaration was his version of the charged events, and statements to the effect that he did not know there had been a complaint filed against him when he returned to the United States from Costa Rica. Appellant obtained tax records from his former employer in 1990, providing them his Texas address. He consulted a Mormon bishop about what happened with Concepcion, and they prayed over appellant's commission of the sin of sex without marriage. Appellant got a job and an apartment in Houston, bought a

6 The prosecutor also noted that "[w]e don't know for sure" if the auto track system was used in 1999. When the Government attempted to argue appellant was responsible for the delay because he left the State in the first instance, the court found there was no evidence appellant knew there was a warrant out for his arrest when he left California. (RT B-73-B-74)

7 The court found the offer of proof of appellant's aunt potential testimony inadequate as character evidence, and any evidence on the state of appellant's car just inadequate. This proffer is transcribed at B-7-B-9. (RT B-76)

car, registered to vote, and maintained his United States passport. He eventually bought two "time shares," and maintained utilities and a telephone in his name. In 1996, he was stopped for speeding, and told about the California warrant: he contacted an attorney, who told him the warrant was not being pursued.[8] (CT 179-184)

Jakob Halfrod's declaration stated he was President of the Texas Stake of the Church of Jesus Christ of Latter-Day Saints: appellant was a member of the Stake from 1993 to 1996, and has a reputation for honesty and integrity. Given the teachings of the Church, appellant would have understood that extra-marital sex with Concepcion was a serious breach of the "Law of Chastity," serious enough to provoke flight. According to Church doctrine, appended to Halfrod's declaration, appellant would have been excommunicated absent "Repentance," confession to a bishop, and "Redemption," such acts of atonement as the Church prescribed. (CT 274-280)

In her declaration, Pardo stated she was a professor in Costa Rica and appellant's older sister; she and appellant were raised in a strict Mormon household, in which premarital sex is considered a sin second only to murder. Pardo was aware appellant sought Redemption in the early 1990's via a Church intermediary for breaking the Law of Chastity. The Church sanctions the sin so severely that, until one performs a series of "Acts of Redemption," one is eternally doomed as a Church "outsider." In addition to meeting with the Church intermediary, a Bishop Fragoso, appellant has worked for the Church on a weekly basis for a number of years. Pardo's declaration also included evidence that the physical scene of the alleged assault had been changed since the date in question, and that Concepcion's place of employment no longer exists. (CT 248-268) Steven J. Johnson's declaration stated that in 1996, appellant installed an air conditioning system in his home; later that year, appellant was detained by Texas police on an outstanding California warrant. Johnson, a Texas attorney, made a series of telephone calls on appellant's behalf, eventually speaking to LAPD Detective Bishop, who told him that although the kidnap/rape warrant was still active, the LAPD was not going to pursue appellant because the victim could not be located. Johnson was never recontacted by California authorities about appellant. (CT 243-246)

8 Trial counsel's declaration was a recitation of the facts supporting her argument that there was particularized prejudice in the delay, as well as an argument that the charges were baseless. (CT 186-191) Counsel filed a supplemental motion/declaration which included her statement that a police officer witness told her he had no recollection of the case. (CT 302-320)

Matt Saunders' declaration indicates he is the manager of Eagle Catering, successor company to Courtesy Catererers, which would have supplied the individual catering truck in which Concepcion worked as a cook. According to Saunders, appellant's account of what Concepcion told him about her work situation comported with general industry practice. Saunders described the physical changes which have occurred on San Fernando Road since 1989, and indicated any evidence of Concepcion's character as an employee was irretrievable. (CT 270-272) In her declaration, Evelyn Kunze, a researcher for a private investigator, stated she used AutoTrackXP, a public records provider, to locate extensive contact information on Concepcion after being previously unable to locate her as "Zumudio." Kunze had no problem finding Concepcion. (CT 282-297)

At the hearing on the motion, Eric Rosoff, a sergeant with the Burbank Police Department, testified he reviewed the reports prepared by a LAPD officer, which listed him as a witness. Rosoff had no independent memory of the incident. (RT D-7-D-9) Pardo testified she went to Strathern and San Fernando in 2004, the location of the kidnaping based on the preliminary investigation reports. The scene is not as was described: there is now a Metro station between the two roads, and no bus stop. It was impossible to find out where the old bus stop had been located, or find Concepcion's place of employment. (RT D-12, D-14-D-19)

The court denied the motion, finding "nothing new" had been added to the defense showing, going on to nutshell:

> That's what these cases basically are about, all of these speedy trial cases are about where somebody should have been arrested, should have been charged, they have be [sic] around for years and due to lack of diligence by the police, or whatever, and the prosecuting agencies, nothing takes place until years later and people are prejudiced by this. [&] But this man fled the scene. He fled. And now the question is: can he be rewarded because he's been able to escape now for 15 years? Should he be rewarded by this? [&] Now because, yes, people memories change, things have changed, the metro link is there now, things change, but now should he get the benefit of this? Should he get rewarded

for this? [&] ... [A]ll of these other witnesses are
basically, you know, I don't want to say fluff.... [&]
But the case is going to come down to: had he been
arrested the same day, the next day, had he stayed
around and this case had come to trial 15 years ago,
it would still come down to what took place in that
automobile between him and her. And they were the
only two people in the automobile. And that's what
the case would come down to.

(RT D-33-D-37) But this is not what this motion should have "come down to."
(*Doggett v. United States, supra,* 505 U.S. at pp. 657-658.)

C. Federal and State speedy trial doctrines as applied

Appellant's Sixth Amendment right to a speedy trial was not implicated
because the delay here was pre-information; appellant was, however, prejudiced
by the excessive delay in this case, and prejudiced sufficiently to constitute a
violation of his state guarantee of a speedy trial. (*People v. Horning, supra,* 34
Cal.4th at pp. 893-895.) The court ruling on the second motion was correct in
that the case against appellant was always a credibility case: this is precisely
the reason loss of evidence which could have bolstered appellant's credibility
was so prejudicial, and why the State's justification for its delay must have been,
in turn, substantial. (*People v. Hartman* (1985) 170 Cal.App.3d 572, 579.) The
justification here did not counterbalance the harm; the court erred in denying
the motion. (*People v. Martinez, supra,* 22 Cal.4th at p. 754; *Ibarra v. Municipal
Court* (1984) 162 Cal.App.3d 853, 858 [court erred in evaluating quality prejudice
without balancing prejudice against reason for delay].)

The prejudice was specific: appellant's car, an examination of which
would have either corroborated or disproved Concepcion's contention that
she could not escape because there were no doorlocks, and that there was
a threatening black flashlight at the ready, had been long since disposed of
by police. Similarly, the tape of the chase broadcast had been destroyed. The
training officer with Carlisle, who examined the car, was either retired or dead.
By the time of trial, there was no way of finding the owner of the lunch wagon
Concepcion cooked for: no way of knowing whether she had, as appellant
said she told him, been late to work before, and whether there was a "second
supervisor," all details which, if they were able to be confirmed, would have
tended to support appellant's version of events. The sexual assault nurse was
not able to be found, and the officer who took Concepcion to the examination

could not remember doing so: so there was no way to reconcile the examining physician's memory of Concepcion's demeanor with the description set forth in the report.

Appellant's aunt died in 2001: not only could she have testified as to whether appellant's car was as he described, but she could have verified his description of himself as a then-devout young man, the sort who would not only have a falling-out about his desire to live in a mission, but who might also, having committed a carnal sin "second only to murder," run in horror, returning to his strict Mormon family in Costa Rica. An account largely mocked by the prosecutor in argument, and which the jury may well have found harder to believe coming from a 37-year-old man than from his 21-year-old self.[9] Rather than fluff, this is the stuff from which defenses are built in credibility contests, as details become makeweight. And this evidence was lost to appellant because of the prosecution's improper delay in prosecuting. (*Strunk v. United States* (1973) 412 U.S. 434, 439, fn. 2.)

While there is no presumption of prejudice under the state test, there must be a balancing between the prejudice sustained by a defendant and the justification for the delay, *i.e.*, substantial justification is required to offset solid prejudice. (*People v. Martinez, supra,* 22 Cal.4th at pp. 755-756; *People v. Horning, supra,* 34 Cal.4th at p. 895.) As the Fourth District has stated:

> Even a minimal showing of prejudice may require
> dismissal if the proffered justification for delay
> be unsubstantial. By the same token, the more
> reasonable the delay, the more prejudice the
> defense would have to show to require dismissal.
> Therein lies the delicate task of *balancing* competing
> interests.

(*Ibarra v. Municipal Court, supra,* 162 Cal.App.3d at p. 858.) Here, the Government's justification was insufficient to counter weigh the harm done:

Though it involved the federal right, the justification in *Doggett v. United States, supra,* 505 U.S. 647, is illustrative. In *Doggett*, the defendant was indicted in February 1980, absconding to Columbia before he could be arrested. In 1981, after the Government discovered the defendant was under arrest in Panama, it asked Panama to "expel," rather than extradite him; the defendant

9 Illustrated in the prosecutor's first volleys: "The first question I had was what guilt about premarital sex causes the kind of reaction the Defendant displayed after he was pulled over by the police? And the second question is kind of the same thing except it is, would the stress of the police cause that kind of reaction?" (RT 1844-1845)

was subsequently released by the Panamanians, returned to Columbia, entered the United States in New York in 1982, and settled in Virginia, where he married, earned a college degree, worked as a computer operations manager, and generally "lived openly under his own name." In 1982, the American Embassy in Panama alerted the State Department that the defendant had gone to Columbia, however, the investigating DEA agent only discovered the defendant was no longer in prison in Panama after he was assigned there in 1985; upon learning the defendant had gone to Columbia, the agent just assumed he'd settled there. The defendant was arrested in September 1988 after authorities ran a credit check on several thousand outstanding arrest warrants. (*Doggett v. United States, supra,* 505 U.S. at pp. 649-650.)

The United States Supreme Court found the eight-and-a-half year delay between indictment and arrest "extraordinary," noting that though the Government claimed it sought the defendant with diligence, "for six years, the Government's investigators made no serious effort to test their progressively more questionable assumption that Doggett was living abroad, and, had they done so, they could have found him within minutes."[10] (*Doggett v. United States, supra,* 505 U.S. at pp. 652-654 [no evidence defendant aware of the charges until his arrest].) Given the "inexcusable oversights" in prosecuting the defendant, resulting in a delay "six times longer" than what generally triggers *Barker* review, the Court reversed. (Id., at p. 658.)

Similarly, in *People v. Hill* (1984) 37 Cal.3d 491, 494-495, the California Supreme Court upheld dismissal for a thirteen-month delay between the time the defendant filed a Penal Code section 1381 letter requesting prosecution, and the time the case was brought to trial, a delay due largely to the Department of Corrections' mistake in telling the District Attorney the defendant was unavailable for trial. The Court generally admonished "'[t]he risk of clerical error or neglect on the part of those charged with official action must rest with the People, not the defendant in a criminal action'" (*People v. Hill, supra,* 37 Cal.3d

10 In response to the State's complaint the Defendant showed no prejudice flowing from the delay, the Court noted that under the Sixth Amendment, "consideration of prejudice is not limited to the specifically demonstrable"; and impairment of the defense is the most difficult form of prejudice to prove, as "time's erosion of exculpatory evidence and testimony 'can rarely be shown.' And though time can tilt the case against either side... one cannot generally be sure which of them it has prejudiced more severely." (*Doggett v. United States, supra,* 505 U.S. at p. 656, quoting *Barker v. Wingo, supra,* 407 U.S. at p. 532.) The weight assigned official negligence compounds over time, its toleration "varies inversely with its protractedness," for "[c]ondoning prolonged and unjustifiable delays in prosecution would both penalize many defendants for the state's fault and simply encourage the government to gamble with the interests of criminal defendants assigned a low prosecutorial priority." (*Doggett v. United States, supra,* 505 U.S. at p. 657.)

at p. 497, quoting *Sykes v. Superior Court* (1973) 9 Cal.3d 83, 94 [failure to rearraign not excused by Attorney General's failure to notify District Attorney of writ of habeas corpus]), finding official negligence insufficient justification to offset the dimming over time of the prosecution witnesses' memories.[11] (*People v. Hill, supra,* 37 Cal.3d at pp. 498-499.)

Contrarily, a "reasonable" delay advancing a "valid police purpose" constitutes adequate justification under any rubric. (*People v. Hartman, supra,* 170 Cal.App.3d at p. 581; *Jones v. Superior Court* (1970) 3 Cal.3d 734, 740-741 [delays necessary for "reasonable law-enforcement operations" will not implicate right].) In *Jones*, the Court reversed based on the 19-month delay between the time the defendant was contacted by police, and charges filed, and when he was eventually brought to trial, during which time the defendant was easily locatable, even as his ability to recall and corroborate his activities were diminished. In so holding, the Court underscored that the need for law enforcement to find a defendant or other witness went to the reasonableness of the delay, not to the application of the right itself. (*Id.,* at pp. 740-741.) In other words, the balance must still be struck.

In *Hartman*, the defendant was charged with a seven-year-old murder: after the first coroner opined death was due to heart disease, the defendant was separately prosecuted for forgery and theft related to misappropriation of the victim's credit cards and a forged check. Due to the persistence of the victim's widow, subsequent autopsies were performed, and murder charges filed. (*People v. Hartman, supra,* 170 Cal.App.3d at pp. 575-577.) In the interim, the coroner's office "misplaced" the victim's brain after the first autopsy, and the coroner who performed that autopsy (and his supervisor) had died; following suit, the victim's heart disappeared after the second autopsy, and the photographs taken at that autopsy went missing. (*Id.,* at pp. 579-580.) Division Three reversed on due process grounds, finding no legitimate justification for the five-year delay after the new coroner's reports had been issued; in so holding, the court emphasized that it is a prosecutor's primary duty to diligently prosecute. (*Id.,* at pp. 580, 583.)

Finally, in *Rice v. Superior Court* (1975) 49 Cal.App.3d 200, 203, the defendant allegedly sold heroin to an undercover officer, then gave him his "home" number; when police attempted to serve the arrest warrant, the Oxnard

11 The Court rejected the State's argument that weakening of the victims' memories only served to help the defendant's case: "to contend that a faded memory aids the Defendant is to assume defendant's guilt; if he is innocent, obviously he would prefer witnesses who can forthrightly so testify." (*People v. Hill, supra,* 37 Cal.3d at p. 498.)

address was that of the defendant's mother. She indicated the defendant did not live there, she did not know where the defendant was living, and would not tell police if she did. An indictment issued; officers made an initial check of bars and motels the defendant frequented, and periodically contacted his mother. Meanwhile, the defendant was living in Oxnard, where he was arrested for traffic offenses and burglary, had an examination as a judgment debtor, applied for a taxi license, and for other employment: none of the participating agencies knew of the warrant because the information was not included in the County computer system. (*Id.*, at p. 204.) Division Four characterized as "obvious negligence" the clerk's failure to advise law enforcement about the warrant, as well as the "most casual effort by the narcotics officers to find defendant. When these officers... really tried to find defendant they had not difficulty; why those same efforts were not expended earlier we are not told." (*Id.*, at p. 205.)

By all accounts, appellant escaped arrest by running from the accident scene on February 21, 1989, and, after spending a few days recuperating at his apartment, went to his job, got his paycheck, and went to Costa Rica to be with his family. Appellant had moved to California from Texas only a few months before the incident; his car was registered in California under his name, and he'd lived with an aunt just before moving to the apartment. A few months after going to Costa Rica, appellant returned to Texas, to the area where he'd grown up. Appellant sent a change of address to his former employer in 1989, and a revised W-2 form was sent to him at his Texas address in 1990. While living in Texas, appellant had a driver's license, registered a car, owned time shares, received paychecks, apparently paid taxes, and otherwise "lived openly under his own name." As detailed, appellant was stopped for speeding in Texas in 1994, was arrested, and told there was a California warrant for his arrest for kidnaping. The next day, appellant was told by Texas police that California did not want him, and released. In 1996, appellant was again held by Texas police, who again contacted the LAPD, and who were then again told, and again told appellant, that the District Attorney didn't want him; appellant followed up by having an attorney contact the LAPD, and was told once more that while there was an active warrant for his arrest, it was not being pursued. (*C.f., Strunk v. United States, supra,* 412 U.S. at p. 439 [recognizing "a prolonged delay may subject the accused to an emotional stress that can be presumed to result in the ordinary person from uncertainties in the prospect of facing public trial... uncertainties that a prompt trial removes."].) But this patchwork of official

incompetence and disinterest does not adequately counter the prejudice suffered by the trial's delay.

What is extraordinary here is that throughout the proceedings on the various speedy trial motions, the fact the Government apparently "lost" appellant's file from 1989 to 1992, and could provide absolutely no account of what, if anything, it did to attempt to locate appellant during those years, was treated as irrelevant to the issue of justification. But "it is the duty of the state to bring a defendant promptly to trial" (*People v. Hill, supra,* 37 Cal.3d at p. 497), and losing a file is proof of official negligence, not its excuse. (*Rice v. Superior Court, supra,* 49 Cal.App.3d at p. 205.) In 1993, police noted appellant's driver's license had expired; there was "no other" information found. Nor was there any excuse made as to why there had been no follow up with appellant's employer, who had his Texas address, or his aunt, who would have known of either his whereabouts, or his family's, or to locate appellant via various national databases. In 1994 and 1996, again, appellant was told that in essence he was not wanted because the victim could not be found. According to the officers with the Fugitive Warrant Unit, it is not responsible for locating victims.

Which was, in turn, no legitimate explanation of the Governments's failure to locate Concepcion: in 1996, a North Hollywood detective newly assigned to the case recreated appellant's warrant package, and tried to find Concepcion, including use of alternative spellings, with no success.[12] The auto track system which eventually located her in 2003, had been used within LAPD since around 1999. There was no reason given for the six-year investigatory gap between 1996 and 2003, no reason given for the failure to find Concepcion using the auto track system between 1999 and 2003. Though locating a witness is an reasonable motivation for reasonable delay, it is not a *carte blanche* for every delay: here, the primary justification offered by the State is bureaucratic at best, the result of an administrative divide between the Fugitive Warrant Unit and the North Hollywood Division. But this is not good enough. Even assuming Concepcion could not have been found during the decade and a half since the incident, the simple fact remains that until the Supreme Court's opinion in *Crawford v. California* (2004) 541 U.S. 36, 53, proscribing admission of extrajudicial testimonial statements as violating the Confrontation Clause, the State could have gone forward with appellant's prosecution based

12 Though there was some discussion of the various official spellings of Concepcion's name, this would not account for any of the delay: though Carlisle spelled the name "Conception," Concepcion herself signed all documents "Concepcion."

on Concepcion's statements to police (and possibly the examining physician). (*Ohio v. Roberts* (1980) 448 U.S. 56; *White v. Illinois* (1992) 502 U.S. 346.) And while this might not have been the optimal way of prosecuting appellant, it was available to the Government for the duration of the fifteen-year delay; if the calculus for determining a constitutional violation is to consider harm to the accused relative to the State's justification, a prosecutorial preference for having a live victim is patently not good enough. The State "cannot simply place gathered evidence of insubstantial crimes on the 'back burner' hoping that it will some day simmer into something more prosecutable...." (*People v. Pellegrino* (1978) 86 Cal.App.3d 776, 781 [delay inexcusable as based on the "lack of interest" in prosecuting based on the state of the evidence]; compare, *People v. Horning, supra,* 34 Cal.4th at pp. 893-895 [defendant's fresh criminality justification for triggering previously refused extradition].) Which is precisely what happened here.

Conclusion

In the fifteen years between the filing of the complaint and appellant's trial, physical evidence was lost/destroyed, and witnesses died, or became otherwise unavailable, memories grew dim and topography was altered. Meanwhile, the State not only did not make reasonable efforts to find appellant, it rejected him for extradition twice. As Division Three has said:

> [T]he crown does not win or lose a case, it merely sees that justice is done. [&] The primary function of the office of the prosecutor is to diligently and vigilantly pursue those who are believed to have violated the criminal codes of the state. [&] While hard blows may be struck against an opponent, the strike may not be withheld without warrant until such time as occasions and adversarial disability.

(*People v. Hartman, supra,* 170 Cal.App.3d at p. 583.) By its extraordinary negligence, the crown here failed to fulfil that duty; appellant's convictions must be reversed. (*People v. Horning, supra,* 34 Cal.4th at pp. 892-893, 895.)

ARGUMENT

APPELLANT'S COUNT 1 THROUGH 9 CONVICTIONS MUST BE REVERSED FOR THE COURT'S FAILURE TO ORDER FULL DISCLOSURE OF POLICE OFFICER CHARACTER EVIDENCE UNDER *BRADY v. MARYLAND*

As noted, in *Pitchess v. Superior Court, supra,* 11 Cal.3d 531, the California Supreme Court set forth the process by which a party can discover citizen complaints against police officers; in *Brady v. Maryland, supra,* 373 U.S. 83, the United States Supreme Court held the prosecution has an affirmative duty in every case to disclose exculpatory evidence to the defense. The ambits of *Pitchess* and *Brady* overlap: *Brady* dictates more generous discovery than *Pitchess.* To the extent the procedures set forth in Penal Code sections 832.5, 823.7, and 832.8 and Evidence Code sections 1043 et seq. abrogate a prosecutor's duty under *Brady,* those provisions are unconstitutional.[1] Appellant's convictions must be reversed for the trial court's failure to order full review and disclosure under *Brady.*

In *Brady v. Maryland, supra,* 373 U.S. 83, the United States Supreme Court found a defendant's fundamental right to a fair trial required disclosure of all material evidence possessed by the state: suppression by the prosecution of evidence favorable to an accused upon request violates due process where the evidence is material either to guilt or to punishment, irrespective of the good faith or bad faith of the prosecution. (*Id.,* at p. 87.) The initial requirement the defense request exculpatory material to trigger the prosecutor's *Brady* duty was abandoned by the Court in *United States v. Agurs* (1976) 427 U.S. 97, 106-108.) which established a three-tiered request-based system for disclosure of exculpatory evidence, later abrogated by the Court in *United States v. Bagley* (1985) 473 U.S. 667, 682, along with any substantive distinction between exculpatory and impeachment evidence.

In *Kyles v. Whitley* (1995) 514 U.S. 419, 433-434, the Court held an individual prosecutor need not be actually aware of *Brady* material to be responsible for its disclosure, because the duty to disclose includes "the duty to learn of any favorable evidence known to the others acting on the government's behalf in the case, including the police." (*Id.,* at pp. 422, 437; *see e.g., In re Brown* (1998) 17 Cal.4th 873, 879, cert. den. 525 U.S. 978 [*Brady* duty

1 In *City of Los Angeles v. Superior Court (Brandon)* (2002) 29 Cal.4th 1, 12, fn. 2, the California Supreme Court expressly reserved opinion on this issue.

encompasses crime lab working with prosecutors]; cf., *People v. Superior Court (Barrett)* (2000) 80 Cal.App.4th 1305, 1317 [*Pitchess* extends to Department of Corrections investigators in prison homicide case].) Justice Souter, writing for the Court, noted this duty is necessarily liberally construed: "... a prosecutor anxious about tacking too close to the wind will disclose a favorable piece of evidence.... This is as it should be."(*Kyles v. Whitley, supra,* 514 U.S. at p. 439; c.f., *Strickler v. Greene* (1999) 527 U.S. 263, 302 (*Brady* case law demonstrates "the special role played by the American prosecutor in the search for truth in criminal trials.").) As soon as there is a *"reasonable probability"* that exculpatory or impeachment evidence could lead to a different result at trial, it becomes material evidence which must be disclosed. (*Kyles v. Whitley, supra,* 514 U.S. at pp. 435-436, emphasis added.) Because materiality is gauged relative to this "reasonable probability," the duty is triggered cumulatively. (*Id.,* at p. 437.) Similarly, issues of Brady materiality are not reviewed in terms of evidentiary sufficiency, but rather whether, absent this evidence, the defendant "received a fair trial, understood as a trial resulting in a verdict worthy of confidence."[2] (*Id.,* at pp. 435-436.) As summarized by the Court in *Strickler v. Greene, supra,* 527 U.S. at pp. 307-308:

There are three components of a true *Brady* violation: The evidence at issue must be favorable to the accused, either because it is exculpatory, or because it is impeaching; that evidence must have been suppressed by the State, either willingly or inadvertently; and prejudice must have ensued. This description fits *Pitchess.*

Pitchess and *Brady* overlap and contradict. In *City of Los Angeles v. Superior Court (Brandon), supra,* 29 Cal.4th at p. 7, the superior court ordered disclosure of a ten-year old complaint of misconduct[3] against an arresting officer pursuant to *Brady* despite section 1045, subdivision (b)(1)'s exclusion of older complaints from discovery. The Court of Appeal upheld the disclosure, the Supreme Court reversed. In its opinion, the Court dilated the connection between *Pitchess* and *Brady* alluded to in *People v. Mooc* (2001) 26 Cal.4th 1216, 1225: *Pitchess* "must be viewed against the larger background of the

2 The best exegesis of this test was set forth in *In re Sassounian* (1995) 9 Cal.4th 535, 545, fn. 7: "A showing by the prisoner of the favorableness and materiality of any evidence not disclosed by the prosecution necessarily establishes at one stroke what in other contexts are separately considered under the rubrics of 'error' and 'prejudice.' For, here, there is no 'error' unless there is also 'prejudice.'" Once a Defendant establishes error, "as a matter of necessity he establishes the prosecutorial nondisclosure was not harmless beyond a reasonable doubt."

3 The officer unjustifiably maced someone and failed to report the incident.

prosecution's constitutional obligation to disclose to a defendant material exculpatory evidence so as not to infringe the defendant's right to a fair trial." (*City of Los Angeles v. Superior Court (Brandon), supra,* 29 Cal.4th at p. 14.) While upholding section 1045, subdivision (b)(1)[4], the majority distinguished between the five-year rule, as it involved the retention/destruction of evidence, and other *Pitchess* provisions, specifically those involving the disclosure of material evidence.[5] (*City of Los Angeles v. Superior Court (Brandon), supra,* 29 Cal.4th at p. 8.) With regard to disclosure of material evidence, the Court unequivocally endorsed the duty of the prosecutor to ascertain impeachment evidence, wherever it may reside:

> In holding that *routine* record destruction after five years does not deny defendant's due process, we do not suggest that a prosecutor who discovers facts underlying an old complaint of officer misconduct, records of which have been destroyed, has no *Brady* obligation. At oral argument, the Attorney General, appearing as amicus curiae on behalf of the City, agreed that, regardless of whether records have been destroyed, *the prosecutor still has a duty to seek and assess such information and to disclose it if it is constitutionally material.*

(*City of Los Angeles v. Superior Court (Brandon), supra,* 29 Cal.4th at p. 12, additional italics added; *Ibid.,* fn. 2 ["Because the issue is not presented here, we do not reach the question of whether Penal Code section 832.7... would be constitutional if it were applied to defeat the right of a prosecutor to obtain access to officer personnel records in order to comply with *Brady.*"]; accord, *Kyles v. Whitley, supra,* 514 U.S. at pp. 437-438.).)

Or, as stated by Justice Moreno's dissent: "Even though police agencies have dominion and control over sustained criminal complaints, the prosecutor, as spokesperson for the government, is required under *Brady* to

4 Precluding discovery of civilian complaints occurring more than five years before the litigated criminal act. (Evid. Code § 1045(b)(1).)

5 As section 1045, subdivision (b)(1) concerned the former, it was more appropriately gauged by the considerations involving the failure to retain evidence set forth in *California v. Trombetta* (1984) 467 U.S. 479, 488-489 and *Arizona v. Youngblood* (1988) 488 U.S. 51, 56. Because retention/destruction of evidence implicates due process only when the evidence at issue is patently exculpatory, it involves a "narrower" prosecutorial obligation than the duty to discover/ disclose material impeachment or exculpatory evidence. (*City of Los Angeles v. Superior Court (Brandon), supra,* 29 Cal.4th at p. 8.)

disclose the same." (*City of Los Angeles v. Superior Court (Brandon), supra,* 29 Cal.4th at p. 29; *see, United States v. Agurs, supra,* 427 U.S. at p. 107 [prosecutor has *Brady* duty to discover/disclose absent request by defendant]; *Kyles v. Whitley, supra,* 514 U.S. at p. 437 [scope of disclosure includes evidence known "to others acting on the government's behalf"]; *Giglio v. United States* (1972) 405 U.S. 150, 154 [prosecutor alone is responsible for disclosure on behalf of State].) In order for the prosecution to properly discharge this duty, it has an affirmative obligation to investigate the personnel files of all significant police officer witnesses, and to disclose to the defense any complaints which may either exculpate the defendant or impeach those witnesses. (*Accord, City of Los Angeles v. Superior Court (Brandon), supra,* 29 Cal.4th at p. 12.)

Historically, California appellate courts have been loathe to insist on full compliance with *Brady* relative to police personnel files. In *People v. Guiterrez* (2003) 112 Cal.App.4th 1463, Division Three held there is no *Brady* duty that prosecutors review police personnel files for material impeachment information given the Supreme Court's opinion in *Alford v. Superior Court* (2003) 29 Cal.4th 1033. Because *Pitchess* has a lesser showing of materiality than *Brady*, Division Three reasoned, the two schemes operate "in tandem" to secure a defendant's due process rights. (*People v. Guiterrez, supra,* 112 Cal. App.4th at p. 1473.) But this analysis obscures the fact *Brady* has no predicate showing of cause requirement relative to the State's duty to review, and the one established under *Pitchess* hitches cart before horse, to both parties' detriment. Moreover, the *Guiterrez* court's absolution of the individual prosecutor's *Brady* obligation is based on faulty readings of *City of Los Angeles v. Superior Court (Brandon), supra,* 29 Cal.4th 1 and *Alford v. Superior Court (People), supra,* 29 Cal.4th 1033. (*People v. Guiterrez, supra,* 112 Cal.App.4th at pp. 1474-1475.) Neither *Brandon* nor *Alford* stands for wholesale ratification of *Pitchess* qua *Brady* – given *Brandon* considered only the propriety of the five-year rule of section 1045, subdivision (b)(1), and *Alford* with whether subdivision (e) limits disclosure to the proceeding triggering *Pitchess* discovery, and the *prosecutor's* right to such discovery. The Supreme Court in both cases reserved judgment on the constitutionality of the *Pitchess* scheme, specifically declining to make the very proclamation attributed to it by Division Three in *Guiterrez*. (*Alford v. Superior Court (People), supra,* 29 Cal.4th at p. 1046, fn. 6; *City of Los Angeles v. Superior Court (Brandon), supra,* 29 Cal.4th at p. 12, fn. 2.) Moreover, the Court has reasserted a proactive prosecutorial obligation under *Brady*:

In holding that *routine* record destruction after five years does not deny defendant's due process, we do not suggest that a prosecutor who discovers facts underlying an old complaint of officer misconduct, records of which have been destroyed, has no *Brady* obligation. At oral argument, the Attorney General, appearing as amicus curiae on behalf of the City, agreed that, regardless of whether records have been destroyed, *the prosecutor still has a duty to seek and assess such information and to disclose it if it is constitutionally material.*

(*Ibid.*, additional italics added; *accord, Kyles v. Whitley, supra,* 514 U.S. at p. 437; *Giglio v. United States, supra,* 405 U.S. at p. 154.) Again: "To the extent a prosecution-initiated *Pitchess* motion yields disclosure of such information, the prosecutor's obligation, as in any case, are governed by constitutional considerations in the first instance." (*Alford v. Superior Court (People), supra,* 29 Cal.4th at p. 1046, fn. 6.) Considerations moreover pressing:

Police abuse "remains one of the most serious and divisive human rights violations in the United States." (Human Rights Watch, Overview to *Shielded from Justice: Police Brutality and Accountability in the United States,* p. 1 (July 1998) (http://www.hrw.org/reports98/police.html).) There is a perennial lack of abuse accountability within police departments, between police and prosecutors, and between public officials and the public, and one manifestation of this is that departments routinely shield abuse complaints from disclosure. (Human Rights Watch, *passim*; Amnesty International, *Race, Rights and Police Brutality in the United States of America* (September 21, 1999) (http://www.amnestyusa.org/rightsforall/police/brutality/brutality-1.html).) This policy problem assumes constitutional significance when complaints of abuse are shielded from criminal defendants. To maintain that the lower *Pitchess* showing adequately preserves a defendant's *Brady* rights (*People v. Guiterrez, supra,* 112 Cal.App.4th at p. 1476) is *post hoc, ergo propter hoc* analysis. If a defendant cannot make a showing under *Pitchess*, he will not get impeachment information he is constitutionally entitled to under *Brady*, which requires no such showing. The due process question thus begged, it should be of no comfort to anyone – prosecutors included – to incarcerate people based on the unimpeached testimony of those who the State might reasonably suspect are liars, thieves, or worse. And if *Brady* is limited to information the

prosecutor "'knowingly possesses or has *the right to possess*'" (*Id.* at p. 1475, quoting *People v. Jordan* (2003) 108 Cal.App.4th 349, 358 [Division Three opinion *idem*]), then appellate courts are, via *Pitchess*, carving out a large and unheralded exception to the United States Supreme Court's opinion in *Kyles*, which held the duty of disclosure included disclosure of all such evidence "known to the others acting on the government's behalf in the case, including the police." (*Kyles v. Whitley, supra,* 514 U.S. at p. 422.)

Contrarily, it is a matter of course in federal court to suppose the Government has, not only a constitutional obligation to disclose impeachment material contained in police personnel files, but a truth-seeking interest in discerning which officers are unworthy of belief:

In *United States v. Cadet* (9th Cir. 1984) 727 F.2d 1453, defendants requested files of all FBI agents investigating their case; the government argued the files should not be subject to discovery because the defense had made no showing of materiality. The Ninth Circuit noted: "'This is true, but it is not the answer to *Brady.* The burden is on the government to produce, not on the defendant.'" (*Id.,* at pp. 1467, quoting *United States v. Deutsch* (5th Cir. 1973) 475 F.2d 55, 58, overruled on another point in *United States v. Henry* (5th Cir. 1984) 749 F.2d 203, 206, fn. 2.) Regarding the State's request that the lower court modify its discovery order to require the prosecutor examine personnel files for "material helpful to the defense," the court found this:

> ... curious and disingenuous in light of the government's constitutional duty under *Brady v. Maryland* [cite] to disclose exculpatory information to an accused. No order was necessary to compel the government to accord due process to these defendants.... The prosecutor's oath of office, not the command of a federal court, should have compelled the government to produce any favorable evidence in the personnel records.

(*United States v. Cadet, supra,* 727 F.2d at p. 1467.) *I.e.:*

> The government is incorrect in its assertion that it is the defendant's burden to make an initial showing of materiality. The obligation to examine the files arises by virtue of the making of a demand for their production.

(*United States v. Henthorn* (9th Cir. 1991) 931 F.2d. 29, 31, quoting *United States v. Cadet, supra*, 727 F.2d at p. 1467; *United States v. Veras* (7th Cir. 1995) 51 F.3d 1365, 1374-1375, cert. den. 516 U.S. 999.)[6] In *United States v. Dominguez-Villa* (9th Cir. 1992) 954 F.2d 562, 565, the government maintained it should have discretion to decide which files to examine, that requiring a search of all law enforcement witness files imposed too great a burden on the state, a burden which outweighed any speculative prospect that something might be found to benefit the defense, and finally, that defendants should have "the duty to demonstrate a substantial basis for the assertion that the file contains material evidence." The federal court again rejected these arguments, underscoring a prosecutor's duty to examine police personnel files under *Brady* is triggered "upon a defendant's request for their production," not on any prerequisite showing of cause or materiality. (*Accord, United States v. Jennings* (9th Cir. 1992) 960 F.2d 1488, 1490-1492 ["AUSA prosecuting a case is responsible for compliance with the dictates of *Brady* and its progeny.... This personal responsibility cannot be evaded by claiming lack of control over the files or procedures of other executive branch agencies."].) And while there is a split among federal appellate courts as to the proper approach to disclosure of citizen complaints – four Circuits assert an affirmative obligation on the part of the State to discern and disclose information in personnel files, three Circuits impose this obligation only where practicable, and another three would take into consideration additional questions of access and actual materiality – all appear to presume a relationship between *Brady, Kyles*, and routine prosecutorial review and appropriate disclosure of police personnel files:

The First, Second, Third, and Seventh Circuits hold the prosecutor responsible for disclosure by all associated parties. (*See, e.g., United States v. Osorio* (1st Cir. 1991) 929 F.2d 753, 760-762 ["'The government' is not a congery of independent hermetically sealed compartments..."]; *United States v. Thornton* (3rd Cir. 1993) 1 F.3d 149, 158, cert. den. 510 U.S. 982 [prosecutors obligated "to make a thorough inquiry of all enforcement agencies that had a potential connection to the witnesses."]; *Carey v. Duckworth* (7th Cir. 1984) 738 F.2d 875, 878 [prosecutors cannot evade Brady by "compartmentalizing information about different aspects of a case."]; *accord, United States v. Payne* (2nd Cir. 1995) 63 F.3d 1200, 1209, cert. den. 516 U.S. 1165.) Two Eighth Circuit

6 Though state courts are not bound by the decisions of lower federal courts, even on federal questions, "they are persuasive and entitled to great weight." (*People v. Bradley* (1969) 1 Cal.3d 80, 86; *Etcheverry v. Tri-Ag Service Inc.* (2000) 22 Cal.4th 316, 320-321.)

opinions matter-of-factly assume a routine prosecutorial duty to review police personnel files pursuant to Brady, though do not otherwise dilate upon the parameters of that duty. (United States v. Pou (8th Cir. 1991) 953 F.2d 363, 366-367, cert. den. 504 U.S. 926; United States v. Civella (8th Cir. 1981) 666 F.2d 1122, 1130.)

The Fifth, Sixth and Eleventh Circuits advance the most restrictive concept of the obligation to disclose; the Fifth Circuit conditions the duty primarily on the prosecutor's access to the material sought. (United States v. Auten (5th Cir. 1980) 632 F.2d 478, 481; Williams v. Whitley (5th Cir. 1991) 940 F.2d 132, 133 ["[T]he prosecution is deemed to have knowledge of information readily available to it."].) Law enforcement files are presumed available to the State. (See e.g., United States v. Deutsch, supra, 47 F.2d at p. 57.) The Sixth and Eleventh Circuits require the defendant "support his contention that the personnel files might contain information of significance to his case" (United States v. Quinn (11th Cir. 1997) 123 F.3d 1415, cert. den. 523 U.S. 1012; United States v. Driscoll (6th Cir. 1992) 970 F.2d 1472, 1482, cert. den. 506 U.S. 1083), though the extent of this showing is unclear (United States v. Pitt (11th Cir. 1983) 717 F.2d 1334, 1339, cert. den. 465 U.S. 1068 [personnel files not disclosed because FBI agent not "important" witness; defendant "was entitled to fish, but not with this thin a pole."]).[7]

The Ninth, Tenth and District of Columbia Circuits opt for a fluid approach, factoring the relationship of the entities involved and the likelihood the materials will prove exculpatory. (E.g., United States v. Bryan (9th Cir. 1989) 868 F.2d 1032, 1036, cert. den. 493 U.S. 858 [district court to determine if prosecution "had knowledge of and access to" Brady material outside district]; Smith v. Secretary of New Mexico Department of Corrections (10th Cir. 1995) 50 F.3d 801, 825, cert. den. 516 U.S. 905 [noting division between Circuits; as district attorney actually knew of separate agency investigations, duty extended to each]; United States v. Brooks (D.C. Cir. 1992) 966 F.2d 1500, 1503 [duty extends to police homicide and Internal Affairs Division files "[g]iven the close working relationship between" agency and prosecutor and fact "there was enough of a prospect of exculpatory materials to warrant a search."]; c.f., United States v. Jennings, supra, 960 F.2d at p. 1490 [obligation to produce "any favorable evidence in the personnel records"].) The Tenth Circuit has as yet

7 Appellant was unable to find viable Fourth Circuit authority on the issue; in an unpublished opinion, the lower court stated personnel files did not have to be disclosed absent proof the files contained material impeachment evidence. (United States v. Watson (4th Cir. 1997) 116 F.3d 474, 1997 U.S. App. LEXIS 20121.)

not determined the precise contours of the obligation to review. (*United States v. Combs* (10th Cir. 2001) 267 F.3d 1167, 1175 ["more constrained approach" lies in relying on finding of immateriality]; *United States v. McElhiney* (10th Cir. 2001) 275 F.2d 928, 933, cert. den. 541 U.S. 1055 [no violation as no evidence witness material or file information favorable].)

California, by comparison, precludes discovery of citizen complaints against police officers by anyone – including prosecutors – without a predicate showing of materiality. (Cal. Evid. Code §§ 1043-1047; Cal. Pen. Code §§ 832.5, 832.7, 832.8; *City of Los Angeles v. Superior Court (Brandon), supra,* 29 Cal.4th at p. 21.) But *Pitchess* grew out of the desire to balance a defendant's need for discovery against a police officer's need for confidentiality (*People v. Jackson, supra,* 13 Cal.4th at p. 1220), and such a conditional statutory privilege must be limited in each case by the countervailing need for information contained in those records. (*But see, City of Los Angeles v. Superior Court (Brandon), supra,* 29 Cal.4th at p. 30, fn. 6, diss. opn. by Moreno, J. [officer's interest in confidentiality of sustained complaints "arguably illegitimate."].) The officers' privilege is not grounded in a constitutional right of privacy, for there is no reasonable expectation of privacy in keeping relevant items from the public,[8] nor is it truly a right of confidentiality, for concerns of confidentiality or potential embarrassment are not proper considerations in determining whether to disclose material in those files. (*See, Welsch v. City and County of San Francisco* (N.D. Cal. 1995) 887 F.Supp. 1293, 1299 [female officer suing for sexual harassment sought documents relating to internal investigation of charges]; *Rosales v. City of Los Angeles, supra,* 82 Cal.App.4th at pp. 424-426 [no private cause of action where statutory procedures for disclosure were violated]; *Bradshaw v. City of Los Angeles* (1990) 221 Cal.App.3d 908, 912, 916-918, 921-922 [no statutory right of confidentiality or constitutional right of privacy applies to public disclosure of results of disciplinary hearing]; c.f., *People v. Superior Court (Gremminger)* (1997) 58 Cal.App.4th 397, 404 [prosecution sought discovery of ex-officer cum defendant's records; Pen. Code § 832.7 exemption applies only to police officers under investigation by the district attorney].) Rather than invest peace officers with substantive rights to be balanced against defendants' rights, the Pitchess statutes codify the workings of a limited privilege, which must

8 In *Rosales v. City of Los Angeles* (2000) 82 Cal.App.4th 419, 427-428, the Court of Appeal found no privacy-based cause of action for a police officer whose files were disclosed in violation of *Pitchess,* finding no reasonable expectation that such records would not be disclosed (if relevant) during litigation. As the officer could not demonstrate a reasonable and legitimate expectation of privacy in his personnel file, his file was not so personal that it "deserved constitutional protection."

necessarily cede to constitutional rights. (See, United States v. Cadet, supra, 727 F.2d at p. 1467; accord, City of Los Angeles v. Superior Court (Brandon), supra, 29 Cal.4th at p. 10.)

And an affirmative duty is a self-executing duty. In Izazaga v. Superior Court (1991) 54 Cal.3d 356, 377, the Court found the reciprocal discovery provisions of Proposition 115 did not diminish a prosecutor's affirmative obligations under Brady, for a prosecutor's duty to disclose such evidence exists "regardless of whether there has been a request for such evidence...." (In re Brown, supra, 17 Cal.4th at p. 879.) The Court went on to underscore the proactive nature of the prosecutor's obligation:

> The prosecutor's duties of disclosure under the due process clause are wholly independent of any statutory scheme of reciprocal discovery. The due process requirements are self-executing and need no statutory support to be effective. ... Furthermore, if a statutory discovery scheme exists, these due process requirements operate outside such as scheme. The prosecution is obligated to disclose such evidence voluntarily, whether or not the defendant makes a request for discovery.

(Izazaga v. Superior Court, supra, 54 Cal.3d at pp. 377-378, emphasis in the original; People v. Bohannon (2000) 82 Cal.App.4th 798, 804; People v. Superior Court (Barrett), supra, 80 Cal.App.4th at p.1305.) Because the prosecutor's due process duties are independent of any statutory scheme of police personnel record confidentiality, the requirements of Brady need no Pitchess support to be effective. As the Pitchess statutes not only require a defendant request material the prosecution is under a pre-existing obligation to provide, but demand a showing of good cause to compel such discovery, they are unconstitutional in criminal cases.

In City of Los Angeles v. Superior Court (Brandon), supra, 29 Cal.4th at p. 11-12, the Court found the five-year rule was a regulatory device affecting the simple retention of evidence, implicating no "fundamental principle of justice" and embodying no due process violation. Complaints over five-years old could be judicially reviewed to determine disclosure under Pennsylvania v. Ritchie (1986) 480 U.S. 39, 46 [94 L.Ed.2d 40, 107 S.Ct. 989], in which the defendant sought confidential Children's Youth Services reports concerning his daughter's molestation. In Ritchie, the United States Supreme Court held that

as Pennsylvania law provided for limited disclosure, such limited disclosure – review by a court pursuant to a court order – was sufficient to protect both the State's confidentiality interests and the defendant's right to discover exculpatory evidence. (*Id.*, at pp. 58-60.) However, while *Ritchie* may sanction the process by which complaints over five years old may be judicially administered, it does not address the crux of the *Pitchess-Brady* problem.

The information at issue in *Ritchie* was statutorily available to law enforcement, and thus, would have been presumptively available to the prosecution under *Kyles*. As *Ritchie* predates *Kyles*, there was no *Brady* duty then-imposed on the prosecutor to be privy to information in the CYS files; however, as *Ritchie* now operates in tandem with *Kyles*, the *Pitchess* statutes, unlike the statute at issue in *Ritchie*, wholly prevent the prosecution from reviewing such confidential material to determine what need be disclosed under *Brady*. (See, *Pennsylvania v. Ritchie, supra,* 480 U.S. at p. 58, fn. 14 ["We express no opinion on whether the result in this case would have been different if the statute had protected the CYS files form disclosure to *anyone*, including law-enforcement and judicial personnel."].)

Too, *Ritchie* was a discovery case. The California Supreme Court treated the five-year plus files as a discovery problem, first relating it to *Trombetta* and then to *Ritchie*. (*City of Los Angeles v. Superior Court (Brandon), supra,* 29 Cal.4th at pp. 8, 12.) But the *Pitchess* statutes, as they implicate *Brady* interests, are not a matter of defense discovery, but of prosecutorial duty.[9] As applied in criminal cases, the *Pitchess* statutes unconstitutionally abrogate the *Brady* duty to review. (*Id.*, at p. 20, fn. 2.)

Because the *Pitchess* statutes are not restricted to the criminal context, they are facially valid. Facially valid statutes unconstitutionally applied are generally reviewed on a case-by-case basis. (*Hale v. Morgan* (1978) 22 Cal.3d 388, 404.) However, the core conflict between *Pitchess* and *Brady* is not amenable to such piecemeal resolution, for it inheres in the provisions of Penal Code sections 832.5, 832.7, and 832.8, and Evidence Code sections 1043 et seq..[10] Though there is a strong presumption in favor of construing

9 The more generalized "fair trial" language in *Pitchess* itself led to a misapprehension of *Pitchess* as emanating from a defendant's discovery rights. (See e.g., *City and County of San Francisco v. Superior Court (Lemas)* (1981) 125 Cal.App.3d 879, 881-882.)

10 The code sections here are constitutionally problematic because while they are arguably facially valid (having no specific reference to criminal defendants), they are uniformly applied in a manner that violates criminal defendants' due process rights under *Brady*. Therefore, it could be argued that the statutes' failure to exclude criminal defendants from their provisions renders them facially invalid and thus subject to prophylactic consideration. At the same time, of course,

statutes so they may be saved from constitutional doubt (*People v. Superior Court (Romero)* (1996) 13 Cal.4th 497, 509), such resuscitation is impossible as these sections are applied in criminal proceedings. (*Tobe v. City of Santa Ana* (1995) 9 Cal.4th 1069, 1084; *People v. Gallegos* (1997) 54 Cal.App.4th 252, 267 ["'absent constitutional constraints, when the Legislature has established policy, it is not for the courts to differ,'" quoting *Gikas v. Zolin* (1993) 6 Cal.4th 841, 851].) As the California Supreme Court said in another context: "No statute can limit the ... due process rights of a criminal defendant." (*Izazaga v. Superior Court, supra,* 54 Cal.3d at p. 378.)

Given *Pitchess* and its codification(s) are predicated on the understanding that law enforcement personnel files may contain impeachment material relevant to a criminal defense, given to withhold such evidence – if material – would violate the defendant's right to a fair trial (*People v. Mooc, supra,* 26 Cal.4th at p. 1227), and given the confidentiality of these files is purely a statutory privilege (*ibid*), what is directly at issue is whether Evidence Code sections 1043 et seq., and Penal Code sections 832.5, 832.7, and 832.8, as they equate constitutional right to statutory interest, burdening the former out of solicitude for the latter, are constitutional as applied in criminal cases. They are not.

First, *Pitchess* requires a predicate showing of good cause by a defendant. (Evid. Code § 1043(b).) *Pitchess* motions may be, and was here, denied because of insufficient affidavits or other deficiencies in providing the trial court "'a specific factual scenario' which establishes a 'plausible factual foundation' for the allegations of officer misconduct committed in connection with defendant." (*California Highway Patrol v. Superior Court, supra,* 84 Cal. App.4th at p. 1020; see e.g., *People v. Samayoa* (1997) 15 Cal.4th 795, 824-827, cert. den. 522 U.S. 1125.) Again, *Brady* is self-executing (*Kyles v. Whitney, supra,* 514 U.S. at p. 434 ["the constitutional duty is triggered by the potential impact of favorable but undisclosed evidence"]); *Pitchess* thus improperly puts a burden of special pleading and proof on the defendant to demonstrate the relevancy of information the Supreme Court has recognized as potential *Brady* material which the accused is entitled. (*People v. Mooc, supra,* 26 Cal.4th at p. 1227.) As suggested by the Court in *City of Los Angeles v. Superior Court (Brandon), supra,* 29 Cal.4th at p. 12, fn. 2], this begs the question, for any

appellant reiterates the invalidity of the statutes as applied in his case. In short, while the challenge here is not primarily facial, there is enough of an impermissible "effect" to the statutes, and the application in appellant's case so completely iterable, that the statute should be held invalid in all criminal cases. (*Bowen v. Kendrick* (1988) 487 U.S. 589, 600-602, 604-606.)

failure of proof on the defendant's part is partly due to the procedural hurdles thrown in his path by *Pitchess* – *i.e.*, the root of the *Brady* error here is not that the State knowingly suppressed material impeachment evidence, but that the State never properly looked for such evidence in the first place: *Pitchess* shields *Brady* material.

Second, *Pitchess* permits only same-genus discovery: if there's an allegation of lying, allegations of dishonesty are discoverable; if allegations of violence, violence is discoverable. (*See e.g., People v. Hustead, supra,* 74 Cal.App.4th at pp. 416-417 [defendant alleged fabricated police report, prior complaints of dishonesty discoverable]; *City of San Jose v. Superior Court, supra,* 67 Cal.App.4th at pp. 1146-1147 [defendant alleged illegal arrest based on excessive force, prior complaints of excessive force discoverable]; *Larry E. v. Superior Court, supra,* 194 Cal.App.3d at pp. 28-33 [defendant alleged he used no force against the officers, officers lied, planted evidence on defendant, prior complaints of aggression and dishonesty discoverable]; *Pierre C. v. Superior Court, supra,* 159 Cal.App.3d at pp. 1122-1123 [minority defendant alleged false arrest, allegations of racial prejudice and false arrest discoverable].) But *Brady* understands an officer's history of violence puts all his credibility at issue, acts of dishonesty contradict one who denies beating a suspect, and racial animus belies impartiality. The purpose of impeachment is to undermine a witness's testimony, either via scalpel or shotgun, and it cannot be the province of the trial court to exclude wholesale impeachment for being insufficiently identical to the case at hand. (Evid. Code § 210.)

Third, violations of *Pitchess* and *Brady* result in different standards of review. Claims of *Pitchess* error are deferentially reviewed for abuse of discretion (*People v. Jackson, supra,* 13 Cal.4th at p. 1219; *People v. Breaux* (1991) 1 Cal.4th 281, 311-312, cert. den. 506 U.S. 873), while the question under *Brady* is not whether there is enough other evidence to convict the defendant, but whether the missing evidence would have undermined confidence in the verdict itself – such as where the lone witness against a criminal defendant can be shown to be a liar, bigot, brutalizer, or thief. (*Kyles v. Whitley, supra,* 514 U.S. at p. 435; *Strickler v. Greene, supra,* 527 U.S. at pp. 307-308; *In re Sassounian, supra,* 9 Cal.4th at p. 545, fn. 7 ["the favorableness and materiality of any evidence not disclosed by the prosecution necessarily establishes at one stroke what in other contexts are separately considered under the rubrics of 'error and prejudice.'"].) Which brings the problem back to its origin:

There is no right equation of the interests here at stake. In *Mooc*, the Court variously termed the officer's stake in his personnel files as a "strong privacy interest," a "'just claim to confidentiality'", and an "interest in privacy."[11] (*People v. Mooc, supra,* 26 Cal.4th at p.1227, quoting *City of San Jose v. Superior Court, supra,* 5 Cal.4th 47, 53.) Evidence Code section 1045, subdivision (d) states the scheme's procedures are to protect that interest and officer from "unnecessary annoyance, embarrassment or oppression." But a criminal defendant is not subject to a comparable degree of "annoyance, embarrassment or oppression." A criminal defendant, deprived of his due process rights, is subject to conviction, imprisonment, and, in some cases, death. (*Chambers v. Mississippi* (1973) 410 U.S. 284, 295; *California v. Trombetta, supra,* 467 U.S. at p. 485.)

Appellant filed both *Pitchess* and *Brady* motions, seeking all exculpatory or impeachment evidence contained in the personnel files of the police-witnesses in this case. The trial court indicated the defense was entitled to *Brady* material, but denied the request in reliance on the prosecutor's statements that he "ran on the District Attorney computer all of the officers listed from both Pomona and Claremont that I had, and I received no *Brady* hits. Therefore, the People have no *Brady* discovery...." (RT A-2) and "[t]hrough the District Attorney Computer I personally, pursuant to District Attorney policy, ran each of the names that counsel mentioned in the two separate motions. I received no hits on any of them through the District Attorney *Brady* computer setting, whatever we have in this thing." (RT A-11-A-12) But this database check does not and cannot discharge the State's constitutional duty: according to the Los Angeles District Attorney's website, the "*Brady* Alert System" is composed of a "*Brady* Compliance Division," acting as a repository for "known *Brady* information," to be maintained in the database and disclosed to defense counsel. For database purposes, materiality is defined as a "reasonable probability of a different outcome" in the case if the evidence had been disclosed, *i.e.,* "where suppression undermines confidence in the outcome. Such evidence must have specific, plausible connection to the case, and must demonstrate more than minor inaccuracies." Examples of specific impeachment evidence include: evidence of a witness's criminal conviction if the crime involves moral turpitude as defined by *Castro-Wheeler,* false reports, pending criminal charges, parole/probation status, "evidence contradicting a prosecution witness' statements or reports," "evidence undermining a prosecution witness' expertise (e.g. inaccurate statements), a finding of misconduct by a Board of Rights or Civil

11 The Court in *Brandon* did not revisit this characterization.

Service Commission "that reflects on the witness' truthfulness, bias or moral turpitude," evidence a witness has a reputation for untruthfulness, evidence a witness has a group-based bias against the defendant as an individual or as a group member, and promises or inducements made to the witness.[12] What is *not* considered *Brady* material are: "[a]llegations that cannot be substantiated, are not credible, or have been determined to be unfounded...."; and the only information from an employee's personnel file to be included "is that which is received pursuant to a *Pitchess* motion, where a court has released information without a protective order prohibiting dissemination of the material, or pursuant to an investigation resulting in a criminal charge filed against the employee." The decision whether to include information concerning peace officer witnesses "will be made using a standard of *clear and convincing evidence*" (emphasis in the original). (Los Angeles County District Attorney's Office, Special Directive 02-08 [Brady Protocol, December 7, 2002][http://da.co.la.ca.us/sd02-08.htm].)

The primary problem here lies in the interplay between the Special Directives: the first acting as scoop, the second as sieve: if the sieve is too fine, the size of the scoop is immaterial. Taken together, the Directives gesture towards *Brady* while thwarting its practical application. Preliminarily, according to Special Directive 02-07, the Los Angeles County District Attorney's Office only provides defense counsel with impeachment information relating to a police officer witness if counsel either files a *Pitchess* motion or otherwise affirmatively alleges untruthfulness. As has been noted *infra*, there is strong argument that *Brady* ought not require a predicate defense demand, given *Brady* creates an independent prosecutorial obligation. And once counsel has triggered the State's performance of its *Brady* duty, the District Attorney's Office then determines whether the officer is "material" to the State's case; if an officer is deemed by the prosecution to be sufficiently material, then the final grid is overlaid: according to Special Directive 02-08, only that material considered by the Brady Compliance Division reliable and credible under a *clear and convincing evidence* standard is to be included in the database.

12 According to the District Attorney's Special Directive 02-07 [Possible Brady Material in the Possession of Law Enforcement, December 7, 2002], potential exculpatory/impeachment evidence includes "statements made by the Defendant or potential defense witnesses that a material law enforcement employee/witness used excessive force." The Special Directive also cited *Brandon* as standing for the proposition that if section 832.7 was used to defeat a prosecutor's "right" to access officer personnel records in order to comply with *Brady*, "it may be unconditional [sic] as applied." The duty to conduct a *Brady* search is triggered by the defense filing of either a *Pitchess* motion or a signed declaration under penalty of perjury by someone with personal knowledge of the officer's untruthfulness. ([http://da.co.la.ca.us/sd02−07.htm].)

Conceptually, the District Attorney's clear and convincing standard for inclusion runs straight afoul of the constitution standard for disclosure set by the Court in *Kyles*, which held, again, that as soon as there is a *"reasonable probability"* exculpatory/impeachment evidence could lead to a different result at trial, it becomes material evidence to be disclosed. (*Kyles v. Whitley, supra,* 514 U.S. at pp. 435-436, emphasis added.) On that basis alone, the County's *Brady* database does not satisfy the State's *Brady* duty and cannot be relied upon as a constitutional matter. Practically, this standard of inclusion improperly filters out everything from a complaint by an arrestee of mistreatment (as arrestees are typically not considered inherent fonts of truth, *c.f., People v. Campa* (1984) 36 Cal.3d 870, 883-884), to misconduct resulting in officer discipline by the Board of Rights, which, as all administrative agencies, uses a preponderance standard in its decisionmaking (Evid. Code § 115), to *Pitchess* information which has met all showings of materiality and been disclosed pursuant to protective order (preventing prosecutors from meeting their *Kyle-Brady* obligation in subsequent cases), to cases in which an officer has been criminally investigated (reasonable suspicion/probable cause), if no charges (beyond a reasonable doubt) are ultimately filed. Not to put too fine a point on it, but an officer could be fired for brutality, and that salient fact would be filtered out of the database.

For California prosecutors to fully comply with the dictates of *Brady*, they must actually *review* the files of their peace officer witnesses for material exculpatory or impeachment evidence to be disclosed to the defense whenever there is a *reasonable probability* such evidence exists. "To the extent this places a burden on the large prosecution offices, procedures and regulations can be established to carry that burden and to insure communication of all relevant information on each case to every lawyer who deals with it." (*Giglio v. United States, supra,* 405 U.S. at p. 154.) If an individual prosecutor is unclear as to the materiality of the evidence at issue, he should submit the information to the superior court for *in camera* inspection and consideration under the dictates of *Brady*. (*United States v. Cadet, supra,* 727 F.2d at p. 1468; *accord, City of Los Angeles v. Superior Court (Brandon), supra,* 29 Cal.4th at p. 15, fn. 3; *c.f., Delany v. Superior Court* (1990) 50 Cal.3d 785, 805-806, 814 [newsperson's shield law may be pierced; necessity for *in camera* hearing].) The defense should not have to divine bias or prove misconduct where the State knows bias and misconduct exist.[13] Appellant was sentenced to 75 years to life in state prison on the

13 *I.e.*, officers know their testimony may be impeached with information contained in their personnel files, and as part of the prosecution team, have a *Brady* duty to disclose this material.

testimony of police who had, by all accounts, beaten him severely; whatever statutory interests the officers had in maintaining the confidentiality of their personnel files, appellant had a greater constitutional stake in their disclosure. (*C.f., Lissner v. United States Custom Service* (9th Cir. 2001) 241 F.3d 1220, 1223 [public interest in disclosing personnel file information outweighed privacy interests of Customs Agents].) As the United States Supreme Court has said: "The right of an accused in a criminal trial to due process is, in essence, the right to a fair opportunity to defend against the State's accusations."(*Chambers v. Mississippi, supra,* 410 U.S. at p. 294.) Or, more precisely:

> ... some burden is placed on the shoulders of the prosecutor when he is required to be responsible for those persons who are directly assisting him in bringing an accused to justice. But this burden is the essence of due process of law. It is the State that tries a man, and it is the State that must insure that the trial is fair.

(*Moore v. Illinois* (1972) 408 U.S. 786, 809-810 (conc. and dis. opn., Marshall, J.).)

Those defendants, like appellant, who have the misfortune to be accused solely by police witnesses may be convicted despite the existence of solid impeachment evidence simply because their accusers wear badges. (*City of Los Angeles v. Superior Court (Brandon), supra,* 29 Cal.4th at p. 24.) The problem is it is too hard to crack the seal of the State here: the State charges, attests, and convicts, and much that might militate against this sequence of events the State too-easily protects from disclosure. As the Court stated in *United States v. Bagley, supra,* 473 U.S. 667:

> "The jury's estimate of the truthfulness and reliability of a given witness may well be determinative of guilt or innocence, and it is upon such subtle factors

(*United States v. Osorio, supra,* 929 F.2d at p. 762 ["it may be a form of insubordination if the investigative agents working on the case for trial counsel are not forthcoming in satisfying the government's disclosure obligations."].) Of course, this brings up the impolite fact that officers who lie, lie. (Berry and Guccione, *D.A. to Seek Discipline Files of Police,* Los Angeles Times (May 4, 2002) p. B1, cols. 4-5.) If the police cannot police the police, it is surely unreasonable to require the defense to do the job. (*United States v. Deutsch, supra,* 475 F.2d at p. 57; *see e.g.,* Landsberg and Gorman, *Inglewood to Act on Citizen Complaints,* Los Angeles Times (August 9, 2002) p. B1, B12, cols. 4-5; Lait and Glover, *Inglewood Police Accused of Abuse in Other Cases: Despite lawsuits and cash settlements, no complaint has been referred for prosecution,* Los Angeles Times (July 15, 2002) p. A1, cols. 1-2.)

as the possible interest of the witness in testifying
falsely that a defendant's life or liberty may depend."
at pp. 682-683, quoting *Napue v. Illinois* (1959) 360 U.S. 264, 269.)
When the Supreme Court set forth the duty of disclosure in *Brady v. Maryland, supra,* 373 U.S. at p. 87, Justice Douglas wrote: "Society wins not only when the guilty are convicted, but when criminal trials are fair; our system of justice suffers when any accused is treated unfairly." To elevate a statutory scheme of privilege and administrative process over a criminal defendant's fundamental right to a fair trial violates the latter's right to prosecutorial review and disclosure, and society's right to policed police: these sections of the Penal and Evidence Codes are unconstitutional as applied to criminal defendants, and courts should be enjoined from enforcing its provisions in criminal cases. (*Bowen v. Kendrick, supra,* 487 U.S. at pp. 600-602; *Broadrick v. Oklahoma* (1973) 413 U.S. 601, 615-616 [37 L.Ed.2d 830, 93 S.Ct. 2908]; *Lammers v. Superior Court* (2000) 83 Cal.App.4th 1309, 1328-1329.) Because the court failed to order proper *Brady* review and disclosure of all material impeachment evidence contained in police witness personnel files, appellant's convictions on counts 1 through 9 must be reversed and those charges remanded for further proceedings consistent with that obligation.[14] (*Merrill v. Superior Court (People)* (1994) 27 Cal.App.4th 1586, 1594.)

14 Again, *Brady* violations lead to reversal only if there was a reasonable probability the material suppressed would have led to a different result at trial. (*Kyles v. Whitley, supra,* 514 U.S. at p. 435-436; *People v. Pinholster* (1992) 1 Cal.4th 835, 939-940, cert. den., 506 U.S. 921; *People v. Bohannon, supra,* 82 Cal.App.4th at pp. 805-806.) However, the violation in this case was there was no *Brady* review in the first place. Taking cue from the *Pitchess* remand procedure outlined *infra,* appellant therefore asks this Court remand to the trial court for full *Brady* review and appropriate disclosure. (*City of Los Angeles v. Superior Court (Brandon), supra,* 29 Cal.4th at p. 15; *accord, People v. Johnson, supra,* 118 Cal.App.4th at pp. 304-305.)

ARGUMENT

APPELLANT'S CONVICTIONS MUST BE REVERSED FOR THE TRIAL COURT'S ERROR IN DENYING APPELLANT'S *BATSON/WHEELER* MOTION

It is axiomatic that "[a] party may not use peremptory challenges to remove prospective jurors solely on the basis of group bias. Group bias is a presumption that jurors are biased merely because they are members of an identifiable group distinguished on racial, religious, ethnic, or similar grounds." (*People v. Fuentes* (1991) 54 Cal.3d 707, 712, citing *People v. Wheeler, supra,* 22 Cal.3d at p. 276.) In *Batson v. Kentucky, supra,* 476 U.S. at pp. 84-89, the Supreme Court held exercise of peremptory challenges based solely on race violates the Equal Protection Clause.[1]

If a party believes its opponent is using peremptory challenges discriminatorily, that party must make a timely objection, followed by a showing that jurors are being excluded based on group bias. (*People v. Wheeler, supra,* 22 Cal.3d at p. 280; *People v. Fuentes, supra,* 54 Cal.3d at p. 714.) After the moving party has established a prima facie case, the burden shifts to the other party to articulate a "race-neutral" explanation for its challenge. (*People v. Wheeler, supra,* 22 Cal.3d at pp. 281-282; *Batson v. Kentucky, supra,* 476 U.S. at pp. 96-98.) Once a race-neutral explanation has been given, the trial court is required to

> ... satisfy itself that the explanation is genuine. This demands of the trial judge a sincere and reasoned attempt to evaluate the prosecutor's explanation in light of the circumstances of the case as then known, his knowledge of trial techniques, and his observations of the manner in which the prosecutor has examined members of the venire and has exercised challenges for cause or peremptorily, for "we rely on the good judgment of the trial courts to distinguish bona fide reasons for such peremptories

1 The three steps of *Batson* are: (1) establishment of a prima facie case by showing the totality of the facts "give rise to an inference of discriminatory purpose," which (2) shifts the burden to the State to articulate a race-neutral justification for the strike so that (3) the trial court must determine whether purposeful racial discrimination has been proved. (*Johnson v. California* (2005) 545 U.S. 162, 167.) The trial court's determination of whether the State has acted with discriminatory intent is to be reviewed under a deferential standard. (*Batson v. Kentucky, supra,* 476 U.S. at p. 98, fn. 21.)

from sham excuses belatedly contrived to avoid admitting acts of group discrimination."

(*People v. Hall* (1983) 35 Cal.3d 161, 167-168, quoting *People v. Wheeler, supra,* 22 Cal.3d at p. 282; *People v. Silva* (2001) 25 Cal.4th 345, 386 [trial court must make a "sincere and reasoned attempt to evaluate each stated reason as applied to each challenged juror"]; *People v. Stevens* (2007) 41 Cal.4th 182, 192-193.)

In cases involving the peremptory dismissal of African-American jurors where the defendant is also African-American, each challenge of each black juror must be independently evaluated because "under *Batson* the striking of a single black juror for racial reasons violates the equal protection clause, even though other black jurors are seated, and even when there are valid reasons for the striking of some black jurors." (*People v. Fuentes, supra,* 54 Cal.3d at p. 715, citing *People v. Battle* (8th Cir., 1987) 836 F.3d. 1084, 1086; *United States v. Gordon* (11th Cir., 1987) 817 F.3d 1538, 1541; *United States v. David* (11th Cir., 1986) 803 F.3d. 1567, 1571; *People v. Gonzalez* (1989) 211 Cal.App.3d 1186, 1193.) The fundamental question on appeal is whether substantial evidence supports the trial court's finding that the prosecutor's justifications were *in fact* race neutral. (*People v. Huggins* (2006) 38 Cal.4th 175, 233.)

As noted, trial counsel made two motions to strike the venire based on *Batson/Wheeler* violations: the first triggered by the prosecutor's dismissal of potential juror #4192, described as an African-American woman, unemployed, separated, who lived with her brothers. She watched Court TV, and had no negative experience with law enforcement. The court found a prima facie case, and inquired; the prosecutor said she didn't like unemployed jurors because they didn't have a stake in the community, the woman did not immediately respond when her badge number was called, and the potential juror appeared to have problems understanding and being understood in English, as demonstrated by the court asking her to repeat herself several times.[2] (RT 3:1540-1543)

Defense counsel argued the woman had an African accent, but did not appear to have any difficulty understanding voir dire, and other jurors were also slow to respond to the badge numbers. (RT 3:1543-1545) The court denied the motion, finding the juror was unemployed, having previously worked for Office Depot, "so there is some education issue there;" the juror was "somewhat" slow to respond to her badge number; was separated; and responded to the

2 The woman apparently had to repeat only one word: the court heard "cult" when she said "court." (RT 3:1530)

court's question about having special DNA training by stating that she watched Court Tv. Defense counsel objected to the court supplementing the prosecutor's justifications.[3] (RT 3:1546-1547)

The second juror, potential juror #7514, was an African-American man, a retired landscaper, unmarried, who had a sister who was a correctional officer. The court again found a prima facie case, and the prosecutor justified the dismissal on grounds the potential juror didn't appear to know where to sit, was elderly, didn't have much experience with family life, said he had prior jury experience, but had been excused from that jury, was slow responding to questions, and had a "physical" speech problem which would make communication with other jurors problematic. (RT 3:1547-1549) Defense counsel pointed out that other elderly jurors had been accepted, that neither the circumstances of the man's family life or his prior jury service were known to the State, and that, although the man may have been slow to respond, he did not appear to be slow or difficult to understand. The court denied the motion, finding the man's halting speech might be a problem given the number of charges at issue. (RT 3:1549-1551)

These are neither adequate nor substantial race-neutral justifications. (*People v. Huggins, supra*, 38 Cal.4th at pp. 227-228, 231.) Relative to potential juror #4192, unemployment is unfortunately associated to a far larger extent with minority populations than with the majority. (*See*, U.S. Dept. of Labor, Bureau of Labor Statistics, "Unemployed persons by marital status, race, Hispanic or Latino ethnicity, age, and sex" (Jan. 2006) [http://www.bls.gov/cps/cpsaat24.pdf].)[4] Although the trial court inferred from the woman's prior place of employment (Office Depot) that she was not well educated, this inference was wholly unsupported. Given that Office Depot also has management-level employees who are also subject to layoffs,[5] the correlation drawn by the prosecutor (and the court) between employment and education seems to

3 The court's addition or expansion of the prosecutor's justifications was improper: "If the stated reason [for exercising the peremptory] does not hold up, its pretextual significance does not fade because a trial judge, or an appeals court, can imagine a reason that might not have been shown up as false." (*Miller-El v. Dretke* (2005) 545 U.S. 231, 252.)

4 According to this study, the total 2006 unemployment rate among the general population was 4.6 percent men and 4.6% women. The unemployment rates by race were: White: 4.0% men, 4.0% women; Black/African-American: 9.5% men, 8.4% women; Asian: 3.0% men, 3.1% women; and Hispanic/Latino: 4.8% men, 5.9% women.

5 (Cal. Emp. Development Dept. "Listing of WARN Notices by Layoff Date (Jan - Jun) - 2006" [http://www.edd.ca.gov/warn/eddwarnlojj06.pdf]; *New York Times*, "Office Depot Says It Will Cut 900 Jobs" [http://www.nytimes.com/2004/11/01/business/01office.html].)

have been a purely race-bound inference – one resting more on "stereotypical assumptions" about African Americans rather than on the individual juror at hand. Even if it could be said that this woman's previous employment indicated a lack of higher education, this too tends to read as coding an impermissible racial bias, as African Americans have an overall lower highest educational attainment level than Caucasians and non-black minority groups.[6]

This is distinguishable from the situation in *Hernandez v. New York* (1991) 500 U.S. 352, 360, in which the Supreme Court found no *Batson* error in striking bilingual Latino jurors on grounds the jurors in question had demonstrated that they would not be able to defer to the official Spanish translation. In appellant's case, there was nothing about these jurors that made them less desirable to the State – other than their race. (*Miller-El v. Dretke, supra,* 545 U.S. at p. 241 [reasons for striking black panel members also applied to some white jurors who served].)[7]

In *Hernandez,* the Court prefatorily noted discriminatory purpose implies that "'the decisionmaker... selected ... a particular course of action at least in part 'because of,' not merely 'in spite of,' its adverse effects upon an identifiable group.'" (*Hernandez v. New York, supra,* 500 U.S. at p. 360, quoting *Personnel Administrator of Mass. v. Feeney* (1979) 442 U.S. 256, 279.) While excluding jurors on the basis of bilingualism might have a disparate impact on Latino jurors, such a disparate impact did not mean a *per se* constitutional violation. However, disparate impact was also not immaterial. Rather, the unequal effect of an apparently race-neutral criterion should be considered in an overall assessment of whether the State acted with discriminatory intent. (*Hernandez v. New York, supra,* 500 U.S. at pp. 361-363.) "[A]n invidious discriminatory purpose may often be inferred from the totality of the relevant

6 As of the 2002 Census, the highest educational attainment in California by race/ethnicity was: White: High School Diploma - 56%; Bachelor's Degree - 21.2%, Graduate/Professional Degree - 12.6%; Latino: High School Diploma - 39%; Bachelor's Degree - 5.1% , Graduate/ Professional Degree - 2.6%; Asian: High School Diploma - 39.5%; Bachelor's Degree - 27.8%, Graduate/Professional Degree - 13.1%; and Black/African-American: High School Diploma - 63.3%; Bachelor's Degree - 11.4%, Graduate/Professional Degree - 5.8%; (Center for Comparative Studies in Race and Ethnicity, Stanford U., *Race and Ethnicity in California: Demographics Report Series – No. 11* (October 2002) "Race and Educational Attainment in California: Census 2000 Profiles, No. 11, October 2002" [http://www.stanford.edu/dept/csre/reports/report_11.pdf].)

7 The California Supreme Court has not yet held that comparative juror analyses are constitutionally required where a prima facie case of discrimination has been found. However, such an analysis may be properly performed in such a situation. (*People v. Huggins, supra,* 38 Cal.4th at p. 232; *People v. Lewis* (2006) 39 Cal.4th 970, 1018.)

facts, including the fact, if it is true, that the [classification] bear more heavily on one race than another." (*Washington v. Davis* (1976) 426 U.S. 229, 242.)

Perhaps most telling, the trial court here did not ratify the prosecutor's statement that juror #4192's accent impaired her ability either to understand or be understood by the other jurors, a statement contradicted by defense counsel. (*Compare, People v. Adanandus* (2007) 157 Cal.App.4th 496, 510-511 [neither court nor counsel contradicted prosecutor's description of rejected juror's demeanor].) Absent any such impairment, an *African* accent is exclusively a marker of race, rather than a race-neutral concern. As the Supreme Court stated, "It may well be, for certain ethnic groups and in some communities, that proficiency in a particular language, like skin color, should be treated as a surrogate for race under an equal protection analysis." (*Hernandez v. New York, supra,* 500 U.S. at p. 371.)

With regards to potential juror #7514, the trial court only affirmed that the potential juror spoke haltingly. There was no indication the slowness of the man's speech had any effect on his ability to be understood. Contrarily, his other characteristics – he was retired, unmarried, and had a family member in law enforcement – were shared by other potential jurors, some of whom were eventually seated. For example, one of the seated alternates was unmarried and had no significant other or children; as defense counsel noted, there were several other elderly and/or retired jurors who were not excused on that basis. (RT 3:1279, 3:1284, 3:1299, 3:1309, 3:1311, 3:1520, 3:1574) A number of other potential jurors had relatives and/or friends in law enforcement, which, while not outright commending them to the prosecution, did not condemn them either. (RT 3:1248, 3:1253, 3:1268, 3:1308, 3:1311, 3:1566) There does not have to be a point-by-point similarity between the rejected black jurors and their non-black counterparts. (*Miller-El v. Dretke, supra,* 545 U.S. at p. 247, fn. 6.) It is enough that there was enough of a similarity between them to belie the prosecutor's proffered justification for removing every black juror called before her. (*Id.,* at p. 241 ["More powerful than bare statistics, however, are side-by-side comparisons of some black venire panelists who were struck and white panelists allowed to serve."].)

In sum, there was not substantial evidence that the reasons tendered by the prosecution were in fact race neutral. For example, all the court did with respect to juror #4192 was verify that the prosecutor's factual statements (the woman was separated) were true. (*Miller-El v. Dretke, supra,* 545 U.S. at p. 252 [*Batson* requires more than "mere exercise in thinking up any rational basis"].)

Again, racial discrimination by the State in jury selection violates the Equal Protection Clause (*Georgia v. McCollum* (1992) 505 U.S. 42, 44); appellant's convictions must be reversed for the violation in his case. (*Miller-El v. Dretke, supra,* 545 U.S. at p. 266.)

ARGUMENT

APPELLANT'S CONVICTIONS MUST BE REVERSED FOR THE TRIAL COURT'S ERROR IN ADMITTING ALL IDENTIFICATION EVIDENCE

Introduction

The only issue at issue in appellant's trial was the identity of the robber. Appellant was identified as the robber by witnesses who had seen appellant in a single-person field-show up, dressed in the hooded sweatshirt by police, handcuffed, surrounded by police, and illuminated by police spotlights, and by witnesses who picked someone else out of a lineup, only to be shown a photograph of appellant, then identified by police as the "real" robber. (RT 402-404, 408-409, 411, 634-635, 641-642) Pretrial identification procedures violate due process if they are "so impermissibly suggestive as to give rise to a very substantial likelihood of irreparable misidentification." (*Simmons v. United States* (1968) 390 U.S. 377, 383.) Identifications which flow from such unconstitutional procedures are inadmissible. (*Manson v. Brathwaite* (1977) 432 U.S. 98, 117.) Appellant's convictions must be reversed for the trial court's admission of identification evidence based on malignant pretrial identification procedures. (*Id.*, at p. 106; *Neil v. Biggers* (1972) 409 U.S. 188, 195; *People v. Gordon* (1990) 50 Cal.3d 1223, 1241-1242, cert. den. 499 U.S. 913.)

A. The pretrial identification procedures here were impermissibly suggestive.

In *Stovall v. Denno* (1967) 388 U.S. 293, the United States Supreme Court gave limited approval to the practice of pretrial identification of a suspect in a single-person show-up. In *Stovall*, defendant was brought handcuffed into his stabbing victim's hospital room, where she lay recovering; defendant was the only black man in the room. Police asked the victim if defendant "was the man," and had him speak for a voice identification. The victim identified defendant as her assailant both in the hospital and in court. (*Id.*, at p. 294.) The Supreme Court preliminarily noted its recent decisions in *United States v. Wade* (1967) 388 U.S. 218 and *Gilbert v. California* (1967) 388 U.S. 263 established a *per se* exclusionary rule when a defendant is subject to a pretrial identification procedure "without notice to and in the absence of counsel" representing defendant. (*Stovall v. Denno, supra,* 388 U.S. at p. 297.) Such a stringent remedy, the Court reasoned, was needed to deter law enforcement from employing suggestive pretrial identification procedures; while a single-person show up (though "widely condemned") might be necessary in some circumstances, the

Court was chary about all "confrontations for identification... [t]he possibility of unfairness at that point is great...." (*Id.*, at p. 298, 302; *United States v. Wade, supra,* 388 U.S. at p. 228 ["the confrontation compelled by the State between the accused and the victims or witnesses to a crime to elicit identification evidence is peculiarly riddled with innumerable dangers and variable factors which might seriously, even crucially, derogate from a fair trial."].)

As Justice Brennan forcefully put the problem in *United States v. Wade, supra,* 388 U.S. 218: "The vagaries of eyewitness identification are well-known; the annals of criminal law are rife with instances of mistaken identification. [...] A major factor contributing to the high incidence of miscarriage of justice from mistaken identification has been the degree of suggestiveness inherent in the manner in which the police presents the suspect to witnesses for pretrial identification." (*Id.*, at p. 228.) Suggestiveness, the Court noted, "can be created intentionally or unintentionally in many subtle ways... the dangers for the suspect are particularly grave when the witnesses' opportunity for observation was insubstantial, and thus his susceptibility to suggestion the greatest." (*Id.*, at p. 229.) Moreover: "It is a matter of common experience that, once a witness has picked out the accused at the line-up, he is not likely to go back on his word later on, so that in practice the issue of identification may... for all practical purposes be determined there and then, before trial." (*Ibid.*, quoting Williams & Hammelmann, Identification Parades, Part I, [1963] Crim. L. Rev. 479, 482; *Simmons v. United States, supra,* 390 U.S. 383-384 ["Regardless of how the initial misidentification comes about, the witness thereafter is apt to retain in his memory the image of the photograph rather than of the person actually seen, reducing the trustworthiness of subsequent lineup or courtroom identification."].) However, in *Stovall*, the Court ruled that the constitutional acceptability of any one confrontation "depends on the totality of the circumstances surrounding it." (*Stovall v. Denno, supra,* 388 U.S. at p. 302.)

In, *Simmons v. United States, supra,* 390 U.S. 377, the Court underscored "each case must be considered on its own facts," and held convictions based on suggestive identifications "will be set aside on that ground only if the ... procedure was so impermissibly suggestive as to give rise to a very substantial likelihood of irreparable misidentification." The irreparable misidentification standard was reaffirmed by the Court in *Neil v. Biggers, supra,* 409 U.S. at p. 195, in which Justice Powell, writing for the majority, went on to elaborate:

> [T]he factors to be considered in evaluating the
> likelihood of misidentification include the opportunity
> of the witness to view the criminal at the time of
> the crime, the witnesses' degree of attention, the
> accuracy of the witnesses' prior description of the
> criminal, the level of certainty demonstrated by the
> witness at the confrontation, and the length of time
> between the crime and the confrontation.

(*Id.*, at p. 199; *accord, Coleman v. Alabama* (1970) 399 U.S. 1, 6 ["the record is utterly devoid of evidence that anything the police said or did prompted [the victim's] virtually spontaneous identification of petitioners..."]; *compare, Foster v. California* (1969) 394 U.S. 440, 443 ["The suggestive elements of this identification procedure made it all but inevitable that [the witness] would identify petitioner whether or not he was in fact 'the man.'"].)

In *Manson v. Brathwaite, supra,* 432 U.S. at p.112, the United States Supreme Court discarded the *Stovall* rule of *per se* reversal in favor of harmless error review; in support of this shift, the Court reiterated the due process standard of fairness at issue, determining that such a standard may be met "so long as the identification possesses sufficient aspects of reliability." (*Id.*, at pp. 106, 113.) The Court concluded: "... reliability is the linchpin in determining the admissibility of identification testimony... The factors to be considered are set out in *Biggers* [citation].... Against these factors is to be weighed the corrupting effect of the suggestive identification itself."(*Id.*, at p. 114; *Neil v. Biggers, supra,* 409 U.S. at p. 198 ["Suggestive confrontations are disapproved because they increase the likelihood of misidentification, and unnecessarily suggestive ones are condemned for the further reason that the increased chance of misidentification is gratuitous."].) Appellant's convictions must be reversed as the identification procedures the police used were so grotesquely and gratuitously suggestive as to render the linchpin hopelessly corrupt. (*Manson v. Brathwaite, supra,* 432 U.S. at p. 113.)

1. The field show-up

In *Stovall v. Denno, supra,* 388 U.S. at p. 302, the United States Supreme Court appreciated the sometime necessity of the single-person show-up while disapproving of its overly-suggestive tendencies. (*People v. Hall* (1979) 95 Cal.App.3d 299, 309 [procedure approved where defendant only black man under 45 on Catalina Island, would have taken hours to assemble line-up, victim also had ample time to observe defendant during rape].) As the

California Supreme Court recognized, "the risks of suggestion are manifestly augmented" in single-person show-ups:

> Whereas in a lineup situation an identifying witness must at least choose among persons having some physical resemblance to one another, a one-to-one viewing requires only the assent of the witness. [citation] Moreover, the possibility of mistaken identification is further increased when, as here, the suspect is displayed to the witness in the company of a uniformed officer...

(*People v. Martin* (1970) 2 Cal.3d 822, 829[1].) In *People v. Sandoval* (1977) 70 Cal. App.3d 73, 85, the purse-snatching victim was told police were bringing the suspect through a particular hallway; she later stated that seeing the defendant at the station "helped" her make her in-court identification. As the appellate court explained, single-person showups "should not be used, however, without a "compelling reason," because of the great danger of suggestion from "a one-on-one viewing." (*Id.*, at p. 85, citations omitted.) Because the single person show-up in *Sandoval* was not justified by any exigency, the pretrial identification was impermissibly suggestive. However, admission of the identification was harmless because there was other "compelling" evidence linking defendant to the robbery. (*Id.*, at p. 86 [testimony of other witnesses supported probation violation finding]; see also; *People v. Cowger* (1988) 202 Cal.App.3d 1066, 1072 [ample time to observe defendant during rape, footsteps leading from victim's

1 The Court in *Martin* went on to hold an impermissible pretrial identification procedure may be cured by clear and convincing evidence that a witness's in-court identification was untainted by the preceding illegality. (*People v. Martin, supra,* 2 Cal.3d at p. 833; *People v. Williams* (1973) 9 Cal.3d 24, 37.) However, this was not part of the analysis used by the United States Supreme Court in *Manson*, which post-dated the California Court's opinion in *Martin*. (*Manson v. Brathwaite, supra,* 432 U.S. at pp. 114-116.) The California Supreme Court's most recent opinion on the issue, *People v. Ochoa* (1998) 19 Cal.4th 353, 412-413, certiorari denied, 518 U.S. 862, cited the same factors outlined in *Biggers* (and used in *Manson*) for determining constitutional reliability, with no mention of an "independent source rule." Insofar as such a rule selectively abridges the rubric of *Manson* and arguably conflicts with the general logic of the Court's decision in *People v. Cuevas* (1995) 12 Cal.4th 252, 264-265 [overruling *People v. Gould* (1960) 54 Cal.2d 621: requirement that out-of-court identifications be corroborated absent other proof connecting Defendant to crime runs afoul of general sufficiency standard], the independent source rule appears to have been properly subsumed under the *Manson* totality standard. (*See e.g., People v. Sanders* (1990) 51 Cal.3d 471, 508, cert. den. 500 U.S. 948 [consideration of *Manson/Biggers* factors in finding no substantial likelihood of misidentification under *Simmons*].)

house to defendant's house].) In sum, though not "inherently unfair" (*People v. Floyd* (1970) 1 Cal.3d 694, 714, cert. den. 406 U.S. 972, overruled on other grounds, *People v. Wheeler* (1978) 22 Cal.3d 258, 287), the single-person show-up is inherently prone to unfairness. (*People v. Bisogni* (1971) 4 Cal.3d 582, 586; U.S. Dept. of Justice, Eyewitness Evidence: A Guide for Law Enforcement, p. 27 ["the inherent suggestiveness of a showup requires careful use of procedural safeguards"] (Oct. 1999).)

Also prone to impropriety is the practice of witness identifications made in the presence of other witnesses (*see e.g., People v. Thomas* (1970) 5 Cal.App.3d 889, 898), and displaying a suspect for identification accompanied by police (*People v. Martin, supra,* 2 Cal.3d at p. 829). In short, whenever the state "improperly suggest[s] something to the witness – i.e., ... wittingly or unwittingly, initiate[s] an unduly suggestive procedure" (*People v. Ochoa, supra,* 19 Cal.4th at p. 413), and that procedure gives rise to a "substantial likelihood of irreparable misidentification" (*Simmons v. United States, supra,* 390 U.S. at pp. 383-384), the identification is inadmissible.

Appellant was apprehended by Sgt. Medrano in an alley near the grocery; Cieza and De Souza were transported by patrol car to the alley ten minutes or twenty after the robbery. (RT 383, 391, 630-621, 633) Cieza testified the transporting officer told them they "had a suspect in custody who matched the description" of the robber, though it may or may not be the same person. (RT 383) De Souza testified "[h]e told us they had apprehended a suspect," but added there was no emphasis on whether or not the person was the robber. (RT 630-631) When De Souza and Cieza arrived at the alley, they stayed inside the patrol car, which parked 50 yards away from where appellant stood, alone, handcuffed between two officers, illuminated by police spotlights, wearing the gray sweatshirt, the hood pulled up over his head to match the description of the robber. (RT 387-388, 632-633, 637-638) Neither witness saw Medrano dress appellant; contrary to Medrano's testimony, neither witness asked that the suspect be dressed in the sweatshirt for viewing. (RT 387-388, 623) Both witnesses positively identified appellant as the robber, De Souza by his "face and the clothes he was wearing." (RT 399, 632-633)

Before the showup, Cieza described the robber to police as Hispanic, about 6'2", 180 to 200 pounds, "heavyset," with dark brown eyes.[2] (RT 378-

2 At the preliminary hearing, Cieza says for the first time that the robber had bushy eyebrows. (RT 389) Appellant has bushy eyebrows; the other men in the pretrial lineup also had bushy eyebrows. (RT 634)

379) De Souza testified the robber's "biggest distinguishing feature was his nose and his bushy eyebrows and his forehead... he had a shaved head."[3] (RT 633) De Souza did not provide this information to police before the showup because "I don't believe that anyone asked me." (RT 632; compare, U.S. Dept. of Justice, p. 27 ["Determine and document, prior to the showup, a description of the perpetrator."].)

In United States v. Wade, supra, 388 U.S. 218, the Court, commenting on the single person show-up in Stovall v. Denno, supra, 388 U.S. at p. 302, found:

> the vice of suggestion created by the [single-person showup] identification... was the presentation to the witness of the suspect alone handcuffed to police officers. It is hard to imagine a situation more clearly conveying the suggestion to the witness that the one presented is believed guilty by the police.

(United States v. Wade, supra, 388 U.S. at p. 234.) What the Court couldn't imagine was the Gardena Police Department's show-up procedure: not to crop a dead horse, but for no apparent exigency or reason, appellant was presented to two witnesses at once and all alone, handcuffed, spotlit and sandwiched between police. (Ibid; Stovall v. Denno, supra, 388 U.S. at p. 302; People v. Bisogni, supra, 4 Cal.3d at p. 586-587; compare, U.S. Dept. of Justice, p. 27 ["When multiple witnesses are involved.... separate witnesses"] .) Police paraded appellant in a hood from a fifty-yard vantage point in a case where the witnesses's best observations of the robber were of his dark brown eyes and a patch of shaved forehead. (Compare, People v. Hall, supra, 95 Cal.App.3d at p. 309.) Police also hooded appellant without indicating they were the ones who had so dressed him for viewing. (People v. Carter (1975) 46 Cal.App.3d 260, 265 [defendant only one in lineup wearing turtleneck sweater identified by victim]; United States v. Wade, supra, 388 U.S. at p. 233; People v. Perkins (1986) 184 Cal.App.3d 583, 589 [witness requested alteration of photo].) Moreover, at least one of the witnesses acknowledged the great clarifying effect of the showup here: Cieza testified at trial she "didn't realize how thin [the robber] was until they actually brought [appellant] out and I saw him completely." (RT 388) This litany of abuse would have corrupted any subsequent identification – it renders untenable an identification made by two witnesses, seated side by side, one

3 Estay, the other store employee, also testified the robber was thin, with a shaved head, but could not discern ethnicity and did not look at the man's face. (RT 920, 925-926)

who described herself as "traumatized" (RT 393), and the other who confessed during the robbery "I was trying to look at the register... I was shook up" (RT 636), both of whom saw only a fraction of their robber's face for a few minutes at most (RT 636). (*People v. Bisogni, supra,* 4 Cal.3d at p. 587; *compare, People v. Thomas, supra,* 5 Cal.App.3d at p. 900.) The field showup and subsequent in-court identification of appellant by Cieza and De Souza should have been suppressed. (*Manson v. Brathwaite, supra,* 432 U.S. at p.113; *Neil v. Biggers, supra,* 409 U.S. at pp. 198-199.)

2. The line-up

Lineups are governed by the same general considerations of fairness as field showups, though not subject to the same presumption of suggestiveness. (*People v. Boyd* (1990) 222 Cal.App.3d 541, 574 ["'Suggestive comments or conduct that single out certain suspects or otherwise focus a witness's attention on a certain person in a lineup can cause such unfairness so as to deprive a defendant of due process of law.'"], quoting *People v. Perkins, supra,* 184 Cal.App.3d at p. 588.) Due process interests are most patently affected in lineups "when there is a causal relationship between the [lineup] procedure and the witness's identification of the defendant." (*People v. Contreras, supra,* 17 Cal.4th at p. 819.)

Two and a half months after the robbery, De Souza and Ahrens were brought to Parker Center for a lineup. The lineup was conducted by Detective Paavola, the lead detective in the case. (RT 403) All participants in the lineup had bushy eyebrows and a shaved head. (RT 402-404, 641) Both De Souza and Ahrens identified suspect number six as the robber; on her lineup card, Ahrens wrote: "I remember his eyes and his voice and his hands." (RT 402-403, 407, 409, 633-634, 641-642) De Souza thought that suspect "looked a little closer to the description that I remembered." (RT 634) Afterwards, while De Souza and Ahrens returned to their car, Det. Paavola showed them a photograph of appellant:

> PROSECUTOR: And that's when you found out you
> had picked the wrong person?
> DE SOUZA: Yes.

(RT 635) Coincidentally, "[t]he officer told us we had both selected the same wrong defendant." (RT 641; RT 402-404, 411, 634-635, 641) This was naturally distressing: as Ahrens said, "I thought I had picked the right person" (RT 413); De Souza agreed, "I was quite shocked when I found out that it was not the same person" (RT 634) police had arrested.

The constitutional malfeasance of the pretrial identification procedure outlined above is perhaps best served by understatement: there are no California cases in which a police officer has corrected a witness's lineup identification of a suspect by displaying a photograph of the defendant and identifying him as the "right one." Such brass-bellied temerity in the face of the Sixth Amendment appears to be relatively rare. But lesser nods in this same direction have been excused only absent any causal connection between procedure and identification. (See e.g., People v. Boyd, supra, 222 Cal. App.3d at p. 574 [comment that #5 would go into "discipline" not suggestive as witness unaware of remark]; People v. Perkins, supra, 184 Cal.App.3d at p. 590 [question whether victim saw anyone who "closely resembled" robber did not indicate defendant was the suspect].) Here, the witnesses positively identified (the same) someone else as the person who robbed the grocery store. Their minds and their identification changed because the lead detective showed them appellant's picture and told them, no, this was their man. In short, appellant would not have been identified as the robber but for the state's flat-out assertion to the victims that he was the robber. (Foster v. California, supra, 394 U.S. at p. 433 ["The suggestive elements in this identification procedure made it all but inevitable that [the witness] would identify petitioner whether or not he was in fact 'the man.'"].) It should have been easy work for the trial court to appreciate the error here and divine its remedy. (Manson v. Brathwaite, supra, 432 U.S. at p. 114 ["reliability is the linchpin in determining the admissibility of identification testimony"].) But this the court did not do.

During the defense motion to exclude the witnesses' identification of appellant, the prosecution argued the reliability of the identifications here was simply a question for the jury, and any improprieties went to the weight to be accorded such testimony, not to its initial admissibility.[4] The court, by its ruling, appeared to agree. (RT 350-362) This unblinking admissibility, however, avoided the duty imposed on trial courts by the United States and California Supreme Courts to exclude "testimony concerning a suggestive and unnecessary identification procedure" which does not "possess sufficient aspects of reliability." (Manson v. Brathwaite, supra, 432 U.S. at p. 106.)

In People v. Gordon, supra, 50 Cal.3d at pp. 1241-1242, after the witness tentatively identified defendant in a lineup, she had a telephone

4 In the hearing on the Motion for New Trial, the prosecutor said any error in admitting the lineup identification evidence was harmless as Cieza had also positively identified appellant; of course, Cieza 's identification was based on an improperly suggestive field showup.

conversation with the investigating officer in which the officer said "you picked the right person." The California Supreme Court approved the trial court's decision to admit the lineup identification and exclude all subsequent identification, because the remark: "... was unduly suggestive and had a corrupting effect on any identification that did, or might, follow – but that in view of [the witness's] certainty, it did not have such an effect on the preceding identification, as it were, "retroactively."*(Ibid.; accord, People v. Martin, supra,* 2 Cal.3d at p. 826 [no harm where victim said defendant "looked like" her assailant, officer called victim to come in for another look, victim said "that's the one"].) But there was no there to be salvaged here. Even the prosecution's rehabilitation of its witnesses[5] was an itchy exercise in revisionism; when asked in court if appellant was the robber, Ahrens testified she was sure he was, for: "I can see him clearer now like I couldn't [during the lineup] when they were just standing there. I could just notice things better."(RT 404) Moreover, Ahrens swore her solid in-court identification was based only on the robbery itself, on those two or three minutes during which she "wasn't paying attention to [the robber's] head" because her attention was focused on his eyes and hands, the same eyes and hands she "remembered" in selecting suspect number 5 from the lineup. (RT 399, 407, 410) De Souza also felt his identification was based only on his memory of the robbery, and was untainted by the lead investigating officer's display of appellant's photograph, taken "at the time, I guess, of apprehension." (RT 639-649) Nor was his final identification based on seeing appellant at the time of that apprehension (i.e., alone, handcuffed, lit up by police spots and dressed up like the robber), but exclusively on those few minutes during which he was primarily "look[ing] at the register... trying to get the register open, because I was shook up." (RT 636)

But all this is not just a matter of police failure to conform to police form. According to one study, in cases in which forensic DNA evidence exonerated wrongly convicted defendants, 90% of those defendants had been originally convicted on the basis of eyewitness identification. (Wells et. al., *Eyewitness Identification Procedures: Recommendations for Lineups and Photospreads* (1998) Law and Human Behavior, vol. 22, no. 6, p. 3.) Relying on standard litigation techniques to ferret out erroneous eyewitness identification is not enough:

5 (Again, no longer a proper analytic factor given *Manson v. Brathwaite, supra,* 432 U.S. at pp. 114-116; *see infra.*, fn. 32.)

> Cross-examination, a marvelous tool for helping jurors discriminate between witnesses who are intentionally deceptive and those who are truthful, is largely useless for detecting witnesses who are trying to be truthful but are genuinely mistaken (citation).

(Wells et al., p. 6.) The problem is, memory is not a matter of taking a mental snapshot and filing it away for later retrieval, but rather the repeated recreation of an impression which is itself the product of revision in conformance to subsequent information. (Purves et. al., eds., Neuroscience (2001 2nd ed.) pp. 668-669.) For example, studies have shown that witnesses who are told by police that they picked the right guy are subject to greater "retrospective certainty" about their choice: given the confirming feedback, eyewitnesses' exaggerate their retrospective calculation of the attention they paid to the triggering event, how good their initial view of the suspect was, how quickly they were able to positively identify the suspect, how willing they were to testify, and even how good they are generally in recognizing strangers' faces. (Bradfield et. al., *The Damaging Effect of Confirming Feedback on the Relation Between Eyewitness Certainty and Identification Accuracy,* pp. 1-2, 5, Journal of Applied Psychology (in press) http://www.psychology.iastate.edu/faculty/gwells/feedback&accuracyms.htm.) This is not due to traditional hindsight effect, but rather to an honest and unconscious effort on the witness's part to infer an internal logic on their own behavior which conforms to the appearance of that behavior in the external world ("self-perception" effect) – to make sense of their selection. (Wells & Bradfield, *Distortions in Eyewitnesses' Recollections: Can the Postidentification-Feedback Effect Be Moderated?* (March 1999) Psychological Science, *v.* 10, no. 2, p. 142.) Furthermore, this "inflated certainty effect" is most acute in cases of misidentification: because the influence of external factors on judgment is "inversely related" to the strength of internal factors on that same judgment, the inflated certainty effect is less on witnesses with a strong "ecophoric similarity" (match between internal memory of culprit and appearance of suspect) than those with less ecophoric similarity. (Bradfield et. al., p. 4.) Basically, people who don't have a strong sense of which person was the culprit are "more susceptible to external influence in the form of a casual comment from the lineup administrator." Where internal cues are weak, external influence is strong. (Bradfield et. al., p. 11; Wells & Bradfield, p. 142; *accord, United States v. Wade, supra,* 388 U.S. at p. 229.)

Echoing Justice Brennan, it is difficult to imagine eyewitness identification evidence so fraught with suggestiveness and the peril of unreliability as one involving first a showup in which a single suspect is presented to the eyewitnesses from a distance, dressed like the culprit, handcuffed between police officers and lit by a police light, his face obscured, and second, a lineup in which the eyewitnesses' identification is "corrected" to the defendant. (*United States v. Wade, supra,* 388 U.S. at p. 234.) The danger of admitting such evidence, as underscored by Justice Rehnquist in *Manson v. Brathwaite, supra,* 432 U.S. at p. 117, reiterated by the researchers, and confirmed by the verdict, is that inherently unreliable and highly prejudicial testimony will not be rejected by the jury – after all, "it was juries who convicted these innocent people." (Wells et al., at p. 3.) Or as stated by United States Supreme Court in *Foster v. California, supra,* 394 U.S. at p. 422, fn. 2:

> The reliability of properly admitted eyewitness identification, like the credibility of other parts of the prosecution's case, is a matter for the jury. But it is the teaching of Wade, Gilbert, and Stovall, supra, that in some cases the procedures leading to an eyewitness identification may be so defective as to make the identification constitutionally inadmissible as a matter of law.

(*Manson v. Brathwaite, supra,* 432 U.S. at p. 117; accord, *People v. Ochoa, supra,* 19 Cal.4th at p. 413 ["'A procedure is unfair which suggests in advance of identification by the witnesses the identity of the person suspected by the police.'"], quoting *People v. Slutts* (1968) 259 Cal.App.2d 886, 891.) As it happens, these principles hold truer still for suggestive post-identification procedures. Because a witness's confidence in an identification is what most sways jurors, not the conditions under which the witness's initial observation was made, reification of an identification, particularly by police, serves to skyrocket that witness's confidence in the correctness of that identification. (Wells & Bradfield, pp. 140, 142.) Bottom-line, if an officer tells you the defendant did it, you become much more confident about saying the defendant did it, and your confidence persuades the jury that the defendant did it, whether or not the defendant did, in fact, do it. Which is, of course, precisely what happened here: "I can see him clearer now like I couldn't [during the lineup] when they were just standing there. I could just notice things better."(RT 404; RT 399, 407, 410, 639-649)

Finally, by the court's ruling, the state here not only reaped the benefit of the officers' gross due process violations, but impuned other constitutional (and accuracy) considerations by suggesting the similarities between lineup participants excused the fact two of its witnesses identified "the wrong person." (RT 357-358; *but see e.g.*, U.S. Dept. of Justice, p. 29 ["Create a consistent appearance between the suspect and fillers with respect to any unique or unusual feature."].) It's as fundamental as a-b-c, but a lineup is supposed to indicate to the state when it may have "the wrong person," not reverse-engineer the memories of its witnesses to conform to its docket. (Wells & Bradfield, p. 142 ["The function of a lineup is to find out what the eyewitness knows from his or her own memory, independently of any influences from the agent administering the lineup."].)

B. The appellate court should use a de novo standard of review for suggestive identification procedures.

As mentioned, in *People v. Gordon, supra,* 50 Cal.3d at pp. 1241-1242, after the witness had tentatively identified the suspect, the officer said something to the effect of "you picked the right one." In approving the trial court's Solomon-like admission of the initial pretrial identification and exclusion of all subsequent identifications as corrupt, the California Supreme Court noted "[i]t is unsettled whether suggestiveness is a question of fact (or a predominately factual mixed question) and, as such, subject to deferential review on appeal, or a question of law (or a predominately legal mixed question) and, as such, subject to review de novo." (*Id.*, at p. 1242; *People v. Ochoa, supra,* 19 Cal.4th at p. 413 [noting standard of review remains unsettled].) A purely mixed question of law and fact is that "in which the '"historical facts are admitted or established, the rule of law is undisputed, and the issue is whether the facts satisfy the [relevant] statutory [or constitutional] standard, or to put it another way, whether the rule of law as applied to the established facts is or is not violated.'"" (*People v. Cromer* (2001) 24 Cal.4th 889, 894, quoting *Ornelas v. United States* (1996) 517 U.S. 690, 696-697, quoting *Pullman-Standard v. Swint* (1982) 456 U.S. 273, 289, fn. 19.) Independent, or de novo review is mandated in such purely mixed questions. (*Thompson v. Keohane* (1995) 516 U.S. 99, 112-113 [de novo review of whether suspect in custody for *Miranda* purposes]; *Ornelas v. United States, supra,* 517 U.S. at p. 696 [de novo review of whether there was reasonable suspicion to stop]; *People v. Cromer, supra,* 24 Cal.4th at p. 894 [de novo review of whether prosecutor exercised due diligence in attempting to secure missing witness].)

Under the Court's analyses in *Thompson* and *Ornelas*, whether a pretrial identification procedure is unconstitutionally suggestive is a purely mixed question of law and fact, and thus should be subject to de novo appellate review. While a suggestive identification procedure "in itself" does not implicate a protected interest (*Mason v. Brathwaite, supra,* 432 U.S. at p. 113, fn. 13, a suggestive identification procedure which gives rise to a substantial likelihood of irreparable misidentification, does. (*Mason v. Brathwaite, supra,* 432 U.S. at p. 114; *Simmons v. United States, supra,* 390 U.S. at pp. 383-384; *accord, Neil v. Biggers, supra,* 409 U.S. at p. 198 ["It is the likelihood of misidentification which violates a defendant's right to due process."]; *People v. Bisogni, supra,* 4 Cal.3d at p. 586 [unfairly conducted showup "may result in the conviction of innocent persons."]) Because unreliable pretrial identification procedures implicate a defendant's due process right to a fair trial, the *Thompson-Ornelas* test to divine whether such an issue presents a pure mixed question of law and fact is applicable. (*See e.g., People v. Cromer, supra,* 24 Cal.4th at p. 901.)

As the California Supreme Court outlined the factors in *People v. Cromer, supra,* 24 Cal.4th at p. 900, the first inquiry is "a matter of determining the historical facts" – here, how the field showup and pretrial lineup were conducted. There is no dispute about the historical facts in this case. (*Compare, People v. Cromer, supra,* 24 Cal.4th at p. 900 [deferential standard to be applied to disputed facts].) The second inquiry – "requir[ing] application of an objective, constitutionally based legal test to the historical facts" (*Ibid.*) – is whether these historical facts constitute an impermissibly suggestive and constitutionally unreliable identification procedure. Such an inquiry is not dependant on a trial court's privileged determination of credibility, as "the crucial question entails an evaluation made *after* determination" of the historical facts (*Thompson v. Keohane, supra,* 516 U.S. at p. 113), nor is such a determination:

> ... so factually idiosyncratic and highly individualized as to lack precedential value. To the contrary, this is an area of constitutional law in which "the law declaration aspect of independent review potentially may guide [law enforcement authorities], unify precedent, and stabilize the law."

(*People v. Cromer, supra,* 24 Cal.4th at p. 901, quoting *Thompson v. Keohane, supra,* 516 U.S. at p. 115; *accord, Ornelas v. United States, supra,* 517 U.S. at p. 697 ["*de novo* review tends to unify precedent and will come closer to providing law enforcement officers with a defined '"set of rules"'"].)

The precedential value of these cases has been presumed by the United States Supreme Court, as evidenced by the Court's an independent review of the pretrial identification at issue in *Mason*: finding that given the *Biggers*-relevant historical facts of the case, the *Simmons* standard had not been met.[6] (*Manson v. Brathwaite, supra,* 432 U.S. at pp. 114-117.) However:

C. Under any standard of review, appellant's convictions should be reversed.

Applying the *Biggers* factors to appellant's case:

1. The opportunity to view. Cieza, who described herself as traumatized, saw the robber only fleetingly, for as she heard his request for money, she glanced up, then down at the robber's gun, then ran screaming from the front of the store. De Souza saw the robber for two or three minutes, during which he was "shook up,"and "looking at the register," trying to get it open for the man with the gun. Ahrens remembered only eyes and hands; she "wasn't paying attention to [the robber's] head." Finally, the robber wore a hood that covered all but his eyes and part of his forehead during the robbery.

2. The degree of attention. Unlike the witness in *Manson*, all witnesses here were civilians, with no particular training or expertise in making observations or identifications. All were under considerable stress, shocked by the sudden presence of a gun in their midst, and, in De Souza's case, focusing on doing what was necessary to comply with the gunman's demands. Fine details about the robber's appearance (e.g., the bushy eyebrows) surfaced only after the showup identification, and cannot be parsed from any suggestiveness in the showup procedure. E.g., Cieza 's admission: "I didn't realize how thin he was until they actually brought him out and I saw him completely."

3. The accuracy of the description. Cieza described the robber as Hispanic, 6'2" and 180 to 200 pounds. This description was revised after the showup. Similarly, De Souza's description of the robber's "bushy eyebrows," like his noteworthy nose, was articulated to police only after appellant was identified in the field showup. That anything more than the tall Hispanic male portion of the description of the robber more or less matched appellant is a chicken and

6 To wit: witness had a good view of the suspect during narcotics buy; witness was a trained police officer, was on-duty, and was of the same race as the suspect; witness provided an accurate description of the suspect before seeing the improperly suggestive photograph; witness was certain of his pretrial identification of suspect at the time the identification was made; description of suspect given "minutes" after crime, confrontation took place two days later; corrupting effect of single-photo identification minimal as "little pressure on the witness to acquiesce in the suggestion..." plus "no coercive pressure to make an identification arising from the presence of another [witness]." (*Mason v. Brathwaite, supra,* 432 U.S. at pp. 114-116.)

egg factor given the showup in this case. (The lineup having been based on the positive showup identification.)

4. The witnesses' level of certainty. De Souza, who had already seen appellant in the field showup, and Ahrens, who hadn't, were certain suspect number 5 was the robber until the police instructed them otherwise. Cieza was certain the man in the field showup was the robber because, from fifty yards away and dressed in a hooded gray sweatshirt, and though much thinner than she remembered, they had the same color eyes.

5. The time between the crime and confrontation. Ten or twenty minutes between robbery and showup; about two and a half months between robbery and lineup. Unlike most suggestive pretrial identification situations, the relatively brief periods of time here reinforce the problem of suggestiveness, for rather than preserving a fresh memory, the showup here simply served to imprint or prime a suggested recollection. The lineup just sealed the deal.

Finally,

6. *Manson's* "corrupting effect of the challenged identification itself."[7] Cieza identified appellant as the robber when shown appellant alone, handcuffed, surrounded by police, lit by police lights, his face largely obscured by the same hooded sweatshirt that covered up most of the robber's face. De Souza and Ahrens identified appellant as the robber because the police told them appellant was the robber.

Conclusion

It is difficult to imagine an identification process more offensive to the dictates of due process. (*United States v. Wade, supra,* 388 U.S. at p. 234.) As "[a] conviction which rests on mistaken identification is a gross miscarriage of justice" (*Stovall v. Denno, supra,* 388 U.S. 297), appellant's conviction must be reversed. (*Manson v. Brathwaite, supra,* 432 U.S. at p. 117.)

7 "Although it plays no part in our analysis," the Court in *Manson* added, "all this assurance as to the reliability of the identification is hardly undermined by the facts that respondent was arrested in the very apartment where the sale had taken place, and that he acknowledged his frequent visits to that apartment." (*Manson v. Brathwaite, supra,* 432 U.S. at p. 116.) Similarly, though it should play no part in this analysis, the fact appellant was arrested traveling in a public thoroughfare is far less probative than an alleged narcotics seller being arrested in a place where narcotics sales have taken place, and admits to frequenting the den.

ARGUMENT

APPELLANT'S CONVICTIONS MUST BE REVERSED BECAUSE THE COURT REFUSED TO PERMIT EXPERT TESTIMONY ON FALSE CONFESSIONS

Pretrial, the State sought to have expert testimony on the phenomenon of false confessions excluded as irrelevant; before hearing testimony on the issue, the court expressed preliminary concerns that such testimony was predicated on an assumption that the confession in question was false, and that there is a causal relationship between specific interrogation techniques and false confessions. (RT 402, 408-410) After an extensive hearing, the court found the proposed testimony inadmissible because, though the expert testified police techniques which induce fear in a suspect may elicit a false confession, the detective testified she did not use fear, and that police use of techniques which might produce a false confession does not mean a particular confession is false: the truth or falsity of the confession was a credibility issue for the jury, given "they are not nincompoops." The court reiterated its earlier concerns, as well as its belief the material relied upon was unreliable under Evidence Code section 801, subdivision (b), adding it did not think false confessions an area generally accepted in the scientific community.[1] (RT 498-503). Appellant's convictions must be reversed as exclusion of this expert testimony violated his Sixth and Fourteenth Amendment rights to a fair trial and to present a defense.

The proposed expert, Dr. Richard Leo, is a professor at the University of California, Irvine, in the Criminology and Psychology Departments, has trained police officers and lectured judges on research on false confessions, the psychological quality of interrogations, including how to avoid intentional or unintentional coercion which lead to false confessions, and how to distinguish between false and true confessions.[2] (RT 411-415) Dr. Leo's conclusion that the primary cause of false confessions is coercive and improper police techniques

1 Defense counsel objected, noting the State did not object under *People v. Kelly, supra,* 17 Cal.3d 24; the court responded, "I don't care if it did or not." (RT 501)

2 Dr. Leo's *c.v.* was introduced as part of the hearing (Motion to Suppress, Def. Exh. A); as the exhibit demonstrates and a review of the literature illustrates, Dr. Leo is one of the leading authorities on the false confession phenomenon, having, at the time of the hearing, authored or co-authored one book (*The Miranda Debate: Law, Justice and Policing* (1998)), nineteen journal articles, five book chapters, and seven shorter articles, along with twenty-nine presentations at various professional meetings (*e.g.*, American Psychological Association, American Society of Criminology, American Sociological Association, Academy of Criminal Justice Sciences, The Law & Society Association).

was based on the literature and studies in his field: there have been cases where confessions have been demonstrably false, and those cases involve specific police interrogation methods and suspect personality traits, as borne out by the experimental research. The court interjected the same techniques can cause true confessions, and the problem was the witness "assume[d] the conclusion." (RT 416-424) The phenomenon of false confessions has been accepted as a legitimate field of study within the social science community, and has an expansive lineage dating back to the beginning of the 20th century. Most people do not know much about the phenomenon: the idea someone who was not mentally ill or tortured would falsely incriminate themselves is counter-intuitive. (RT 420-421, 424)

The reasons cited by the Central Park jogger defendants (later exculpated via DNA)[3] for their false confessions included being frightened, their belief confessing was the only way to "get out of there," and that police lied about what was going to happen to them; in that case, as in this, police taped only the confession, not the preceding hours of interrogation.[4] In many false confession cases, police fail to tape the actual interrogation; the primary causes of false confession are police misconduct and coercion. (RT 426-428, 430) If one does not know a confession is false, one cannot infer truth or falsity from the interrogation techniques themselves. (RT 427) Techniques which have been shown to induce false confessions include implicit or explicit threats, promises, and deprivations. Lengthy interrogations are common: the Central Park jogger case involved fourteen to thirty hours of questioning between the five defendants. Individuals who have low I.Q.'s or are highly suggestible are

3 Dr. Leo testified the only means of conclusively determining a confession is false would be via exculpatory forensic evidence, a finding that no crime occurred (e.g., the murder victim was not murdered), or subsequent apprehension of the real perpetrator (the Central Park jogger case perpetrator underwent a jailhouse conversion and came forward). (RT 447-448, 450)

4 This is a standard interrogation tactic, criticized by courts and commentators as obscuring issues of voluntariness and wasting judicial resources. (See e.g., Commonwealth v. DiGiambattista (Mass. 2004) 813 N.Ed.2d 516 ["As is too often the case, the lack of any recording has resulted in the expenditure of significant judicial resources [], all in an attempt to reconstruct what transpired during several hours of interrogation.., and to perform an analysis of the constitutional ramifications of that incomplete reconstruction...."]; Slobogin, Towards Taping, 1 Ohio St. J. Crim. L. 309-310 (2003) ["pre-interrogation interrogation," conducted "before the tape is turned on," functions to "let[] the cat out of the bag" without fear of memorializing involuntary confession].) Four states and the District of Columbia (DC St. ' 5-116.01) now mandate taping of police interrogations: Alaska (Stephan v. State (Alaska S.Ct. 1985) 711 P.2d 1156, 1161); Illinois (725 ILCS ' 5/103.2.1); Maine (Me c. 341 ' 2803-B(1)(K)); Minnesota (Minn. R. Crim. Pro. 11.11). For a survey, see, Sullivan, Police Experiences with Recording Custodial Interrogations (2004) Center on Wrongful Convictions, Northwestern U. Sch. of Law [http://www.law.northwestern.edu/wrongfulconvictions/Causes/CustodialInterrogations.htm].)

more prone to falsely confess. Sleep deprivation can affect someone's ability to resist coercion, but specific causation is problematic: notions of causality are considered in terms of correlations and patterns. However, these techniques overall may cause the suspect to become afraid and feel they have no choice but to confess. (RT 430-434, 447)

Dr. Leo reviewed the police reports and appellant's confession. In his opinion, confronting a suspect with evidence against him is not in itself coercive, but additionally telling this suspect he will be incarcerated for 250 years is "not only unnecessary and unprofessional, but mostly communicates a threat which would be coercive." (RT 434-435) Supplying any suspect with information about the crime is a poor investigation technique because it interferes with the ability of the interrogator to discern who is genuinely knowledgeable about the offense and would be a likely perpetrator, and who is simply parroting back information to the police, thus muddying the question whether a confession is false. In several false confession cases, the State obtained convictions by citing the suspects' knowledge about details of the crimes as proof they were the perpetrators; later it was revealed police provided the suspects this information before obtaining the taped confession. (RT 435-437) Dr. Leo was prepared to testify about police interrogation methods, psychological coercion, the phenomenon of false confessions, accepted and relevant principle findings in the field, good and bad investigative techniques in terms of giving a suspect information, issues of corroboration, taping, and preserving a record. (RT 437)

The court then asked Dr. Leo to render an opinion on the veracity of appellant's confession. Dr. Leo noted there was no record of most of appellant's interrogation: he recalled there were six hours of questioning involving two sessions, five hours of which were not taped. The last hour indicated poor police practice: "...it sounds like the detectives are confessing, not the client. They are feeding him information. They are badgering him. They are telling him what occurred, and he's just going along most of the time, saying, uh-huh, yeah or not saying anything at all. And they are telling him, you have to say this, you said it before, you have to say it now."(RT 437-438)

Dr. Leo could not say whether it was a true or false confession, because that would have been decided by what happened in the preceding, untaped, five hours. Aside from the reference to appellant's going away for 250 years, Dr. Leo did not recall anything explicitly coercive: the 250 years, however, suggested appellant may have been threatened prior to the taped portion, either with the length of time itself, or the possibility of greater

punishment. That appellant resisted certain statements or suggestions by police or was confronted with thirty-one cases and told he was linked to them via DNA evidence would not alone show coercion, but might be coercive in terms of eliciting a false confession when combined with sleep deprivation, the effect of the evidentiary chart, and fear created by the threat of Lengthy incarceration. The chart presented to appellant further facilitated his telling the officers what they wanted to hear. (RT 439-445, 449-451, 453-454, 472-477) Dr. Leo emphasized that what the jury would find most helpful would be knowing false confessions do occur, and the sorts of practices/techniques that tend to elicit such confessions: the jury could then determine the weight to accord this testimony. (RT 444, 452)

Dr. Leo was right. As a general matter, the trial court here engaged in a pattern of creating straw men which it then proceeded to immolate: though the State's objection was on relevancy alone, the court's self-sustained objections included relevancy, section 352, *People v. Kelly, supra,* 17 Cal.3d 24, section 801, subdivision (b) unreliability, and its more free-wheeling objection to the empirical validity of the phenomenon of false confessions. Though the court's analysis of each of these was incorrect in its own way, the more fundamental error was that the evidence was being offered to supplement, not supplant, the jury's credibility determination here, and thus ought have been allowed. (*People v. Page* (1991) 2 Cal.App.4th 161, 185; *United States v. Hall* (7th Cir. 1996) 93 F.3d 1337, 1345, cert. den. 527 U.S. 1029; *see generally, Davis v. Alaska* (1974) 415 U.S. 308, 317; *Chambers v. Mississippi* (1973) 410 U.S. 284, 303.)

Confessions are the highest and most satisfactory proof of guilt. (*Dickerson v. United States* (2000) 530 U.S. 428, 433, quoting *King v. Warickshall,* 1 Leach 262, 263-264, 168 Eng. Rep. 234, 235 (K. B. 1783) ["A free and voluntary confession is deserving of the highest credit, because it is presumed to flow from the strongest sense of guilt...but a confession forced from the mind by the flattery of hope, or by the torture of fear, comes in so questionable a shape... that no credit ought to be given to it; and therefore it is rejected."].) The notion of a false confession goes against this core concept because "the confession of a crime is usually as much against a man's permanent interests as anything well can be...no innocent man can be supposed ordinarily to be willing to risk life, liberty, or property by a false confession." (3 Wigmore on Evidence (Chadbourn rev. 1970) ' 820(b)(c) at pp. 301-306; *Hannon v. State* (Wyo. 2004) 84 P.3d 320, 350-351 [error in excluding psychiatric testimony to explain defendant's propensity to false confession]; Kassin and Wrightsman, *Coerced Confessions,*

Judicial Instructions, and Mock Juror Verdicts 11 J. Applied Soc. Psychol. 489 (1981) [jurors disinclined to believe in false confession].) The phenomenon of false confessions is distinguished from the question of constitutional voluntariness: as the latter is an issue of evidentiary admissibility—involuntary confessions are inadmissible—and the former a matter of evidentiary weight—a repudiated confession obtained under circumstances associated with the phenomenon may be unreliable. One precludes jury consideration, the other augments it. (*Dickerson v. United States, supra,* 530 U.S. at p. 434; *Crane v. Kentucky* (1986) 476 U.S. 683, 687-688.) The court should not have excluded the testimony as it was offered based on its notion of what the testimony might include:

Prefatorially, the court acted improperly in eliciting Dr. Leo's opinion on the ultimate fact at issue—the truth or falsity of appellant's confession, then excluding his testimony because the court did not believe that opinion had a reliable evidentiary basis, *i.e.*, that if Dr. Leo's opinion that appellant's confession was false was predicated on appellant's statement that his confession was false, this was not a reliable section 801 evidence. But Dr. Leo never intended to testify as to whether appellant's confession was true or false, just as "[i]n light of [the] historical use of syndrome evidence, it would be a dramatic departure... to permit use of battered women's syndrome evidence to predict the actual state of mind of a particular individual at a given moment." (*People v. Erickson* (1997) 57 Cal.App.4th 1391, 1401.) Here, the court's invitation/smackdown would make any evidence regarding the non-*Miranda* circumstances of a confession irrelevant because its relevance would necessarily be predicated on the assertion the confession was false. (*Contra, Crane v. Kentucky, supra,* 476 U.S. at pp. 687-688.)

Given this, it is difficult to comprehend the court's relevancy ruling: appellant's confession was offered by the State as true, and the defense contended it was false. Though Dr. Leo planned on testifying only on the phenomenon of false confessions in general and on various interrogation techniques and police practices which have been associated with the phenomenon, he also testified the constellation of factors present at appellant's interrogation could be considered similarly coercive/improper. (*Compare, People v. Son* (2000) 79 Cal.App.4th 224, 241; *see generally,* Leo and Ofshe, *The Decision to Confess Falsely: Rational Choice and Irrational Action,* 74 Denv. U.L. Rev. 979 (1997) [detailing police methodologies associated with false confessions; exhaustive annotation of then-current research]; White, *False Confessions and the Constitution: Safeguards Against Untrustworthy*

Confessions, 32 Harv. C.R.-C.L. L. Rev. 105-157; Redlich and Goodman, *Taking Responsibility for an Act Not Committed: The Influence of Age and Suggestibility*, Law and Human Behavior, vol. 27, no. 2, 141-156 (Apr. 2003); Conti, *The Psychology of False Confessions*, The J. of Credibility Assessment and Witness Psychology, vol. 2, No. 1, 14-36 (1999).)[5] The Supreme Court has held "evidence about the manner in which a confession was secured will often be germane to its probative weight, a matter that is exclusively for the jury to assess." (*Crane v. Kentucky, supra,* 476 U.S. at p. 688, emphasis added.) In *Crane*, the trial court, after finding the defendant's confession voluntary,[6] excluded evidence of the physical/psychological circumstances of that confession at trial; in reversing, the Supreme Court in acknowledged exclusion of such evidence improperly disables the defendant "from answering the one question every rational juror needs answered: If the defendant is innocent, why did he previously admit his guilt?" (*Id.*, at p. 689.)

The main of the false confession phenomenon was outlined by Dr. Leo in his testimony; in brief, the scientific literature indicates certain police techniques are associated with false confessions, and certain personality types susceptible to falsely confess when confronted with those techniques. The articles break false confessions down by type: the voluntary false confession (person confesses absent police influence), coerced-compliant false confession (confession provoked by extreme methods of interrogation, suspect confesses "to get it over with"), and coerced-internalized false confession (confession provoked because the anxious, fatigued, pressured, or confused suspect is subject to suggestive methods of interrogation, and comes to believe in his own guilt). Other aspects of the phenomenon can include wanting to please the interviewers, who may or may not be seen as the suspect's [only] friends in the situation: as the predicate of the interview from the police standpoint is to elicit a confession from someone the interviewer believes is guilty, cooperation with police (confession) becomes more in the suspect's perceived self-interest than non-cooperation (denial of guilt). A suspect may confess from fear of official prejudice in not confessing or hope of gaining some advantage by confessing.

5 The sociological/psychological literature on the topic is too vast to catalogue; the citations here provided in turn provide a sampling of the relevant research.

6 Commentators have similarly criticized courts for considering *Miranda* the "ultimate issue" in regulation of interrogation tactics, leading to "judicial myopia about voluntariness." (Slobogin, *supra; see also,* Leo and White, *Adapting to Miranda: Modern Interrogators' Strategies for Dealing with the Obstacles Posed by Miranda,* 84 Minn. L. Rev. 397, 410 (1999) ["interrogators may employ any interrogation tactics not prohibited by the due process voluntariness test"].

Tactics which create the sort of coercive environment that can cause a susceptible suspect to falsely confess include deprivation of food, sleep, or medical attention, use of fabricated evidence of guilt, excessively aggressive, intimidating, or prolonged questioning. Commentators note high-profile cases without many viable suspects put more pressure on police to solve, making those interrogations more prone to coercion. (Conti, *passim*; Ofshe and Leo, *The Decision to Confess Falsely*; White, *supra*, at p. 133.) There was no evidence put forth by the People to counter any of this.

In *People v. Page, supra,* 2 Cal.App.4th 184, expert testimony had been allowed on general factors which might influence someone to falsely confess, examples of those factors, and explanations of relevant psychological experiments in the field; the trial court excluded opinion evidence on the reliability of defendant's confession, though counsel was able to argue application of the expert testimony to that confession. The First District found no constitutional violation in the exclusion because this "marginally curtailed" testimony did not deprive defendant of the ability to present evidence on the circumstances of his interrogation, but "merely affected the *way* the defense could link the theories presented by the expert to the evidence introduced at trial. It did not prevent it from making that connection." (*Id.,* at p. 187.) There was no abuse of discretion under section 801 because there had been no *"wholesale"* exclusion; citing *People v. McDonald* (1984) 37 Cal.3d 351, 370-371, the *Page* court reiterated expert testimony is permitted where the testimony does not seek to "'take over the jury's task of judging credibility.... does not tell the jury that any particular witness is or is not truthful...,'" but rather informs the jury of factors that might affect the issue of reliability "'in a typical case; and to the extent it may refer to the particular circumstances'" of the present case, may be limited to explaining "'the potential effects of those circumstances....'" (*People v. Page, supra,* 2 Cal. App.4th at p. 188, original emphasis.)

In *United States v. Hall, supra,* 93 F.3d at p. 1342, the Seventh Circuit reversed the conviction, finding exclusion of expert testimony on false confessions error insofar as it represented a too-cursory conclusion that the proposed testimony invaded the province of the jury and was thus not "helpful" under the federal rules. The appellate court underscored the trial court's failure to explicitly analyze the question under *Daubert v. Merrell Dow Pharmecuticals, Inc.* (1993) 509 U.S. 579, 589, and chastised the lower court as it "overlooked the utility of valid social science," summarizing:

Dr. Ofshe's testimony[7], assuming its scientific validity, would have let the jury know that a phenomenon known as false confessions exists, how to recognize it, and how to decide whether it fit the facts of the case being tried. [&] The district court's conclusion therefore missed the point of the proffer. It was precisely because juries are unlikely to know that social scientists and psychologists have identified a personality disorder that will cause individuals to make false confessions that the testimony would have assisted the jury in making its decision. It would have been up to the jury, of course, to decide how much weight to attach to Dr. Ofshe's theory, and to decide whether they believed his explanation of Hall's behavior or the more commonplace explanation that the confession was true. [Cite] But the jury here may have been deprived of critical information it should have had in evaluating Halls case.

(*United States v. Hall, supra,* 93 F.3d at p. 1345.) Just as the jury was here deprived:

As appellant's trial court noted, there is a judicial divide on the admissibility of expert testimony on false confessions: some courts find it flatly inadmissible (*Vent v. State* (Alas. App. 2003) 67 P.3d 661, 670; *Riley v. State* (Ga. S.Ct. 2004) 604 S.E.2d 488, 682; *State v. Cobb* (Kan. App. 2002) 43 P.3d 855, 869), others partially admissible (*People v. Page, supra,* 2 Cal.App.4th at p. 187; *Scott v. State* (Tex. App. 2005) 165 S.W.3d 27, 78-81; *Miller v. State* (Ind. S.Ct.

7 The proposed expert, and Dr. Leo's frequent collaborator. (*See e.g.,* Leo and Ofshe, *The Truth About False Confessions and Advocacy Scholarship,* The Crim. L. Bulletin, vol. 37, no. 4, 293-370 (2001); Leo and Ofshe, *Using the Innocent to Scapegoat Miranda: Another Reply to Paul Cassell,* The J. of Crim. L. and Criminology, vol. 88, no. 2, 557-577 (1998); Leo and Ofshe, *The Consequences of False Confessions: Deprivations of Liberty and Miscarriages of Justice in the Age of Psychological Interrogation,* The J. of Crim. L. and Criminology, vol. 88, no. 2, 429-496 (1998); Leo and Ofshe, *Missing the Forest for the Trees: A Response to Paul Cassell's "Balanced Approach" to the False Confession Problem,* Denver U. L.Rev., vol. 74, no. 4, 1135-1144 (1997); Ofshe and Leo, *The Decision to Confess Falsely: Rational Choice and Irrational Action, supra;* Ofshe and Leo, *The Social Psychology of Police Interrogation: The Theory and Classification of True and False Confessions,* Studies in Law, Politics & Society, vol. 16, 189-251 (1997).

2002) 770 N.Ed.2d 763, 773),[8] and still others, led by the Seventh Circuit in *Hall,* wholly admissible (*State v. Stringham* (Ohio App. 2003) 2003 Ohio 1100 [2003 Ohio App. LEXIS 1055]; *United States v. Raposo* (SDNY 1998) [1998 U.S. Dist. LEXIS 19551], cert. den. 530 U.S. 1210.)[9]

Leaving aside the fundamental unfairness of a trial court making a *Kelly* finding where no *Kelly* objection had been made, and precluding the defense from making a *Kelly* showing after making its *Kelly* objection/finding, the rock-bottom fact remains that *Kelly* does not apply to expert psychological testimony. (*People v. Therrian* (2003) 113 Cal.App.4th 609, 614-615; *People v. Ward* (1999) 71 Cal.App.4th 368, 373-375.) And, if the trial court here did apply (though it did not so indicate) *Kumho Tire Co., LTD. v. Carmichael* (1999) 526 U.S. 137, 141 so as to require a *Kelly*-like showing of acceptance in the socio-psychological community of the phenomenon of false confessions, it erred in finding insufficient acceptance. And if there was an insufficient showing of scientific acceptance under *Kumho,* the court erred in not permitting the defense to directly address that objection after it was raised by the court.

The *Kelly* rule has three prongs: (1) establishment of method reliability via witness testimony; (2) qualification of witnesses testifying as experts; and (3) proof "correct scientific procedures were used in the particular case." (*People v. Kelly, supra,* 17 Cal.3d at p. 30; *People v. Bolden* (2002) 29 Cal.4th 515, 544-545, cert. den. 538 U.S. 1016.) Reliability is established under prong one when the technique has "gained general acceptance in the particular field to which it belongs." (*People v. Soto* (1999) 21 Cal.4th 512, 519.) General acceptance means consensus, "drawn from a typical cross-section of the relevant, qualified scientific community." (*People v. Leahy* (1994) 8 Cal.4th 587, 612.) Acceptance does not mean:

> ..."that the court decide whether the procedure is reliable as a matter of scientific fact: the court merely determines from the professional literature and

8 In *United States v. Adams* (10th Cir. 2001) 271 F.3d 1236, 1245-1246, cert. den 535 U.S. 978, the Tenth Circuit found expert credibility testimony inadmissible given the facts of the case.

9 In *Regina v. Oickle* (2000) 147 C.C.C. (3d) 321, the Supreme Court of Canada promulgated a set of rules demonstrating its "growing understanding of the problem of false confessions," citing Dr. Leo's work in the field with particular approval, and noting "false confessions are rarely the product of proper police techniques." (*Id.,* at pp. 341-342, 344.) The Court recommended videotaping of entire interviews, eschewing tactics such as use of false evidence, threats and/or promises, even if inchoate ("it would be better" to confess), trickery, and deprivation/oppression. (*Id.,* at pp. 345-353.) Quoting Wigmore, the Court summarized that voluntariness is "'a shorthand for a complex of values,'" applicable to the problem at hand. (*Id.,* at p. 355, quoting 3 Wigmore on Evidence (Chadbourn rev. 1970) ' 826, p. 351.)

expert testimony whether or not the new scientific technique is accepted as reliable in the relevant scientific community and whether "scientists significant either in number or expertise publicly oppose [a technique] as unreliable.'"

(*People v. Soto, supra,* 21 Cal.4th at p. 519, quoting *People v. Axell* (1991) 235 Cal.App.3d 836, 854, citations omitted.) Determinations of general acceptance/reliability are mixed questions of law and fact, subject to limited de novo review: the reviewing court is to deferentially consider all supportable findings of historical fact or credibility, then decide "as a matter of law, based on those assumptions, whether there has been general acceptance." (*People v. Morganti* (1996) 43 Cal.App.4th 643, 663; *People v. Hill* (2001) 89 Cal.App.4th 48, 57.)

Here, the trial court counted how many courts had admitted false confession expert testimony and how many had not; however, under *Kelly,* "'the needed consensus is that of scientists, not courts.'" (*People v. Morganti, supra,* 43 Cal.App.4th at p. 663, quoting *People v. Reilly* (1987)196 Cal.App.3d 1127, 1135.) The appellate courts excluding the testimony have done so for a variety of reasons, some unrelated to *Kelly* concerns (the testimony invades the province of the jury (*Adams*); the evidence is inapposite (*Ramos*)), some related to an insufficient showing of expertise (*Kolb v. State* (Wyo. S.Ct. 1996) 930 P.2d 1238, 1351), and some simply finding no abuse of discretion either way (*Vent*). Contrarily, those courts admitting the testimony, including the Indiana Supreme Court, the Canadian Supreme Court, find the phenomenon—as a phenomenon—a settled matter of sociological/psychological fact. For part of the problem is the trial court's rulings here muddled the issue: the testimony as proposed was neither diagnostic nor interpretive, but rather sought to explain how and under what circumstances someone might falsely confess, an action counterintuitive to most rational minds. (*United States v. Shay* (1st Cir. 1995) 57 F.3d 126, 133 ["Common understanding conforms to the notion that a person ordinarily does not make untruthful inculpatory statements"]; c.f., *State v. Stringham, supra,* 2003 Ohio App. LEXIS 1055 at p. 46, fn. 14 [expert "proposed to testify primarily about psychological reasons why a person would give a voluntary but false confession," error to exclude].)

Nutshelled, the court's objection to Dr. Leo's testimony appeared to be that the court disagreed with the conclusions reached by the social scientists/psychologists in the field; the court's primary objection in this regard being there wasn't a "one-to-one correlation" between false confessions and

coercive interrogation techniques because the same techniques could lead to true confessions. (RT 429) But this is not a legitimate reason to exclude valid expert testimony: in a slew of other situations, section 801 permits experts to testify about things whose *in se* nature is not inherently dispositive as to the ultimate issue, but does illuminate the evidence at hand. And does so, frankly, by openly "assuming the conclusion" to be proved. In other words, and by other example: the Child Sexual Abuse Accommodation Syndrome details a pattern of behavior including failure to seek protection from the abuser, delayed disclosure of the abuse, and retraction or denial of abuse. According to the CSAAS, this behavior is, though counterintuitive to general precepts about victimization, consistent with molestation. This behavior is also consistent with lying about being molested, but the expert testimony is nonetheless admitted, and it is up to the jury to accord the phenomenon whatever evidentiary weight it is worth in a particular case. (*People v. Bowker* (1988) 203 Cal.App.3d 385, 391 ["there was no evidence presented to the trial court which would support the notion that CSAAS may be properly and accurately used to determine when a child has been abused."].) So too is similar testimony admitted under similar conditions, and admitted "solely to disabuse jurors of 'common sense' misconceptions about the behavior of persons in the affected groups, such as rape victims and abused children, and not to prove a fact in issue." (*People v. Erickson, supra,* 57 Cal.App.4th at p. 1401, citing *People v. Bledsoe* (1984) 36 Cal.3d 236, 247-248 [Rape Trauma Syndrome]; *People v. Humphery* (1996) 13 Cal.4th 1073, 1088 [Battered Wife Syndrome].) Expert testimony is routinely admitted in sex cases which consists of a forensic nurse practitioner testifying that there was no trauma detected to the interior or exterior genitalia of the victim, and that such an absence is consistent both with being raped/molested and with not being raped/molested. (*See e.g., People v. Roberto v.* (2001) 93 Cal.App.4th 1350, 1357; *People v. O'Neal* (2000) 78 Cal.App.4th 1065, 1071; *People v. Fond* (1999) 71 Cal.App.4th 127, 130.) As the Wyoming Supreme Court said in finding false confessions evidence admissible under *Crane:*

> In a long series of cases, we have allowed expert testimony in criminal cases to explain victims' behavior. [Cites] Generally, we have done so because such testimony was useful in disabusing juries of widely held misconceptions about the behavior of victims of particular crimes so they could evaluate the evidence free of the constraints of popular

myths. [Cite] We found such testimony relevant and helpful in explaining to the jury the typical behavior patters of victims of certain crimes and helping jurors understand why a particular victim behaved as he or she did.

(*Hannon v. State, supra*, 84 P.3d at p. 82.) Under section 801, expert opinion testimony is admissible so long as the opinion is related to a subject beyond common experience, though, as one court has noted: "a trial court is not compelled to exclude the expert just because the testimony may cover matters within the average juror's comprehension.... Even though the jury may have beliefs about the subject, the question is whether those beliefs are correct." (*Boyer v. State* (Fla. App. 2002) 825 So.2d 418, 419, citing *United States v. Hall, supra*, 93 F.3d at p. 1342; accord, *Crane v. Kentucky, supra*, 688-689.) Inasmuch as this sort of testimony is admissible to explain victims' counterintuitive behavior to juries, general guarantees of reciprocity would require the same evidentiary consideration be given the accused. (*Wardius v. Oregon* (1973) 412 U.S. 470, 474.)

It is also improper for a judge to use her personal expertise in "philosophy and symbolic logic" to countermand an entire field of study in social psychology: whatever Humean critique the court might have brought to bear on the issue of causality was beside the point.[10] Again, the epistemological pedigree of the study of false confessions is well-established: an area of study for approximately one hundred years, according to the testimony in appellant's case, documented by a raft of studies, according to appellate opinions before his trial court (e.g., *People v. Page, supra*, 2 Cal.App.4th at pp. 181-183 [describing research in "field of conformity compliance persuasion"]), and despite the noted difficulty in establishing scientific bases for similar evidence. (*People v. Stoll* (1989) 49 Cal.3d 1136, 1161-1162; *People v. Cegers* (1992) 7 Cal.App.4th 988, 997-998.) The trial court's cavils about the conclusions reached by the false confession research only goes to show how "beyond common experience" the topic truly is: as Dr. Leo would have testified, it is counterintuitive to think that (short of torture) someone might falsely confess, or that police could unintentionally coerce a false confession. But these things happen, and tend

10 The court here appears to have forgotten that science, unlike philosophy, often concerns itself with the descriptive and inductive over the prescriptive and deductive. (*See generally,* Salmon, W., *Causality and Explanation* (Oxford UP, 1998); de Regt, H., *Can Causalists and Unificationists Live Together in Peace?* (Free University of Amsterdam [logica.rug.ac.be/censs2002/abstracts/De%20 Regt.htm] [outlining the debate between unificationists and causal-mechanicalists].)

to happen under a certain constellation of factors, a number of which appear in appellant's case:

As noted, appellant was arrested at 8:00 p.m. in Oxnard, and transported to Long Beach: during this drive, he was given his *Miranda* advisements and told he had been arrested for sexual assault. Appellant was then interviewed at the Long Beach police station from 9:40 p.m. until approximately 12:45 a.m., and was given water and a package of Gummi Bears in the interview. During the 1:00 a.m. drive from station to jail, the transporting officer questioned appellant about his escape route in the Doe # 16 assault. Appellant was picked up from the jail at 9:00 a.m., and the second portion of the station interrogation began at 9:45 a.m., and lasted until the end of the taped portion of the interrogation, at 12:25 p.m.. Appellant was thus effectively and serially interviewed for over six hours, with a break for housing/sleeping. This is a relatively long interview, by confession standards, and may have felt even longer to a suspect who had been in continuous police custody since his arrest the night before. It is worth noting in this regard that appellant had asked to see his mother during the first station portion of his interrogation, and the detectives told him he could, but not until "after *our entire interview* was complete." (RT 461, emphasis added.) Appellant was never told he had the right to make any telephone calls, and whatever anxiety he felt about his mother finding out he'd been arrested as the Belmont Shore Rapist would have increased as time went on, as the possibility of press coverage increased. In the taped portion, Detective Collette pushed this, telling appellant his mother was another one of his victims, as she was elderly, sick, had cancer, and was "losing her son." Having told appellant he had to wait to talk to his mother until the interview was complete may have contributed to a sense of coercion, especially under the rubric of compliant-coercion—confessing "to get it over with" and reach his ailing mother before the media did.

The "getting it over with" in appellant's case could have felt even more compelling insofar as the case against him as presented to him was a done scientific deal. Throughout his interrogation, appellant was confronted with a chart indicating he was suspected of thirty-one serious sexual offenses, and was repeatedly reminded that conclusive DNA proof linked him to twelve of those cases. That the actual DNA link here was between cases arguably constitutes fabrication of evidence, that the chart states there is fingerprint evidence where no fingerprint evidence existed, was fabrication. (Peo. Exh. 20) In any event, the forensic nature of the evidence confronting appellant would

certainly contribute to a sense of hopelessness, or the futility of denying guilt, a coercion exacerbated by the threat latent in the officers' telling him that he was going away for "a very long time," "several hundred years to life [sic] in prison."[11]

Appellant was spoon-fed details of the crimes, corrected, even in the taped portion, on the particulars of offenses he was supposed to know the most about. A jury would have benefitted from not just the general notion that it's bad police work to tell a suspect the details of a crime, but from the specific fact that in many false confession scenarios, the thing unusually used to confirm guilt—that a perpetrator knows things an innocent suspect can't—has been infected by the interrogation itself. The exchange about appellant's breaking the pot is illustrative: appellant has no idea where the pot was, guesses wrong about knocking it over, and is essentially told he must have kicked it. When asked if he stole a small car or a large car, appellant says, "Small car, I guess," as if being questioned about a spate of auto thefts rather than rapes, and the details of one car blur into another. Appellant guesses and guesses wrong about the louvers in the window, and when asked if it was possible he took them, his incorporation of that suggestion is immediate, and immediately approved. He has no idea what a colostomy bag is, though what a colostomy bag is, is self-evident—and had supposedly been explained to him by his victim. He seems to forget whether he said he wore a cockring or couldn't remember or didn't. He said he attempted to assault Doe #13, who told police she was not assaulted; he said he was not injured by Doe #16, who drew blood from her assailant. The taped portion of the interrogation is mostly a series of yes ma'ams and yes sirs and uh-huhs and O.K.s, and failures to remember and, on occasion, an overt nod to the parroting process: "Then why, why don't you guys read your notes. You guys already read, you guys asked me the questions." (CT 911) Getting back to the louvers:

> Defendant: That was just the same questions you
> had asked me earlier prior to...
> Collette: But you never answered it.
> Defendant: (Sigh)
> Collette: I asked you, I asked you if it was possible.
> Defendant: It was
> Collette: that you took the louvers and..
> Defendant: O, yes, yes
> Kriskovic: And uh,

11 Appellant was also questioned about attacks in the Seattle area.

Defendant: Yes, yes.

Kriskovic: And if you actually took 'em with you and you said, you said you actually left 'em on the property.

Defendant: Yes.

Kriskovic: Do you remember that?

Defendant: Yes.

Kriskovic: O.K. But then you also said that it was a possibility 'cause we couldn't find 'em that you might have taken them with you and dumped them somewhere. Was that correct?

Defendant: Maybe.

Kriskovic: O.K. A possibility is there?

Defendant: May, maybe.

Kriskovic: O.K. maybe. O.K..... (CT 912-913)

The taped portion of the interview began with the detectives' admonishing appellant that he'd been "very cooperative," and when appellant does not confirm the detectives' statement regarding one of the crimes, the mood turns: Collette: "Are you playing games with us?" Defendant: "Maybe." (CT 911) As in the telling: Collette: "O.K. Did we ever threaten you with anything?" Defendant: "Not to my knowledge, no." Dr. Leo characterized the authorities' questioning here as "badgering," and appellant's responses sound like those of a badgered child, further evoking the coerced-compliant model.

At times, the detectives also engaged in a version of the "minimizing" technique described in the research by providing appellant with explanations or atonement, ways of seeing himself and/or the offenses which might encourage further confession according to the coerced-compliant model (also playing into the "hope of advantage" motivation for these confessions). Examples of this include Collette's amending appellant's "It's the truth" explanation for his cooperation to: "'Cause it's the truth and I think you said you were very sorry for, to the community, the victims. Remember that?" and the "I mean you are a very remorseful... And you've apologized to us for all these victims. Have you not?" "You're on the verge of crying right now. Right? 'Cause you feel bad. Right?" "I think you even said, you've just been making bad decisions and doing hideous things to all these women. Isn't that about what you said?" "Did you also tell us that you, you owe a 'Great debt.'" And:

Collette: Feel free to say anything you feel like saying. I know you like, every one and a while yesterday you'd say, how bad you feel for all these people. If you want to say that, say it in your words, you know. You know the tape is going and if you want to say that feel free to say that. To say whatever you want. PAUSE 'Cause you do feel bad. You look down a lot you know. We can tell. You're about ready to cry right now. Right? 'Cause it bothers you. You just said, you explained by saying "I've just been making a lot of bad decisions." You said it was just about sex and that was it.

Kriskovic: You know, I asked you earlier this morning about a statement that if you, if you had to make a statement to a victim, what was it that, that you would say and you gave us a statement did you not?

Defendant: Yes, ma'am.

Kriskovic: Yeah. Well, let me ask you again. What would you say to those victims right now? PAUSE I don't want to read what I have in my notes. I want you to speak from the heart.

Defendant: I said I can't undo what I have done and I sincerely regret and I wish that it never happened.

Kriskovic: O.K. (CT 927)

This may have been a recapped attempt by a guilty man to assuage his conscience, or it may have been the effect of a constellation of coercive interrogation tactics. But without Dr. Leo's testimony, the jury was not aware there was such a constellation, or that such a constellation, when worked upon a compliant personality, was empirically associated with false confessions.

Nor was the jury appraised that the primary coercion would have occurred during the untaped portion of the interrogation. Detective Kriskovic testified the main of the interrogation was not taped because the interview took place in a "temporary building" without the capacity to house the equipment needed for a lengthy interview, and also so as to build a rapport with appellant. Given the detectives had been appraised of appellant's whereabouts throughout the day of his arrest, it would seem a simple matter to arrange for whatever equipment was needed to properly record a lengthy interview in a case in which

so many resources had been expanded. And it feels disingenuous to maintain a working tape recorder would damage rapport more than a chart accusing someone of thirty-one rapes. This is all common sense. What Dr. Leo's testimony would have provided was the uncommon knowledge that recording only the final "confession" (and not the predicate interview) is also a police tactic associated with false confessions as only the fruit of the interrogation is memorialized: the confession is concretized, whereas the interview, and the techniques employed by the interviewer, are subject to the vagaries of memory and the difficulty of piercing the final veil of the taped statement. As Dr. Leo said, any coercion of appellant took place before the tape was turned on.

Finally, the trial court, in finding appellant's confession voluntary under *Miranda*, put specific stock in his failure to dispute the detectives' statements, his resigned/sad tone, and his asking the detectives what they thought of him "personally," interpreting these things as demonstrations of voluntariness; appellant's asking the detectives what they think of him is "interesting and unusual" because:

> ... it goes to the fact that the confession was voluntary. Because if one's will is overborne, one is afraid, one is intimidated, one is pushed into confessing, it would be an anomaly, to say the very least, for that individual to inquire of the very people who are overbearing his will, "I'd like to know what you think of me personally." The two just don't go together." (RT 697)

But under the compliant-coerced false confession model, they do. With the benefit of the proffered expert testimony, the jury could have seen this same exchange as confirming appellant's desire for police approval—reassurance that he was somehow still a good person in the eyes of authority, reassurance bought with his acceptance of guilt. Again, high-profile cases create their own frustrations and confession-related pressures: there was an ongoing, heavily-staffed Belmont Shore Rapist task force in the Long Beach police department; where the case was publically considered "a priority"; flyers describing the perpetrator (a description which did not match appellant) were posted throughout the city, a cadre of usual suspects had been genetically tested, to no end, another man arrested for some of the charged offenses and still others tried and convicted for other crimes originally thought to part of the series. The question is not whether appellant falsely confessed. But the question is whether

the jury should have been permitted access to testimony about the general phenomenon of false confessions which could have contextualized appellant's confession and the police tactics used to obtain that confession. The court here said the jurors were not "dithering nincompoops."[12] If not nincompoops, they ought have been appraised of the expert testimony here: "We are not persuaded that juries are incapable of evaluating properly presented references to psychological 'profiles' and 'syndromes.'" (People v. Stoll, supra, 49 Cal.3d at p. 1161, fn. 22.) Instead, they were left with just what the State left them with: "He said he did it. [...] It's common sense. No grown man, no 32-year old man is going to say yes to a bunch of crimes. [...] An innocent man does not admit raping people unless he did it." (RT 2258-2260) But, knowing of the false confession phenomenon, now consider appellant's taped question to the detective: "So you're saying to say yes?"

Appellant's convictions must be reversed unless it can be shown beyond a reasonable doubt exclusion of this evidence did not contribute to the verdicts. Chapman v. California (1967) 386 U.S. 18, 24; Arizona v. Fulminante (1991) 499 U.S. 279, 310.) This cannot be shown: the most damning parcels of proof against appellant were the DNA evidence and his confession, one used to prop the other. The DNA evidence was subject to scientific opinion; the confession should have been. (People v. Page, supra, 2 Cal.App.4th at p. 185; Davis v. Alaska, supra, 415 U.S. at p. 317.)

12 Contrarily, the court thought the jury could rely on its knowledge of the phenomenon of false confessions as gleaned from television. (RT 498)

ARGUMENT

APPELLANT'S CONVICTIONS MUST BE REVERSED AS THE COURT
ERRED IN ADMITTING HIS STATEMENTS TO POLICE OBTAINED IN
VIOLATION OF APPELLANT'S FIFTH AND SIXTH AMENDMENT RIGHTS

Introduction

Pretrial, appellant moved to suppress statements made to the interrogating detective as obtained pursuant to an invalid waiver.[1] After a lengthy hearing on the motion, the court found appellant knowingly and inferentially waived his constitutional rights. (*North Carolina v. Butler* (1979) 441 U.S. 369, 372-376.) During appellant's interrogation, after being repeatedly advised of his rights and asked to sign the waiver, appellant asked, "But if I sign will it affect me?" The detective's answered, "Your signature means that you understand your rights." (Aug. RT A-9-A-10) Appellant's convictions must be reversed because there was not sufficient showing appellant understood either the nature of the rights being waived or the consequences of such a waiver. (*See, People v. Whitson* (1998) 17 Cal.4th 229, 248; *see also, Moran v. Burbine* (1986) 475 U.S. 412, 421 ["... waiver must have been made with a full awareness of both the nature of the right being abandoned and the consequences of the decision to abandon it."].)

A. Implicit waivers

The keystone is necessarily *Miranda v. Arizona, supra,* 384 U.S. 436: a defendant's statements obtained pursuant to custodial interrogation may not be used against him unless he was first advised that he has a right to silence, anything he says may and will be used against him, he has a right to have an attorney present during questioning, and if he cannot afford counsel, one will be appointed for him before questioning. A defendant may "knowingly and intelligently waive these rights," but "unless and until such warnings and waiver" are proved by the State at trial, interrogation evidence is inadmissible. (*Id.*, at pp. 478-479.) Silence does not constitute a valid waiver, nor will a waiver be presumed "simply from the fact that a confession was eventually obtained." (*Id.*, at p. 475.) As the advisement assures the accused is aware of the nature of the rights secured him, the admonition that anything said can and will be used

1 In noticing the oral motion, counsel indicated appellant was not properly advised of his rights, his waivers were defective, and he did not specifically waive his right to have an attorney present during questioning. (RT 7) As the motion developed, however, the primary theory advanced by counsel was appellant's waiver was not knowingly given. (RT 7-8, 349-357)

against him assures he is cognizant "of the consequences of foregoing" those rights. (*Id.*, at p. 469.) And so the touchstone lies in the keystone: "It is only through an awareness of these consequences that there can be any assurance of real understanding and intelligent exercise of the privilege." (*Ibid.*, reaffirmed by *Dickerson v. United States* (2000) 530 U.S. 428, 431-432, 443-444; *see generally, People v. Bradford* (1997) 14 Cal.4th 1005, 1021-1033, cert. den. 522 U.S. 953; *see also, Moran v. Burbine, supra,* 475 U.S. at p. 421.)

In *North Carolina v. Butler, supra,* 441 U.S. 369, after advising the defendant and ascertaining he had an 11th grade education and was literate, the interrogating FBI agents gave him an "Advice of Rights" form, which he refused to sign. Saying he understood his rights, the defendant indicated that although he wanted to talk, he did not want to sign anything. In its opinion, the Court underscored the concept of waiver is *de facto* rather than *de jure*: while an express waiver is solid proof of a valid waiver, it is not conclusive proof. By the same token, though courts "must presume" that there is no waiver absent an express waiver, "silence, coupled with an understanding of rights and a course of conduct indicating waiver" may constitute implied waiver. (*Id.,* at p. 373; *see, People v. Whitson, supra,* 17 Cal.4th at p. 248; *see also, United States v. Hayes* (4th Cir. 1967) 385 F.2d 375, 377, cert. den. 390 U.S. 1006 [no "talismanic approach" to determination].) In *People v. Whitson, supra,* 17 Cal.4th 229, the California Supreme Court surveyed the law on implied waiver, capsizing it into a two-pronged analysis of voluntariness (*i.e.*, freedom from intimidation, coercion and deception) and awareness (*i.e.*, nature of rights waived and consequences of waiver). (*Id.,* at pp. 248-249; *accord, Moran v. Burbine, supra,* 475 U.S. at p. 421.) The totality of the circumstances must demonstrate the accused knew the sort of rights actually at stake and what would happen should those rights be relinquished. (*Fare v. Michael C.* (1979) 442 U.S. 707, 724-725; *accord, People v. Bradford, supra,* 14 Cal.4th at pp. 1021-1033.) The State may prove this by a preponderance at trial, and the trial court's findings in this regard will be upheld only if supported by substantial evidence, while the reviewing court considers the issue *de novo.* (*See generally, People v. Whitson, supra,* 17 Cal.4th at p. 248; *People v. Bradford, supra,* 17 Cal.4th at pp. 1021-1033; *see also, Colorado v. Connelly* (1986) 479 U.S. 157, 168

In *People v. Whitson, supra,* 17 Cal.4th 229, defendant was injured in the automobile collision which was the basis for the murder charges against him; he was interrogated on three separate occasions shortly after the collision. At the time of his interrogations, defendant was being treated for a head wound,

with attendant lapses in consciousness; as a general matter, defendant was "borderline retarded," with a 6th-grade reading level and a history of attention-deficit disorder. (*Id.*, at p. 236.) At the suppression hearing, officers testified defendant was advised of his rights at each of the three interviews, and once, six months earlier, had been similarly advised pursuant to an unrelated shoplifting incident.[2] Though defendant was injured in the crash, the interviewing officers indicated that at every interrogation, defendant was asked if he understood his rights, defendant said he did, and the interview proceeded with no effort by defendant to end questioning or request an attorney. (*Id.*, at pp. 237-239.) In finding an implied waiver, the Supreme Court noted the absence of any evidence, including the fact of defendant's injury and "relatively low intelligence," contradicting his affirmative representation that he understood his rights and was willing to talk. To ice the cake, defendant had been made aware of those rights during a previous encounter with police, and had responded to that advisement in similar fashion. (*Id.*, at p. 249-250; *see also, People v. Nitschmann* (1995) 35 Cal.App.4th 677, 680-683 [implied waiver where no evidence defendant confused/misled/reluctant to talk].)

Implied waivers have generally been found where defendants agree to talk to police (*see e.g., People v. Hart* (1999) 20 Cal.4th 546, 643, cert. den. 528 U.S. 1085 [defendant told police post-advisement, "Okay, I'll talk to you."]), where defendants say they understand their rights and subsequently give statements to police (*see e.g., United States v. Cazares* (9th Cir. 1997) 121 F.3d 1241, 1244 [defendant orally indicated understood rights read in Spanish and English]; *United States v. Frankson* (4th Cir. 1996) 83 F.3d 79, 82-83 [defendant answered "yes" to question whether understood rights; immediately began answering questions]; *People v. Medina* (1995) 11 Cal.4th 694, 752, cert. den. 519 U.S. 854 [defendant responded affirmatively that he understood his rights; gave tape-recorded statement to police]; *People v. Davis* (1981) 29 Cal.3d 814, 823-826 [16-year-old said he understood rights, gave statement]; *People v. Johnson* (1969) 70 Cal.2d 541, 558, cert. den. 395 U.S. 969, disapproved on other grounds in *People v. DeVaughn* (1977) 18 Cal.3d 889, 899, fn. 8 [defendant said understood rights]), and where defendants do not deny having understood the advisements before speaking with police (*Terrovona v. Kincheloe* (9th Cir. 1990) 912 F.2d 1176, 1179-1180 [defendant, an "'articulate and college-educated

2 The interrogating officer on the shoplifting episode testified defendant said he understood his rights and was willing to be interviewed by police. (*People v. Whitson, supra,* 17 Cal.4th at p. 237.)

adult,' does not seriously contend he did not understand his rights..."]; *United States v. Hayes, supra,* 385 F.2d at p. 378 ["at no stage in the proceedings has the appellant ever denied that he understood the warnings given him..."]). Contrarily, no implied waiver was found where a defendant explicitly said that he did not want to talk about the charges (*see e.g., United States v. Lopez-Diaz* (9th Cir. 1980) 630 F.2d 661, 665 [defendant refused to discuss drugs in van, but confessed to being an escaped prisoner]). There appears to be no case finding waiver where a defendant indicates that while he understands his rights, he does not understand the effect of foregoing those rights. Given the two-step waiver analysis set forth by the courts, a defendant who does not grasp the consequence of waiving his rights cannot be said to have implicitly waived those rights. (*People v. Whitson, supra,* 17 Cal.4th at pp. 248-249.)

B. Appellant's interrogation

In pertinent part:

> MV3: Before I can start talking with you, because you have rights in this country, you know that.
>
> MV2: Yes.
>
> MV3: And, and, and before we start the law says that I have to explain your rights to you. Okey [sic]?
>
> MV2: I don't want to lose my family, in the first place, I love them very much.
>
> MV3: Okay, okay, let me explain to you before we start, we can't start until I have explained your rights to you, those are the rules, okay?
>
> MV2: Of course.
>
> MV3: You understand you have the right not to talk, do you understand?
>
> MV2: Uh-huh.
>
> MV3: Okay. That is, not to force you, if you just don't want to talk you don't want to, you don't have to say anything.
>
> MV2: Oh, that is fine.
>
> MV3: Uh... what you say can be used against you in court, do you understand? Okay. Uh... is that a yes?
>
> MV2: Yes.
>
> MV3: Okay. You have the right to have an attorney present here while we talk, do you understand?

MV2: Uh-huh.

MV3: Okay. If you want an attorney but you don't have money, the court will give you one before we talk, do you understand? Okay, do you want the FOLDER on, on, your case?[3]

MV2: Yes, please.

MV3: Okay. Okay. I am going to sign here.

MV2: How long will I be in jail, do you know?

MV3: Well, that depends on how everything goes, uh... your record, many things, it depends on ... [OV]

MV2: I want to know since it's the first time that I got caught on this, I don't...

MV3: Uh-huh. And that, that is going, is going to be seen in your history, in your...

MV2: Also, I would truly like, since it is my family, I want to say hello to them... [OV][4]

MV3: These are the rights that I have just read to you...[OV]

MV2: Uh-huh.

MV3: And they can be read to you again. SEE IF WE MAKE IT [sic] if you don't understand your rights or if you want to talk about one.

MV2: If you read them to me again it's better.[5]

MV3: Okay, it's fine. These are your rights that, that I have just read. You have the right not to talk.

MV2: Uh-huh

MV3: Whatever you say can be used against you in court, you have the right to have an attorney present here while we talk, if you want an attorney but you don't have the money the court will give you one

3 The revised translation, introduced as People's Exhibit 5, alters this last sentence to: "Okay do you want to talk about your case?" (Aug. RT B-5; RT 338)

4 The revised translation alters this to: "Also, I would truly like, since it is my family, I want to say loose them..." (Aug. RT B-6) The interpreter who prepared the revision testified this was "I don't want to lose them." (RT 340)

5 The revised translation reads: "Why don't you read it to me better." (Aug. RT B-6; RT 340, 346-347)

before we talk. If you understand your right place your signature here.

MV2: But I want you to explain is the right of how it is because I don't seem to be able to understand you.

MV3: Okay, okay. Uh... you have the right not to talk, that is, that I can't force you to... [OV]

MV2: When you say with...

MV3: ... about what the children are saying, of what they are saying...

MV2: Uh-huh.

MV3: ... your wife, of what the next person[6] that follows is going to say, of all of them, of all...

MV2: Uh-huh.

MV3: ... of all in this case.

MV2: Yes.

MV3: I have a tape of Cipriana [sic], I have a tape[7] of... [OV]

MV2: Cipriana [sic]? [UI] with my daughter?

MV3: Yes, I have already spoken with her, I have already, I have... [OV]

MV2: [OV] Her side. Uh-huh.

MV3: I have Alisha [sic]'s side.

MV2: Uh-huh.

MV3: I have the side of, of, Dani.

MV2: Uh-huh.

MV3: Okay, what I don't have is your side and every story has two tails.[8] Isn't it true?

MV2: Yes, yes, yes.

MV3: And the truth is between us, no?

MV2: Yes, yes, yes, of course.

6 The revised translation changes "follows" to "Cipri," so the line reads, "to say to Cipri." (Aug. RT B-7; RT 340)

7 The revised translation changes "tape" in each instance to "the side of." (Aug. RT B-8; RT 340)

8 The revised translation changes "two tails" to "two sides." (Aug. RT B-8; RT 341)

MV3: Okay, that is your first right, you have the right not to say anything, that is, you don't have to tell me your side if you don't want to. (SNEEZE)[9]

MV2: Uh-huh.

MV3: What you say can be, can be used in court, that is, that I can't, I can't, I can't lie to you and say [OV]

MV2: Uh-huh [UI][OV]

MV3: [OV] Hey, I am not going to say anything and that way they can't, no.

MV2: Uh-huh.

MV3: Everything that we talk about is because of[10] another reas... is because of the REPORT, is for the report.

MV2: The report.

MV3: You have the right to have an attorney. An attorney is someone that represents you in court.

MV2: Uh-huh.

MV3: Okay?

MV2: Uh-huh.

MV3: If you don't have money for an attorney the court will give you one for free.

MV2: Okay. Perfect.

MV3: Those are your rights. If you want to talk to me I am here, willing, ready. Sign here. If you don't want to talk, let me know.

MV2: But if I sign will it affect me? If I sign?

MV3: Your signature means that you understand your rights.

MV2: All right.

MV3: The rights that, that, that I have, have, have just explained to you.

MV2: Uh-huh.

MV3: That is what it means.

9 The revised translation changes the sneeze to a sigh. (Aug. RT B-8; RT 341)

10 The revised translation changes this to "on the record." (Aug. RT B-9; RT 344)

MV2: Because sometimes I think that, that had I
done one more thing to be going to jail and well I
don't want to.
MV3: We are simply here to get the truth.
MV2: Okey.
MV3: Okey? Truth does not change.

(Aug. RT A-4-9) Appellant then went on to admit various sex acts with Cipriana, Alicia, and Dani. (Aug. RT A-20, A-23, A-28-A-41, A-44-A-50, A-54-A-56, A-58-A-62, A-65)

At the suppression hearing, the interrogating detective confirmed that he told appellant his statements were for "a report" rather than advising him they would be used against him in court. When counsel inquired if the detective had asked appellant how much education he had received, the trial court sustained the State's relevancy objection.[11] (RT 18-21) The detective did not tell appellant that if he signed the paper he would be relinquishing his rights: the detective testified that instead he understood appellant's question about the "affect" of signing the waiver as meaning "am I signing some kind of statement or something." Later, the detective clarified he thought appellant was asking: "'what is this that I'm signing' or 'what does it mean?' And I took that to mean he was asking me what the piece of paper meant." The detective noted he had initially readvised appellant because it appeared appellant did not understand the concept of constitutional "rights." After several readvisements, the detective explained that appellant's signature on the waiver form just meant he "understood his rights." (RT 21-26, 323-324, 331-332) The detective described appellant as "cooperative" and "forthcoming"[12] throughout the interrogation. (RT 25-26, 321)

During the suppression hearing, the court reviewed the entire videotaped confession, as well as a dual language transcript of the confession and its amended translation; the judge was Spanish-speaking, and brought his interpretations to bear on translation issues. The court easily found no

11 Defense counsel noted appellant's lack of education, citing his block-print signature on the waiver form. (RT 29, 329-330) However, the court maintained education was irrelevant, at one point asiding: "... irrespective whether he's a father or not, educated or not, common sense transcends whether you have a first grade education or PhD. Common sense is common sense." (RT 36; but see, Terrovona v. Kincheloe, supra, 912 F.2d at p. 1180 [defendant described as "articulate and college-educated adult" in finding implied waiver].)

12 During his second round of testimony, the detective appeared to change his mind, and volunteered he thought appellant was actually "playing dumb," his questions designed to "buy time, to stall, to think." (RT 329)

evidence of duress[13] and more than adequate advisements, but was prefatorily concerned about appellant's actual understanding of the advisements. (RT 31, 34-36, 310-312, 343-344, 362-364) The court then thought appellant "warmed up" as the "conversation begins," and though "he may have had at the beginning perhaps had a problem understanding the theory of rights... as the advisements continue one time, two times, three times, he begins to ask and he's asking very relevant questions which leads the court to believe, and I'm not trying to bootstrap their argument, that perhaps he doesn't like where this conversation is going." The court also downplayed appellant's question as to the "affect" of signing the waiver, reasoning that "[t]he issue is not a card or a piece of paper because that's irrelevant." In short, "the court gets a feeling that he knew his rights"; in sum, "the defendant's behavior, his conversation, his demeanor, totality of circumstances not only as to what is being said, but how it is being said from one side to the other... the court finds that the defendant knowingly, voluntarily understood those rights, and that he inferentially waived those rights." (RT 364-365)

The problem here is the cart has been put square before the horse. Appellant's final question, "But if I sign, how will it affect me?" belies his preceding "uh-huhs" as much as his previous statements of incomprehension ("If you read them to me again it's better/Why don't you read it to me better"; "But I want you to explain is the right of how it is because I don't seem to be able to understand you") belied his earlier "uh-huhs." Rather than referencing a stall or dodge or even a newly-dawning sense he was being primed for prosecution, appellant seemed to believe his interrogation matter of course, and that it might actually help him home—after he asks about the "affect" of signing, appellant muses, "... sometimes I think that, that had I done one more thing to be going to jail and well I don't want to." (Aug. RT A-10) Not to put too fine a point on it, but appellant did not seem to get either the sort of situation he was in or his

13 Though the interrogation was not without its compressures: when appellant initially and adamantly denied improperly touching Cipriana, the detective continued to insist he had; even as appellant seemed to capitulate, he continued to refute the allegation. (Aug. RT A-42-A-45) A call and response tactic which has been disfavored by courts for some time: "To highlight the isolation and unfamiliar surroundings, the [interrogation] manuals instruct the police to display an air of confidence in the suspect's guilt and from outward appearance to maintain only an interest in confirming certain details. The guilt of the suspect is to be posited as fact.".... "To be alone with the suspect is essential to prevent distraction and to deprive him of any outside support. The aura of confidence in his guilt undermines his will to resist. He merely confirms the preconceived story the police seek to have him describe." (*Miranda v. Arizona, supra,* 384 U.S. at 450, 455; *see also, Pope v. Zenon* (9th Cir. 1994) 69 F.3d 1018, 1023-1024, cert. den. 537 U.S. 828, orr'd in part, *United States v. Orso* (9th Cir. 2001) 266 F.3d 1030, 1138-1139.)

rights within that situation. (*Compare, United States v. Hayes, supra,* 385 F.2d at p. 378.)

Moreover, this misapprehension was bolstered by the detective's later affirmations:

> But, what is going to happen, what is going to happen if you don't tell me the truth, if you like to me? [&] I am not making promises to you, I am not telling you that, I am not, I am simply giving you the opportunity of taking care or [sic] everything, all of this....[&]... So as not to have, no, not have, that fear that the year is going to go by, goes by... next year or two years from now, from now. This is the time to take care of everything. (Aug. RT A-52) This is the time to take care of everything. This is your opportunity to fix it. (Aug. RT A-53) ... it's the only way that you are going to be able to fix this. (Aug. RT A-69)

And by his earlier emphasis on "the report," specifically, his statements to the effect that appellant's interview was in service of "the report" the officer was preparing for the District Attorney's consideration:

> MV3: I spoke with Rodrigo and said this and this, went to, to serve the report. That report I am going to, to, to take to court and the attorney of the district, he's called DISTRICT ATTORNEY [sic]...
>
> MV2: Yes.
>
> MV3: ... is going to decide which charges, what type of charges or what is going to happen. Okay. They are the ones that decide that. Yes I am going to put in my report...
>
> MV2: Uh-huh.
>
> MV3: ... that Rodrigo is sorry...
>
> MV2: Please.
>
> MV3: ... and that he promises that this is never going to happen again.
>
> MV2: Of course not.
>
> ..
>
> MV2: I swear to you on my children that I have there.

MV3: And, I am going to put that in my report, okay?

MV2: Thank you very much... [OV]

(Aug. RT A-68-A-69) While these statements were accurate in the letter, they did not convey the spirit—a more adversarial quality best set forth in an explanation of what it means for something to be used in court. (*Moran v. Burbine, supra,* 475 U.S. at p. 421.)

Nor did appellant possess any personal characteristics which would have supplemented or corrected such a failure of comprehension. (*See generally, Fare v. Michael C., supra,* 442 U.S. at pp. 724-725.) He was uneducated, had no prior arrest experience, and apparently spent most of his free time watching Christian cartoons. (Aug. RT A-6, A-11-A-12, A-17, A-46; *compare, People v. Whitson, supra,* 17 Cal.4th at pp. 249-250; *Terrovona v. Kincheloe, supra,* 912 F.2d at p. 1180.)

As defense counsel aptly argued, the officer's understanding of appellant's lack of understanding militates against an implied waiver based on such an understanding; appellant "clearly doesn't get the American system. Which is understandable because he's not from North America. He's not at least from the United States and wasn't raised in this particular system. Doesn't speak the language and doesn't understand the concept of having rights and to discourse or have a conversation with the police who would more likely than not authority figures whom you have to obey where he comes from." (RT 350) And it appears Mexican police procedure is to interview suspects after receiving a citizen complaint about a crime; the officers prepare a report partially based on this interview, for review by the equivalent of the District Attorney. That official then interviews the accused, without counsel, and decides whether to prosecute. ("Mexican Criminal Law" [http://www.mexonline.com/buisness/bergercl.htm]; U.S. Dept. of State; "Summary of Mexican Law and Individual Rights in Mexico" [http://usembassy.state.gove/posts/mx2/wwwhaca1.html]; *c.f., United States v. Wolf* (9th Cir. 1987) 813 F.2d 970, 972, fn.3.) So for appellant, unlike the various American defendants whose educational and experiential "understanding" would comprehend a constellation of constitutional consequences, understanding the rights as described by the detective would not necessarily include understanding the result of forgoing those rights. (*People v. Whitson, supra,* 17 Cal.4th at pp. 249-250.)

Conclusion

A statement indicating understanding of rights coupled with compliance will generally support a finding of an implied waiver because these facts provide

"substantial proof" of an intent to knowingly waive. (*See e.g.*, *People v. Hart, supra*, 20 Cal.4th at p. 643; *United States v. Cazares, supra*, 121 F.3d at p. 1244.) But such a statement and such compliance has constitutional significance only insofar as the defendant truly grasps the "affect" of relinquishing those rights— and that question is not constitutionally satisfied by an officer's assurance that all that is at stake is "that you understand your rights" nor by "the fact that a confession was eventually obtained." (*Miranda v. Arizona, supra*, 384 U.S. at p. 475.) Appellant's conviction must be reversed because there is not substantial proof he impliedly waived his Fifth and Sixth Amendment rights; his subsequent confession was thus improperly used against him at trial, and to devastating "affect." (*C.f., Fields v. Wyrick* (1983) 464 U.S. 1020, 1023, diss. opn. by Marshall, J., [need to show implied waiver based on "full comprehension of the consequences."].)

ARGUMENT

PETITIONER WAS DENIED EFFECTIVE ASSISTANCE OF COUNSEL BECAUSE COUNSEL FAILED TO ADEQUATELY CHALLENGE THE STATE'S DNA EVIDENCE

Without unduly repeating analysis and arguments articulated in other pleadings in this case, including petitioner's motion for new trial (CT 211-255; AOB 29-33; ARB 2-5), defense counsel did not make basic legal challenges to the State's DNA evidence because he was unaware they existed. (Exh. A.) Simply put, defense counsel first failed to move to exclude irrelevant match statistics that assumed petitioner's guilt, a practice specifically disapproved by Division Five in *People v. Pizarro, supra,* 110 Cal.App.4th at pp. 543-545, 600-601,[1] a disapproval left untouched by the Supreme Court in *People v. Wilson* (2006) 38 Cal.4th 1237,[2] as well one which constituted a violation of petitioner's 5th Amendment rights. Second, counsel failed to object to testimony by the State's expert witness that assumed petitioner was the contributor to the mixed source sample, or to cross-examine the State's expert on his analytic assumption that petitioner was the other contributor, or to object, on grounds of *Pizarro* and the Fifth Amendment, to the improper random match probability and likelihood ratio testimony presented by the State. (*Contra, People v. Pizarro, supra,* 110 Cal.App.4th at pp. 543-545, 600-601.) Because trial counsel failed to adequately prepare the DNA portion of the defense case, trial counsel also failed to provide expert testimony on these issues to counter the State's improper proof. Competent counsel would have done otherwise. (*Strickland v. Washington, supra,* 466 U.S. at p. 687; *People v. Pizarro, supra,* 110 Cal.App.4th at pp. 543-545, 600-601; Exh. B.)

All the forms of error here—failure to move to exclude, failure to object, failure to cross-examine, failure to offer contrary proof—stem from trial counsel's failure to appreciate the kind of evidence the State was offering. DNA evidence is, though potentially scientifically complex, basically like every other kind of evidence: relevant or irrelevant. If there is proof that a forensic sample contains the perpetrator's genetic profile, and there is evidence that

1 (As a prong three error under *People v. Kelly* (1976) 17 Cal.3d 24, 30.)

2 Review has been granted in *People v. Prince*, formerly at 134 Cal.App.4th 786, in which Division Five reiterated its *Pizarro II* holding that match statistics involving specified ethnic groups are irrelevant absent evidence that the *perpetrator*, not the *defendant* is a member of one of those groups.

the defendant has the same genetic profile, the genetic evidence is relevant. If there is evidence the forensic sample contains a partial or ambiguous profile, then evidence the defendant has a genetic profile that *could* be included as one of the alternative profiles suggested by the forensic data is irrelevant. Evidence that the perpetrator has "black, brown or blond hair," or alleles at a particular locus of 15/14 **or** 14 **or** 14/16 is irrelevant "when there is no way of establishing which one hair color or genotype the perpetrator actually possesses." (*People v. Pizarro, supra,* 110 Cal.App.4th at p. 600.) More importantly, the defendant's hair type or genotype cannot legitimately be used to fill in the State's blanks—if the defendant has blond hair, this does not answer the question what color the perpetrator's hair was; if the defendant is a 15/14 at one locus, this does not resolve the issue of the perpetrator's genotype at that site. By extension, the mixed calculation, whether random match probability or likelihood ratio, being a calculation which takes all possible genetic combinations into account, may be the most *scientifically* accurate way to account for the permutations of proof, but is of no *legal* consolation. As the Fifth District stated in *Pizarro*: "When evidence is lacking on a certain act such as that fact cannot be established, the situation does not justify consideration of *all possible alternatives to that fact.* Only the one fact is relevant." (*Ibid.*) If the State cannot establish that one fact—e.g., that the contributor-perpetrator's alleles were 14/15 at a particular locus—*independently* from the fact that the defendnat also had a 14/15 at that site, not only there is no relevant evidence at that locus, but admission of statistical evidence based on all possible genotypes improperly inculpates when it ought exculpate. In other words, if the forensic sample indicates the contributor-perpetrator was either a 14/15 or a 14, or a 15, and the defendant was a 14/15, then there are two other potential genetic profiles in the sample which would *exclude* the defendant. In such case, it is misleading and improper to use a statistical computation that is partially based on those two *exculpating* profiles as positive proof of the defendant's guilt.[3] (*Id.*, at pp. 600-601)

Furthermore, saying a suspect "cannot be excluded," or declaring an "inclusion" based on a "partial match" is good science and bad law: if a single allelic difference would mean exclusion, then using a partial match as proof of guilt is based on the same improper presumption of guilt, for only if the defendant is presumed to be the contributor-perpetrator is a partial match significant.

3 Part of the issue is that these statistics are exponential: if 8 of 13 loci are suspect, then the numbers upon which the fact finder can reliably rely drop from 1013 to 105; there is a radical difference in something having a match probability of 1 in 10,000,000,000,000 and 1 in 100,000.

Because only if the defendant and the contributor-perpetrator have the same full genetic profile is the fact they share a partial profile relevant; as in *Pizarro*, the State in this case used petitioner's profile to "fill in" the missing or ambiguous portions of the mixed source profile, thereby allowing the prosecution to make the argument that partial matches were "inclusive" rather than "exclusive," and thus alleviating its burden of proving the predicate fact that petitioner and the other contributor to the sample had the same genetic profile, *i.e.*, that petitioner was the contributor, and therefore the perpetrator. (*Contra, People v. Pizarro, supra*, 110 Cal.App.4th at p. 600.) For, as in *Pizarro*, interpretation of the DNA evidence in petitioner's case was:

> ...consistently and expressly based on the assumption that the DNA mixture contained *defendant's* DNA rather than the *perpetrator's* DNA. [&] But the assumption that defendant was the perpetrator was improper and the FBI therefore should not have relied on defendant's genotype to "prove" the perpetrator's genotype, which was a preliminary fact required to render the match evidence and the statistical evidence relevant under section 403. [...] [T]he profile frequency... was not relevant to prove the rarity of the perpetrator's profile, unless it was established that the *perpetrator's profile* included the heterozygous D2 genotype.

(*Id.*, at pp. 598-599.) Because trial counsel here did adequately understand the scientific evidence, he did not know what to do when confronted with its improper interpretation. Because trial counsel did not know what was meant by ambigious loci—those sites where two or three genotypes are detected when four (or three, where the contributors share genotypes) must be present for there to be a complete reading and source attribution—and did not know that ambiguous loci cannot legally be included in the calculation of probability statistics—the defense was mortally crippled in its ability to counter the State's case. Because counsel was unaware of the legal and scientific impropriety of "calling" an inculpatory allele without substantial predicate proof of its existence—such as when the analyst testified he saw a 14 allele at one locus, although the level at which the allele was seen was so low as to render it non-cognizable by both the test manufacturer and relevant laboratory standards—the defense stood impotent in the face of unfairly damning evidence. It is worth

remembering the jury was unable to reach a verdict on the count for which there was no DNA evidence.

It is not that "DNA evidence is different" (*People v. Venegas* (1998) 18 Cal.4th 47, 81): it is that DNA evidence is literally and metaphorically exponential. What is called the "prosecutor's fallacy" in DNA cases is that there aren't enough people on the planet to find another similarly-profiled perpetrator, when the numbers actually refer only to the odds of randomly finding such a one. (National Research Council, *The Evaluation of DNA Evidence* (1996), pp. 31, 133, 198.) But if the prosecutor cannot establish the preliminary fact of the *perpetrator's* genetic profile before comparing that profile to the defendant's profile, the statistical match evidence has no basis in law or science, and trial counsel should have known this. (*People v. Williams, supra,* 44 Cal.3d at 943.)

There was one primary piece of DNA evidence introduced in petitioner's case, People's Exhibit No. 38, the chart promulgated by criminalist Paul Coleman based on his analysis of Colin's underpants. For the Court's convenience, People's Exhibit No. 38 has been replicated by counsel:[4]

ID	1	2	3	A	4	5	6	7	8	9	10	11	12	13
S	16, 17 (15)	17 (14) (16)	19> 20 (26)	XY	14, 15	27, 32.2 (29)	13, 15 (12) (14)	11> 13 (12)	13 (11)	12 (10)* (11)	11, 12	6, 7 (8)	8	11, 12
C	16, 17	17	19, 20	XY	14, 15	27, 32.2	13, 15	11, 13	13	12	11, 12	6, 7	8	11, 12
D	15, 16	14, 16	26	XY	14	29, 32.2	12, 14	11, 12	11	10, 11	12	6, 8	8	11, 14

4 Based on counsel's examination of the oversized chart as admitted into evidence; there is some shorthanding to conserve space. (*Accord,* CT 239, attached as Exhibit D.)

"ID" refers to "Sample ID," "A" refers to amylogenen, the sex chromosome, and numbers 1 through 13 refer to the testing loci as follows: (1) D3S1358; (2) vWA; (3) FGA; (4) D8S1179; (5) D21S11; (6) D18S51; (7) D5S818; (8) D13S217; (9) D7S820; (10) D16S39; (11) TH01; (12) TPOX; (13) CSF1P0. The three vertical columns are "S" = underwear stain, C = Colin's oral reference sample, and D = petitioner's oral reference sample. Coleman explained that "()" represented a "weaker type," *i.e.*, less than a 50% peak; ">" represented an allelic imbalance greater than 68% of the highest peak within the locus, and "*" indicated where an allele had been detected by Profiler Plus or CoFiler, but not both. (RT5:1561-1562; Peo.'s Exh. No. 38.)

As demonstrated below, there are eight loci open to multiple evidentiary interpretations;[5] for example, at D3S1368, the underwear sample showed the presence of three genotypes: 16, 17, and a smaller amount of 15. Colin's genotype was 16/17. This meant the other contributor would have a genetic profile of either 16, 15 or 17, 15. By this same token:

Locus	Underwear	Colin profile	2nd contributor
vWA	17 (14)(16)	17	17/14 or14/16
FGA	19, 20 (26)	19/20	19/26 or 20/26 or 26
D8S1179	14, 15	14/15	14 or 14/15 or 15/15
D21S11	27, 32.2 (29)	27/32.2	27/29 or 32.2/29 or 29
D5S818	11, 13 (12)	11/13	12/13 or 11/12 or 12
D13S317	13 (11)	13	13/11 or 11
D16S539	11, 12	11/12	11 or 11/12 or 12
THO1	6, 7 (8)	6, 7	7/8 or 6/8

5 In the new trial motion, new counsel argued there were nine ambigious loci (Supp. RT 1:218); the following is based on appellate counsel's independent review of People's Exhibit No. 38.

Again, only the fact of the second contributor's genotypes in the mixed samples is relevant: petitioner's genotype is irrelevant to that fact unless it can be independently shown that petitioner was the second contributor. But State's expert reverse-engineered the problem, resolving all interpretation issues by referring to petitioner's profile. For example, looking at locus D3S1358, Coleman stated that because the 15 allele could not have come from Colin, he looked to petitioner's profile, found the 15, and "[i]f he gave the 15, he certainly had to also give a 16. You can't give just the 15. So—But his, 16, *assuming he is the source—*" (RT 5:1564-1565, emphasis added.) But Coleman could not properly assume petitioner was the source. The source was someone who was **either** a 15/16, such as petitioner, **or** a 15 **or** a 15/17, someone other than petitioner. Note that in the above chart, petitioner's profile has been omitted, because to *look to petitioner's profile as a guide to selecting among the possible genetic combinations would be to commit the same error that the State's expert was permitted to commit by virtue of counsel's dereliction.*

Additionally, locus D7S820, as represented in the State's exhibit, was:

	underwear stain	Colin ref.	Def. ref.
D7S820	12 (10)* (11)	12	10, 11

However, the 12 (10)* (11) result on the underwear sample means that not only were there multiple interpretations of the second contributor profile at that locus (11/10 **or** 10/11), but the presence of the 10 allele was *not detected* by one of the test kits. If the point of using both Profiler Plus and CoFiler kits for forensic DNA testing is to accurately identify the alleles present, and one of the kits does not identify a particular allele as being in the mix, then it is patently incompetent lawyering to allow testimony that the inculpatory allele was not only present, but *could be attributed to petitioner.* Similarly, at locus CSF1P0, Coleman testified that although there was *no* 14 allele that "tested out," *i.e.,* none that reached any scientfically-approved threshold of detectability—he did "see" "some" 14—petitioner's genotype at that site. Trial counsel cross-examined Coleman on this issue, but this was half the job.[6] Trial counsel should have moved to strike the testimony or excluded it as irrelevant under *Pizarro*; too, even if the expert's unreported eyeball-identification were admissible under

6 On direct, Coleman testified that as a matter of policy, his laboratory wanted to "ensure high reliability, and one of the ways we do that is *we don't go below our guidelines,* our set amounts." (RT5:1549, emphasis added)

prong three, the possible genotypes at that site would then also include 14 and 12/14, constituting a separate *Pizarro* error in allowing that testimony to go unchallenged.[7] (Exh. B &1.)

Finally, Coleman was permitted to testify that "without exception" the "minor" alleles "could have" originated from petitioner. There are three things wrong with this testimony, three things that any competent trial attorney would have, if not pounced on, at least tended to: "without exception" is patently false, as the above chart indicates—there are a number of alternative genetic scenarios which would have conclusively excluded petitioner as a contributor to the mix. Second, there was no confirmed 10 allele at one locus, and the non-cognizable existence of that 14 allele at another: the *lack* of reliable or verifiable gentoypes does not constitute a reliable genetic profile of a minor contributor. And "could have" means it's not necessarily so.

None of this was gone into in petitioner's case. Again and again, what should have worked in petitioner's favor was used as proof of his guilt. What was done was inexcusably inadequate for defending a case whose only objective evidence was a forensic DNA mixed-source sample. (Exh. B) Petitioner's convictions should be reversed for this dereliction. (*People v. Pope, supra*, 23 Cal.3d at p. 424; *People v. Pizarro, supra*, 110 Cal.App.4th at pp. 543-545, 600-601.)

7 There are two other statistical tacks that the analyst could have taken, given the State's analysis of the evidence: either the analyst could have created a random match probability statistic which did not include the ambiguous loci (the approach approved in *Pizarro*), or the analyst could have created a random match probability statistic which included all possible genetic profiles at the ambiguous loci, not just petitioner's. In terms of a likelihood ratio, the ambiguous loci could be similarly excluded or expanded to account for these additional interpretations, given that likelihood ratio is a calculation methodology, not a means of resolving ambiguous test data.

ARGUMENT

APPELLANT'S SVP COMMITMENT MUST BE REVERSED AS
THERE IS INSUFFICIENT EVIDENCE HIS PRIOR CONVICTIONS
QUALIFY AS SEXUALLY VIOLENT OFFENSES AND FOR THE
CONTRARY MANDATORY PRESUMPTION CONTAINED IN
CALJIC NO. 4.19 AS GIVEN APPELLANT'S JURY

Introduction

The Sixth and Fourteenth Amendments require a defendant be convicted only on proof beyond a reasonable doubt of each element of every charged offense. (*In re Winship* (1970) 397 U.S. 358, 364.) Similarly, to sustain a commitment under Welfare & Institutions Code section 6600, the State must have proved beyond reasonable doubt an individual was convicted of two or more sexually violent offenses, has an ongoing diagnosed mental disorder rendering him a danger to the health and safety of others, and is likely to engage in sexually violent criminal behavior in the future. Oral copulation is a qualifying offense when committed by force or duress, or when committed on a child under the age of fourteen. (Welf. & Inst. Code §§ 6600(b), 6600.1(a).) Appellant was convicted of violating Penal Code section 288a, subdivision (f), oral copulation of an unconscious person against two separate victims; however, there was no evidence that relative to at least one of the victims, force or duress was used. Given insufficient proof appellant had two prior sexually violent convictions, and given appellant's jury was provided an improper mandatory presumption that all subdivision (f) priors are qualifying priors, appellant's commitment must be reversed. (*Jackson v. Virginia* (1979) 443 U.S. 307, 318-319; *People v. Johnson* (1980) 26 Cal.3d 557, 576-578.)

A. Sufficiency of evidence of qualifying priors.

"The test to determine sufficiency of the evidence is "whether, on the entire record, a rational trier of fact could find appellant guilty beyond a reasonable doubt." (*People v. Johnson, supra,* 26 Cal.3d at pp. 576-578.) As the Supreme Court said in *Johnson,* "our task... is twofold. First, we must resolve the issue in light of the *whole record....* Second, we must judge whether the evidence of each of the essential elements... is *substantial....*" (*Id.,* at pp. 576-577, italics in the original]; see *also, People v. Barnes* (1986) 42 Cal.3d 284, 303.) Substantial evidence must support each essential element underlying the verdict: "'it is not enough for the respondent simply to point to 'some' evidence

supporting the finding.'" (*People v. Johnson, supra,* 26 Cal.3d at p. 577, quoting *People v. Bassett* (1968) 69 Cal.2d 122, 138.) Nor does a "50 percent probability" of an element constitute substantial evidence. If the facts as proven equally support two inconsistent interpretations, the judgment goes against the party bearing the burden of proof as a matter of law. (*People v. Allen* (1985) 165 Cal.App.3d 616, 626, citing *Pennsylvania R. Co v. Chamberlain* (1933) 288 U.S. 333, 339.) Evidence that fails to meet this substantive standard violates the Due Process Clause of the Fourteenth Amendment and article I, § 15 of the California Constitution. (*Jackson v. Virginia, supra,* 443 U.S. at pp. 318-319; *People v. Johnson, supra,* 26 Cal.3d at pp. 575-578.)

As the Court is aware, this issue was raised in appellant's previous appeal from his previous commitment. However "each recommitment requires fresh evaluation of [defendant's] current mental health and criminal predilection." (*Hubbart v. Knapp* (9th Cir.) ___ F.3d. ___ (2004 U.S.App. LEXIS 16667) (August 13, 2004).) *I.e.,* each new petition to extend a commitment "constitutes a new and separate civil action." (*Burris v. Hunter* (2003) 290 F.Supp.2d 1097, 1101; Welf. & Inst. Code §§ 6604, 6605.) Thus, the sufficiency of the evidence that appellant's prior offenses qualify as sexually violent offenses may be challenged in this appeal from this new civil action, as the sufficiency of the evidence on any other element may be similarly challenged. (*See, People v. Barragan* (2004) 32 Cal.4th 236, 246 [to distinguish "law of the case" doctrine].) In this case, the presumptive effect of appellant's prior commitment resulted in an impermissible bootstrapping of one commitment to another so that the element of the qualifying priors was simply not established by the State.

As a prefatory matter, in its opinion regarding appellant's previous commitment, this Court found the priors qualified because oral copulation of an unconscious person is done "by force" if it occurs after administration of an intoxicant to preclude or overcome resistence. Because there was evidence appellant gave Jonathan alcohol before orally copulating him, and because Jonathan was legally incapable of consent, both to the oral copulation and to the consumption of alcohol, the Court reasoned, appellant orally copulated Jonathan "by force." Before trial in the present case, defense counsel moved to dismiss, arguing there was no evidence the counts involving Jonathan were counts involving the use of alcohol – and there was ample evidence appellant also orally copulated Jonathan when Jonathan was simply asleep, also in violation of subdivision (f). The State countered by opining that given a subdivision (f) offense would include use of alcohol, and that given alcohol was

used by appellant "most of the time," there wasn't "any difference." Counsel noted the difference was section 288a, subdivision (I) – which specifically criminalizes oral copulation of a person given intoxicants to prevent resistence, and which was not the charge pled to. The trial court, while noting the lack of controlling authority (though incorrectly assigning this to the fact the prior opinion was unpublished), denied counsel's motion because "there has been a finding *before* that there were satisfactory predicate offenses...." (RT 4-8, emphasis added.) This is all wrong:

Again, each commitment is a separate civil action, requiring separate findings of proof beyond a reasonable doubt of *each* of the requisite elements: as set forth in section 6600, the determination of SVP status includes a determination regarding the qualifying priors; as set forth in section 6601, subdivision (d), the SVP evaluation procedure must consist of the independent opinion of two practicing psychiatrists/psychologists the individual meets all the commitment criteria; as set forth in subdivisions (b) and (c) the evaluation must consider the individual's social, criminal and institutional history. In sum, the SVP commitment procedure includes a requirement the State's evaluators find the candidate has two qualifying criminal convictions. (*Accord, People v. Superior Court (Ghilotti)* (2002) 27 Cal.4th 888, 894.) This did not happen here:

Dr. Hupka testified appellant's priors satisfied the offense element of section 6600 based upon his apparent belief that section 288a, subdivision (f) was an enumerated SVP-qualifying offense; Dr. Sreenivasan simply relied upon appellant's first commitment proceeding to satisfy the first prong. As a predicate matter, the State did not present evidence that two experts made the requisite first prong determination: by relying upon the finding of a separate civil action, Dr. Sreenivasan wholly abrogated his obligation to make an independent determination appellant met all criteria. (*Contra, People v. Superior Court (Gary)* (2000) 85 Cal.App.4th 207, 214-215 [recommitment requires full evaluation as prescribed in SVPA]; *Butler v. Superior Court* (2000) 78 Cal.App.4th 1171, 1180-1181.) Dr. Hupka's assumption section 288, subdivision (f) is included in the list of qualifying offenses, an assumption shared by the State at trial, is belied by the language of the SVP act itself, the distinction between force and consent embedded in the predicate offense at hand, and the facts as adduced.

Section 6660, subdivision (b) states in pertinent part:

(b) "Sexually violent offense" means the following acts when committed by force, violence, duress, menace, or fear of immediate and unlawful bodily

injury on the victim or another person... oral
copulation in violation of Section ... 288a of the
Penal Code.

Section 288a, in turn, proscribes a constellation of oral copulations, including
forcible oral copulations: subsection (c)(2) directly proscribes forcible oral
copulation;[1] subsection (c)(3) proscribes oral copulation where duress is
supplied by threats of retaliation against the victim or another (and there is a
reasonable possibility the threat will be executed); subsection (d) proscribes
forcible oral copulation in concert, which includes both the force proscribed in
subsection (c)(2) and (3), as well as oral copulation in concert where the victim
is unable to give consent; and subsection (k) proscribes oral copulation where
duress is supplied by threats to use public authority (such as deportation, arrest,
etc.) against the victim (and there is a reasonable belief the perpetrator is a public
official). Subsection (f), by contrast, contains no force or duress language – nor
could it, for the essence of the offense is *absolute* lack of consent, not forced or
compelled consent. (*People v. Dancy* (2002) 102 Cal.App.4th 21, 34-35.)

In *People v. Dancy, supra,* 102 Cal.App.4th 21, defendant and victim
had been involved in a long-term consensual sexual relationship in which victim
frequently woke to find defendant having sex with her: this was acceptable,
though not discussed. The relationship was otherwise tumultuous, pocked by
argument, drug use, and physical violence. One night, defendant gave victim
a cigarette outside their workplace; victim regained consciousness at home
mid-morning the following day, with facial injuries defendant ascribed to a
fall. Defendant medicated victim, victim lost consciousness, victim woke up
naked and alone in a motel room, victim lost consciousness again, and spent
the next two days going in and out of consciousness, sometimes waking to
find herself alone, sometimes with defendant, who was either feeding her,
tending to her injuries, or, twice, having sexual intercourse with her. When victim
found defendant on top of her, she tried to tell him to stop, she didn't want sex;
defendant told her she could "handle it/hang," not stopping until he ejaculated.
(*Id.*, at pp. 26-28.)

The Sixth District prefatorailly noted some subdivisions of Penal Code
section 261, the rape statute, contained a lack of consent element and some did
not: "'[w]hen the Legislature has used a term or phrase in one part of a statute

1 "Any person who commits an act of oral copulation where the act is accomplished
against the victim's will by means of force, violence, duress, menace, or fear of immediate and
unlawful bodily injury on the victim or another person shall be punished by imprisonment in the state
prison for three, six, or eight years."

but excluded it from another, courts do not imply the missing term or phrase in the part of that statute from which the legislature has excluded it."' (*People v. Dancy, supra,* 102 Cal.App.4th at p. 34, quoting *People v. Gardeley* (1996) 14 Cal.4th 605, 621-622, cert. den. 522 U.S. 854.) Moreover, there was a reason for such purposeful exclusion: the gravamen of the crime of rape of an unconscious person is that the victim is unable to consent at the time of intercourse: "a man who intentionally engages in sexual intercourse with a woman he knows to be unconscious is clearly aware that he is wrongfully depriving the woman of her right to withhold her consent to the act at the time of penetration." (*Id.,* at p. 36.) Thus, any consent given in advance (overt or implied) cannot extend to intercourse with an unconscious victim because the victim, by virtue of her incapacity, is unable to give her *ad hoc* consent – regardless whether she would have consented or not consented had she been conscious. (*In re John Z.* (2002) 29 Cal.4th 756, 762.)

By this same token, section 288a, subdivision (f) proscribes oral copulation of an unconscious person because the unconscious person – like the minor – is *unable* to consent. There can be no grafting of a force element onto this lack of consent, for this would run afoul of the legislative intent to penalize oral copulation of an unconscious person because it is *nonconsensual by definition*, not because it would be otherwise forced: "The statute uses the words 'incapable of resisting' to describe the victim's *actual* lack of *awareness* of the act rather than in reference to the victim's *hypothetical lack of consent* to the act." (*People v. Dancy, supra,* 102 Cal.App.4th at p. 35, emphasis in the original; see generally, *People v. Snook* (1997) 16 Cal.4th 1210, 1215 ["When looking to the words of the statute, a court gives the language its usual, ordinary meaning. [Citations.] If there is no ambiguity in the language, we presume the Legislature meant what it said and the plain meaning of the statute governs."].) Performing a sex act on someone who is not cognizant of the nature of the act is a violation of that person's consciousness – the bedrock ability to perceive the world and make choices which respond to and modify that world – the ability, in sum, to cognitively engage. The fact Jonathan was legally incapable of consenting to oral copulation does not automatically render the subdivision (f) conduct forcible, rather, it underscores the point that the crime appellant committed/pled to was a violation of Jonathan's *a priori* consciousness, not his possible *a posteriori* resistance.[2] Because there was no evidence in any event

2 This is inexact, as there was no evidence produced to support the thesis that Jonathan would have resisted were it not for the alcohol. Not to put too fine a point on it, but to analogize,

that appellant used force to effect his oral copulations, there was no evidence appellant's prior conviction was for a sexually violent offense.

Which leads to the tripartite error here: there was an insufficient finding pursuant to section 6600 that appellant qualified as an SVP; there was insufficient evidence at trial that appellant qualified as an SVP; and the instruction to the jury that a conviction for oral copulation of an unconscious person constituted a conviction for a sexually violent offense was an unconstitutional (and incorrect) mandatory presumption. As has been detailed, Dr. Hupka's prong one conclusion was legally erroneous and cannot stand. Given Dr. Sreenivasan did not make any prong one finding in this proceeding, there was legally insufficient evidence the two evaluators determined as a predicate matter appellant satisfied the SVP criteria, and thus, his commitment must be reversed. (*People v. Superior Court (Ghilotti), supra,* 27 Cal.4th at p. 895 ["an evaluator's recommendation for or against commitment or recommitment is invalid if there appears a reasonable probability it was influenced by the evaluator's legal error...."]; *accord, People v. Scott* (2002) 100 Cal.App.4th 1060, 1064 [no requirement two experts testify at trial so long as two experts performed requisite pre-trial determination].)

Looking to the whole record for proof appellant committed the requisite prong one conduct is similarly unavailing. (Welf. & Inst. Code § 6600(a); see, *People v. Otto* (2001) 26 Cal.4th 200, 208, 212 [section 6600(a)(3) permits use of multiple-level hearsay to prove details of prior sex convictions].) Again, the offenses involving Mark stemmed from an incident in which appellant picked up Chris and a friend, and supplied them with beer; Chris passed out, waking to find appellant orally copulating him. The only mention of force was a notation in Dr. Hupka's report, which summarized notes from the probation officer's report, that after Chris came to, appellant "held him down, told him to be quiet, and continued to orally copulate him." There were no transcripts of testimony by Chris himself, or any other statements to support the notion force was (atypically) used by appellant in that episode. (RT 233, 307) Assuming the probation officer's notation constitutes "substantial proof" of forcible oral

what appellant did by orally copulating Jonathan while Jonathan was unconscious was deprive Jonathan of the choice to resist – had Jonathan resisted, and had appellant used force or duress to complete the copulation, appellant would have been guilty, *inter alia,* of section 288, subdivision (b) forcible child molestation. Had Jonathan chosen to participate in the copulation, appellant would have nonetheless been guilty of section 288, subdivision (a) non-forcible child molestation. In other words, lack of consent does not equate to use of force in the child molestation context just as lack of consent is not determinative as to whether force was used in the context of oral copulation of an unconscious person. Leaving aside the issue of majority, Jonathan could have freely consented to his oral copulation while awake, but once asleep/unconscious, appellant would still have been guilty of violating subdivision (f).

copulation of Chris, there is not even that modicum of proof with regards to Jonathan. The offenses involving Jonathan occurred during the two years Jonathan lived with appellant: there was evidence appellant encouraged Jonathan to drink alcohol, and orally copulated him when and if he passed out. There was also evidence appellant orally copulated Jonathan when Jonathan was simply asleep. (RT 228-229) Nearly twenty years ago, when appellant pled to the offenses involving Chris and Jonathan, the State did not require, as part of that plea, that appellant plead to allegations force was used. The State did not require, as part of that plea, that appellant plead to administering intoxicants for the purpose of sexual advantage. (*People v. Kelly* (1990) 220 Cal.App.3d 1358, 1368-1369.) For the State to reverse-engineer an element of force into the Jonathan conviction is unwarranted and unfair. (*See generally, People v. Anzalone* (1999) 19 Cal.4th 1074, 1081.) As was the mandatory presumption instruction given appellant's jury:

B. Mandatory presumption re: qualifying priors.

"Presumptive instructions are either mandatory or permissive. A permissive instruction "does not require... the trier of fact to infer the elemental fact from proof by the prosecutor of the basic one and ... places no burden of any kind on the defendant." (*Ulster County Court v. Allen* (1979) 442 U.S 140, 157.) Permissive presumptions are constitutional so long as the permitted inference is rational. (*Yates v. Evatt* (1991) 500 U.S. 391, 402, fn. 7; *Francis v. Franklin* (1985) 471 U.S. 307, 314-315.) Mandatory presumptions instruct the jury "it must infer the presumed fact if the State proves certain predicate facts," on the other hand, mandatory presumptions are either conclusive or rebuttable. (*Francis v. Franklin, supra,* 471 U.S. at p. 314; *see also, Sandstrom v. Montana* (1979) 442 U.S. 510, 517-518; *Patterson v. New York* (1977) 432 U.S. 197, 210, 215.) A conclusive presumption removes an element from jury consideration after the State proves the predicate facts giving rise to the presumption. (*Francis v. Franklin, supra,* 471 U.S. at p. 314, fn. 2.) A rebuttable presumption does not entirely remove an element from consideration, but requires the jury find the presumed element "unless the defendant persuades the jury that such a finding is unwarranted." (*Ibid.*) Presumptive instructions are constitutionally "pernicious" insofar as they impermissibly shift the burden of proof to the defendant, thereby violating the Due Process clause. (*Yates v. Evatt, supra,* 500 U.S. at p. 401 [*Francis* instructions improperly "shifted the burden of proof on *intent* to the defendant."], emphasis added; *see also,* U.S. Const. Fourteenth

Amend.; Cal. Const., art. I, § 15; *Sandstrom v. Montana, supra,* 442 U.S. at p. 514.)

The Court in *Francis v. Franklin, supra,* 471 U.S. 307, delineated a two-step process for determining whether a jury instruction creates an improper presumption, prefatorially noting "[a]nalysis must focus initially on the specific language challenged," though

> ... the inquiry does not end there. If a specific portion of the jury charge, considered in isolation, could reasonably have been understood as creating a presumption that relieves the State of its burden of persuasion on an element of an offense, the potentially offending words must be considered in the context of the charge as a whole. Other instructions might explain the particular infirm language to the extent that a reasonable juror could not have considered the charge to have created an unconstitutional presumption.

(*Id.*, at p. 315.) If a specific instruction both "alone and in context of the overall charge, could have been understood by reasonable jurors to require them to find the presumed fact if the State proves certain predicate facts," the instruction is constitutionally noxious, and the reviewing court then determines whether the error was harmless in the case at hand. (*Carella v. California* (1989) 491 U.S. 263, 265; *Neder v. United States* (1999) 527 U.S. 1, 9-10.) It was not.

As modified for appellant's jury, CALJIC No. 4.19 read, in part:

> The term "sexually violent predator" means a person who, (1) has been convicted of a sexually violent offense against two or more victims for which he or she received a [determinate] sentence, and (2) has a diagnosed mental disorder that makes him or her a danger to the health and safety of others in that it is likely that he or she will engage in sexually violent [predatory] criminal behavior. [¶] "Sexually violent offense" means the following acts when committed by force, violence, duress, menace or fear of immediate, and unlawful bodily injury on the victim or another person, and that result in a conviction of 288a(F) oral cop. unconscious person. [¶] For the

purposes of this proceeding, nay of the following shall be considered a conviction for a sexually violent offense: [¶] [A.][A prior or current conviction that resulted in a [determinate] prison sentence for an offense described above.]

(CT 268-269; RT 829-830)[3] This language dictated that if appellant's jury found he had the charged prior convictions, those convictions must be found sexually "violent" for prong one purposes. This constitutes an improper mandatory presumption: more precisely, it was an improper mandatory conclusive presumption in violation of the Due Process Clause. (*Francis v. Franklin, supra,* 471 U.S. at p. 314, fn. 2.)

Improperly presumptive jury instructions are to be reviewed for harmless error, defined as "whether the force of the evidence presumably considered by the jury in accordance with the instructions is so overwhelming as to leave it beyond a reasonable doubt that the verdict resting on that evidence would have been the same in the absence of the presumption. It is only when the effect of the presumption is relatively minimal... that the presumption did not contribute to the verdict rendered." (*Yates v. Evatt, supra,* 500 U.S. at p. 405; *Rose v. Clark* (1986) 478 U.S. 570, 582; *People v. Odle* (1988) 45 Cal.3d 386, 414, cert. den. 534 U.S. 888; *People v. Dyer* (1988) 45 Cal.3d 26, 63-64, cert. den. 525 U.S. 1033.) In *Pope v. Illinois,* the Court noted the appellate inquiry is whether the predicate facts "'conclusively'" establish intent "'so that no rational jury could find that the defendant committed the relevant criminal act but did not *intend* to cause injury.'" (*Pope v. Illinois* (1987) 481 U.S. 497, 503, quoting *Rose v. Clark, supra,* 478 U.S. at pp. 580-581; *c.f., People v. Forrester* (1994) 30 Cal.App.4th 1697, 1702-1703.)

The error here was not harmless: there was ample evidence Jonathan's oral copulations were not forcible, and thus, were not violent, and thus, appellant did not suffer the requisite two sexually violent prior convictions, and thus, his current commitment cannot stand.[4] (*Yates v. Evatt, supra,* 500 U.S. at p. 405.)

3 Emphasized by the State at argument: "He has five prior convictions of oral copulation of an unconscious person. Those offenses qualify under this law as sexually violent offenses, since I explained earlier that like the offense against Jonathan, you wouldn't normally classify it as violent, but the law classifies any times [sic] you use drugs or alcohol to make a victim vulnerable to an assault, that qualifies as a sexually violent offense. (RT 751)

4 Anticipating a waiver argument from the Government: there is no waiver as defense counsel litigated the issue whether the priors qualified legally pretrial, and lost, decisively. No further objection was needed, as further objection would have been futile. (*People v. Hill* (1998) 17 Cal.4th 800, 820.) If objection was required, it was ineffective assistance of trial counsel to fail to object,

Conclusion

To be committed as a sexually violent predator, appellant must have been convicted of two sexually violent offenses: Penal Code section 288a, subdivision (f) is not *de jure* a violent offense, and there is not substantial evidence appellant committed two *de facto* forcible oral copulations. This paucity of proof, compounded by an instruction which mandated the jury ignore this paucity of proof, cannot sustain appellant's SVP commitment. (*Jackson v. Virginia, supra,* 443 U.S. at pp. 318-319; *People v. Johnson, supra,* 26 Cal.3d at pp. 575-578.)

as there could be no reasonable tactical justification for admission. (*See generally, Yarborough v. Gentry* (2003) 540 U.S. ___; *Strickland v. Washington* (1984) 466 U.S. 668, 687; *People v. Jones* (1994) 24 Cal.App.4th 1780, 1784, fn. 5; *compare People v. Mendoza Tello* (1997) 15 Cal. 4th 264, 266-267.)

ARGUMENT

APPELLANT'S CONVICTIONS MUST BE REVERSED FOR THE REDACTION OF APPELLANT'S REQUESTS TO TAKE A POLYGRAPH TEST FROM HIS TAPED POLICE INTERVIEW

Introduction

As noted, appellant was interviewed by a detective about Maddie's allegations of abuse; during that interview, the detective lied about the contents of the tape recording surreptitiously made by appellant's wife. Also during that interview, appellant repeatedly asked for, and was promised, the chance to take a "lie detector test" to prove his innocence. The interview tape was redacted before it was presented to the jury, and all references to a polygraph examination were excised. (CT 45, 171-172; RT 1004-1007, 1017, 1208, 124-1251) Though polygraph evidence is generally inadmissible absent stipulation to the contrary, a party may bring out an entire conversation to elucidate that part of the conversation otherwise offered into evidence. (Evid. Code § 351.1, 356.) Appellant's insistence on a polygraph examination was part and parcel of his response to the accusations levied against him; exclusion of that response turned an affirmative denial of guilt into an adoptive admission, breaching the provisions of Evidence Code section 356[1] and violating appellant's Sixth Amendment rights to present a defense and to a fair trial. (*Davis v. Alaska* (1974) 415 U.S. 308, 318; *Washington v. Texas* (1967) 388 U.S. 14, 23.)

A. Polygraph Evidence generally excluded

Evidence Code section 351.1 proscribes admission of polygraph evidence, including the offer or refusal to take a polygraph examination, unless otherwise stipulated to by the parties.[2] (*People v. Espinoza* (1992) 3 Cal.4th 806, 818, cert. den. 512 U.S. 1253; *People v. Fudge* (1994) 7 Cal.4th 1075, 1122-1123, cert. den. 514 U.S. 1124 [no showing polygraph reliable, no constitutional deprivation in excluding].)

1 Section 356: "Where part of an act, declaration, conversation, or writing is given in evidence by one party, the whole on the same subject may be inquired into by and adverse party; when a letter is read, the answer may be given; and when a detached act, declaration, conversation, or writing is given in evidence, any other act, declaration, conversation, or writing which is necessary to make it understood my also be given in evidence."

2 In pertinent part, subsection (a): "Notwithstanding any other provision of law, the results of a polygraph examination, the opinion of a polygraph examiner, or any reference to an offer to take, failure to take, or taking of a polygraph examination, shall not be admitted into evidence in any criminal proceeding... unless all parties stipulate to the admission of such results."

In *People v. Thornton* (1974) 11 Cal.3d 738,[3] the California Supreme Court rejected the argument that a defendant's willingness to take a polygraph should be admissible as "a badge of innocence." In so holding, the Court reasoned that just as polygraphs "themselves are not considered reliable enough to have probative value, 'a suspect's willingness or unwillingness to take such a test is likewise without enough probative value to justify its admission.'" (*Id.* at p. 764, quoting *People v. Carter* (1957) 48 Cal.2d 737, 752 [erroneous admission of defendant's refusal to take test].) In *People v. Espinoza, supra,* 3 Cal.4th 806, the Court reaffirmed both ban and basis: exclusion of polygraph evidence is proper because there is no inherent probative value to be gleaned from the test, or from the offer or refusal to take the test. (*Id.,* at p. 817; *accord, People v. Price* (1991) 1 Cal.4th 324, 420, cert. den. 506 U.S. 851 [no due process right to introduce test results if test not generally accepted as reliable]; *People v. Jones* (1959) 52 Cal.2d 636, 653, cert. den. 361 U.S. 926 [polygraph tests "do not scientifically prove the truth or falsity of the answers given during such tests."].) And most recently, in *People v. Maury* (2003) ___ Cal.4th ___ (2003 Cal. LEXIS 2623, filed April 24, 2003), the Court confirmed the prohibition against such proof, asiding that it would soon determine whether this exclusion is absolute or whether defendants are entitled to a *Kelly/Frye* hearing on the admissibility of proposed polygraph evidence.[4] (*People v. Kelly* (1976) 17 Cal.3d 24, 30-32; *Frye v. United States* (D.C. Cir. 1923) 293 F. 1013, 1014.)

In sum, an offer to take a polygraph test is inadmissible because there is no there there and because "exclusion of the polygraph evidence [does] not preclude him from introducing any factual evidence of the charged offense and [does] not prohibit him from testifying on his own behalf." (*People v. Maury, supra,* ___ Cal.4th ___ (2003 Cal. LEXIS 2623, at p. 128; *United States v. Scheffer* (1998) 523 U.S. 303 [federal rule precluding polygraph "barred [defendant] merely from introducing expert opinion testimony to bolster his own credibility."].) But appellant's case does not implicate the scientific validity or invalidity of the polygraph as lie detector; rather, appellant's case involves the far simpler principle that some statements must be contextualized to be understood, or, more importantly, not to be misunderstood. (Evid. Code § 356; *People v. Zapien* (1993) 4 Cal.4th 929, 959, cert. den. 510 U.S. 919.)

3 Overruled on other grounds in *People v. Flannel* (1979) 2 Cal.3d 668, 684.

4 In *People v. Wilkinson* (2002) 102 Cal.App.4th 72, review granted December 11, 2002, S111028. (*People v. Maury, supra,* ___ Cal.4th ___ (2003 Cal. LEXIS 2623, p. 128.)

B. Evidence Code section 356 and the "Rule of Completeness"

In *United States v. Scheffer, supra,* 523 U.S. 303, Justice Thomas, writing for the plurality, noted the interests served by the military rule excluding polygraph evidence included "ensuring that only reliable evidence is introduced at trial, preserving the jury's role in determining credibility, and avoiding litigation that is collateral to the primary purpose of the trial." (*Id.*, at p. 309.) Because there was no scientific consensus regarding polygraph evidence (*id.*, at p. 309-311 [scientific community "extremely polarized" re: reliability of polygraph]), and because "'the *jury* is the lie detector'" (*id.*, at p. 313, emphasis in the original, quoting *United States v. Barnard* (1974) 490 F.2d 907 912, cert. den. 416 U.S. 959), and because admission of polygraph evidence would necessarily involve litigation on test methods generally and each test specifically (*id.*, at p. 315), the fair trial rights of the defendant to present evidence must cede to the government interests of judicial reliability and efficiency. (*Id.*, at pp. 316-317.)

In his concurrence, Justice Kennedy, joined by Justices O'Connor, Ginsburg and Breyer, criticized the *per se* exclusion of polygraph evidence, and would leave to the various jurisdictions the decision whether the jury's role is usurped via introduction of a polygraph test. (*Id.*, at pp. 318-319 [agreeing with the dissent that juries are not so easily swayed].) Justice Steven's dissent opposed the *per se* rule of exclusion as inconsistent with the Sixth Amendment right to present a defense. (*Id.*, at pp. 325-328.) As the holding of a plurality opinion is the narrowest ground upon which an agreement of five justices may be inferred, the only postulate properly gleaned from the Court's decision in *Scheffer* is that admission of polygraph evidence implicates the trinity of State interests identified by the plurality. (*See, Marks v. United States* (1977) 430 U.S. 188, 193.) In other words, the Evidence Code section 351.1 ban on polygraph evidence must cede to a defendant's right to present evidence if the proof otherwise serves the government's evidentiary interests. Given the mandate of section 356, appellant's multiple offers to take a lie detector test would have served these interests, and it was error to exclude them. (*People v. Arias* (1996) 13 Cal.4th 92, 156.)

As noted, section 356 permits introduction of the whole of a conversation if the whole is necessary to understand the part already introduced. (*People v. Arias, supra,* 13 Cal.4th at p. 156 ["The purpose of this section is to prevent the use of selected aspects of a conversation, act, declaration, or writing, so as to create a misleading impression on the subjects addressed."]; *People v. Hamilton* (1989) 48 Cal.3d 1142, 1174 [opponent entitled to place

whole of part introduced Aprovided the other statements have *some bearing upon, or connection with*, the admission or declaration in evidence."], emphasis in original.) As the First District put it: "If the part not given is explanatory of or in any way qualifies or modifies the part given, then, in such case, the part not given by the witness may be shown." (*People v. Gambos* (1970) 5 Cal.App.3d 187, 193.)

In appellant's case, the trial court permitted the prosecutor to introduce part of appellant's interview with the detective, specifically excising those parts in which appellant asked to take a lie detector test, and those parts in which the detective promised to provide a polygraph, and then attempted to discourage appellant from taking the test. (CT 48-89 [unredacted tape], 132-170 [redacted tape as admitted into evidence].) Comparing the two in pertinent part:

Unredacted Interview	Redacted Interview
O'Quinn: That's what she's saying, yeah. I just wanna get—	O'Quinn: That's what she's saying, yeah. I just wanna get—
Defendant: I wanna take a lie detector test so I can—	
O'Quinn: Ok. (CT 48)	O'Quinn: Ok. (CT 133)
..	..
O'Quinn: —all I'm saying --	O'Quinn: —all I'm saying—
Defendant: I wanna take a lie detector test.	
O'Quinn: I'll let you do that by the way. We can do that.	
Defendant: I want to because I did not touch that girl—did not lay one hand on that girl.	Defendant: —did not lay one hand on that girl.
O'Quinn: Ok.... (CT 60-61)	O'Quinn: Ok... (CT 145)
..	..
Defendant: That is—that blows me away. I mean, I—I wanna take a detect—	Defendant: That is—that blows me away. I mean, I—
O'Quinn: Well I can do that—I can—	
Defendant: (Unintelligible)—because I did not touch my daughter. (CT 65)	Defendant: (Unintelligible)—because I did not touch my daughter. (CT 149)
..	..
Defendant: No. I did not take her hand.	Defendant: No. I did not take her hand.

O'Quinn: Ok.
Defendant: This is why I want to take a lie detector test.
O'Quinn: Well I want to do that. We don't have a guy up here regular every day. So I can't—(unintelligible)
Defendant: (unintelligible)
O'Quinn: But I would like to do that.
Defendant: Alright.
O'Quinn: (unintelligible) open mind to doing it.
Defendant. I No. I.
O'Quinn: Ok.
Defendant: I want to do that.
O'Quinn: Um. What I really—a—again I only want the truth Alan. I'm not interested in anything but the truth. (CT 67)

..

O'Quinn: Ok.—(unintelligible)—doing like she's not really watching but she is, ya know and Maddie came in and she's watching—
Defendant: Yeah. I mean that's all that happened though. That's all that happened. I did not try to grab her hand, to do anything, I did not stick [sic] a finger in her butt—and I wanna put that—and I want name—you know lie detector. (unintelligible)
O'Quinn: Why would she lie about this?
(CT 71)

..

O'Quinn: There [sic] gonna say He's flat out lying. He lied—

O'Quinn: Ok.

O'Quinn: Um. What I really—a—again I only want the truth Ron. I'm not interested in anything but the truth. (CT 151)

..

O'Quinn: Ok.—(unintelligible)—doing like she's not really watching but she is, ya know and Maddie came in and she's watching—
Defendant: Yeah. I mean that's all that happened though. That's all that happened. I did not try to grab her hand, to do anything, I did not stick [sic] a finger in her butt—and I wanna put that—and I want name—(unintelligible)
O'Quinn: Why would she lie about this?
(CT 155)

..

O'Quinn: There [sic] gonna say He's flat out lying. He lied—

Defendant: Oh, when I take this lie detector, I wanna take this lie detector test—

O'Quinn: Well we will, we will.

Defendant: —before we go into court and everything.

O'Quinn: I don't know if it's gonna be before the first hearing. But before the preliminary—

Defendant: I wanna—I wanna have it done before I even go into court because I don't even want to have that slight suspicion that you know—

O'Quinn: You know a lie detector is not fool proof. You understand that.

Defendant: Oh. Well what about that knew [sic] one that they have that they hook up to the brain and everything it's supposed to be a positive thing—

O'Quinn: I don't—the department uses one that hook up to your blood pressure and your breathing and—all on a computer.

Defendant: I want one where it's—this is—this is—I did not touch her and I want to make that perfectly —

O'Quinn: Oh I understand Alan,

Defendant: —and um—.

O'Quinn: —that's all I'm gonna write is that you didn't touch her. Ok? (CT 75)

..

O'Quinn: Well she describes that her pants got pulled down—(unintelligible)

Defendant: (unintelligible)—can't you put her on a lie detector test

O'Quinn: (unintelligible)—they won't allow me to.

Defendant: —and um—.

O'Quinn: —that's all I'm gonna write is that you didn't touch her. Ok? (CT 159)

..

O'Quinn: Well she describes that her pants got pulled down—(unintelligible)

Defendant: A[sic] Cause this that's that's totally such (unintelligible)
O'Quinn: (unintelligible)
Defendant: —when you put me on that lie detector test its not going to be one hundred percent sure for me—
O'Quinn: Le me tell you—let me tell you what she said B (CT 82)

O'Quinn: (unintelligible)—let me tell you what she said—(CT 165)

...

...

O'Quinn: Ok. Um, do have any questions for me?
Defendant: No.
O'Quinn: Ok.
Defendant: I just think its you know—
O'Quinn: The polygraph, um, I wont [sic] be able to set it up or tomorrow there's no way ok, it's usually a week in advance they usually have a regular polygraph guy here and if was [sic] here I could come over in the morning walk you across the parking lot—
Defendant: Um hum.
O'Quinn: —and do the polygraph, ok? Unfortunately the guy uh is not he's coming back to that position but he won't be there for another month or so, uh, as it stands I got to set it up about a week in advance. You're gonna get a uh, uh, public defender tomorrow—
Defendant: Um hum.
O'Quinn: I'm just telling ya straight up the first thing he's gonna say is do not take a polygraph.
Defendant: Why? I want to take one.
O'Quinn: That's his decision, that's that's because they're not usable in

O'Quinn: Ok. Um, do have any questions for me?
Defendant: No.
O'Quinn: Ok.
Defendant: I just think its you know—

Defendant: Um hum.

court ok? Polygraph results plus or minus for or negative is not usable in court is a tool that I use to help determine if somebody's guilty or not.

Defendant: Um hum.

O'Quinn: If the examiner tells me he past [sic] that polygraph with flying colors I do stat looking seriously at maybe we got something else going on here.

Defendant: Well there is something else going on here. That's why I want to take this damn thing—(unintelligible)

O'Quinn: (unintelligible) All I'm telling ya is I can set it up fo about a week from now. I will if you tell me to go ahead.

Defendant: I want to.

O'Quinn: Ok.

Defendant: I want to. I want it actually earlier. I don't wan [sic] to spend time in jail and can't afford to do bail and everything to get out.

O'Quinn: I'll set it up at he [sic] earliest possible time and what I'll do is they'll ship you up here and I'll walk you across the parking lot and we'll go with the polygraph ok? Uh, if when you talk to the public defender I'm just telling you what he's gonna tell ya—

Defendant: Um hum.

O'Quinn: That's your decision. At that point in time you'd make the call of listening to him or going and getting it done.

Defendant: Um hum.

O'Quinn: I'll recontact you and in fact I'll give you my card if you if after you talk to him you still feel you want one by all means ill [sic] order (unintelligible)—
Defendant: No I want one I don't care what he says I want one.
O'Quinn: Ok.
Defendant: It's nothing I mean No. I want that done.
O'Quinn: Well call me collect and say hey set it up cause I want it scheduled and I'll tell you when it's when it's gonna be set for um—
Defendant: I can't see if (unintelligible) (CT 84-85)

Defendant: I can't see if (unintelligible) (CT 167)

..

O'Quinn: Uh, that that's my fear is the way—
Defendant: Yeah.
O'Quinn: —things are stacking up. So Ok. Uh, let me let 'em know ad then I'll tell 'em. But I was gonna set up a polygraph lie detector if you're interested?
Defendant: Yes I am.
Unknown voice: (unintelligible) (CT 87)

O'Quinn: Uh, that that's my fear is the way—
Defendant: Yeah.
O'Quinn: —things are stacking up. So Ok. Uh, let me let 'em know and then I'll tell 'em.

Unknown voice: (unintelligible) (CT 169)

..

O'Quinn: Ok, alright Alan.
Defendant: Thank you.
O'Quinn: Ok, take care. I'll be in touch or give me a call on that polygraph, alright?
Defendant: Alright.
O'Quinn: He's gonna tell you tomorrow, don't do it.
Defendant: No, I want one.

O'Quinn: Ok, alright Alan.
Defendant: Thank you.
O'Quinn: Ok, take care. (CT 170)

O'Quinn: It's your decision, if you
want one call me.
Defendant: Ok.
O'Quinn: Ok.
Defendant: I'll do that.
O'Quinn: Alright (unintelligible) (CT
89)

Thus, the conversation as heard by the jury was nothing like the conversation as had by appellant. Preliminarily, appellant kept returning, unprompted, to the topic of the polygraph, alternatively pinning his exculpatory hopes on its ability to verify his account and to disprove the allegations against him, as set forth by the detective. This was not a simple offer to take a test, or the acceptance of one such offer, but was an accused's repeated insistence on being given some real opportunity to prove his innocence. (*Compare, People v. Espinoza, supra,* 3 Cal.4th at p. 815 [defendant "agreed to take" polygraph].) Redaction of appellant's statements in this regard gutted the interview—the eviscerated interrogation transformed appellant for the jury, wresting the appearance of passivity from a proactive and persistent reality. (CT 48 [compare] 133, 67 [compare] 151, 75 [compare] 159, 82 [compare] 165, 84-85 [compare] 167, 89 [compare] 170) In other words, the part not given "qualifies or modifies the part given," and so the part not given—appellant's demand to have his veracity put to the test—should have been shown. (*People v. Gambos, supra,* 5 Cal.App.3d at p. 193.)

Moreover, a close reading of the two transcripts reveals at least two instances in which deletion of appellant's references to a polygraph turned affirmative denials of guilt into the functional equivalent of adoptive admissions.[5] (See generally, Evid. Code ' 1221[6]; *People v. Preston, supra,* 9 Cal.3d at p. 313-314.) To wit:

5 Though the California Supreme Court has carefully caveated the adoptive admissions exception does not apply under circumstances which "'lend themselves to an inference that [the accused] was relying on the right of silence guaranteed by the Fifth Amendment to the United States Constitution...'" (*People v. Reil* (2000) 22 Cal.4th 1153, 1189, quoting *People v. Preston* (1973) 9 Cal.3d 308, 313-314), lower courts have noted that by the same token, "there is no reason for a blanket rule against the application of an adoptive admission analysis to statements made in a custodial setting." (*People v. Castille* (2003) 108 Cal.App.4th 469, 480.)

6 Evidence Code section 1221 provides: "Evidence of a statement offered against a party is not made inadmissible by the hearsay rule if the statement is one of which the party, with knowledge of the content thereof, has by words or other conduct manifested his adoption of his belief in the truth."

O'Quinn: There [sic] gonna say He's flat out lying. He lied—

Defendant: —and um—.

O'Quinn: —that's all I'm gonna write is that you didn't touch her. Ok? (CT 159)

......................................

O'Quinn: Well she describes that her pants got pulled down—(unintelligible)

O'Quinn: (unintelligible)—let me tell you what she said—
(CT 165)

Omitted from the first exchange is the critical caesarea:

Defendant: Oh, when I take this lie detector, I wanna take this lie detector test—

O'Quinn: Well we will, we will.

Defendant: —before we go into court and everything.

O'Quinn: I don't know if it's gonna be before the first hearing. But before the preliminary—

Defendant: I wanna—I wanna have it done before I even go into court because I don't even want to have that slight suspicion that you know—

O'Quinn: You know a lie detector is not fool proof. You understand that.

Defendant: Oh. Well what about that knew [sic] one that they have that they hook up to the brain and everything it's supposed to be a positive thing—

O'Quinn: I don't—the department uses one that hook up to your blood pressure and your breathing and—all on a computer.

Defendant: I want one where it's—this is—this is—I did not touch her and I want to make that perfectly—

O'Quinn: Oh I understand Ron,

(CT 75) And from the second:
Defendant: (unintelligible)—can't you put her on a lie detector test

O'Quinn: (unintelligible) —they won't allow me to.

Defendant: A[sic] Cause this that's that's totally such (unintelligible)

O'Quinn: (unintelligible)

Defendant: —when you put me on that lie detector test its not going to be one hundred percent sure for me—

(CT 82) It is of no significance that the jury in this case was not instructed on adoptive admissions (CALJIC No. 2.71.5), for the hearsay exception is, as other 'firmly rooted' exceptions are, predicated on the understanding there is something not just inherently, but patently, trustworthy about incriminating admissions. (Lilly v. Virginia (1999) 527 U.S. 116, 127 [[voluntary admissions "carry a distinguished heritage confirming their admissibility..."].) And it is this obvious trustworthiness that makes appellant's apparent silence so devastating:

In *People v. Castille, supra,* 108 Cal.App.4th at p. 484, the First District explained that once a statement has been explicitly or inferentially adopted by a defendant, the statement becomes "'*his own admissions*, and are admissible on that basis as a well-recognized exception to the hearsay rule.'" (*Ibid.*, quoting *People v. Silva* (1988) 45 Cal.3d 604, 624, cert. den. 488 U.S. 1019.) Given the defendants in *Castille* had waived their right to remain silent, and had answered various questions posed by their interrogators, confirming and clarifying various facts, their silence in the face of other statements was an adoptive admission which fell "within a firmly rooted exception to the hearsay rule...." (*People v. Castille, supra,* 108 Cal.App.4th at p. 485; see, *Lilly v. Virginia, supra,* 527 U.S. at p. 126 ["Established practice... must confirm that statements falling within a category of hearsay inherently 'carry special guarantees of credibility' essentially equivalent to, or greater than, those produced by the Constitution's preference for cross-examined trial testimony."], quoting *White v. Illinois* (1992) 502 U.S. 346, 356.) Similarly, appellant had waived his right to silence, had protested some accusations, admitted others, elucidated some facts, explained others, and, as far as the jury was concerned, adopted the charge of lying levied against him by the detective, and at least once admitted to pulling down Maddie's pants. (*People v. Fauber* (1992) 2 Cal.4th 792, 851-853, cert. den. 507 U.S. 1007 ["The circumstances afforded defendant the opportunity to deny responsibility, to refuse to participate, or otherwise to disassociate himself form the planned activity; he did not do so."].) Appellant's apparent silence in the face of other accusations was an unfair representation, and fundamentally so.

Conclusion

The objection to polygraph evidence rests on trial court's trined mandate of "ensuring that only reliable evidence is introduced at trial, preserving the jury's role in determining credibility, and avoiding litigation that is collateral to the primary purpose of the trial." (*United States v. Scheffer, supra,* 523 U.S. at p. 309.) But these duties are also served by making sure the jury has before it the whole of the evidence partially presented in order to reliably determine credibility. Just as the sum of the evidence under section 356 is deemed greater than the proffered part, so appellant's right to a fair trial and to present all the evidence in his behalf was greater than the State's interest in presenting a truncated and misleading view of the evidence. Because the guilty verdict in this case was not "surely unattributable" to this error, appellant's convictions must be reversed. (*Sullivan v. Louisiana* (1993) 508 U.S. 275, 279.)

VANESSA PLACE

126

ARGUMENT

APPELLANT'S SEX OFFENSE AND KIDNAPING CONVICTIONS MUST BE REVERSED FOR THE PREJUDICIAL ADMISSION OF IRRELEVANT EXPERT TESTIMONY ON PIMPING "STRATEGIES"

Introduction

As noted, Dr. Lois Lee, director and founder of Children of the Night, testified to an assortment of techniques pimps sample from in dealing with prostitutes. In the pretrial hearing to determine the admissibility of her testimony, Lee testified she ran a shelter for child prostitutes, which then housed 18 children. She has been working with prostitutes since 1973, has spoken with thousands of prostitutes and hundreds of pimps, and studied the autobiographies of Malcolm X and Iceberg Slim, pimps in the 1940s. In the 1970s, Lee wrote a paper called "The Pimp and His Game," still used by law enforcement to show child prostitutes how they were manipulated by their pimps. Lee has not interviewed any modern-day pimps directly, but has "seen their literature and their interviews on television." (RT 1512-1513, 1519-1523)

At the hearing, Lee testified "the game" involves a series of twenty-two psychological strategies used to "entice... young women into prostitution, to maintain them in the role of prostitute, and to ... ensure that their money is given to a pimp." Lee described the strategies in cognitive terms, learned by pimps in an apprenticeship program. All strategies are not used by all pimps: more strategies are used by more sophisticated pimps.[1] (RT 1512, 1518) Prostitutes are often paired for competition in opposite types: a lesbian with a nonlesbian, an attractive woman with an unattractive woman, a heavy woman with a thin one. There is a stratification system established in which one woman is "bottom whore," the privileged "main lady," and the others compete for her position. The less sophisticated/educated the pimp, the more likely he is to physically dominate his prostitutes; the more educated/sophisticated pimps use other men to effect violence for control. Pimps compete with other pimps for women; the more successful/violent pimp is the better competitor. To preserve his illusion of complete control, pimps take credit for all that happens to a prostitute

1 One such strategy, known as "deep squeeze," involves meeting a young woman, asking her questions to discern her weaknesses, to identify how to alienate her, to convert her identity. A woman who'd been sexually exploited would be told how she could take advantage of society. Other strategies involve manipulation of wealth and possessions: the pimp is only caretaking her money, or will invest it in some future plan.

on the street, good or bad. (RT 1513-1516, 1519) Appellant was described as a "guerilla pimp" to Lee. (RT 1517) Prostitutes typically want to please their pimp, which includes performing sex acts on the pimp. Oral copulation is "part of the ritual." (RT 1523) In overruling the defense objection to admission, the trial court indicated Lee's testimony was relevant on the question of credibility in terms of consent, i.e., to rebut any suggestion the victims were free to leave "at numerous points in their relationship," and that Lee was qualified to tender such proof on this matter, which was outside the jury's ken. (RT 1530-1533)

Lee's testimony before appellant's jury recapped her expertise, then detailed the workings of the prostitute/pimp relationship, analogizing it at one point to the "Battered Wife Syndrome, where despite the abuse and the degradation, many times they return to the abuse and the degradation." (RT 1544) Lee explained the mechanics of recruitment, whereby young women who have often been previously sexually traumatized, are enticed and/or coerced into working for a pimp, the commonplace of prostitutes choosing up pimps,[2] and pimps trading prostitutes. Lee testified her paper "'A Pimp and His Game,' characterized twenty-two strategies that pimps use to manipulate young women and get them involved in prostitution." The paper is used by counselors in her shelter to present to children so they can identify strategies used on them: "it helps them try and figure out what happened to them, where they can see that the kinds of things that the pimp did to them was not personal. It wasn't their fault. It was actually part of a strategy of a series of strategies *in order to get them to be prostitutes and keep them in that role.*"[3] (RT 1550-1551, 1567-1570) Lee testified pimps confirm these strategies, bragging how they don't have to physically dominate, "even if they did," and how "they seem to take pride in being able to dominate a woman mentally rather than physically, even though both happens." Lee noted not all pimps use all strategies, some "maybe

2 Contrary to Lee's testimony (and concordant with Cerise's), other researchers have found that "because pimps respect free enterprise and competition, women are free to 'chose up' whenever they are dissatisfied with their current pimp....[&] ...[I]t is in the pimp's best interest to keep his women happy." (http://www.wmich.edu/destinys-end/pimping%20game.htm)

3 In her Children of the Night website profile, Lee states she "abandoned a promising career as a scholar and social policy expert" to devote herself to "rescuing America's children from the ravages of street prostitution." She describes her efforts to help child prostitutes as "single-minded," citing her creation of the Hollywood children's drop-in center, the Children of the Night home, and her other work as an instructor at the Los Angeles Police Academy "training juvenile detectives in how to detect, treat, and rescue" child prostitutes, her frequent service as "an expert witness for federal and state prosecutors enforcing laws against dangerous pimps." Of her dissertation, Lee notes it is "relied upon by vice officers, district attorneys, and U.S. attorneys nationwide as a guide for their treatment of child prostitutes, for jury education, and for the prosecution of dangerous pimps." (http://childrenofthenight.org/site/founder.html)

use a particular five or ten or whatever, but it's tried and true. You can see it in the music and culture and the movies and the documentaries, the newspaper articles." (RT 1551, 1570-1571) Lee testified a pimp uses a combination of physical violence and mind control to confuse "a girl," so to "maintain control of her." (RT 1552) Lee also attested to the phenomenon of being out-of-pocket, the concept of a bottom bitch, competition between prostitutes, the importance of prostitute loyalty to the pimp, and the use of punishment by pimps, including "forced sodomy, any kind of forced sex...." Lee testified a prostitute will orally copulate her pimp to curry his favor. (RT 1555-1560, 1566-1567)

This testimony was irrelevant on any and all questions as a matter of expert opinion—there is no legitimate "Prostitute Syndrome" available or necessary to explain why an *adult* woman would not leave her pimp, and the pimping strategies attested to were, unlike evidence of Child Sexual Abuse Accommodation Syndrome or Battered Wife Syndrome or Rape Trauma Syndrome, irrelevant as to the testimony of the State's witnesses, and especially irrelevant relative to the issue of consent. But what this evidence lacked in probity, it made up for in prejudice, and appellant's sex offense and kidnapping convictions must be consequently reversed. (Evid. Code § 210, 720; see, *People v. Bledsoe* (1984) 36 Cal.3d 236, 250-252.)

A. Expert Testimony: In General

Expert testimony is admissible only if the subject matter the expert is testifying to is "sufficiently beyond common experience that the opinion of an expert would assist the trier of fact." (Evid. Code § 720(a).) An expert may testify to an opinion based on matter, either personally perceived or known by the expert or made known to the witness, regardless of admissibility, which reasonably may be relied upon by an expert in forming an opinion upon the subject of the testimony. (Evid. Code § 801(b); *People v. Catlin* (2001) 26 Cal.4th 81, 137, cert. den. 535 U.S. 976.) A trial court is to exclude from an expert's testimony any hearsay "whose irrelevance, unreliability, or potential for prejudice outweighs its proper probative value." (*People v. Carpenter* (1997) 15 Cal.4th 312, 403, cert. den. 531 U.S. 838 [abuse of discretion standard]; *People v. Coleman* (1985) 38 Cal.3d 69, 91-93.) Further, an expert's recitation of source material "does not transform inadmissible matter into 'independent proof' of any fact." (*People v. Gardeley* (1996) 14 Cal.4th 605, 619, cert. den. 522 U.S. 854.) For, at base:

> ... any material that forms the basis of an expert's opinion testimony must be reliable. [Cite.] For

"the law does not accord to the expert the same
degree of credence or integrity as it does the data
underlying the opinion. Like a house built on sand,
the expert's opinion is no better than the facts on
which it is based."

(*Id.*, at p. 618, quoting *Kennemur v. State of California* (1982) 133 Cal.App.3d
907, 923.)

As a preliminary matter, Lee's testimony should not have been admitted
because Lee's testimony was a sandcastle; as a secondary matter, it was an
edifice irrelevant to the issues at hand: there was plenty of lay evidence attesting
to the pimp/prostitute relationship between appellant and Nikki and appellant
and Ice, and the regimen of sex and violence and dependance contained in that
relationship—a relationship, as Lee testified, well- (and accurately) represented
to the public—was not something outside a layperson's ability to comprehend.
The only issue the expert testimony was actually offered for was the issue of
consent: Lee's testimony was that though prostitutes may consent to orally
copulate a pimp, or accompany him, this consent is *legally* invalid as the
product of the pimp's strategy of mind control. But this sort of testimony runs
afoul of the Supreme Court's specified limits on proper expert testimony and on
the general role of the expert witness:

B. Lee's testimony as analogized

In *People v. Bledsoe, supra,* 36 Cal.3d at pp. 241-243 the California
Supreme Court held expert evidence a victim was suffering from rape trauma
syndrome was not admissible to prove a rape had occurred. Though a then-
recent concept, rape trauma syndrome (an "umbrella terminology" used to
refer to the various reactions a woman might experience after being raped) had
been comprehensively documented in the relevant scientific literature and was
"generally recognized" within the relevant community as a therapeutic tool for
working with rape victims.[4] (*Id.*, at pp, 248-251.) As a therapeutic tool, rape
trauma syndrome:

 ... was not devised to determine the "truth" or
 "accuracy" of a particular past event—i.e., whether,

4 Rape trauma syndrome had been first documented in a 1974 article published in the
American Journal of Psychiatry (Burgess & Holmstrom, *Rape Trauma Syndrome* (19974) 131
Am.J.Psychiatry 981, 983); the Court in *Bledsoe* also cited subsequent studies (Fox & Scherl,
Crisis Intervention with Victims of Rape (1972) 17 Social Work 37, 37-42; Notman & Nadelson,
The Rape Victim: Psychodynamic Considerations (1976) 133 Am.J.Psychiatry 408, 409; Kilpatrick,
Rape Victims Detection, Assessment and Treatment (Summer 1983) Clinical Psychologist 92, 94),
including a "comprehensive" 1979 publication (McCahill, et. al., *The Aftermath of Rape* (1979)).

in fact, a rape in the legal sense occurred.... rape counselors are taught to make a conscious effort to avoid judging the credibility of their clients. [&] Thus, as a rule, rape counselors do not probe inconsistencies in their clients' descriptions of the facts of the incident, nor do they conduct independent investigations to determine whether other evidence corroborates or contradicts their clients' renditions.... [N]one of the studies has attempted independently to verify the "truth" of the clients' recollections or to determine the legal implication of the clients' factual accounts.

(*Id.*, at p. 250.) By comparison, the "relatively narrow set of criteria or symptoms"classified as battered child syndrome were intended as a diagnostic tool to facilitate identification of potential abuse. (*Ibid.; People v. Jackson* (1971) 18 Cal.App.3d 504, 506-507[outlining the six elements necessary for diagnosis].)

While rape trauma syndrome evidence was admissible to explain facets of victim behavior—such as to rebut suggestions the victim's post-rape conduct was incongruous with having been raped, or to "disabuse the jury of... popular myths"—there was no legitimate grounds for admission when it was offered purely to corroborate the victim's allegation of rape—such as when the victim's post-incident trauma was entirely consistent with having been raped. (*People v. Bledsoe, supra,* 36 Cal.3d at p. 248; *compare, Carney v. Santa Cruz Women Against Rape* (1990) 221 Cal.App.3d, 1009, 1026 [rape trauma evidence admissible in civil suit to explain victim's recantation].) The Court noted lay jurors were "fully competent" to consider evidence of the victim's post-attack distress, and allowing an expert to suggest that manifestations of rape trauma syndrome indicated the victim had been raped "'unfairly prejudices the appellant by creating an aura of special reliability and trustworthiness.'" (*People v. Bledsoe, supra,* 36 Cal.3d at p. 251, quoting *State v. Saldana* (Minn. 1982) 324 N.W.2d 227, 230.) Under these conditions, use of the term "rape trauma syndrome" is "likely to mislead the jury into inferring that such a classification reflects a scientific judgment that the witness was, in fact, raped." (*People v. Bledsoe, supra,* 36 Cal.3d at p. 251, fn. 14.) Most salient, the Court's decision in *Bledsoe* was part predicated on the nature of rape as a specific intent crime: a man's good-faith but mistaken belief in the woman's consent to intercourse legally negates the rape, although the woman may have an equal good-faith

belief that she had not so consented, and would thus suffer the same clinical trauma as the victim of a legally cognizable rape. (*Id.*, at p. 250, fn. 12.)

Similarly, child sexual abuse Accommodation syndrome evidence is evidence of a discreet set of victim behaviors (five stages of post-trauma behavior) offered to explain why child victims do not disclose, or engage in delayed or partial disclosure of their abuse; like the rape trauma syndrome, the child sexual abuse Accommodation syndrome was first developed as a therapeutic tool, and is predicated on the clinical assumption the child was molested. (*People v. Bowker* (1988) 203 Cal.App.3d 385, 389, 391-392 [noting "numerous" appellate cases citing *Bledsoe* to preclude experts from testifying as to the credibility of a particular victim based on CSAAS]; *In re Sara M.* (1987) 194 Cal.App.3d 585, 593; *People v. Roscoe* (1985) 168 Cal.App.3d 1093, 1096-1067 [syndrome evidence introduced to rebut defense attack on credibility].) In *People v. Bowker, supra,* 203 Cal.App.3d 384, the court found generalized CSAAS testimony inappropriate under *Bledsoe*: "the evidence must be tailored to the purpose for which it is being received.... at minimum the evidence must be targeted to a specific 'myth' or 'misconception' suggested by the evidence.... Where there is no danger of jury confusion, there is simply no need for the expert testimony." (*Id.*, at pp. 393-394 [also noting necessity for jury to be instructed not to use expert testimony to determine truth of the allegations.].) Where there was no specific myth/misconception at stake, the prosecutor's uncircumspect use of CSAAS theory improperly "constructed a 'scientific' framework into which the jury could pigeonhole the facts of the case." (*Id.*, at p. 395; *compare, People v. Patino* (1994) 26 Cal.App.4th 1737, 1745; *People v. Houseley* (1992) 6 Cal.App.4th 947, 955-956; *People v. Gilbert* (1992) 5 Cal.App.4th 1372, 1386.)

And unlike battered women's syndrome, the admissibility of the evidence here has not been legislatively approved. Evidence Code section 1107 codified admission of battered women's syndrome evidence "when relevant to a contested issue at trial other than whether a criminal defendant committed charged acts of domestic violence." (*People v. Humphrey* (1996) 13 Cal.4th 1073, 1988-1089 [BWS[5] relevant to reasonableness and subjective existence of defendant's belief in the need to defend]; *accord, People v. Gadlin* (2000) 78 Cal.App.4th 587, 593-594 [BWS relevant to explain recantation of assault

5 In its synopsis of the syndrome, the Court cited several published decisions detailing battered women's syndrome symptomology (most significantly *People v. Aris* (1989) 215 Cal. App.3d 1178, 1194, which further catalogues cases considering the syndrome) as well as a 1993 Harvard Law Review Note on battered women who kill their abusers (*People v. Humphrey, supra,* 13 Cal.4th at p. 1084.)

allegation.].) In *People v. Gomez* (1999) 72 Cal.App.4th 405, 415-417, Division Three found battered women's syndrome evidence irrelevant absent a sufficient showing the woman was a battered woman: a single violent incident, without other indicia of abuse, was not enough to warrant testimony on the syndrome; in *People v. Williams* (2000) 78 Cal.App.4th 1118, 1128-1129, Division Four disagreed, holding the evidence admissible despite the lack of prior incidents to rebut allegations of accidental injury and to explain why the woman allowed the alleged abuser to return home post-abuse. (*See*, 1 Witkin Cal. Evid. (4th ed. 2003) Opinion Evid. § 50.)

In approving admission and use of the above evidence, the attesting experts and reviewing courts cited a myriad of published sources documenting the existence and effect of each syndrome. There was no such there here: Lee's strategies appear to be her sauce-like reduction of various mass media representations by pimps of pimping, as anecdotally confirmed by her work with child prostitutes. Compared to BWS, CSAAS, and rape trauma syndrome evidence, there were no studies cited, no published articles provided—nothing, in sum, to support this self-acknowledged crusader's "expert" testimony. And again, the gravamen of this testimony went directly and impermissibly to the ultimate issue, as the court improperly permitted Lee to testify in essence that Nikki did not, contrary to what she told appellant, agree to go back to the hotel with him, and Nikki and Ice did not, contrary to their testimony, consent to sex with appellant because they were incapable of legal consent. This, of course, the expert cannot do. (*People v. Bledsoe, supra,* 36 Cal.3d at p. 251.)

In fact, Lee's "The Pimp and His Game" testimony most closely resembled the improper profile evidence condemned in *People v. Robbie* (2001) 92 Cal.App.4th 1075, 1082-1083. In *Robbie*, the State introduced an expert who testified the comments and behaviors attributed to defendant were consistent with a common behavior pattern of rapists. In reversing, the court noted the inadmissibility of profile evidence, described as "'a listing of characteristics that in the opinion of law enforcement officers are typical of a person engaged in a specific illegal activity.'" (*Id.*, at p. 1084, quoting *United States v. McDonald* (10th Cir. 1991) 933 F.2d 1519, 1521, cert. den. 502 U.S. 897.) Profile evidence cannot prove guilt because it is improperly syllogistic, asserting:

> [C]riminals act in a certain way; the defendant acted
> that way; therefore, the defendant is a criminal. Guilt
> flows ineluctably from the major premise through
> the minor one to the conclusion. The problem is the

major premise is faulty. It implies that criminals, and
only criminals, act in a given way. In fact, certain
behavior may be consistent with both innocent and
illegal behavior, as the People's expert conceded
here.

(People v. Robbie, supra, 92 Cal.App.4th at p. 1085; compare, People v. McAlpin
(1991) 53 Cal.3d 1289, 1299 [fact there is no profile of typical child molester
properly admitted].) Under the syllogism provided appellant's jury, pimps use
force and mind control to override the will of their prostitutes; appellant acted as
a traditional pimp; therefore, appellant overrode the will of Nikki and Ice (and is
thus guilty of kidnaping and forcible oral copulation). As in Robbie, the problem
is Lee testified prostitutes agree to stay in-pocket, and may want to sexually
service their pimps in order to curry his favor,[6] and though Lee might ascribe
such a desire to false consciousness, there is a difference between the role of
the therapist and the role of the jury in this regard—a jury must determine what
a defendant thought relative to the woman's consent relative to the "ad hoc"
event charged, not how the victim's conscious or apparent consent was belied
by her paradigmatic oppression. (People v. Robbie, supra, 92 Cal.App.4th at p.
1087; see also, People v. Reeder (1976) 65 Cal.App.3d 235, 242 [scientific proof
"may in some instances assume a posture of mystic infallibility in the eyes of a
jury of laymen"].) In argument, the State summed up expert and error: "[W]hen
the defendant met each of these women, he did overcome their will. Each act of
force or violence or threat that he made to them was an act in furtherance of the
game. It was an act in furtherance of overcoming their will. Each act, whether
it was violence, by physical force or words."[7] (RT 1908) But, again, there is no
there here—for each act could equally be the move of a player in the Game.

6 In Robbie, the expert testified rapists engage in cognitive distortions which make them
believe in their victims' consent; the appellate court found this testimony also inadmissible as
outside the expert's realm of expertise and the scope of the proffered testimony. (People v. Robbie,
supra, 92 Cal.App.4th at p. 1087.) Lee testified that while prostitutes may think themselves "in love"
with their pimps, this too is illusory (and thus obviates their consent).

7 This view is referred to as "domination theory," its main tenet is women within a
patriarchy have no free choice, so "sex workers who claim to have chosen sex are victims of false
consciousness. False consciousness suggests that oppressed persons unconsciously internalize
the dominant ideology. Domination theory states that women who claim to enjoy and freely engage
in heterosexual sex have been shaped by the practices and ideology of male dominance...." (http://
www.wmich.edu/destinys-end.htm, quoting Wahab & Sloan, 1997 p. 5.) This theory is currently
opposed by an alternative sociological construction which acknowledges the existence of a sex
workers' rights movement whose members ascribe to three contrary tenets: "First, members
of the movement do not believe that all sex work is forced and / or coerced. On the contrary,
activists argue that many sex workers freely choose the occupation (Jenness, 1993; Pheterson,

Conclusion

Unlike the rape trauma syndrome, battered child/women's syndrome, and child sexual abuse Accommodation syndrome, the testimony here does not purport to clarify anything a lay person could not intuit: *i.e.*, pimps dominate prostitutes to make them beholden to pimps. (*C.f. People v. Gardeley, supra,* 14 Cal.4th at p. 617 [use of expert testimony on culture and habits of gang sociology and psychology "well established"].) Nikki, Ice and Smith all testified to the rules of the game, and all were quite cogent on appellant's use of affection/force to keep his position, and of their own use of sex/obedience to prove their fealty. It was error to admit the testimony, and it was prejudicial error: the issue of consent was the contested heart of the State's kidnaping and sex offense case, and there was, moreover, no limiting instruction given the jury regarding the proper use of Lee's testimony. (*Contra, People v. Bledsoe, supra,* 36 Cal.3d at p. 247; *People v. Houseley, supra,* 6 Cal.App.4th at p. 958-959; *People v. Bowker, supra,* 203 Cal.App.3d at p. 394.) The court has a sua sponte duty to instruct on general principles of law relevant to issues raised by the evidence (*People v. Crew* (2004) 31 Cal.4th 822, 835, cert. den. 158 L.Ed.2d 497, 124 S.Ct. 2018; *People v. Michaels* (2002) 28 Cal.4th 486, 529-530.) Because Lee's testimony went directly to an issue upon which neither her expertise nor any expertise was qualified to address, and because the jury was not advised that it could not consider her testimony on that issue, appellant's convictions for kidnaping and forcible oral copulation must be reversed. (*See, People v. Bledsoe, supra,* 36 Cal.3d at p. 248.)

1989). Second, members argue that sex work should be recognized as legitimate work (Jenness, 1993; Pheterson, 1989). Third, members argue that it is a violation of a woman's civil rights to be denied the opportunity to engage in sex work (Jenness, 1993; Pheterson, 1989). Consequently, the presence of sex workers' rights groups has provided a space for sex workers to speak for themselves and educate others including social workers about their varied experiences, desires and needs." (Wahab, *"For their own good?": sex work, social control and social workers, a historical perspective,* J. of Sociology & Social Welfare, vol. 29, issue 4, Dec. 2002.)

ARGUMENT

APPELLANT'S CONVICTIONS MUST BE REVERSED FOR INEFFECTIVE ASSISTANCE OF COUNSEL BASED ON THE FAILURE TO OBJECT TO ADMISSION OF UNCHARGED OTHER OFFENSE EVIDENCE INVOLVING THE SAME VICTIM

Darcy testified to four acts which would constitute a violation of Penal Code section 288, subdivision (a); the prosecutor elected the kissing incident and the digital penetration as counts one and two, respectively. The incident in the kitchen, where appellant asked Darcy if he could "touch it," while reaching for her vagina and the tickling incident, when Darcy asked her cousin if appellant touched her, were admitted as uncharged offense evidence, and the jury instructed under CALJIC No. 10.43 [Lewd Act with Child—Evidence of Other Offenses—Same Child] that such evidence could only be considered on the question of intent.[1] But lewd intent inhered in the charged acts, as they could not be performed absent such intent. The sole purpose and effect of admitting the two additional offenses was Darcy's self-corroboration, improper under Evidence Code section 1101, subdivision (b), and prejudicial under section 352. (*People v. Ewoldt* (1994) 7 Cal.4th 380, 407-408; *People v. Hoover* (2000) 77 Cal.App.4th 1020, 1026.) Trial counsel failed to object to the admission of this irrelevant and prejudicial testimony. A failure which deprived appellant of his Sixth Amendment right to effective assistance of counsel; appellant's convictions must therefore be reversed. (*Strickland v. Washington* (1984) 466 U.S. 668, 687; *accord, People v. Ewoldt, supra,* 7 Cal.4th at pp. 407-408.)

Prefatorially, a criminal defendant has the right to "the reasonably competent assistance of an attorney acting as his diligent conscientious advocate." *People v. Ledesma* (1987) 43 Cal.3d 171, 215, quoting *United States v. DeCoster* (D.C. Cir. 1973) 487 F.2d 1197, 1202; *People v. Pope* (1979) 23 Cal.3d 412, 424.) A conviction must be reversed when trial counsel's performance falls outside the bounds of reasonable representation and, but for counsel's aberrant behavior, it is reasonably probable that a result more favorable to the defendant would have been reached. *Strickland v. Washington,*

1 No. 10.43, as given to appellant's jury: "Evidence has been introduced for the purpose of showing lewd or lascivious acts between the defendant and alleged victim on one or more occasions other than that charged in this case. [&] If you believe this evidence, you may use it only for the limited purpose of tending to show the defendant's lewd dispositions or intent toward the child. [&] You must not consider that evidence for any other purpose." (CT 1:28; RT 6:1514-1515)

supra, 466 U.S. at p. 687.) While most tactical determinations are immune from appellate attack, the right to effective assistance of counsel "is denied if trial counsel makes a critical tactical decision which would not be made by diligent, ordinarily prudent lawyers in criminal cases." (*People v. Pope, supra,* 23 Cal.3d at pp. 424, 426 ["there simply could be no satisfactory explanation" for counsel's in/action].) Given there was no legitimate basis to admit the other offense evidence in appellant's case, and given the damage such testimony did to his case, there can be no plausible tactical justification for counsel's failure to object to its admission. Appellant's convictions must be reversed for the deprivation of his constitutional right to effective assistance of counsel. (U.S. Const. Sixth Amend.; *Yarborough v. Gentry* (2003) 540 U.S. 1, 11; *People v. Mendoza Tello* (1997) 15 Cal. 4th 264, 266-267.)

As a general matter, Evidence Code section 1101, subdivision (a) proscribes admission of character evidence and/or evidence of specific instances of conduct to prove conduct on a specific occasion. Subdivision (b)[2] of section 1101 allows introduction of evidence of uncharged offenses committed pursuant to the same plan or design as the charged misconduct, subject to the constraints of section 352.[3] (*People v. Ewoldt, supra,* 7 Cal.4th at p. 404.) In *People v. Stanley* (1967) 67 Cal.2d 812, the California Supreme Court reaffirmed the inadmissibility of other crimes evidence to prove criminal propensity; the various exceptions to that rule, later codified in section 1101, subdivision (b), were inapplicable where the other crimes evidence was supplied by the victim in the charged offense. (*Id.,* at p. 817-818.) Though "rigid rules" for the admissibility of evidence should be avoided:

> [W]here the basic issue of the case is the veracity of
> the prosecuting witness and the defendant as to the
> commission of the acts charged, the trier of fact is
> not aided by evidence of other offenses where that

2 Evidence Code section 1101, subdivision (b): "Nothing in this section prohibits the admission of evidence that a person committed a crime, civil wrong, or other act when relevant to prove some fact (such as motive, opportunity, intent, preparation, plan, knowledge, identity, absence of mistake or accident, or whether a defendant in a prosecution for an unlawful sexual act or attempted unlawful sexual act did not reasonably and in good faith believe that the victim consented) other than his or her disposition to commit such an act."

3 Evidence Code section 352: "The court in its discretion may exclude evidence if its probative value is substantially outweighed by the probability that its admission will (a) necessitate undue consumption of time or (b) create substantial danger of undue prejudice, of confusing the issues, or of misleading the jury."

> evidence is limited to the uncorroborated testimony
> of the prosecuting witness.

(Id., at p. 817.) The Court in *Stanley* reasoned if the only purpose of the uncharged offense testimony was to corroborate the account of the victim, and the only evidence of the charged offense was the uncorroborated account of the victim, the testimony regarding the uncharged offense was thus "only an attempt to corroborate her own testimony... [which] could not be said to in any way render the guilt of the defendant more probable than if she had testified that the act had been done but the once charged in the information." *(Ibid.*, citing *People v. Smittcamp* (1945) 70 Cal.App.2d 741, 745-751.)

The Supreme Court confirmed this logic in *People v. Thomas* (1978) 20 Cal.3d 457, based on the statutory scheme of section 1101: according to the opinion in *Thomas, Stanley* stood purely for the proposition a prosecuting witness cannot self-corroborate, "for such evidence '[adds] nothing to the prosecution's case... [and] involves a substantial danger of prejudice to defendant.'" *(People v. Thomas, supra,* 20 Cal.3d at p. 469, quoting *People v. Stanley, supra,* 67 Cal.2d at p. 819.) In *People v. Ewoldt, supra,* 7 Cal.4th 380, the Court curbed automatic application of *Stanley*, first reiterating the earlier decision's prefatory caution regarding "rigid rules" of evidence, then observing that what had come to be viewed as a blanket proscription against admissibility of uncorroborated same-witness testimony was founded on the faulty premise that "the *sole* purpose in admitting evidence of uncharged misconduct is to corroborate the testimony of the complaining witness." *(Id.*, at p. 407, emphasis added.) While uncorroborated testimony by the same victim of uncharged offenses "may have less probative value" than testimony provided by a third party, such testimony might be admissible to "place the charged offenses in context," or prove some other fact "material to the protection's case." *(Id.*, at pp. 407-408.) In *Ewoldt*, the victim's account of her first, uncharged, molestation was relevant to prove when the "recurring pattern" of molestation began, was no more inflammatory than the evidence of the charged offenses, and was overall unlikely to have affected the verdict. *(Id.*, at p. 408.) However, the kernel of *Stanley* remained: if the only purpose served by the uncharged offense testimony is self-corroboration, the evidence should not be admitted. *(Id.*, at pp. 407-408; Use Note, CALJIC No. 10.43.)

As noted, No. 10.43 was given in this case, instructing the jury that it was to use the uncharged offense evidence solely to prove appellant's intent towards Darcy. (CT 1:28; RT 6:1514-1515.) The acts Darcy complained of,

however—an attempt to tongue-kiss her and digital penetration followed by smelling and licking the finger—are patently lewd. In *People v. Kelly* (1967) 66 Cal.2d 232, the Supreme Court noted:

> It is not and should not be the law, however, that defendant's not guilty plea places his intent in issue so that proof of sex offenses with others is *always* admissible. Such evidence is admissible in cases where the proof of defendant's intent is ambiguous, as when he admits the acts and denies the necessary intent because of mistake or accident. [citations] But where the acts, if committed, indisputably show an evil intent and the defendant does not specifically raise the issue of intent, the better reasoned cases hold that evidence of other crimes is admissible only when they were performed with the prosecuting witness [citation], or where the offenses are not too remote and are similar to the offense charged and are committed with persons similar to the prosecuting witness. Then they are admissible as showing a common scheme or plan.

(*Id.*, at pp. 242-243, emphasis in the original.) Similarly, in *People v. Moon* (1985) 165 Cal.App.3d 1074, the First District stated if the only prosecution evidence of other offenses is the uncorroborated testimony of the prosecution witness, "the basic issue is the veracity of the witness and the defendant, and the trier of fact is not aided by the uncorroborated testimony of [that] witness...." (*Id.*, at p. 1079, citing *People v. Dunnahoo* (1984) 152 Cal.App.3d 561, 574.) Extending the logic of *Moon*, in *People v. Rios* (1992) 9 Cal.App.4th 692, the Fourth District held in cases where uncharged offenses are offered to prove intent, that evidence need not be corroborated under *Stanley* so long as there is corroboration of the charged offense. (*Id.*, at p. 708.) In sum, where the intent of the act is made manifest by the act itself, other crimes evidence proffered to prove intent is irrelevant, unless offered on some other subdivision (b) point, such as the existence of a common plan or design. (*See e.g., People v. Hoover, supra,* 77 Cal.App.4th at p. 1026; *accord, People v. Bunyard* (1988) 45 Cal.3d 1189, 1206.)

But there was no other purpose for which the kitchen incident or the tickling episode were relevant, no *Ewoldt* "context" needed or established by

their admission, so the testimony, not being probative, was only prejudicial. (*Compare, People v. Miller* (2000) 81 Cal.App.4th 1427, 1447-1448.) "If defendant engaged in this conduct, his intent in doing so could not reasonably be disputed. [Citations.] As to these charges, the prejudicial effect of admitting evidence of similar uncharged acts, therefore, would outweigh the probative value of such evidence *to prove intent.*" (*People v. Ewoldt, supra,* 7 Cal.4th at p. 406.)[4] Other crimes evidence is presumptively prejudicial (*c.f., People v. Falsetta* (1999) 21 Cal.4th 903, 915, cert. den. 1089, quoting *People v. Alacala* (1984) 36 Cal.3d 604, 631, cert. den. 510 U.S. 897 ["Such evidence 'is [deemed] objectionable, not because it has no appreciable probative value, *but because it has too much.'*..."], emphasis in the original); if the other offense evidence is not substantially probative, its substantially prejudicial effect trumps. (*People v. Thompson* (1980) 27 Cal.3d 307, 318 ["Since 'substantial prejudicial effect [is] inherent in [such] evidence,' uncharged offenses are admissible only if they have *substantial* probative value. If there is any doubt, the evidence should be excluded."], quoting *People v. Kelly, supra,* 66 Cal.2d at p. 239; *see also, People v. Avila* (2006) 38 Cal.4th 491, 586-587.) But the prejudice in appellant's case was more than presumptive: Darcy's testimony on the acts underlying the charged counts was sketchy at best: her tongue-kissing incident was without contextualization or detail, and her account of the digital penetration seemed as random and abrupt. The kitchen incident and the tickling episode were the only allegations fleshed with some other facts which made those accounts, and thereby, Darcy's whole story, persuasive to the jury.[5] In short, half of Darcy's testimony was devoted to other offense evidence that served no purpose beyond her self-corroboration. Appellant's attorney had no reason to stand by and let this testimony in: because of his omission and its admission, appellant's convictions must be reversed. (*People v. Ewoldt, supra,* 7 Cal.4th at pp. 407-408; *People v. Pope, supra,* 23 Cal.3d at pp. 424, 426.)

4 In *People v. Balcom* (1994) 7 Cal.4th 414, 422-423, the Court found the defendant's not guilty plea put the element of intent at issue: *Balcom* involved an allegation of forcible rape. However, a rape charge always implicates intent because the act itself, performed without the requisite intent, is not unlawful. (*People v. Mayberry* (1975) 15 Cal.3d 143, 155, 154.) Contrarily, an act of child molestation involving either substantial (digital penetration) or explicit (tongue-kissing) sexual conduct *cannot* be performed without the requisite lewd intent. Therefore, the *Ewoldt* exception in cases involving a patently unlawful intent still applies. (*People v. Hernandez* (1964) 61 Cal.2d 529, 532 ["The primordial concept of *mens rea,* the guilty mind, expresses the principle that it is not conduct alone but conduct accompanied by certain specific mental states which concerns, or should concern, the law."].)

5 Though it is worth noting in this regard that the State did not call Charity as a witness.

ARGUMENT

APPELLANT'S CONVICTIONS ON THOSE COUNTS INVOLVING RIKKI E. MUST BE REVERSED AS THE WITNESS'S FACIAL COVERING DURING TRIAL VIOLATED APPELLANT'S SIXTH AMENDMENT RIGHT TO CONFRONTATION AND TO A FAIR TRIAL

As noted, Rikki E. testified wearing large sunglasses and a head scarf. Defense counsel repeatedly objected to the disguise, noting that even after the scarf was removed during testimony, Rikki's eyes and the top portion of her face were not visible through the dark glasses.[1] (RT 4:665, 4:768-770, 5:903-904, 7:1155) The Sixth Amendment right to confrontation is primary: not only "written on faded parchment," the guarantee is predicated on "something deep in human nature that regards face-to-face confrontation between accused and accuser as'essential to a fair trial in a criminal prosecution.'" (*Coy v. Iowa* (1988) 487 U.S. 1012, 1017, quoting *Pointer v. Texas* (1965) 380 U.S. 400, 404.) Rikki's trial guise enabled her to "'hide behind the shadow,'" to accuse appellant without having to meet him face-to-face, or "look [him] in the eye and say that" (*Coy v. Iowa, supra,* 487 U.S. at pp. 1018-1019, quoting Pollitt, The Right of Confrontation: Its History and Modern Dress, 8 J. Pub. L. 381 (1959)), and while in certain situations this fundamental right may be countermanded, this was not that (*Maryland v. Craig* (1990) 497 U.S. 836, 856-857). There was no finding by the trial court that Rikki's eyes needed to be so shaded, that face needed to be so obscured, and no policy reason served by either veiling which justified abridging appellant's right to barefaced confrontation. (*Id.,* at p. 857.) Appellant's convictions on counts 3, 4, 9, 10, 18, and 19 must therefore be reversed. (U.S. Const., Sixth Amend., *Coy v. Iowa, supra,* 487 U.S. at p. 1020; *People v. Murphy* (2003) 107 Cal.App.4th 1150, 1157-1158.)

When Rikki E. was first brought into the courtroom, for a hearing on her availability,[2] defense counsel noted she was wearing a green scarf covering her head and dark sunglasses "concealing her eyes," and that the witness had looked away from appellant and counsel throughout the proceedings. (RT 4:665) The court also told Rikki prior to swearing her in to turn towards the

1 In his section 1118 motion, counsel indicated Rikki removed the scarf after the first day of testimony. (RT 7:1155)

2 At the time, the prosecutor was seeking to have Rikki's preliminary hearing testimony admitted under Evidence Code section 240(a)(4), given Rikki was not subject to contempt proceedings by virtue of Code of Civil Procedure section 1219, subdivision (b).

prosecutor, "look directly at the District Attorney... You don't have to look at anybody else if you don't want to." (RT 4:670) Rikki E. then testified that she didn't want to testify, that she was told if she did, something would happen to her; she began crying during this testimony. (RT 4:672-676) The court found Rikki had "sufficiently demonstrated to the court that she is in extreme traumatic condition," permitting use of the preliminary hearing testimony, but that the court wanted to wait and see if she would change her mind. (RT 4:676-678)

Rikki did, and was brought back in to the courtroom, again wearing "very dark sunglasses hiding most of her face above the nose, and the green scarf...." Counsel objected under the Confrontation Clause to Rikki's testifying so covered. The court stated the Confrontation Clause gave the defendant "the right to be in the courtroom with the witness... [and] the right to ask questions of a witness," indicating Rikki was "visible for your observation if you wish to see, and most importantly, the witness is visible for observation by the triers of fact." When counsel asked if the court concurred that the sunglasses obscured Rikki's face, the court said:

> I don't concur at all. I do concur she has on glasses and something covering the top of her head; the very top of her head is exposed. I don't see where that is an impediment at all for the defense to observe this witness while she is in court. [&] At any rate, whatever observations the defense makes, the defense is at no disadvantage. Everyone is seeing the exact same thing and playing on the same field.

(RT 4:769-770) Counsel renewed the objection, reiterating he could not see through the glasses; the court did not change its position. (RT 4:770) During Rikki's testimony, counsel added an Evidence Code section 352 objection to his constitutional complaint, noting that while Rikki was no longer wearing the scarf, she still wore the dark glasses. The court acknowledged the objection without further comment. (RT 5:903-904)

In *Coy v. Iowa, supra,* 487 U.S. at pp. 1014-1015, two thirteen-year-old child molestation victims testified, pursuant to statute, from behind a screen which was placed between the defendant and the witness stand: the screen enabled the defendant "dimly to perceive" the witnesses, but the witnesses could not see the defendant. The Supreme Court reversed. Justice Scalia, writing for the majority, stressed the special place the right of confrontation holds in the constitutional Pantheon, noting it is not just a right by way of

granting, but by way of right: a "lineage that traces back to the beginnings of Western legal culture" coupled with "something deep" that mandates a man be accused only by someone willing to "'look[] at the man whom he will harm greatly by distorting or mistaking the facts.'" (*Id.*, at pp. 1015, 1019, quoting Z. Chafee, The Blessings of Liberty 35 (1956); *Crawford v. Washington* (2004) 541 U.S. 36, 43.) To this end, the Confrontation Clause guarantees criminal defendants the right to cross-examination, and "a face-to-face meeting with witnesses appearing before the trier of fact." (*Coy v. Iowa, supra,* 487 U.S. at p. 1016; *Pennsylvania v. Ritchie* (1987) 480 U.S. 39, 51.)

Though the Court indicated the right to confrontation was not absolute, and left for another occasion the question whether there could be a particularized finding to except the right "only when necessary to further an important public policy," the Court roundly dismissed any such presumptive necessity:

> The State can hardly gainsay the profound effect upon a witness of standing in the presence of the person the witness accuses, since that is the very phenomenon it relies upon to establish the potential "trauma" that allegedly justified the extraordinary procedure in the presnet case. That face-to-face presence may, unfortunately, upset the truthful rape victim or abused child; but by the same token it may confound and undo the false accuser, or reveal the child coached by a malevolent adult. It is a truism that constitutional protections have costs.

(*Coy v. Iowa, supra,* 487 U.S. at p. 1020.) The Clause does not force a witness to look at a defendant, but if that witness chooses to look elsewhere, well, "the trier of fact will draw its own conclusions." (*Ibid.; see e.g., People v. Sharp* (1994) 29 Cal.App.4th 1772, 1784-1785, cert. den. 514 U.S. 1130.)

The particularized exception was elaborated upon in *Maryland v. Craig, supra,* 497 U.S. at p. 844, in which the Court approved a statute authorizing a child witness to testify via one-way, closed-circuit television; the constitutional preference for face-to-face confrontation was appropriately overridden given the State's substantial and compelling interest in the welfare of child abuse victims, and the statutory requirement that the procedure be found actually necessary to secure a witness's testimony—that there be a case-specific finding that seeing the defendant would so distress the witness as to interfere

with his ability to communicate. (*Id.*, at pp. 842-843, 849, 853, 860.) Even in this, the Court reiterated the right may not be "easily dispensed with," and its abrogation was justified only where "necessary to further an important public policy and only where the reliability of the testimony is otherwise assured." (*Id.*, at p. 850, citing *Coy v. Iowa, supra*, 487 U.S. at p. 1021.)

Thus, in *People v. Williams* (2002) 102 Cal.App.4th 995, 1006, Division Two upheld a conviction where a developmentally and physically disabled domestic violence victim testified by way of videotaped examination. Unlike the trial court in *Coy*, the court in *Williams* had held a hearing in which the witness's psychotherapist[3] testified the victim had a very strong fear reaction whenever she talked about her abuse, would begin crying and become hopeless and helpless, potentially suicidal. The therapist testified the victim entered into a panic state as trial approached, and opined she would not be able to testify in a courtroom where all parties were present; while other domestic violence victims might be able to testify before their batterer, the therapist thought this victim would not be a reliable witness if forced to do so. The witness's physician concurred, opining the victim was too mentally ill to testify in court, but could testify outside the defendant's presence. (*Id.*, at pp. 1004-1006.)

In affirming, the *Williams* court found the principles and protocols of *Maryland v. Craig, supra*, 497 U.S. 836, applicable, emphasizing the importance of the "uncompromising" expert testimony regarding that particular victim as added to public policy of protecting abuse victims generally. Further, evidence the victim would not be able to testify reliably in front of the jury indicated, for this case, that face-to-face confrontation would "actually be counterproductive to ascertainment of the truth." (*People v. Williams, supra*, 102 Cal.App.4th at p. 1009.) There was also no harm flowing from the presentation of taped testimony[4] because the witness's testimony was "sufficiently corroborated to ensure its reliability," and other elements of confrontation were present, including oath, opportunity to cross-examine, and "the ability to observe the witness's demeanor...." (*Id.*, at pp. 1007-1008.)

3 The psychotherapist had been treating the witness for seven years, the last two or three years of which for posttraumatic stress and major depressive disorder; the therapist had been aware of the domestic violence for four to five years. (*People v. Williams, supra*, 102 Cal.App.4th at p. 1004.)

4 The appellate court indicated that while it would have been better had the trial court considered bringing in a support person before resorting to videotaped testimony, it was unlikely, given the expert's opinion, that use of a support person would have prevented the predicted harm to the witness from testifying. (*People v. Williams, supra*, 102 Cal.App.4th at p. at p. 1008.)

Contrarily, in *People v. Murphy, supra,* 107 Cal.App.4th 1150, the Sixth District reversed the defendant's forcible oral copulation and felony false imprisonment convictions because the trial court allowed the thirty-one-year-old complaining witness to testify behind a one-way glass. The court's decision to use the glass was based on the prosecutor's representation the victim was "disturbed" by seeing the defendant, and the court's observation that the witness was hyperventilating, crying, sobbing, and "keening" during in-court testimony, occasionally rendering her testimony inaudible. The trial court noted paramedics had to be called during the witness's preliminary hearing testimony because of the same sort of problems, and stated its belief that the one-way glass was necessary to get her full account; finally, the court found the defendant's view of the witness was not "significantly or constitutional[ly] altered" by the glass. (*Id.*, at pp. 1152-1153.)

The appellate court held the "adequate showing of necessity" required by *Maryland v. Craig* included an evidence-based finding that interference with the right to face-to-face confrontation was needed to protect the welfare of the witness at hand, and that the witness's trauma not be based on testifying generally, or the courtroom itself, but "*by the presence of the defendant.*'" (*People v. Murphy, supra,* 107 Cal.App.4th at p. 1156, quoting *Maryland v. Craig, supra,* 497 U.S. at pp. 855-856, emphasis in *Murphy.*) For as the Supreme Court stated, "[d]enial of face-to-face confrontation is not needed to further the state interest in protecting the child witness from trauma unless it is *the presence of the defendant* that causes the trauma...." (*Ibid.*, emphasis added.) Prefatorially, the court found there was not the same transcendent or compelling state interest in protecting adult, as opposed to child, victims of sex crimes from psychological trauma occasioned by testifying before the accused. And, as a policy matter, while most of the features of cross-examination may be preserved by use of the one-way glass, the State interest in ascertaining the truth is presumptively subverted by the lack of face-to-face confrontation. (*People v. Murphy, supra,* 107 Cal.App.4th at p. 1157.)

In this specific regard, the *Murphy* court noted the witness:

> ... testified under oath in a public courtroom during trial..... The *jury was able to observe* the witness's demeanor as she testified. The defendant was present, *was able to observe* the witness, and had the opportunity to fully cross-examine her.

(Id., at p. 1157, fn. 2, emphasis added.) But that ability in appellant's case was unduly constrained, for in addition to failing to identify a transcendent State interest in protecting adult sex offense victims from the trauma of testifying, or to hold any evidentiary hearing on the necessity of Rikki E.'s facial coverings, the court allowed a significant portion of Rikki's face to be obscured during her testimony, preventing appellant and the jury from observing her as is constitutionally guaranteed. (*Coy v. Iowa, supra,* 487 U.S. at p. 1021.)

Again, the Government did not tender, and the court did not cite, any articulated governmental policy of protecting adult sexual assault or pimping/pandering victims from the trauma of testifying. Code of Civil Procedure section 1219 does not prohibit a court from finding a sex offense victim in contempt for refusing to testify: that power is explicitly preserved by the special provisions of section 128.[5] Rather, section 1219 simply proscribes jailing the victim who refuses to testify.[6] These statutes manifest no special State intent to confer upon adult sexual abuse victims any privileged position or extra solicitude beyond the general protection of unavailability under section 240; however, subdivision (a) (5)(c) of that section, in accordance with *Maryland v. Craig, supra,* 497 U.S. at pp. 855-856, requires:

> Expert testimony which establishes that physical or mental trauma resulting from an alleged crime has caused harm to a witness of sufficient severity that the witness is physically unable to testify or is unable to testify without suffering substantial trauma may constitute a sufficient showing of unavailability pursuant to paragraph (3) of subdivision (a). [&] As used in this section, the term "expert" means a physician and surgeon, including a psychiatrist, or any person described by subdivision (b), (c), or (e) of Section 1010.

None of which was presented.

5 Subdivision (d) of which states: "Notwithstanding Section 1211 or any other law, if an order of contempt is made affecting the victim of a sexual assault, where the contempt consists of refusing to testify concerning that sexual assault, the execution of any sentence shall be stayed pending the filing within three judicial days of a petition for extraordinary relief testing the lawfulness of the court's order, a violation of which is the basis for the contempt."

6 As provided in pertinent part in subdivision (b): "Notwithstanding any other law, no court may imprison or otherwise confine or place in custody the victim of a sexual assault for contempt when the contempt consists of refusing to testify concerning that sexual assault."

Again, the only evidentiary hearing held in this regard concerned whether Rikki E.'s preliminary hearing testimony could be admitted in lieu of her trial testimony. In that hearing, Rikki testified that "people" had threatened her and her family if she chose to testify at trial, and that she was afraid to testify. She cried. No other testimony was presented. More to the point, there was no evidence to suggest that unless Rikki wore large sunglasses and a scarf, she would be unable to testify accurately in front of appellant, or that she was afraid of testifying in front of *appellant* at all. And even if Rikki's testimony itself could be construed as somehow sufficient to establish her unavailability under section 240, subdivision (a)(5)(c), the fact remains she chose to testify, and having so chosen, appellant could not be deprived of his full confrontation rights absent evidence it was *appellant's* presence that frightened her, rather than her general fear of testifying against a pimp: that one witness may be more susceptible than another to intimidation, more frightened by third party threats, or may find the forum of a public trial—especially against the backdrop of "the game"— more inherently frightening, is not a showing of necessity.[7] And no showing of necessity is necessarily an inadequate showing. (*Maryland v. Craig, supra,* 497 U.S. at p. 855; *People v. Murphy, supra,* 107 Cal.App.4th at p. 1157; *see also, Hoschheiser v. Superior Court* (1984) 161 Cal.App.3d 777, 792 ["before a child victim is excused from testifying in the presence of the jury and the accused on the premise that he will suffer additional injury, the basis for such a premise must be established both in fact as well as in logic, and its dimensions must be spelled out in terms of its nature, degree and potential duration."].)

Appellant obviously knew who Rikki was. And he was able to cross-examine her. But with half of her face hidden, her eyes always veiled, appellant was unable to have the face-to-face confrontation he was constitutionally guaranteed. Nor is this a cosmetic promise. Neither appellant nor his jury could see if, as Justice Scalia said, Rikki was "looking studiously away" from appellant, as, sometimes, liars will. In responding to counsel's motion for new trial, the prosecutor dismissed the issue of Rikki E.'s modified appearance by saying the witness "could appear anyway she wanted to appear." (RT Supp.1:29) But a witness cannot obscure part of his face in the face of a defendant's right to confrontation,[8] for it is no small matter to obscure a man's eyes:

7 Again, according to Detective Haight, none of the witnesses were cooperative at the preliminary hearing, which is not unusual in a pimping case because of the fear most prostitutes have of most pimps.

8 By this token, in other contexts, the desire to obscure part or all of the face generally cedes to other interests. In New Zealand, a petty fraud prosecution became a matter of national

"The eyes are mirror to the soul." Anonymous; "The face is the mirror of the mind, and eyes without speaking confess the secrets of the heart." St. Jerome; "I have looked into your eyes with my eyes, I have put my heart near your heart." Pope John XXII; "The eyes have one language everywhere." George Herbert, *Jacula Prudentum* (1651); "What we learn only through the ears makes less impression upon our minds than what is presented to the trustworthy eye." Horace; "It is better to trust the eyes rather than the ears." German proverb; "The way to see by Faith is to shut the eye of reason." Benjamin Franklin, *Poor Richard's Almanack* (1758);

> In loving thee thou know'st I am forsworn,
> But thou art twice forsworn, to me love swearing;
> In act thy bed-vow broke, and new faith torn,
> In vowing new hate after new love bearing:
> But why of two oaths' breach do I accuse thee,
> When I break twenty? I am perjured most;
> For all my vows are oaths but to misuse thee,
> And all my honest faith in thee is lost:
> For I have sworn deep oaths of thy deep kindness,
> Oaths of thy love, thy truth, thy constancy;
> And, to enlighten thee, gave eyes to blindness,
> Or made them swear against the thing they see;
> For I have sworn thee fair; more perjured eye,
> To swear against the truth so foul a lie!

Shakespeare, *Sonnet 152*; and, of course, "Who are you going to believe, me or your own eyes?" Chico Marx, *Duck Soup* (1933).

Nor was Rikki E.'s testimony the bedrock stuff which could survive her semi-hiding: her account was rife with inconsistences, small and large,

debate when two Muslim witnesses refused to testify without their burqas; the court ultimately ruled the women had to testify unveiled, to protect "the right of the accused to look their accuser in the eye," but they would only be exposed to view by the defendant, the trier of fact, and female courtroom personnel. (Smith, N., "Lifting the Veil," *New Zealand Listener*, Nov. 27-Dec. 3, 2004, vol. 196, no. 3368; "Burquas must come off in court" (Jan. 17, 2005) [http://tvnz.co.nz/view/news_national_story_skin/46886].) A Florida woman who had a driver's license issued with a photograph of her wearing a niqab, sued to be permitted to keep the photo after post-September 11, 2001 legislation proscribed such identification; the Florida DMV offered to have only female personnel take the veil-less picture in a room not exposed to public view. A state appellate court denied the request for declaratory relief, finding national security interests overode disruption of the woman's religious practices. (Sukinik, K., "Civil Liberties in the Face of 9-11: The Case of Sultaana Freeman," *Rutgers J. of Law & Religion* (Oct. 22, 2003) [http://www camlaw.rutgers.edu/publications/law religion/new_devs/RJLR_ND_68.pdf].)

about her willingness to prostitute and/or have sex with appellant, and the extent and duration of their relationship, and the hows and whys of lies told to police; part of her testimony was stricken when she decided while testifying that she "didn't want to talk about it." Moreover, by allowing Rikki E. to cover her eyes, the court—even if inadvertently—suggested Rikki's disguise was justified, and as the only legitimate justification would be Rikki's legitimate fear of appellant, the court's ruling implied a judicial belief in her credibility and a concomitant predetermination of his guilt. (*Compare, People v. Williams, supra,* 102 Cal.App.44th at p. 1009.) It cannot be said that depriving appellant of his right to face-to-face confrontation with Rikki E. had no effect on those verdicts; appellant's convictions on counts must therefore be reversed. (*Maryland v. Craig, supra,* 497 U.S. at pp. 855-856; *Coy v. Iowa, supra,* 487 U.S. at p. 1021; *People v. Murphy, supra,* 107 Cal.App.4th at p. 1157.)

ARGUMENT

APPELLANT'S SIXTH AMENDMENT RIGHT TO CONFRONTATION WAS
VIOLATED BY ADMISSION OF TESTIMONY BASED ON A SEXUAL ASSAULT
EXAMINATION REPORT PREPARED BY A NON-TESTIFYING DECLARANT

As noted, the nurse who performed the sexual assault forensic examination did not testify at trial. Rather, her former supervisor testified that the examination was carried out according to standardized procedures, captured on a standardized form. (RT 2:902, 2:904-908, 2:926-927) According to supervisor's testimony, a medical history was taken from Andrea during the examination, and physical findings (vaginal tears) found, findings consistent with the history provided. (RT 2:912-922, :924-925, 2:927-930, 2:933-935) Defense counsel objected on hearsay grounds and under *Crawford v. Washington* (2004) 541 U.S. 36. The court found the report admissible as a business record under Evidence Code section 1271 and under *Crawford* because the statement was not made to a police officer. (RT 2:915-918) This testimony violated appellant's Sixth Amendment right to confrontation: the nurse practitioner who performed the examination was acting as a government official, or, more precisely, a government official engaged in the preparation of testimonial statements, or statements to be used in a criminal trial. (*People v. Uribe* (2008) 162 Cal.App.4th 1457, 1481; *People v. Jefferson* (2008) 158 Cal.App.4th 830, 842-844.)

In *Crawford*, the Court held that the Sixth Amendment precludes admission of "testimonial" hearsay against a criminal defendant unless the declarant is unavailable and the defendant has had an opportunity for cross-examination. (*Crawford v. Washington, supra,* 541 U.S. at pp. 54, 68.) What is "testimonial" was defined as statements made under circumstances suggesting they were the equivalent of testimony or intended to be available for use at trial. (*Id.*, at pp. 51-52.) What is not testimonial was what was admissible at the time of the Founding, including business records and statements in furtherance of a conspiracy. (*Id.*, at p. 56.)

Subsequently, in *Davis v. Washington* (2006) 547 U.S. 813, the Court held statements of an ongoing emergency made to a 911 operator were not testimonial. In so holding, the Court reiterated the focus of the Confrontation Clause on testimonial hearsay did not just mark "its 'core,' but its perimeter." A mid-crime emergency call is not testimonial because its fundamental purpose is to "enable police assistance to meet an ongoing emergency." (Id., at p. 828.)

The fact of the exigency itself is what makes the statement nontestmonial because the matter at hand is a call for help against an imminent threat, not a narrative about a past offense for which the caller is seeking governmental redress. (*Id.*, at pp. 827-828 ["... the elicited statements were necessary to be able to *resolve* the present emergency, rather than simply to learn (as in *Crawford*) what had happened in the past."].) Thus, in *Hammon v. Indiana*, the companion case to *Davis*, statements made to officers responding to a *post-crime* emergency call were an "easier" testimonial determination – "There was no emergency in progress." (*Id.*, at p. 829.) The statement in *Hammon* was testimonial because "[o]bjectively viewed, the primary, if not indeed the sole, purpose of the interrogation as to investigate a possible crime – which is, of course, precisely what the officer *should* have done." (*Ibid.*, emphasis in the original.)

In *People v. Geier* (2007) 41 Cal.4th 555, 609, the California Supreme Court held that forensic laboratory reports prepared by a non-testifying declarant are admissible under *Crawford*. However, it would be specifically wrong to apply *Geier* to testimony concerning a sexual assault forensic examination. Moreover, *Geier* is wrong—both in its legal analyses and in its factual predicates.

Taking the broader point first, it is important to note there is currently near-even split among state supreme and federal circuit courts on the question of whether DNA laboratory analysis reports violate the Confrontation Clause.[1] (*See e.g., Commonwealth v. Verde* (Mass. 2005) 827 N.Ed.2d 701, 705 [forensic reports not testimonial because business records]; *United States v. Ellis* (7th Cir. 2006) 460 F.3d 920 [drug blood test not testimonial]; *State v. O'Maley* (N.H. 2007) 932 A.2d 1 [blood alcohol analysis not testimonial]; *State v. Forte* (N.C. 2006) 629 S.E.2d 137 [DNA analysis not testimonial]; *State v. Dedman* (N.M. 2004) 103 P.3d 628 [blood alcohol analysis not testimonial]; *Hinojos-Mendoza v. People* (Colo. 2007) __ P.3d 2007 WL 2581700 [laboratory report identifying contraband testimonial]; *State v. March* (Mo. 2007) 216 S.W.3d 663 [same]; *Thomas v. United States* (D.C. 2006) 914 A.2d 1 [same]; *State v. Caulfield* (Minn.

1 Petition for certiorari was filed in *Geier* on November 14, 2007 (Case No. 07-7770); certiorari was recently granted in *Melendez-Diaz v. Massachusetts* (March 1, 2008; Case No. 07-591), which raised a *Crawford* issue as to forensic laboratory results: in *Melendez-Diaz*, the petitioner is challenging a Massachusetts law that permits admission of a certified analyst's report as prima facie evidence of laboratory drug analysis. (*Melendez-Diaz v. Massachusetts*, 870 N.E.2d 407.)

2006) 722 N.W.2d 304 [same]; *City of Las Vegas v. Walsh* (Nev. 2005) 124 P.3d 203 [nurse's affidavit who drew blood for alcohol analysis testimonial].)[2]

In *Geier*, the Cellmark laboratory director testified as to the results, including the statistical results, of a DNA analysis of forensic samples taken from a murder victim's body; the director did not perform the analyses, but testified they were done in accordance with company protocols by a laboratory technician. (*People v. Geier, supra,* 41 Cal.4th at p. at p. 596.) The Court found the Cellmark reports nontestimonial based on a reading of *Crawford* and *Davis* that de-emphasized whether a statement was made in anticipation of trial (or whether it might have been reasonably anticipated that it would be used at trial) in favor of focusing on the temporal circumstances under which the statement was made. More particularly, according to the Court, the constitutional question is whether the statement was "a contemporaneous recordation of observable events." (*People v. Geier, supra,* 41 Cal.4th at p. 607.) Although forensic laboratory reports were always made either by or to law enforcement officers for possible use at a later trial, they were not descriptions of a "past fact related to criminal activity," but rather recordings of observations made during testing, *i.e.*, "a contemporaneous recordation of observable events." Furthermore, to the extent the business records exception applies, it applies because forensic laboratory records are, like business records, similarly routinized and standardized. (*Id.*, at pp. 605-607.) Too, DNA analysis reports are "not themselves accusatory" because the results can either inculpate or exculpate, and any directly inculpatory result had been delivered to the jury via the testimony of the laboratory director—who was subject to cross-examination. (*Id.*, at p. 607.)

This characterization of *Crawford* and *Davis* as exempting "contemporaneous recordation of observable events" misapplies the focus of the former through the lens of the latter: *Davis* was a man calling in the middle of a crime scene, describing what was happening so that the police could intervene. The statement was exempt from the Confrontation Clause because the purpose of the call was to stop the crime, not to solve (and prosecute) it. As the Supreme Court wrote:

2 Appellate courts are as divided. (*See e.g., Pruitt v. State* (Ala. Crim. App. 2006) 954 So.2d 611 [certificate of drug analysis nontestimonial]; *People v. Meekins* (N.Y. App. Div. 2006) 828 N.Y.S.2d 83 [DNA analysis nontestimonial]; *State v. Laturner* (Kan. Ct. App. 2007) 163 P.3d 367 [report certifying contraband testimonial]; *State v. Moss* (Ariz. Ct. App. 2007) 160 P.3d 1143 [report of drugs in blood sample testimonial]; *State v. Smith* (Ohio Ct. App. 2006) 2006 WL 846342 [report substance contained contraband]; *State v. Miller* (Or. Ct. App. 2006) 144 P.3d 152 [certificate of chemical analysis testimonial]; *Deener v. State* (Tex. App. 2006) 214 S.W.3d 522 [same].)

> Statements are nontestimonial when made in the course of police interrogation under circumstances objectively indicating that the primary purpose of the interrogation is to enable police assistance to meet an ongoing emergency. They are testimonial when the circumstances objectively indicate that there is no such ongoing emergency, and that the primary purpose of the interrogation is to establish or prove past events potentially relevant to later criminal prosecution.

(*Davis v. Washington, supra,* 547 U.S. at p. 823, 829 [statements in *Hammon* "easier" because "[i]t is entirely clear from the circumstances that the interrogation was part of an investigation into possibly criminal past conduct... There was no emergency in progress.... Objectively viewed, the primary, if not indeed the sole, purpose of the interrogation was to investigate a possible crime...."].) Put another way, contemporaneity is *one* of the 'indicia of reliability' or "particularized guarantee[] of trustworthiness" that the Court in *Ohio v. Roberts* (1980) 448 U.S. 56, 66 held could be relied upon as an adequate substitution for confrontation, but not the most significant one. (*C.f., People v. Dennis* (1998) 17 Cal.4th 468, 529 [spontaneous declarations "carry sufficient indicia of reliability to satisfy the Sixth Amendment's confrontation clause"] cert. den. 525 U.S. 912.) Too, the *Roberts* test was overruled in *Crawford v. Washington, supra,* 541 U.S. at p. 68, as the Court found it had proven itself insufficient to satisfy the dictates of the Confrontation Clause[3] a reliability standard "had the capacity to admit core testimonial statements that the Confrontation Clause plainly meant to exclude." (*Id.*, at p. 63, 61 ["Admitting statements deemed reliable by a judge is fundamentally at odds with the right of confrontation."].)

Thus, the crux of *Crawford*, reiterated in *Davis*, was not *timing* but *purpose*. The equation is simple: statement for criminal prosecution = testimonial; statement for emergency = nontestimonial. (*Davis v. Washington, supra,* 547 U.S. at p. 823; *see e.g., People v. Morris* (2008) 166 Cal.App.4th 363, 370 [rap sheets are not testimonial hearsay because "not prepared for the *primary* purpose of criminal prosecution."].) If a statement is made for anticipated use in a criminal prosecution, it is subject to the requirements of the

3 (*Crawford v. Washington, supra,* 541 U.S. at p. 62 ["The legacy of *Roberts* in other courts vindicates the Framers' wisdom in rejecting a general reliability exception. The framework is so unpredictable that it fails to provide meaningful protection from even core confrontation violations."].)

Confrontation Clause. Forensic reports—including forensic reports of sexual assault examinations—are such statements; they are so subject. (*Id.*, at pp. 828, 830.) To the dubious extent that contemporaneity rules, it does not apply to forensic testing or examination. Neither the nurse nor the analyst is not recording the crime *in media res*, but considering evidence gathered some time after the criminal fact, and analyzed/interpreted some time after that. (*Compare, Davis v. Washington, supra,* 547 U.S. at p. 832 ["Amy's narrative of past events was delivered at some remove in time from the danger she described."].) This puts such reports square in the testimonial camp, as a statement generated "simply to learn (as in *Crawford*) what had happened in the past." (*Davis v. Washington, supra,* 547 U.S. at p. 827.) Indeed, the fact that what is being examined is called "evidence" is proof itself that the undertaking is essentially and quintessentially testimonial. (Evid. Code § 140 ["'Evidence' means testimony, writings, material objects, or other things presented to the senses that are offered to prove the existence or nonexistence of a fact."].)

A forensic DNA test is neither, strictly speaking, "observable," nor an "event." The analyst's observations are not recordation of facts, such as whether the man who shot at you had blond hair and a large tattoo, but recordation of opinions, and, ultimately, conclusions, based on the collation and analysis of test data, collation and analysis definitionally dependent upon the individual analyst's education and experience, and subject to the individual vagaries of interpretive analysis. To the degree "observable event" analogies can be made, the recordation of DNA analysis is more like the recordation of whether the man who has fallen down fell because he was drunk, had epilepsy, had narcolepsy, had an inner ear disorder, slipped on a banana peel, or didn't fall at all. A forensic nurse practitioner's report of a sexual assault examination likewise chronicles a police-instigated gathering of forensic evidence and clinical observations coupled with statements given by the victim to be presented to the prosecution via police. The "observable event" is, like the DNA analysis, the recordation of whether the physical examination is consistent with the history provided—*i.e.*, whether it seems as if a crime has been committed.

The Court's business records analogy (*People v. Geier, supra,* 41 Cal.4th at pp. 606-607) is similarly inapt: the common law "shop book rule" exception for regularly kept business records cannot be torqued into a broad exception for reports by entities whose very business it is to generate prosecutorial evidence. (*Palmer v. Hoffman* (143) 318 U.S. 109, 113-114 [records "calculated for use essentially in the court," whose "primary utility is in litigating" outside

the common law rule]; see also, *State v. Miller* (Or. Ct. App. 2006) 144 P.3d 1052, 1058-160 [delineating history of business records exception: state crime laboratory reports outside exception].) Contrary to the *Geier* Court's aside that DNA evidence might also exculpate a suspect (*People v. Geier, supra,* 41 Cal.4th at p. 607), the larger (and better) point is that forensic laboratory and forensic sexual assault reports are prepared solely in anticipation of criminal prosecution of someone.[4] (*People v. Cage* (2007) 40 Cal.4th 965, 984 ["the statement must have been given and taken primarily for the purpose ascribed to testimony—to establish or prove some past fact for possible use in a criminal trial"].)

Finally, the Court's argument in *Geier* that to the degree testimonial statements were introduced, they were introduced by a witness at trial, thereby duly subject to cross-examination (*People v. Geier, supra,* 41 Cal.4th at p. 607) is illogical given the way the jury is told to consider such testimony. Under either CALCRIM No. 332 ["... consider the ... reason the expert gave for any reason on which it is based. If you find that any fact has not been proved, or has been disproved, you must consider that in determining the value of the opinion..."] or CAJIC No. 2.80 ["An opinion is only as good as the facts and reasons on which it is based. If you find that any fact has not been proved, or has been disproved, you must consider that in determining the value of the opinion...."], the jury is charged with the predicate determination of whether the basis for the witness's opinion has been adequately proved. Absent the opportunity to cross-examine the working analyst or nurse examiner, cross-examination of the person relying on the examiner's report cannot meaningfully test the basis for that person's conclusions. If *Geier* is correct, the Sixth Amendment could be satisfied by a police officer testifying that his police report was a verbatim account of what a witness reported having seen at the time the witness said he saw it. (*Contra, Davis v. Washington, supra,* 547 U.S. at p. 827.) But "'[N]o man shall be prejudiced by evidence which he had not the liberty to cross examine.'" (*State v. Webb* (Sup. Law & Eq. 1794) 2 N.C. 103, quoted in *Crawford v. Washington, supra,* 541 U.S. at p. 49.) And, as the Supreme Court has emphasized: "That inculpating statements are given in a testimonial setting is not an antidote to the confrontation problem, but rather the trigger that makes the Clause's demands most urgent." (*Crawford v. Washington, supra,* 541 U.S. at p. 65.)

4 While forensic DNA analysis may exculpate one man, it will necessarily inculpate another, for its function is exclusively inculpatory, as amply demonstrated in "cold hit" prosecutions, in which the suspect-defendant is first identified via DNA analysis. (*See e.g., People v. Johnson* (2006) 139 Cal.App.4th 1135, 1146.)

This logic led the Sixth District to find a *Brady*[5] violation in the failure of the prosecution to turn over a videotape of a forensic sexual assault examination. (*People v. Urbie, supra,* 162 Cal.App.4th at p. 1463.) The court rejected the Government's claim that the examination was not investigative, given "it was spearheaded by the police, who advised [the examiner] of a report of alleged sexual abuse in which [the subject] was the victim." (*Id.,* at p. 1479.) Thus, when the private hospital performed the examination, it was "'in fact, "'acting on the government's behalf or 'assisting the government's case.'"'" (*Id.,* at p. 1481, citations omitted.) In support of its holding, the Sixth District cited *Medina v. State* (Nev. 2006) 143 P.3d 471, 476, in which the appellate court held that it was the duty of a sexual assault nurse examiner to gather evidence for possible prosecution, and therefore, the nurse was a "police operative" within the purview of *Crawford*—and, therefore, the victim's statements made to the nurse were subject to the requirements of the Confrontation Clause. (*People v. Uribe, supra,* 162 Cal.App.4th at p. 1482.) Andrea's examination was similarly at the instigation of police: not only was she driven by them to the hospital for the sexual assault examination, as noted, but the testifying supervisor explained that "[t]his is a police driven program and law enforcement driven program. And so that if a patient as a complaint of sexual assault, it is determined that they will go to the State of California, a specialized center, to have forensic examiner do an interview and collect the evidence, hand the evidence over, take photographs and testify in court." (RT 2:904) The examination procedure itself was designed "through the Office of Criminal Justice Planning," which also developed the standardized form used in this case. (RT 2:905) Once completed, the "original copy" of the form goes to law enforcement, the second copy "into the evidence exam kit to the crime lab" and the third remained "with the Department." (RT 2:906)

Appellant's convictions must be reversed for the improper admission of the sexual assault examination report in violation of appellant's Sixth Amendment rights. (*Crawford v. Washington, supra,* 541 U.S. at p. 49.)

5 *Brady v. Maryland* (1963) 373 U.S. 83.)

ARGUMENT

APPELLANT'S CONVICTIONS ON COUNT 3 AND 7/9 MUST BE REVERSED AS THERE IS INSUFFICIENT EVIDENCE OF CHILD MOLESTATION

Appellant's conviction for two counts of violating Penal Code section 288, subdivision (a) must be reversed as there was insufficient evidence to support a finding he molested his son. (*See generally, Jackson v. Virginia* (1979) 443 U.S. 307, 318-319; *People v. Cardenas* (1994) 21 Cal.App.4th 927, 939.)

As the Supreme Court said in *Johnson*, "our task... is twofold. First, we must resolve the issue in light of the *whole record*.... Second, we must judge whether the evidence of each of the essential elements... is *substantial*...." *People v. Johnson* (1980) 26 Cal.3d 557, 576--577, italics in the original]; *see also, People v. Barnes* (1986) 42 Cal.3d 284, 303.) Substantial evidence must support each essential element underlying the verdict: "'it is not enough for the respondent simply to point to 'some' evidence supporting the finding.'" (*People v. Johnson, supra,* 26 Cal.3d at p. 577, quoting *People v. Bassett* (1968) 69 Cal.2d 122, 138.) Nor does a "50 percent probability" of an element constitute substantial evidence. If the facts as proven equally support two inconsistent interpretations, the judgment goes against the party bearing the burden of proof as a matter of law. (*People v. Allen* (1985) 165 Cal.App.3d 616, 626, citing *Pennsylvania R. Co v. Chamberlain* (1933) 288 U.S. 333, 339.) In short, the test to determine sufficiency of the evidence is "whether, on the entire record, a rational trier of fact could find appellant guilty beyond a reasonable doubt." *People v. Johnson, supra,* 26 Cal.3d at pp. 576-578.) Evidence that fails to satisfy this test violates the Due Process Clause of the Fourteenth Amendment and article I, § 15 of the California Constitution. (*Jackson v. Virginia, supra,* 443 U.S. at p. 319; *People v. Johnson, supra,* 26 Cal.3d at pp. 575-578.)

To sustain a conviction of violating Penal Code section 288, subdivision (a), against a sufficiency challenge, the State must have proved that the defendant touched a child with the proscribed lewd and lascivious intent. (*People v. Martinez* (1995) 11 Cal.4th 434, 452; *see also, People v. Alvarez* (2002) 27 Cal.4th 1161, 1182; *People v. Murphy* (2001) 25 Cal.4th 136, 145-146.) There is not proof enough of that here:

As a predicate matter, the State generally asserted the entire assault was sexually motivated; the State then specifically assigned the two bite wounds as the basis for the charged molestations. (RT 2772-2773, 2776) The

factors cited as proof of the overall sexual nature of the attack were appellant's apparent pre-assault removal of his T-shirt; appellant's undressing Jacob before hitting him; that Jacob was beaten in the bedroom, and there were no sheets on the bed; and that blood was smeared around Jacob's groin area "consistent with groping." (RT 2773-2776, 2811-2812) But the most dispositive fact was the location of the first bite: "... right around the nipple. How much more control of a sexual, explicit area of the bite to tell you this wasn't sexually motivated. [&] And once you find this bite was sexually motivated, you can only then reasonably find that the bite below it, the abdomen, was just as sexually motivated." (RT 2776) The problem is none of these factors, alone or ensemble, constitute evidence of lewd intent, let alone substantial evidence. (*See, People v. Martinez, supra,* 11 Cal.4th at p. 444.)

In *People v. Martinez, supra,* 11 Cal.4th 434, the Supreme Court clarified that any touching of a child intended for sexual gratification is a violation of section 288. (*Id.,* at p. 444.) To determine whether a particular touching was done with the requisite intent, all circumstances are to be considered, including the act itself, the defendant's extrajudicial statements, other charged or uncharged acts of lewd conduct, the relationship of the parties, "and any coercion, bribery, or deceit" employed to either facilitate or secret the offense. (*Id.,* at p. 445; *see also, People v. Scott* (1994) 9 Cal.4th 331, 344, fn. 7; *People v. Falsetta* (1999) 21 Cal.4th 903, 917, cert. den. 529 U.S. 1089; *People v. Cantrell* (1973) 8 Cal.3d 672, 681, overruled on other grounds, *People v. Flannel* (1979) 25 Cal.3d 668, 685 ; *People v. Hyche* (1942) 52 Cal.App.2d 661, 664; *People v. McCurdy* (1923) 60 Cal.App. 499, 502-503.) Taking these in turn:

As identified by the State, the two molestation charges in this case were based on the two bite wounds: one around Jacob's right nipple, the other an inch to the right of his navel. However, contrary to the prosecutor's argument, these injuries were neither proof conclusive, nor even necessarily indicative, of sexual intent. The pediatric intensivist testified bite marks were "fairly unusual" in trauma cases; a bite wound on the nipple area "would leave someone—would lead a physician to be concerned that further investigation into sexual assault would be indicated." (RT 1879) The prosecutor then asked if the intensivist was concerned about sexual assault in this case, and the intensivist answered he was. (RT 1879) But concern is not evidence, and there was no evidence here of sexual assault: the injuries were overwhelmingly concentrated about the head and face, the most severe damage done directly to Jacob's eye; Jacob's rectum was uninjured, and otherwise showed no abnormalities, his buttocks

and genitals were similarly normal; he had no memory of any lewd touching; appellant made no statements admitting or even suggesting he harbored any sexual intent toward Jacob; there were no other incidents of lewd conduct toward Jacob or anyone else; and the force used was that used in the injury itself, not to achieve some additional satisfaction.[1] By comparison:

In *People v. Martinez, supra,* 11 Cal.4th 434, the defendant grabbed one of his thirteen-year-old victims around the waist and attempted to kiss her as she struggled free; a short time later, he grabbed the other victim about the neck and tried to push her out of a public park as he hugged her to him and grabbed her chest. *(Id.,* at p. 439.) Tallying the significant factors—the assaults took place at a junior high school and a park, defendant attempted to kiss one victim and touched the breasts of another—because "neither girl knew defendant and because he behaved in a predatory fashion, no purpose other than sexual gratification reasonably appears." *(Id.,* at p. 452.) Similarly, in *People v. Alvarez, supra,* 27 Cal.4th 1161, the sleeping thirteen-year-old victim felt something "crawling" on her stomach, beneath her shirt; she woke to find defendant, former boyfriend of her mother's friend, standing over her, his hand over her nose and mouth. During the ensuing struggle, defendant pressed down on the victim's throat. Defendant previously told his ex-girlfriend he wanted to have sex with her and the victim simultaneously; he also told the victim he'd dreamt they kissed and had sex. *(Id.,* at pp. 1167-1168.) In reversing the lower court's corpus delicti ruling, the Supreme Court found sufficient independent evidence of lewd intent: defendant entered the victim's apartment at night, surreptitiously, went directly to where the victim was sleeping, the victim felt something touch her stomach, under both her shirt and a blanket, defendant attempted to silence and restrain the victim when she awoke, and defendant returned to the victim's home twice after the attack, suggesting his "obsessive, and likely sexual, interest in the victim." *(Id.,* at pp. 1181-1182.) And in *People v. Marquez* (1994) 28 Cal.App.4th 1315, the defendant, who had a history of beating his two-year-old nephew, admitted to police on several occasions he'd put his finger in the boy's rectum and tried to put or put part of his penis in the child's anus. When examined, the boy's face, legs and buttocks were cut and

1 In *People v. Smith* (2002) 98 Cal.App.4th 1182, the defendant administered "hundreds" of "identical, undifferentiated acts which occurred regularly: buttock fondlings, playful spankings in which defendant forcibly held Victim down and spanked his bare buttocks; and violent spankings." *(Id.,* at p. 1189.) The appellate court noted defendant was not entitled to a sua sponte instruction on the right of parental discipline but was, in any event, "entitled to argue that he lacked any sexual intent when he touched Victim." *(Id.,* at p. 1196.) But unlike *Smith,* there were no predicate or separate fondlings to contextualize the hitting here.

bruised, his penis bruised, the area between his buttocks bloody and bruised, his anus red, torn, swollen and apparently lubricated with something like Vaseline. The pediatric expert opined the child had been repeatedly sodomized given his loss of sphincter control. (*Id.*, at pp. 1319-1320.) Again, this is not that.

As the Court noted in *Martinez*, "[i]t is common knowledge that children are routinely cuddled, disrobed, stroked, examined, and groomed as part of a normal and healthy upbringing... [T]he only way to determine whether a particular touching is permitted or prohibited is by reference to the actor's intent as inferred from all the circumstances." (*People v. Martinez, supra,* 11 Cal.4th at p. 450.) The actor's intent in this case was manifest: not to put too fine a point on it, but appellant literally beat the shit out of Jacob. The touching here was impermissible because it was violent in the extreme, the biting part of a panoply of abuse—again, when admitted to the hospital, Jacob was unconscious, his eyes swollen, tissue protruding from the right eye, blood was coming from his broken nose, his lips were swollen and bruised, there was blood splattered on his face, chest, abdomen and legs, and his body befouled by his own waste. He was in critical condition, defined by the doctor as "impending death." If there was blood smeared around his groin, there was more blood smeared around his head and shoulders, as well as on appellant and throughout the apartment.

Jacob testified appellant called him into the bedroom, undressed him, then punched him in the nose and on the back. Jacob could not recall how his stomach had been injured. The acts here were awful. But they were not sexual. Whatever prompted appellant to attack his son—to break his nose, to gouge out his eye, to beat him badly enough to nearly cause his death—it was not sexual gratification. Appellant's sentence on counts 3 and 7/9 must be reversed, and appellant may not be retried on those charges. (U.S. Const., Fifth Amend.; *Lockhart v. Nelson* (1988) 488 U.S. 33, 34; *Burks v. United States* (1978) 437 U.S. 1, 10-11 [double jeopardy precludes retrial "for the purpose of affording the prosecution another opportunity to supply evidence which it failed to muster in the first proceeding"].)

ARGUMENT

APPELLANT'S PENAL CODE SECTION 289 CONVICTION MUST BE REVERSED AS BASED ON CONSTITUTIONALLY INSUFFICIENT EVIDENCE

Appellant was convicted of sexual penetration, though there was nothing "sexual" about it. To sustain a conviction for violating section 289[1], there must be substantial evidence that the unlawful penetration was sexual in nature, *i.e.*, was motivated by sexual intent. Otherwise, the section is anomalous given its constellation of attendant statutes, and the nature of the evil to be addressed. (*Contra, People v. White* (1986) 179 Cal.App.3d 193, 204-205.)

The familiar test to determine sufficiency of the evidence is "whether, on the entire record, a rational trier of fact could find appellant guilty beyond a reasonable doubt." (*People v. Johnson* (1980) 26 Cal.3d 557, 576-578; *People v. Davis* (1995) 10 Cal.4th 463, 509 [facts viewed in light most favorable to the prosecution].) As the Supreme Court said in *Johnson,* "our task... is twofold. First, we must resolve the issue in light of the *whole record....* Second, we must judge whether the evidence of each of the essential elements... is *substantial....*" (*Id.*, at pp. 576-577, italics in the original]; *see also, People v. Barnes* (1986) 42 Cal.3d 284, 303.) Substantial evidence must support each essential element underlying the verdict: "'it is not enough for the respondent simply to point to 'some' evidence supporting the finding.'" (*People v. Johnson, supra,* 26 Cal.3d at p. 577, quoting *People v. Bassett* (1968) 69 Cal.2d 122, 138.) Nor does a "50 percent probability" of an element constitute substantial evidence. If the facts as proven equally support two inconsistent interpretations, the judgment goes against the party bearing the burden of proof as a matter of law. (*People v. Allen* (1985) 165 Cal.App.3d 616, 626, citing *Pennsylvania R. Co v. Chamberlain* (1933) 288 U.S. 333, 339.) Evidence that fails to meet this substantive standard violates the Due Process Clause of the Fourteenth Amendment and article I, § 15 of the California Constitution. (*Jackson v. Virginia* (1979) 443 U.S. 307, 319; *People v. Johnson, supra* 26 Cal.3d at pp. 575-578.)

[1] The statute provides, in pertinent part: "(a)(1) Any person who commits an act of sexual penetration when the act is accomplished against the victim's will by means of force, violence, duress, menace, or fear of immediate and unlawful bodily injury on the victim or another person shall be punished by imprisonment in the state prison for three, six, or eight years. [¶] (k)(1) "Sexual penetration" is the act of causing the penetration, however slight, of the genital or anal opening of any person or causing another person to so penetrate the defendant's or another person's genital or anal opening for the purpose of sexual arousal, gratification, or abuse by any foreign object, substance, instrument, or device, or by any unknown object."

In *People v. White, supra,* 179 Cal.App.3d 193, the defendant was convicted of violating section 289 by penetrating the minor victim's anus. The defense maintained there was insufficient evidence to convict because there was insufficient evidence the penetration was sexually motivated. The Fifth District disagreed, finding no sexual or lewd intent necessary. According to the court, "sexual abuse" in this context simply means abuse involving a sexual area of the body. (*Id.,* at pp. 205-206.) With the benefit of hindsight, the Fifth District was incorrect. As has been amply demonstrated by numerous statutory provisions post-*White,* section 289, like its surrounding statutory prohibitions, contemplates "sexual abuse" as is commonly understood—abuse that is sexual. Put another way, section 289 is both a "sex offense" and a "sexual offense," a legislative prohibition against sexually invasive sexual assault. Because there was no sexual aspect to appellant's conduct, it cannot be categorized as a sex offense, and appellant's section 289 conviction—unlike her more conduct-appropriate child abuse conviction—cannot stand. (*People v. Johnson, supra,* 26 Cal.3d at pp. 575-578.)

In other contexts, courts have underscored the purposeful legislative distinction between "sex" and "sexual offenses." So that:

> As used in this section the term "sex offense" means any offense for which registration is required by Section 290 of the Penal Code; or any felony or misdemeanor which is shown by clear proof or the stipulation of the defendant to have been committed primarily for purposes of sexual arousal or gratification. (Welf. & Inst.Code § 6302, emphasis added.)

By the same token, in *People v. Henderson* (1980) 107 Cal.App.3d 475, 492, the MDSO defendant complained his jury had not been specially instructed as to the requisite intent. He argued that they should have been specifically told that he had to have harbored a *sexual* intent during the beating of the child which was the basis of his prior section 273a conviction. The appellate court disagreed, finding the trial court had properly instructed on the section 6302 requirements, including the above definition of "sex offense" as an offense committed for the primary purpose of sexual gratification. (*Id.,* at p. 493.) In *People v. Dasher* (1988) 198 Cal.App.3d 28, 34, the defendant argued that "sexual offense" was synonymous with "sex offense" for MDSO purposes. Rejecting this argument, the Fourth District called the two "apples and oranges," under the MDSO law:

a "sex offense" is a "narrowly defined group of crimes" triggering commitment proceedings, while a "sexual offense" refers to any sexually-motivated crime, the commission of which would indicate a predisposition to commit sex offenses (and thus, the propriety of any ensuing MDSO commitment). (*Ibid.*, at pp. 34-35.) Significantly, section 289 proscribes "*sexual* abuse," not "sex abuse." For it is not the just act of penetrating a particular set of body parts that is proscribed, but the evil of doing so with sexual intent. (*C.f., People v. Jones* (2001) 25 Cal.4th 98, 109-110 [commission of "sexual" offense continues as long as assailant maintains control over the victim].)[2]

Section 289 ["Forcible acts of *sexual* penetration"] is part of a panoply of eighteen statutes that proscribe sex offenses, ranging from bigamy to incest to "the crime against nature." (Pen. Code, ch. 5.) Among these are sections 288.3 and 288.4, which prohibit contacting a minor "with intent to commit a *sexual* offense"; section 288.5 "continuous *sexual* abuse of a child"; section 288.7, prohibiting "*sexual*" intercourse or sodomy with a child under the age of 10; and section 289.6, prohibiting "*sexual* activity with confined consenting adult." The "sexual offense" for which contact is proscribed in section 288.3 is "an offense specified in Section 207, 209, 261, 264.1, 273a, 286, 288, 288a, 288.2, 289, 311.1, 311.2, 311.4, or 311.11." Section 288.4 punishes arranging a meeting with a child "motivated by an unnatural or abnormal *sexual* interest in children" for purposes of self-exposure. Section 289.6, subdivision (d) includes in its definition of "sexual activity" sexual intercourse, sodomy, touching the breasts or sexual organs of another/oneself in the presence of another "with the intent of arousing, appealing to, or gratifying the lust, passions, or sexual desires of" oneself/another—and sexual penetration. (Emphasis added throughout.)

The following chapter (Pen. Code, ch. 5.5 ["Sex Offenders"]) details the lifetime registration requirement following conviction for violation of certain enumerated sex offenses, including sexual penetration. (Pen. Code § 290(c).) The Legislature found the registration requirement necessary because first, sex offenders "pose a potentially high risk of committing further sex offenses after release" and second, the public must have "information concerning persons convicted of offenses involving unlawful *sexual* behavior" in order to protect themselves. Additionally, because of the public's interest in public safety,

2 In *People v. Perez* (1979) 23 Cal.3d 545, 552, the Court considered whether section 654 precluded multiple punishment for separate sex crimes pursuant to the same intent "i.e., to obtain sexual gratification." The Court rejected the argument because the intent was too broad, however, there is the unquestioning and absolute assumption that sex crimes share a sexually-motivated intent. (*People v. Jones, supra,* 25 Cal.4th at p. 110, fn.7.)

"[p]ersons convicted of those offenses involving unlawful *sexual* behavior" have a concomitant reduced expectation of privacy. (Pen. Code § 290.03(a)(1)(2)(3).) And Welfare and Institutions Code section 6600, subdivision (b) defines "sexually violent offense" for purposes of commitment as a Sexually Violent Predator as a prior conviction for, among other things, section 289, when committed by force, violence, duress, menace, or fear of immediate great bodily injury.

Thus, the statutory language, its statutory placement, the consequence of its violation all demonstrate that section 289 is a *sex offense* that proscribes *sexual conduct*. Everyone at appellant's trial, including the court and the prosecutor, agreed that her conduct was, while abusive, not sexual.[3] As the court commented, "Well, I could say sexual penetration for the purpose of abuse. But sexual abuse? How about physical abuse?" (RT 12:3019, 12:3021) And it was her non-sexual violation of section 289 that was argued to appellant's jury. (RT 12:3111-3112)

Appellant was convicted of child abuse, but should not have been convicted of sexual abuse. As there is insufficient evidence of sexual abuse, appellant's conviction on count 1 must be reversed. (*Jackson v. Virginia, supra,* 443 U.S. at p. 319; *People v. Johnson, supra,* 26 Cal.3d at pp. 575-578.)

3 Defense counsel had requested the word "sexual" be removed from the jury instruction on sexual penetration; the prosecutor argued that this was unnecessary because the instruction was self-explanatory. The court decided not to "tamper" with the standard instruction. (RT 12:3017-3023, 12:3028)

ARGUMENT

THERE IS CONSTITUTIONALLY INSUFFICIENT EVIDENCE TO SUPPORT APPELLANT'S CONVICTIONS FOR ATTEMPTED RAPE AND ASSAULT WITH INTENT TO RAPE IN COUNTS 15 AND 16, AND ASSAULT WITH INTENT TO RAPE IN COUNTS 1 AND 11

Appellant was convicted of attempted rape (count 15, Pen. Code §§ 664/261; CT 2:489) and assault with intent to commit "rape, sodomy, oral copulation, and a violation of sections 264.1, 288 and 289 (count 16, Pen. Code § 220; CT 2:490). To sustain a conviction under Penal Code section 220, there must be substantial evidence that the defendant assaulted another person with the intent to commit rape. (*People v. Bradley* (1993) 15 Cal.App.4th 1144, 1154, disapproved on other grounds, *People v. Rayford* (1994) 9 Cal.4th 1, 7.) To sustain a conviction for attempted rape, there must be substantial evidence that the defendant intended to rape the victim. (*People v. Rundle* (2008) 43 Cal.4th 76 137-140, disapproved on other grounds, *People v. Doolin* (2009) 45 Cal.4th 390, 421, fn.22; *People v. Osband* (1996) 13 Cal.4th 622, 692-693.) In this case, there was substantial evidence of neither. (*Jackson v. Virginia, supra,* 443 U.S. at p. 319.)

Prefatorily, this argument is directed toward the assault charges as based on a theory of intent to rape, which was the verdict returned by the jury: the verdict forms on counts 1, 11, and 16 all find appellant guilty of "assault with intent to rape." (CT 2:436, 3:445) And which was the sole theory of liability argued to the jury by the prosecution (RT 6:2170 ["Count 1, 4, 11 and 16, the assault with intent to commit a sex offense, presumably rape in this case."] ["And when the defendant acted, he intended to commit rape."].) The prosecutor also highlighted the relevance of the rape instruction as to all of the assault charges. (RT 6:2180) If the verdict in count 16 was predicated on sexual penetration, the conviction must be reversed as appellant cannot properly be convicted of both the completed act and its attempt. (*People v. Moran* (1970) 1 Cal.3d 755, 762; *People v. Cole, supra,* 31 Cal.3d at p. 682.) There is no evidence that appellant intended to effect any of the other enumerated sexual offenses. (*People v. Raley* (1992) 2 Cal.4th 870, 891.) But there was none relative to the rape theory, either.

By way of comparison, the defendant in *People v. Bradley, supra,* 15 Cal.App.4th at p. 1155 grabbed and kissed the victim, fondled her breasts, moved his hand under her shorts towards her vagina, pressed his erection

against her back, and, when his companion said he would not mind getting "a piece of that," responded, "Don't worry, I will." The reviewing court found this enough proof to support the reasonable inference that the defendant intended to rape the victim: the standard of proof is met when the defendant "sets out to 'use whatever force is required to complete the sexual act against the will of the victim.'[citation] 'It is the state of mind of the defendant...which is in issue.'" (*Id.*, at p. 1154.) Or, as trenchantly put by the Court in *People v. Nye* (1951) 38 Cal.2d 34:

> When a strange man enters a woman's bedroom, covers her mouth with his hand, grasps her wrist while she screams and kicks, releases her when she bites his hand, and makes no effort to take any property, it is reasonable to infer that he intended to commit rape, particularly when such an intent is shown by his attempt to rape another woman under similar circumstances.

(*Id.*, at p. 37, disapproved on other grounds in *People v. Ricon-Pineda* (1975) 14 Cal.3d 864, 871.) In *People v. Wright* (1990) 52 Cal.3d 367, the defendant was convicted of felony murder based on rape; the Supreme Court rejected his sufficiency argument, finding that the presence of the defendant's sperm outside the victim's genitals was sufficient to establish, at the very least, attempted rape, and thus, to satisfy the felony-murder rule. (*Id.*, at p. 405.)

Similarly, in *People v. Osband supra,* 13 Cal.4th at pp. 692-693, that the attempted murder victim's underclothing and pantyhose were torn and pushed aside, coupled with the defendant's statement that he attacked the victim because he was having a "bad day," in addition to the defendant's sperm having being found in a separate (murder) victim's vagina, constituted sufficient evidence that the defendant intended to rape the attempted murder victim.

Too, in *People v. Rundle, supra,* 43 Cal.4th 76, the attempted-rape felony murder conviction/special circumstances finding was supported by evidence that the 15-year-old victim's badly decomposed body was found nude, with her arms bound behind her back, and she had refused to have sex with her boyfriend earlier that evening, before meeting the defendant. Although the forensic evidence was inconclusive as to whether a sexual assault had occurred, the defendant told police that he "had sex" with the victim, then strangled her because he was scared. The defendant also admitted raping another murder victim, found similarly nude, her hands tied behind her. According to the Court,

the combination of circumstantial evidence and the defendant's statements, plus the absence of evidence that a sexual assault did not occur, were sufficient to allow the jury to infer the defendant intended to rape the 15-year-old victim. (*Id.*, at pp. 138-140.)

Not to put too fine a point on it, but there was no comparable evidence presented in appellant's case, *i.e.*, no substantial evidence that appellant specifically intended to *rape* his victims. Again, "[i]t is the state of mind of the defendant, not the victim, which is in issue." (People *v.* Roth (1964) 228 Cal. App.2d 522, 532 [victim's conduct/intent pertinent only insofar as it may help jury assess defendant's conduct/intent] .) More precisely:

Count 1—Carine testified that appellant dropped his pants and showed his underwear to her and her mother; her mother screamed and left the room. He was approximately 5 feet away, apparently not touching her, when he exposed his genitals.[1] Throughout, appellant was gyrating, dancing, asking Carine if she had called for an exotic dancer. He grabbed her arm only *after* she began calling 911: according to Carine, appellant was trying to "hold onto" or "pull up" "his pants with one hand and then grab me with the other." (RT 5:1842-1847, 5:1853-1854, 5:1865) Carine's mother only saw that appellant was wearing women's underwear, then tried not to look again. She also testified appellant grabbed Carine when she tried to leave the kitchen, while the dog was barking at appellant. (RT 5:1877, 5:1879, 5:1893) The prosecutor argued that appellant intended to rape Carine, but was prevented from doing so when she ran away, and that the arm-grab proved the intent to rape. (RT 6:2171)

Count 11—Lara testified that appellant approached her, saying, "Look down, my grandma lives down there." He then grabbed her from behind, one arm around her chest, the other between her legs, unsuccessfully trying to "pull me up." She struggled; he dragged her about 10 feet towards his stopped car. He did not grope or touch her breasts. He did not grope her vagina. (RT 3:639-641, 3:664, 3:666, 3:677-678) The prosecutor argued that appellant's grabbing: "clearly applying the elements of an assault with the intent to commit a sex offense, the People believe, rape in that case as well." (RT 6:2172)

Counts 15 and 16—Juliana testified that appellant was waiting in her bathroom when she returned to her apartment after stepping outside to smoke. Appellant tried to kiss her, put his hand between her legs, and partially digitally

[1] Carine's testimony as to the sequence of events is confused: she testified on direct that appellant exposed himself before she called 911, then testified on cross-examination that he grabbed her after she started calling 911, and exposed himself after that. (RT 5:1846-1847, 5: 1853) In either case, the grabbing and exposure appear to have been separate events.

penetrated her. The prosecutor argued that "clearly he intended to commit a sexual offense, namely, rape in that particular case." (RT 6:2172) Although Juliana screamed out that appellant was trying to rape her, and although this conclusion was not unreasonable under the circumstances as known to her, it does not constitute proof of appellant's intent to rape, versus his intent to commit *some other form of sexual assault*—more precisely, the sexual penetration that appellant did complete, or the sexual battery that was his target offense against Haygouhi. Or some other form of assault. Again, Carine testified that appellant exposed himself to her; her mother testified that she didn't see his penis, just his panties. The three girls in the school restroom testified appellant also persistently showed them his panties. Lara testified appellant grabbed her between the legs, over her clothes, but it was in an attempt to lift her up and carry her to his car. He had also approached her saying look, my grandma lives down there. And appellant's grandma did live down there. (RT 3:625, 5:1975-1976) Haygouhi testified appellant grabbed her buttocks, then showed her his panties and asked her if she wanted to touch is penis. Nor was there other circumstantial evidence in Juliana's case, such as an erection or exposed genitals, from which to infer that appellant had the specific intent to rape.

In sum, while appellant may well have a distinct pattern of sexual or fetishistic exposures and sexualized grabbings, he has never evidenced any specific inclination to rape. He did not say anything to Juliana or any of his victims which would have indicated that he was harboring such an intent, nor was there any other circumstantial evidence from which to infer that he had the specific intent to rape Juliana at the time he assaulted her,[2] or intended to rape Lara when he grabbed her, or, in the case of Carine, that he intended to do anything beyond the act of exposing his genitals and/or his panties. The testimony indicates that appellant grabbed Carine's arm, not to rape her, but to stop her from calling the police, just as appellant ran into Sheroian's house, not to steal something, but to get away from the police Carine called. Too, Carine testified she did not believe appellant's penis was erect. (RT 5:1871; *compare, People v. Bradley, supra,* 15 Cal.App.4th at p. 1155.) And while appellant has no history of rape, he does have a modus operandi of bizarre exhibitionism,

2 Or that he intended to rape Endzanoush when he grabbed her and tried to kiss her. Endzanoush testified appellant grabbed her around the chest "like a kid," they struggled, and she tried to drag herself away. They "ended up going down" on the street, appellant on top of Endzanoush, holding her arms and trying to kiss her, and her trying to push him off. (RT 4:1239, 4:1241, 4:1246-1251, 4:1259-1261) The prosecutor argued: "[w]hat possible explanation could there be, other than the fact that he intended to rape that woman that day...." (RT 6:2171-2172) The jury did not agree.

assaultive gropings, unwanted kisses, and nonconsensual appreciation of his ladies' underpants. (*People v. Raley, supra,* 2 Cal.4th at p. 891; *compare, People v. Rundle, supra,* 43 Cal.4th at pp. 138-140.)

In *People v. Raley, supra,* 2 Cal.4th 870, the defendant, a security guard at a private mansion, was convicted of murdering a 16-year-old girl and the attempted murder of her 17-year-old girlfriend. The surviving victim testified the defendant made her orally copulate him, and the defendant told both girls they would have to "fool around" with him to be set free. (*Id.,* at pp. 881-884, 890) The Supreme Court found that the inference that "fool around" meant exclusively oral copulation was insufficient to sustain the conviction of attempted forcible oral copulation of the murder victim. "[I]t is speculative to infer that because defendant committed an oral copulation on one victim, he necessarily attempted the same crime on another victim... *as opposed to any other forcible sexual assault....*" (*Id.,* at p. 891; *c.f., People v. Holt, supra,* 15 Cal.4th at pp. 668-669.) Again, "[c]onviction of the crime of attempted forcible rape requires proof the defendant formed the specific intent to commit the crime of rape and performed a direct but ineffectual act, beyond mere preparation, leading toward the commission of a rape." (*People v. Rundle, supra,* 43 Cal.4th at pp. 137-140.) This proof, like proof appellant attempted to rape Juliana, and assaulted the other women with the specific intent to rape them, does not exist in this case. Appellant's convictions in counts 1, 11, 15 and 16 must be reversed. (*People v. Raley supra,* 2 Cal.4th at pp. 890-891; *Jackson v. Virginia, supra,* 443 U.S. at p. 319.)

VANESSA PLACE

ARGUMENT

APPELLANT'S DUE PROCESS RIGHTS WERE VIOLATED AS THERE WAS INSUFFICIENT EVIDENCE TO SUPPORT HIS CONVICTION BASED ON THE LACK OF A VICTIM

Courts once considered rape accusations "easily to be made and hard to be proved, and harder to be defended by the party accused, though never so innocent" (*People v. Huston* (1941) 45 Cal.App.2d 596, 597, orr'd, *People v. Burton* (1961) 55 Cal.2d 328, 352[1]); the pendulum has since swung to its other end-point, and such allegations seem near-sacrosanct, free from the scrutiny given even an ordinary charge of robbery. If a person had a habit of pressing money into another's hands, and if that person never once complained of being robbed, the State would not prosecute the recipient of his largesse under the conceit that no one in his right mind would be so prodigal. If a woman has not complained of rape and if she, as far as it can be known, freely participated in a sexual encounter with someone, the State may not incarcerate that someone based on a violation of the Gentleman's Rule, as interpreted by the State. Appellant's convictions should be reversed as there was insufficient evidence to sustain the charge. (*Jackson v. Virginia* (1979) 443 U.S. 307, 318-319; *People v. Mayfield* (1997) 14 Cal.4th 668, 735, cert. den. 522 U.S. 839.)

The test to determine sufficiency of the evidence is "whether, on the entire record, a rational trier of fact could find appellant guilty beyond a reasonable doubt." (*People v. Johnson* (1980) 26 Cal.3d 557, 576-578 ["[O]ur task... is twofold. First, we must resolve the issue in light of the *whole record*.... Second, we must judge whether the evidence of each of the essential elements... is *substantial*...." at pp. 576-577, italics in the original]; *see also, People v. Barnes* (1986) 42 Cal.3d 284, 303.) Substantial evidence must support each essential element underlying the verdict: "'it is not enough for the respondent simply to point to 'some' evidence supporting the finding.'" (*People v. Johnson, supra,* 26 Cal.3d at p. 577, quoting *People v. Bassett* (1968) 69 Cal.2d 122, 138; *see generally, People v. Frye* (1998) 18 Cal.4th 894, 953, cert. den. 526 U.S.

1 Quoting 1 Hale P. C. (1736) 635, 636 ["It must be remembered, that it is an accusation easily to be made and hard to be proved, and harder to be defended by the party accused, though never so innocent; [and we should] be the more cautious upon trials of offenses of this nature, wherein the court and jury may with so much ease be imposed upon without great care and vigilance; the heinousness of the offense many times transporting the judge and jury with so much indignation that they are over hastily carried to the conviction of the person accused thereof by the confident testimony sometimes of malicious and false witnesses."]

1023.) Nor does a "50 percent probability" of an element constitute substantial evidence. If the facts as proven equally support two inconsistent interpretations, the judgment goes against the party bearing the burden of proof as a matter of law. (*People v. Allen* (1985) 165 Cal.App.3d 616, 626, citing, *Pennsylvania R. Co v. Chamberlain* (1933) 288 U.S. 333, 339.) Evidence that fails to meet this substantive standard violates the Due Process Clause of the Fourteenth Amendment and article I, § 15 of the California Constitution.[2] (*Jackson v. Virginia, supra,* 443 U.S. at p. 319; *People v. Johnson, supra,* 26 Cal.3d at pp. 575-578.)

Though rare, there are cases in which convictions have been secured not just on legally insufficient evidence, but legally insupportable evidence. Bearing in mind the appellate court reviews the whole record in the light most favorable to the judgment (*People v. Osband* (1996) 13 Cal.4th 622, 690, cert. den. 519 U.S. 1061), and "[g]enerally, doubts about the credibility of [an] in-court witness should be left for the jury's resolution," (*People v. Mayfield, supra,* 14 Cal.4th a p. 735, quoting *People v. Cudjo* (1993) 6 Cal.4th 585, 609, cert. den. 513 U.S. 850 ["Except in these rare instances of demonstrable falsity, doubts about...."]), testimony may nonetheless be rejected:

> ... when it is inherently improbable or incredible,
> i.e., "unbelievable *per se*," physically impossible, or
> "wholly unacceptable to reasonable minds."

(*Oldham v. Kizer* (1991) 235 Cal.App.3d 1046, 1065, quoting *Evjy v. City Title Ins. Co.* (1953) 120 Cal.App.2d 488, 492; *People v. Huston* (1943) 21 Cal.2d 690, 693, orr'd, *People v. Burton, supra,* 55 Cal.2d at p. 352; *People v. Fremont* (1941) 47 Cal.App.2d 341, 349-350.) The Supreme Court has specified the requisite quantum of proof in these cases as that evidence which asserts "something has occurred that it does not seem possible could have occurred under the circumstances disclosed." (*People v. Headlee* (1941) 18 Cal.2d 266, 267-268 [such deficit presents a question of law]; *accord, People v. Mayberry* (1975) 15 Cal.3d 143, 150; *People v. Thorton* (1974) 11 Cal.3d 738, 754, overruled on other grounds, *People v. Flannel* (1979) 25 Cal.3d 668, 684; *People v. Grant* (1942) 53 Cal.App.2d 286, 287.) Under those circumstances, the appellate court "will assume that the verdict was the result of passion and prejudice."

2 "A state-court conviction that is not supported by sufficient evidence violates the due process clause of the Fourteenth Amendment and is invalid for that reason.... [A] California conviction without adequate support separately and independently offends, and falls under, the due process clause of article I, section 15." (*People v. Thomas* (1992) 2 Cal.4th 489, 545, cert. den. 506 U.S. 1063 (con. & dis. opn. of Mosk, J.), citation omitted.)

(*People v. Headlee, supra,* 18 Cal.2d at p. 267.) As put in *People v. Nino* (1920) 183 Cal. 126:

> This court will not reverse a judgment given upon
> a verdict unless there is no evidence to support it,
> or *when the evidence relied upon to uphold it is so
> inconsistent* or improbable as to be incredible, or
> when it so clearly and unquestionably preponderates
> against the verdict as to convince the court that it
> was the result of passion or prejudice on the part
> of the jury.

(*Id.*, at p. 128, emphasis added.)

For example, in *United States v. Chancey* (11th Cir., 1983) 715 F.2d 543, a conviction for kidnaping across state lines was reversed because the testimony of the purported victim, in the words of the court, "simply cannot pass muster...." (*Id.*, at p. 547.) Muster, in *Chancey*, being the complaining witness's failure to report her kidnaping, escape her kidnapper, or seek assistance in either case from a series of potential saviors, including a police officer. Because there was plenty of evidence the defendant and witness has engaged in a "transcontinental copulation spree," but only her testimony that the journey was nonconsensual, the court reviewed the credibility of this testimony. As the Eleventh Circuit put it, the rule that credibility issues are for the jury:

> ... does not address the problem, however, which
> arises when the testimony credited by the jury is so
> inherently incredible, so contrary to the teachings
> of basic human experience, so completely at odds
> with ordinary common sense, that no reasonable
> person would believe it beyond a reasonable doubt.
> The mere fact that the testimony is in the record is
> not enough. If a witness were to testify that he ran a
> mile in a minute, that could not be accepted, even if
> undisputed.[3] If one testified, without dispute, that he
> walked for an hour through a heavy rain but none of
> it fell on him, there would be no believers.

3 The current indoor one-mile record is 3 minutes, 4.45 seconds for men (set by Hicham El Guerrouj on February 12, 1997), and 4 minutes, 17.14 seconds for women (set by Doina Melinte on February 9, 1990). (Http://www.guinessbookofworldrecords.com.)

(*Id.*, at pp. 546-547.) Though the complaining witness in *Chancey* swore there was no consent, "her every *act* and *deed*" attested to her complicity, and thus the defendant's conviction could not stand. (*Id.*, at p. 547.) Simply put, there was no good evidence a rape occurred.

The prosecution's theory of the rape, based on Zabia's taped behavior—as she goes from seeming to complain of discomfort to groaning in pleasure, from staring silently at the camera to smiling and calling appellant "baby," from putting her hands lightly over her vagina to wrapping her legs around appellant's waist, from laying stock still while appellant moves her body to laughing with appellant at the end, to, finally, tellingly, never complaining of any sexual transgression by appellant, let alone of a criminal offense—is a predicate for a criminal conviction "so inconsistent ... as to be incredible," and "so clearly and unquestionably preponderates against the verdict as to [be] the result of passion or prejudice on the part of the jury." (*People v. Nino, supra,* 183 Cal. at p. 128.) The problem is almost less factual and more jurisprudential: the rapes here are rapes solely by virtue of the *State's* post-coital characterization. But the rock-bottom line is that a prosecutor's rape may not be a woman's rape—the State's translation of a sexual act into a victimization absent proof that there was a victim—that any woman actually felt herself victimized by virtue of having sex forced upon her—cannot be deemed legally sufficient evidence upon which to sustain a criminal conviction and predicate a twenty-eight year prison sentence.

Penal Code section 263 states that any sexual penetration, "however slight," is sufficient to constitute a rape because: "The essential guilt of rape consists in the outrage to the person and feelings of the *victim* of the rape." (Emphasis added.) In *In re John Z.* (2003) 29 Cal.4th 756, the Supreme Court overruled *People v. Vela* (1985) 172 Cal.App.3d 237, which had held no rape could be committed once a woman initially consents to sex. The *Vela* court maintained the level of outrage necessary for a rape conviction "could hardly be of the same magnitude as that resulting from an initial nonconsensual violation of her womanhood," therefore, there was no rape in withdrawal of consent cases. (*Id.*, at p. 243.) In overruling *Vela*, the high Court found that outrage was not an element of rape to be independently proved, but was rather subsumed in the element of lack of consent. (*In re John Z., supra,* 29 Cal.4th at p. 762.) Preliminarily, "we have no way of accurately measuring the level of outrage the victim suffers from being subjected to continued forcible intercourse following withdrawal of her consent. We must assume the sense of outrage is substantial."

(*Id.*, at p. 761.) Secondarily, the degree of outrage is immaterial because "'[t] he outrage is complete'" when the act of sexual intercourse is done against a woman's will. (*Ibid.*, quoting *People v. Roundtree* (2000) 77 Cal.App.4th 846, 851.) In *In re John Z.*, the victim had testified that while initially she consented to sex with the defendant, at some point she tried to get away, and the defendant kept pushing her back down. The victim told the defendant that if he cared about her, he wouldn't be doing this to her, and if he did want a relationship with her, he should wait and respect that "*I don't want to do this.*" The victim testified on cross-examination she also told the defendant she needed to go home as she tried to move away from him. (*In re John Z., supra,* 29 Cal.4th at pages 758-760, emphasis added.) The Court characterized this testimony as "substantial evidence" that the victim withdrew her consent, quoting the appellate court's observation that "Given *[the victim's] testimony*, credited by the court, there was *nothing equivocal about her withdrawal* of any initially assumed consent.'" (*Id.*, at p. 762, emphasis added.) This is not that.

There was no testimony Zabia wished to withdraw her consent. There was no testimony Zabia did not appreciate, in any sense of the word, appellant's attentions. If the legal definition of outrage for rape prosecutions is the fact of forcible nonconsensual intercourse, there was no outrage to Zabia attested to by Zabia. But under any definition of outrage, none was done to Zabia, or her feelings *by appellant*: in point of too-ironic fact, what outrage Zabia has demonstrably suffered has occurred via the State's decision to play and play a videotape of an intimate encounter between her and appellant that she wished to keep private. The Government went into appellant's bedroom and his bed, and broadcast something never intended for publication, proving only the State's disapproval of appellant's behavior.

Along with the easily made/hard defended homily about rape cases, it was once thought "'[t]here is no class of prosecutions attended with so much danger, or which afford so ample an opportunity for the free play of malice and private vengeance...'" (*People v. Adams* (1939) 14 Cal.2d 154, 166-167, quoting *People v. Benson* (1856) 6 Cal.221, 223.)[4] That time has passed, along with the skepticism that girded such concerns. In most cases, this is laudable. But appellant's case is not most cases: appellant's case is a criminal prosecution predicated on the offense done to the Government's sensibilities, not to the person of a victim. (*People v. Breault* (1990) 223 Cal.App.3d 125, 140-141; *In re Paul C.* (1990) 221 Cal.App. 3d 43, 54.)

4 Overruled on other grounds, *People v. Burton, supra,* 55 Cal.2d at p. 352.

No then yes, ow, then ooh, stop, then oh baby: the fact was, and remains, Zabia has never complained of being raped, never testified that her will was overborne or that she was too intoxicated to freely consent to a kind of sex she seemingly enjoyed, and voluntarily repeated. She was not a murder victim, not a child. She was, and is, presumptively capable of determining whether she suffered the outrage to her autonomy that rape laws redress. It was reprehensible for the State to prosecute appellant for a crime not complained of, to make public a video meant private, to (even in absentia) parade a woman against her will into a courtroom and force her to play victim. This was not a trial, it was a puppet-show. The State cannot be permitted to play puppet-master, and put people in prison for private acts which have, according to the participants, hurt no one. On a policy level, this prosecution made a mockery of women as independent agents, responsible for themselves and their decisions. On a evidentiary level, there is not sufficient evidence to sustain appellant's convictions. (*Compare, People v. Byrnes* (1948) 84 Cal.App.2d 64, 69, cert. den. 335 U.S. 847; *People v. Fremont, supra,* 47 Cal.App.2d at pp. 348, 350; *see also, People v. Franz* (2001) 88 Cal.App.4th 1426, 1439, 1447; *People v. Green* (1980) 27 Cal.3d 1, 55 [evidence to be of "solid value" to sustain conviction].) Because the evidence appellant raped Zabia does not pass constitutional muster, his convictions must be reversed, and appellant may not be retried on those allegations. (U.S. Const., Fifth Amend.; *Lockhart v. Nelson* (1988) 488 U.S. 33, 34; *Burks v. United States* (1978) 437 U.S. 1, 10-11.)

ARGUMENT

APPELLANT'S CONVICTIONS IN COUNTS 5, 9 AND 10 MUST BE REVERSED AS THERE IS CONSTITUTIONALLY INSUFFICIENT EVIDENCE TO SUSTAIN THE VERDICTS, GIVEN THE CONSENSUAL RELATIONSHIP BETWEEN PROSTITUTE AND PIMP

Introduction

Women are chattel. This is the predicate proposition of prostitution, pimping, and appellant's oral copulation prosecution. In constitutional terms, there is insufficient evidence of lack of consent to sustain the convictions on counts 5, 9 and 10; in criminal terms, the women consented to oral copulation on demand, thus, like participants in mutual combat, they waived their right to passive withdrawal of that consent; in civil terms, the women knowingly agreed to sexually service appellant as part of their quasi-contractual arrangement with appellant, and there was nothing to undo that agreement; in terms of common-sense, the law ought not override the legal exercise of free will freely misapplied. (*Jackson v. Virginia* (1979) 443 U.S. 307, 318-319; *People v. Mayfield* (1997) 14 Cal.4th 668, 735, cert. den. 522 U.S. 839; *Molko v. Holy Spirit Ass'n*. (1988) 46 Cal.3d 1092, 1118, cert. den. 490 U.S. 1084.)

A. Consent: General Sufficiency

The test to determine sufficiency of the evidence is "whether, on the entire record, a rational trier of fact could find appellant guilty beyond a reasonable doubt." (*People v. Johnson* (1980) 26 Cal.3d 557, 576-578 ["[O]ur task... is twofold. First, we must resolve the issue in light of the *whole record*.... Second, we must judge whether the evidence of each of the essential elements... is *substantial*...." at pp. 576-577, italics in the original]; *see also, People v. Barnes* (1986) 42 Cal.3d 284, 303.) Substantial evidence must support each essential element underlying the verdict: "'it is not enough for the respondent simply to point to 'some' evidence supporting the finding.'" (*People v. Johnson, supra,* 26 Cal.3d at p. 577, quoting *People v. Bassett* (1968) 69 Cal.2d 122, 138; *People v. Frye* (1998) 18 Cal.4th 894, 953, cert. den. 526 U.S. 1023.) Nor does a "50 percent probability" of an element constitute substantial evidence. If the facts as proven equally support two inconsistent interpretations, the judgment goes against the party bearing the burden of proof as a matter of law. (*People v. Allen* (1985) 165 Cal.App.3d 616, 626, citing, *Pennsylvania R. Co v. Chamberlain* (1933) 288 U.S. 333, 339.) Evidence that fails to meet this substantive standard

violates the Due Process Clause of the Fourteenth Amendment and article I, §
15 of the California Constitution.[1] (*Jackson v. Virginia, supra,* 443 U.S. at p. 319;
People v. Johnson, supra, 26 Cal.3d at pp. 575-578.) Though rare, there are
cases in which convictions have been secured not just on legally insufficient
evidence, but legally insupportable evidence. Bearing in mind the appellate
court reviews the whole record in the light most favorable to the judgment
(*People v. Osband* (1996) 13 Cal.4th 622, 690, cert. den. 519 U.S. 1061), and
"[g]enerally, 'doubts about the credibility of [an] in-court witness should be left
for the jury's resolution," (*People v. Mayfield, supra,* 14 Cal.4th a p. 735, quoting
People v. Cudjo (1993) 6 Cal.4th 585, 609, cert. den. 513 U.S. 850 ["Except in
these rare instances of demonstrable falsity, doubts about...."]), testimony may
nonetheless be rejected:

> ...when it is inherently improbable or incredible, i.e.,
> "unbelievable *per se*," physically impossible, or
> "wholly unacceptable to reasonable minds."

(*Oldham v. Kizer* (1991) 235 Cal.App.3d 1046, 1065, quoting *Evjy v. City Title
Ins. Co.* (1953) 120 Cal.App.2d 488, 492; *see also, People v. Huston* (1943)
21 Cal.2d 690, 693, overruled on other grounds, *People v. Burton* (1961) 55
Cal.2d 328, 352; *People v. Fremont* (1941) 47 Cal.App.2d 341, 349-350.) The
Supreme Court has specified the requisite quantum of proof in these cases as
that evidence which asserts "something has occurred that it does not seem
possible could have occurred under the circumstances disclosed." (*People v.
Headlee* (1941) 18 Cal.2d 266, 267-268 [such deficit presents a question of
law]; *accord, People v. Mayberry* (1975) 15 Cal.3d 143, 150; *People v. Thorton*
(1974) 11 Cal.3d 738, 754, cert. den. 420 U.S. 924, overruled on other grounds,
People v. Flannel (1979) 25 Cal.3d 668, 684; *see also, People v. Grant* (1942)
53 Cal.App.2d 286, 287.) Under those circumstances, the appellate court "will
assume that the verdict was the result of passion and prejudice." (*People v.
Headlee, supra,* 18 Cal.2d at p. 267; *People v. Nino* (1920) 183 Cal. 126, 128
["This court will not reverse a judgment given upon a verdict unless there is
no evidence to support it, or when the evidence relied upon to uphold it is
so inconsistent or improbable as to be incredible, or when it so clearly and

1 "A state-court conviction that is not supported by sufficient evidence violates the
due process clause of the Fourteenth Amendment and is invalid for that reason.... [A] California
conviction without adequate support separately and independently offends, and falls under, the due
process clause of article I, section 15." (*People v. Thomas* (1992) 2 Cal.4th 489, 545, cert. den. 506
U.S. 1063 (con. & dis. opn. of Mosk, J.), citation omitted.)

unquestionably preponderates against the verdict as to convince the court that it was the result of passion or prejudice on the part of the jury."].)

In *United States v. Chancey* (11th Cir., 1983) 715 F.2d 543, a conviction for kidnaping across state lines was reversed because the testimony of the purported victim, in the words of the court, "simply cannot pass muster...." (*Id.*, at p. 547.) Muster, in *Chancey*, being the complaining witness's failure to report her kidnaping, escape her kidnapper, or seek assistance in either case from a series of potential saviors, including a police officer. Because there was plenty of evidence the defendant and witness has engaged in a "transcontinental copulation spree," but only her testimony that the journey was nonconsensual, the court reviewed the credibility of this testimony. As the Eleventh Circuit put it, the rule that credibility issues are for the jury:

> ... does not address the problem, however, which arises when the testimony credited by the jury is so inherently incredible, so contrary to the teachings of basic human experience, so completely at odds with ordinary common sense, that no reasonable person would believe it beyond a reasonable doubt. The mere fact that the testimony is in the record is not enough. If a witness were to testify that he ran a mile in a minute, that could not be accepted, even if undisputed. If one testified, without dispute, that he walked for an hour through a heavy rain but none of it fell on him, there would be no believers.

(*Id.*, at pp. 546-547.) Though the complaining witness in *Chancey* swore there was no consent, "her every *act* and *deed*" attested to her complicity, and thus the defendant's conviction could not stand. (*Id.*, at p. 547.)

The sex offense convictions in this case were similarly baseless. The State's theory was Nikki and Ice were incapable of consenting to sex with appellant because of the "brainwashing" done by him in his role as pimp to their ho. Even if, the prosecution argued, the women initially consented, and even if that consent were somehow valid, the specific copulations charged were outside the ambit of the consent given because of the particular circumstances surrounding—or, in Ice's case, the leitmotif—of that particular copulation. To this end, the State presented an expert witness on the sociology of pimping to articulate the ways a pimp will works his will over the will of the women working for him. But the State's thesis falls on its own terms: there was no

distinction between the relationship of appellant and the women before the acts complained of which vitiated the fundamentally consensual nature of that relationship. And because the pimp/prostitute paradigm contains within it the understanding that sex on demand is part of the package,[2] one party to that relationship cannot *sub silentio* withdraw from the agreement and thereby trigger criminal liability in the other party.

B. Consent: Waiver

Waiver is "the intentional relinquishment of a known right after knowledge of the facts." "Waiver always rests upon intent." (*Roesch v. De Mota* (1944) 24 Cal.2d 563, 572; *see also, Bastanchury v. Times Mirror Co.* (1945) 68 Cal.App.2d 217, 240 ["A waiver is an intentional relinquishment of a known right or such conduct as warrants an inference of the relinquishment of such right and may result from an express agreement or be inferred from circumstances indicating an intent to waive."].) Though the concept of waiver is commonly invoked in the criminal context by the State to assert voluntary relinquishment by the accused of a right otherwise conferred by the State,[3] the principles of waiver are not confined to single-party application. (*Wardius v. Oregon* (1973) 412 U.S. 470, 472, 474 [Due Process Clause of the Fourteenth Amendment incorporates a guarantee of reciprocity.]; *accord, Keith G. v. Suzanne H.* (1998) 62 Cal.App.4th 853, 856 ["What is good for the goose is good for the gander. Here what was bad for the goose is now bad for the gander."].) For example, in *People v. Noland* (1948) 83 Cal.App.2d Supp. 819, the appellate department reversed a conviction for failure to yield the right-of-way where the pedestrian, upon seeing defendant/driver improperly enter the intersection, stopped and motioned for defendant/driver to go on. Though the pedestrian would have been hit by the errant driver had he not stopped, the fact the *actus reus* of the offense had been fully committed was not enough to sustain the verdict:

> The right of way is not, then, a duty which the
> pedestrian must exercise, but something which may
> be waived; it comes within the rule of section 3513,
> Civil Code, that "Anyone may waive the advantage
> of a law intended solely for his benefit."

2 (See, *American Pimp* (MGM/UA 2000), Hughes, Albert & Alan, dirs. [the Hughes brothers' film features interviews with pimps and prostitutes, detailing the whole game, as well as a consideration of pimp-as-historic-entrepreneur in the urban African-American community.].)

3 (See e.g., *United States v. Ruiz* (2002) 536 U.S. 622 [defendant may waive *Brady* rights as part of plea agreement].)

(*People v. Noland, supra,* 83 Cal.App.2d Supp. at p. 821; *see also, Michaels v. Pacific Soft Water Laundry* (1930) 104 Cal.App. 349, 363.) By the same token, the absolute right of a woman to withhold or withdraw her consent to sex may be waived, so long as that waiver is, again, knowing. This thesis is codified in Penal Code section 288a in both its general proscription of nonconsensual oral copulation, and its detailed prohibitions against obtaining consent via fraudulent representation of either the nature of the act or its perpetrator (Pen. Code § 288a(f)(4) [fraudulent medical purpose], (j) [fraudulent spousal relationship]), or via the inability to fully legally consent (Pen. Code § 288a(f) (1-3)[victim unconscious, unaware of act], (h)[victim incompetent/incapable of legal consent], (I) [victim intoxicated].). (*See,* 1 Witkin Cal. Crim. Law (3rd ed. 2003) Defenses ' 87 ["Consent of the victim is ordinarily not a defense to a criminal prosecution unless lack of consent is an element of the offense."].)[4] By voluntarily entering into a pimp/prostitute relationship with appellant, a relationship in which all parties understood oral copulation on demand was inherent in that relationship, Nikki and Ice waived the assumption of lack of consent now inhering in sex offense prosecutions. (*See,* CALJIC No. 1.23.1 [consent as affirmative cooperation].)

Nikki testified she'd had at least two pimps before meeting appellant; she knew the rules of "pimping a ho," including the rule of sex on demand. Nikki testified when she first got together with appellant, she didn't want to orally copulate him because she knew that would cement their professional relationship; however, she orally copulated him at his request within an hour of that first meeting because she "felt safe." Appellant had slapped her during that meeting. Before Nikki orally copulated appellant, he told her he was a pimp, and she told him she was a prostitute. Nikki testified she orally copulated appellant ten times during the course of their relationship, and had vaginal intercourse with him twice: according to Nikki, every uncharged act was consensual—she was "with" appellant in Los Angeles like Smith was "with" him in Oakland, *i.e.,* she was appellant's friend, his bottom bitch, and she wanted to make him happy.

Ice testified she'd had three pimps before meeting appellant; when he picked her up at the Oakland track, she knew some of the rules of the game, including what it meant to choose up a pimp. During the course of their six-

4 (CALJIC No. 1.23 ["To consent to an act or transaction, a person (1) must act freely and voluntarily and not under the influence of threats, force, or duress; (2) must have knowledge of the true nature of the act or transaction involved; and (3) must possess the mental capacity to make an intelligent choice whether or not to do something proposed by another person."].)

month pimp/prostitute relationship, Ice orally copulated appellant about three times a week, depending on his mood. Ice testified she did so because she "knew the consequences of not pleasing him," but more, because "he was my world. He was my daddy." She wanted to be his "good loyal white bitch. I was a good bitch." Ice told her parents she had a good pimp, and testified she became a prostitute because "instead of working for $8.00 an hour at Starbucks, I could work for $300.00 an hour." She testified she was savvy to the dangers of disease, rape, and robbery, to the "ho or die" credo, to the fact that moving up in the world of prostitution involves pleasing the pimp, which entails literalizing all cliches of corporate capitalism—the bosses get the cash earned by the workers and the workers orally copulate the bosses. Ice was an ambitious prostitute: she wanted to be appellant's bottom bitch, to please him, to have sex with him to please him.

On the occasion charged in count 9, Ice testified appellant forced her head onto his penis, pushing it "really far down" her throat. When she would come up for air, he pushed her head back down, telling her to continue and to swallow his ejaculate. On the event charged as count 10, Ice orally copulated appellant in front of another prostitute to demonstrate, in appellant's words, "how you give your pimp head." Ice testified appellant forced her head onto his penis and his penis down her throat; she then had consensual sex with the other woman at appellant's behest, fell asleep, woke on the floor, got back on the bed, appellant grabbed her head again and pulled it onto his penis, and she orally copulated him again. In both encounters Ice evidenced, by her testimony, an attitude, in the words of CALJIC No. 1.23.1, of willing cooperation. Always playing, as she attested, the part of a good loyal bitch, and playing it well.[5]

By way of comparison, in *People v. Dancy* (2002) 102 Cal.App.4th 21, 24-27, defendant and victim had been involved in a long-term consensual sexual relationship in which victim frequently woke to find defendant having sex with her: this was acceptable, though not discussed. The relationship was otherwise tumultuous, pocked by argument, drug use, and physical violence. One night, defendant gave victim a cigarette outside their workplace; victim regained consciousness at home mid-morning the following day, with facial injuries defendant ascribed to a fall. Defendant medicated victim, victim lost consciousness, victim woke up naked and alone in a motel room, victim lost consciousness again, and spent the next two days going in and out of

5 It is worth noting in this regard that Ice testified she continued to consensually orally copulate appellant three times a week both before and after the charged events.

consciousness, sometimes waking to find herself alone, sometimes with defendant, who was either feeding her, tending to her injuries, or, twice, having sexual intercourse with her. When victim found defendant on top of her, she tried to tell him to stop, she didn't want sex; defendant told her she could "handle it/ hang," not stopping until he ejaculated. The Sixth District rejected defendant's theory of "advance consent" to his rape of an unconscious person convictions as such consent would not negate "the wrongfulness of the man's conduct in knowingly depriving the woman of her freedom of choice both at the initiation of and during sexual intercourse." The court distinguished between a man who engages in sexual intercourse with a conscious woman under the reasonable but mistaken belief in her consent,[6] reasoning:

> The decision to engage in sexual intercourse is necessarily an ad hoc decision made at a particular time with respect to a particular act. While a woman may expressly or impliedly consent to *conscious* sexual intercourse in advance, she remains free to withdraw that consent, and ordinarily has the ability to do so since she is conscious.

(*People v. Dancy, supra,* 102 Cal.App.4th at p. 37; *accord, In re John Z.* (2002) 29 Cal.4th 756, 762 ["[A]ssuming arguendo that [victim] initially consented to, or appeared to consent to, intercourse with defendant, substantial evidence shows that she withdrew her consent and, through her actions and words, communicated that fact to defendant."]; *People v. Roundtree* (2000) 77 Cal. App.4th 846, 851.)

By way of analogy, a party to mutual combat must communicate withdrawal from that agreement to regain the privilege of self-defense waived by virtue of his participation, *i.e.*, there is no longer a right of defense unless the party both withdraws from the fight and *informs the other participant* of his withdrawal. (*C.f., People v. Button* (1865) 106 Cal. 628, 632; *People v. Hernandez* (2003) 111 Cal.App.4th 582, 588-589; 1 Witkin Cal. Crim. Law (3rd ed. 2003) Defenses § 75.) Assuming Nikki and Ice did intend to withdraw from the pimp/prostitute relationship, and thus regain their right to withhold consent at the time of the charged offenses, they did not communicate this withdrawal to appellant:

Nikki testified she told appellant after leaving the swap meet that she hadn't called him for a few days because she'd been in the hospital; back at

6 (*People v. Mayberry, supra,* 15 Cal.3d at p. 155.)

the Comfort Inn, he said she had to get him money as she'd been gone and *she agreed*. Appellant then asked Nikki if she "missed him," she said she did, he unzipped his pants, and she orally copulated him. Though she testified she was "frightened in her mind" of appellant at this point, and secretly did not want to orally copulate him, there was no difference in the objective scenario between this oral copulation of a pimp by his ho and all prior oral copulations she'd consented to in that role. And though Nikki more specifically testified she "knew how he would react" after her being gone so long, the point is she never informed him she'd decided to terminate their pimp/prostitute relationship. Rather, by telling appellant she was hospitalized (as she had been before), and affirmatively agreeing to go back to work (as she had done before), Nikki gave every indication their relationship was as it had been; by responding affirmatively to both appellant's did you miss me question and to his invitation to oral sex, Nikki not just continued, but confirmed this consent. And again, Ice never gave appellant any indication she was anything but his happy hooker, going so far as to tell her parents what a great pimp he was, and telling Smith how much she looked forward to orally copulating appellant. In short, Nikki and Ice consented to oral copulation with appellant when they agreed to be his hos, and that *conscious* consent could only be revoked by an affirmative withdrawal from the pimp/ho agreement.[7] (*See, People v. Hecker* (1895) 109 Cal. 451, 463 [ineffectual attempt to communicate withdrawal does not reinstate right].) Given neither woman withdrew that consent or, alternatively, communicated her withdrawal to appellant, they waived their right of presumptive lack of consent, *i.e.*, there was constitutionally insufficient evidence of lack of consent. (*In re Winship* (1970) 397 U.S. 358, 364.)

C. Consent: Brainwashing.

Nor does the prosecution's "brainwashing" theory obviate the need for some indicia of lack of consent to sustain these convictions. As a preliminary matter, there was no proof of "brainwashing"—the State produced one expert who testified pimps use certain techniques to manipulate prostitutes. Just as prostitutes use certain techniques to manipulate tricks, as attested to by Nikki and Ice (*e.g.*, how to work a track, how to negotiate prices, how to identify police officers). Brainwashing, in the legal arena, means something more than a talk-show notion of intentional dependance:

7 Employing the language of contract law does not avoid the mandate of Civil Code sections 1667 and 1668 against unlawful contracts; the principles are invoked here by way of analogy and by way of general due process concepts of fairness and reciprocity.

In *Molko v. Holy Spirit Ass'n, supra,* 46 Cal.3d 1092, plaintiffs sued the Unification Church for false imprisonment, fraud, intentional infliction of emotional distress, and restitution. Plaintiffs, former members of the Church, claimed Church members knowingly misrepresented the Church's identity to plaintiffs to induce their initial participation in the Church: plaintiffs were then subject to an intense program of "coercive persuasion or mind control"[8] which rendered their subsequent association with the Church involuntary. (*Id.*, at p. 1108.) The Supreme Court affirmed the summary judgment for the Church on the false imprisonment claim, but reversed summary judgment for the Church on the remaining allegations. (*Id.*, at p. 1128.) As defined by the Court, brainwashing is "'a forcible indoctrination to induce someone to give up basic political, social, or religious beliefs and attitudes and to accept contrasting regimented ideas.'" (*Id.*, at p. 1109, quoting Webster's Ninth New Collegiate Dict. (1987) p. 175.) The basic methodology is "'creation of a controlled environment that heightens the susceptibility of a subject to suggestion and manipulation through sensory deprivation, physiological depletion, cognitive dissonance, peer pressure, and a clear assertion of authority and dominion. The aftermath of indoctrination is a severe impairment of autonomy and [of] the ability to think independently, which indues a subject's unyielding compliance and the rupture of past connections, affiliations, and associations.'" (*Molko v. Holy Spirit Ass'n, supra,* 46 Cal.3d at p. 1109, quoting *Peterson v. Sorlien* (Minn. 1981) 299 N.W.2d 123, 126.)

The Court in *Molko* found the allegation of brainwashing presented a factual question precluding a grant of summary judgment; the Court went on to consider whether the First Amendment precluded imposition of liability on a religious organization for deceiving nonmembers into subjecting themselves to coercive persuasion, noting such tactics as fasting, poverty, silence, and cloistered living may simply be "intensive religious practice." (*Molko v. Holy Spirit Ass'n, supra,* 46 Cal.3d at pp. 1110. 1116-1117, 1120, 1122.) In finding the Church potentially liable, the Court focused on one supreme fact: plaintiffs were *lied* to about the true nature of the Church *before* they participated in its practices. (*Id.*, at p. 1110.) As trenchantly put by Justice Mosk, writing for the Court:

> [I]t is one thing when a person knowingly and voluntarily submits to a process involving coercive influence, as a novice does on entering a monastery

8 The Court in *Molko* used "coercive persuasion," "mind control," and "brainwashing" interchangeably. (*Molko v. Holy Spirit Ass'n, supra,* 46 Cal.3d at p. 1109, fn. 10.)

189

VANESSA PLACE

or a seminary.... But it is quite another when a
person is subjected to coercive persuasion *without
his knowledge or consent.*

(*Id.*, at p. 1118, emphasis added.) The State has an interest in protecting
its citizens from "being *deceived* into submitting *unknowingly* to such a
dangerous process," an interest in protecting the family from its members
being "*unknowingly* subjected to coercive persuasion," and a generalized
interest in the "substantial threat to public safety, peace and order posed by
the *fraudulent* induction of *unconsenting* individuals into an atmosphere of
coercive persuasion." (*Ibid.*, emphases added.) The Court declined either to
criminalize brainwashing, to authorize involuntary deprogramming, or to require
informed consent prior to initiating conversions: such counter-persuasion
tactics would unduly burden a religious organization's freedom to practice. (*Id.*,
at pp. 1118-1119.) By this same token, the Court noted, "[w]ere a nonreligious
organization—e.g., a group espousing a political or social cause—to deceive a
person into unknowingly submitting to coercive persuasion, the same liability
would ensue." (*Id.*, at p. 1119.)

This was not that: Nikki and Ice willingly became prostitutes, and
knowingly entered into a prostitute/pimp relationship with appellant. Appellant
did not "brainwash" them: they were *already* prostitutes when they met
appellant, and knew full well the rules of "pimping a ho." Appellant did not
deceive either woman as to the nature of the pimping relationship, and both
women agreed to participate in the game.[9] However upsetting this may be to
the State, that upset is addressed via the proscriptions against pimping and
prostitution, not via forcible oral copulation prosecutions. Not to put too fine a
point on it, but if the State can use a brainwashing theory to vitiate Nikki and
Ice's consent in this case, it can start rounding up a fair number of husbands
and boyfriends who also believe a woman perforce obliged to sexually service
her chosen man. But this the State cannot do: the First Amendment likewise
protects the right of intimate association (*Boy Scouts of America v. Dale* (2000)
530 U.S. 640, 698, fn. 26; *Board of Dirs. of Rotary Int. v. Rotary Club of Duarte*
(1987) 481 U.S. 537, 544; *Roberts v. United States Jaycees* (1984) 468 U.S. 609,
617-620), and a generalized right of privacy has been read into the Bill of Rights

9 *N.b.*, to the extent Nikki quit appellant, she manifest her mental independence from
him; Nikki testified she'd quit an earlier pimp for "too much foolishness." Ice similarly evidenced
appellant's lack of mind control when she started skimming cash from clients and stashing the
money in her dildo. And, contrary to her enslavement scenario, Ice noted she knew her clothes
came from prostitutes who'd quit appellant.

190

as a whole (*Eisenstadt v. Baird* (1972) 405 U.S. 438, 453-454). Though the *sexual* relationship of a ho and her pimp may be repugnant to this, or any other, Court, it is a form of freely chosen intimate association between adults. As described by the State's expert, it is a "very traditional male-female relationship," and — unlike their economic relationship — not subject to criminal sanction.

D. Consent: Undue Influence

Even if the prostitute is sociologically disadvantaged in her relationship with the pimp so her consent to sex is not truly voluntary, there is no legal support for this proposition cum supposition. Undue influence is "the use, by one in whom a confidence is reposed by another, or who holds a real or apparent authority over him, of such confidence or authority for the purposes of obtaining an unfair advantage over him." (Civ. Code § 1575.) It is "that kind of influence or supremacy of one mind over another by which that other is prevented from acting according to his own wish or judgment" (*Bolander v. Thompson* (1943) 57 Cal.App.2d 444, 448), whereby a party uses its "'dominant psychological position in an unfair manner to induce the subservient party to consent to an agreement to which he would not otherwise have consented'" (*Molko v. Holy Spirit Ass'n, supra,* at p. 1125, quoting Calamari & Perillo, The Law of Contracts (2d ed. 1977) pp. 274-275.). Again, this is not that: Nikki and Ice both testified that in entering into a pimp/ho relationship, they not only were consenting to an agreement to which they had previously consented with prior pimps, but continued in this consent by continuing to work for appellant under the agreed-upon rules of the game.

There is an offensively obvious reason the State used a prostitution expert whose expertise was primarily in working with children — the State wanted to present the women in this case as quasi-children, incapable of truly consenting to the conditions of the pimp/ho relationship, including the condition of sex on demand. But these were not children. They were adults. More, they were adults patently capable of extricating themselves from situations they did not want to be in — Nikki left Georgia, left her boyfriend, left two other pimps, and left appellant — Ice left college, her parents, and appellant — and of returning when they wanted and as they felt was in their best interests. They were adults who had been prostitutes *before* meeting appellant — women knew the game and what the game involved, and still wanted to play. To decide after the fact that the pay for that play was too high is understandable, but not actionable. Some women may well have psychological vagaries which make them more likely to sign up for the game, just as some men may have psychological

conditions which predispose them to enlist in mutual combat. But the law does not protect these men from the consequences of their choice, and it is insulting for the law to do so for women. (*C.f., Stanton v. Stanton* (1975) 421 U.S. 7, 10 [illegitimate for State to assume social roles are functions of gender]; *see also, Craig v. Boren* (1976) 429 U.S. 190, 208-209.) In the words of Jade Smith, "A pimp is never there to get in the car with you when you're doing a trick. He's not there to hold your trick's dick. He's not there while you're having sex with a trick. If you want to leave or whatever, leave."

Conclusion

Because the evidence of lack of consent on counts 5, 9 and 10 does not pass constitutional muster (*People v. Franz* (2001) 88 Cal.App.4th 1426, 1439, 1447; *People v. Green* (1980) 27 Cal.3d 1, 55 [evidence to be of "solid value" to sustain conviction]), appellant's convictions for forcible oral copulation must be reversed, and appellant may not be retried on those allegations. (U.S. Const., Fifth Amend.; *Lockhart v. Nelson* (1988) 488 U.S. 33, 34; *Burks v. United States* (1978) 437 U.S. 1, 10-11 [double jeopardy precludes retrial "for the purpose of affording the prosecution another opportunity to supply evidence which it failed to muster in the first proceeding"].)

ARGUMENT

THE PENAL CODE SECTION 186.22(B) ENHANCMENTS MUST BE REVERSED AS THERE IS INSUFFICIENT EVIDENCE THAT THE UNDERLYING OFFENSES BENEFITED THE RELEVANT CRIMINAL STREET GANG

Section 186.22, subdivision (b)(1) enhances the sentence for an underlying felony when that felony is "committed for the benefit of, at the direction of, or in association with any criminal street gang, with the specific intent to promote, further, or assist in any criminal conduct by gang members...." As previously stated, the crimes here did not further or promote the SouthSide Chiques insofar as it was flatly attested that there was no overt relationship between the rapes and the gang, and that sex offenses are considered antithetical to SouthSide's ideology and detrimental to an individual member's status within the gang. Thus, there was no evidence that these rapes were gang-related in the usual sense. (*Supra*, at pp. 29-31.) To avoid this failure of proof, the State proceeded by way of more circuitous routes. The first was a kind of Rube Goldberg schematic in which the three defendants (a) committed the charged offenses while (b) active members of the SouthSide Chiques. Despite (c) the SouthSide Chiques' condemnation of such offenses, commission of which would (d) lead to loss of status within the gang and (e) damage the gang's reputation relative to other Latino street gangs, the defendants' crimes could (f) potentially gain media notoriety, infamy that would then (g) benefit SouthSide as a "violent, aggressive gang that stops at nothing and does not care or anyone's humanity." (RT 3:648-649, 4:721) The alternate argument was that the three defendants acted as a band of brothers who needed no larger gang: by committing the acts in concert, they were "in association," and their offenses properly enhanced. (RT 5:890, 5:897) Otherwise articulated, the individual sexual benefit each of the defendants received by raping the victim, and their ability to brag to one other about the exploit, elevated their status between them, thereby benefiting the gang because the three were the gang for purposes of the target offense. (RT 575-576, 3:646-650, 4:721, 5:895-897) Taking these in turn:

The first scenario, in which the SouthSide Chiques benefit because all criminality benefits a criminal street gang is problematic as it means that any crime committed by a gang member may be enhanced for promoting the gang

because it is a crime. This turns subdivision (b) into something of a strict liability scenario: gang member + crime = crime for benefit of gang. But this is not the law as practically understood by its enforcers. As noted, Det. Holland testified as to the general benefits of gang members working together in general to commit crimes, including confidence-boosting, multi-tasking, and bearing witness to the larger gang about their confederates' positive exploits. (RT 3:626-628, 3:647) And when given a hypothetical in which the defendants' were described only as members of the SouthSide Chiques—omitting their family relationship, and their prior encounters with the victim—the detective opined that the rape was done for the benefit of/at the direction of/in association with the gang because the defendants were "all active participants in SouthSide Chiques." (RT 3:645-648)

This loosely comports with the Fourth District's opinion in *People v. Morales* (2003) 112 Cal.App.4th 1176, 1198, in which the gang expert testified that the fact that three gang members acted together to commit the charged robberies meant the crime was committed "in association with" gang members in satisfaction of the statute. This was true even though the witness did not testify that the defendants had the specific intent to promote or further criminal conduct by the gang by these robberies. If all crimes committed by gang members acting in association are gang crimes *per se*, then these were gang crimes for purposes of the enhancement. "If all men are mortal, then Socrates, being a man, is mortal." (*Ibid.*) But this is like believing that the criminal activities of the Aryan Brotherhood are promoted if three of its members were to help Mexican nationals illegally enter the United States. Although the crimes would be anathema to the Brotherhood's rules and beliefs,[1] the gang's overall reputation for criminality would still be enhanced based purely on the illicit nature of the underlying offenses, and subdivision (b) properly applied.

However, when given an alternative hypothetical in which the defendants were identified as relatives, the victim having had consensual sex with at least two of them, and with no mention of the gang during the evening, the detective opined the crime was not done under the auspices of the gang.

1 The Aryan Brotherhood is a White supremacist prison gang; as attested to in a number of cases, White supremacist gangs believe the White race is superior, non-Whites are subhuman, and absolute fidelity is owed to fellow White supremacists. (See *e.g., People v. Lindberg, supra,* 45 Cal.4th at pp. 42, 46.) According to evidence given in *People v. Schmaus* (2003) 109 Cal.App.4th 846, 850-851, one of the Aryan Brotherhood's rules is "not tolerating—and indeed, killing—inmates involved in sex offenses such as child molestation and rape." In this, the Aryan Brotherhood is in philosophic accord with Latino street gangs, according to the expert who testified in appellant's case.

(RT 4:674-675) What the detective's difference of opinion reflects is the common sense notion that "[e]xcept in *West Side Story*, gang members do not move in lock-step formation" (*Mitchell v. Prunty* (1997) 107 F.3rd 1337, 1342), and that subdivision (b) aims at specially punishing crimes committed to promote the gang. The "assistance" language being not an alternative route to guilt, one less harder to prove because it comes with its own presumed intent, but one which, like the benefit/promote language, is designed to punish actions that strengthen the gang *qua* gang.

Similarly, in *United States v. Garcia* (9th Cir. 1998) 151 F.3rd 1243, the federal appellate court found insufficient evidence to support the defendant's conviction for conspiracy to assault with a dangerous weapon based on the prosecutor's theory that "by agreeing to become a member of a gang, [defendant] implicitly agreed to support his fellow gang members in violent confrontations." (*Id.*, at p. 1245.) A "basic agreement" to back up fellow gang members "at most establishes one of the characteristics of gangs but not a specific objective of a particular gang, let alone a specific agreement on the part of its members to accomplish an illegal objective." (*Id.*, at p. 1246.) Quoting an earlier appellate opinion, the *Garcia* court noted that allowing gang membership to serve as such evidence invited "absurd results" by making any gang member liable for another member's act at any time "'so long as the act was predicated on 'the common purpose of "'fighting the enemy.'"'" (*Ibid.*, quoting *Mitchell v. Prunty, supra,* 107 F.3rd at p. 1341, overruled on other grounds, *Santamaria v. Horsley* (1998) 133 F.3rd 1242, 1248.) But the larger problem is that using the general gang practice of supporting one another in a confrontation provides readymade proof of joint intent, which "smacks of guilt by association." (*Mitchell v. Prunty, supra,* 107 F.3rd at p. 1342.) "This is contrary to fundamental principles of our justice system. '[T]here can be no conviction for guilt by association.'" (*United States v. Garcia, supra,* 151 F.3rd at p. 1246, quoting *Melchor-Lopez* (9th Cir. 1980) 627 F.2nd 886, 891.)

In sum, there was plenty of evidence that the defendants were members of the SouthSide Chiques, ample evidence that the SouthSide Chiques had a pattern of criminal activity, and opinion evidence that the defendants knew of their gang's criminality. (RT 3:632-636, 4:669-671) What was lacking was any evidence that the activities of these defendants were committed to promote the gang, to further the gang, or to assist each other *as gang members*. Put another way: "The expert's testimony was singularly silent on what criminal activity of *the gang* was furthered or intended to be furthered" by the sex offenses here.

(*Garcia v. Carey* (9th Cir. 2005) 305 F.3rd 1099, 1103, emphasis added [without more, testimony concerning "turf-orientation" of gang insufficient to establish that robbery was committed to facilitate other gang crimes].)

And there is no version of a "subset" or mini-gang that supports the imposition of the enhancement here: gangs are not Russian nesting dolls in which each set of three serves as synecdoche for the whole. In *People v. Williams* (2008) 167 Cal.App.4th 983, the defendant was convicted of murdering a woman and being an active participant in a criminal street gang; the gang enhancement was found true. The defendant argued that he was an active participant in Small Town Peckerwoods only, and thus, the criminal activities of other Peckerwood gangs could not be considered as evidence against him. The expert witness testified that based on name and White supremacist ideology, Small Town Peckerwoods was a faction of the larger Peckerwood gang. The Fifth District reversed the gang conviction and finding, holding that having a similar name and beliefs were not in themselves enough to allow the status of the larger group to be attributed to the smaller: "some sort of collaborative activities or collective organized structure must be inferable from the evidence, so that the various groups reasonably can be viewed as parts of the same overall organization." (*Id.*, at pp. 987-988.) By this same token, appellant, his twin brother and his cousin cannot be considered to have acted as a working subset of the SouthSide Chiques simply because the three were members of SouthSide. Going outside the rules of the gang means going rogue; going rogue means going outside the gang. By their crimes, the defendants distanced themselves from their gang—their crimes cannot be enhanced by virtue or vice of their gang membership. (*Compare, People v. Ortega* (2006) 145 Cal.App.4th 1344,1357 ["No evidence indicated the goals and activities of a particular subset were not shared by the others."].) The section 186.22, subdivision (b) enhancement must be reversed. (*People v. Williams, supra,* 167 Cal.App.4th at pp. 978-988.)

ARGUMENT

THERE IS CONSTITUTIONALLY INSUFFICIENT EVIDENCE TO CONVICT PETITIONER OF PANDERING BY ENCOURAGMENT

The facts of petitioner's case are as set forth at pages 2 through 4 of the appellate opinion. In its opinion, the lower court found sufficient evidence to sustain petitioner's conviction based in part on its belief that the pandering prosciption includes solicitation of someone believed to already be a prostitute to continue prostituting. (Opn., at pp. 4-6.) In so holding, the appellate court improperly broadened the definition of pandering: a crime specifically intended to address the evil of enlisting non-prostitutes into prostitution, not to discourage prostitutes from changing pimps. (*People v. Wagner* (2009) 170 Cal.App.4th 499, 506; Pen. Code § 266i (a)(2) [violation where person "encourages another *to become* a prostitute."].) Moreover, the Second District's published opinion conflicts with another published opinion in which the Fourth District held that the offense cannot be committed where the person solicited is already a prostitute. (*People v. Wagner, supra,* 170 Cal.App.4th at p. 506.) The question posed in petitioner's case is thus both simple and broad: what constitutes pandering by encouragement?

Penal Code section 266i, subdivision (a)(2) reads in pertinent part:

(a) Except as provided in subdivision (b), any person who does any of the following is guilty of pandering, a felony, and shall be punishable by imprisonment in the state prison for three, four, or six years: [¶] (2) By promises, threats, violence, or by any device or scheme, causes, induces, persuades or encourages another person to become a prostitute.

Within the meaning of the statute, "active 'encouragement'" means something more than simply urging someone to prostitution. (*People v. Hashimoto* (1976) 54 Cal.App.3d 862, 865.) In *People v. Bradshaw* (1973) 31 Cal.App.3d 421, relied upon by the lower court here, the defendant solicited an undercover police officer whom he believed was a prostitute to enter a brothel under his supervision. On appeal, the defendant argued that "encouragement" to pander implied success and that one could not encourage someone to become a prostitute who already was (or who was believed to already be) a prostitute. (*Id.,* at p. 424.) In its opinion in petitioner's case, the Second District rejected the

argument, holding that the crime of pandering does not require either that active encouragement lead to success in securing a prostitute or that the person pandered be new to prostitution. (Id., at pp. 425-426; see also, People v. Patton (1976) 63 Cal.App.3d 211, 218 [noting potential for social harm in encouraging established prostitute to "alter her business relations."].)

In People v. Hashimoto, supra, 54 Cal.App.3d 862, the defendant, a travel agent seeking to provide fuller service for his international customers, offered to regularly refer Japanese tourists to an undercover police officer posing as a prostitute. (Id., at pp. 864-865.) Unlike Division Four, which had decided Bradshaw, Division Two of the Second District Court of Appeal in Hashimoto looked at the dictionary meaning of "encourage" ("to urge, foster, stimulate, to give hope or help"), relying upon at least one of the reference works rejected by its fellow court. In so doing, Division Two found "active encouragement" lay in the defendant's proposal to change the solicitee's "business relations by reducing her price in exchange for volume," noting that the pandering statute was intended to discourage prostitution by discouraging augmentation and expansion of a prostitute's business, or increasing the supply of prostitutes.[1] (Id., at pp. 866-867; accord, People v. Almodovar (1987) 190 Cal.App.3d 732, 736-738 [police officer turned prostitute pandered by setting up "date" for police officer she was encouraging to prostitute]; People v. Patton, supra, 63 Cal.App.3d at p. 2, 13-215 [defendant pandered by encouraging 16-year-old runaway to work for him as a prostitute].)

As a prefatory matter, the appellate court in this case rejected petitioner's argument that his encouragement was of the inactive variety, based on petitioner's use of various tricks of the trade. (Opn., at pp. 4-5.) But the fact petitioner may have been in fact a pimp does not actually address whether his offer constituted "active" solicitation. Peitioner promised the undercover police officer—whom he approached on the street, believing her to be a

1 "Active" according to www.dictionary.reference.com (citing the Random House Unabridged Dictionary (2006), means, in part: "1. engaged in action; characterized by energetic work, participation, etc.; busy: an active life. 2. being in a state of existence, progress, or motion: active hostilities. 3. involving physical effort and action: active sports... 5. characterized by action, motion, volume, use, participation, etc.: an active market in wheat; an active list of subscribers. 6. causing activity or change; capable of exerting influence (opposed to passive): active treason... 9. requiring or giving rise to action; practical: an active course." These standard definitions compliment the aim of anti-pimping/pandering legislation: "to discourage prostitution by discouraging persons other than the prostitute from augmenting and expanding a prostitute's operation, or increasing the supply of available prostitutes." (People v. Hashimoto, supra, 54 Cal.App.3d at p. 867; c.f., People v. Hernandez (1998) 46 Cal.3d 194, 201 [words and phrases to be construed in light of statutory scheme].)

working prostitute—no business augmentation, no expansion, no increase in either demand or supply. Though the lower court found substantial evidence of inducement/encouragement because petitioner had the accoutrements of a pimp and asked the undercover officer to come prostitute for him, under the usual terms and conditions (opn., at p. 5), there was no practical effort made or evidence adduced that petitioner could have actively encouraged anyone's prostitution.[2] Unlike the defendants in *Bradshaw* and *Hashimoto*, petitioner didn't promise opportunity for advancement, expansion or a profitable new market; unlike the defendants in *Patton* and *Almodovar*, petitioner was simply attempting to continue the prostitute's status quo. More of the same is not more.[3] (*People v. Bradshaw, supra,* 31 Cal.App.3d at p. 424.)

Contrary to the court's opinion here, the appellate court in *People v. Wagner, supra,* 170 Cal.App.4th 499, rejected the Government's argument that encouraging a change in business relationship qualified as pandering under *Bradshaw* and *Hashimoto*. The Fourth District found that *Bradshaw*, the first case to propose that pandering included soliciting someone to engage in prostitution who was already a prostitute did so "in an utterly unconvincing fashion." (*People v. Wagner, supra,* 170 Cal.App.4th at p. 506.) In its expansion of the statutory definition of pandering, the *Bradshaw* court had relied upon the opinion in *People v. Frey* (1964) 228 Cal.App.2d 33, 39, though the *Frey* opinion itself "*did not actually address the issue.*" (*People v. Wagner, supra,* 170 Cal. App.4th at p. 506, original emphasis.) The Fourth District could find no support for the proposition "anywhere else." (*Ibid.*) Given the principle that "cases are not authority for propositions not considered" (*People v. Superior Court (Zamudio)* (2000) 23 Cal.4th 183, 198), and the rule of lenity (*People v. Avery* (2002) 27 Cal.4th 49, 57-58 ["[W]hen a statute defining a crime... is susceptible of two reasonable interpretations, the appellate court should ordinarily adopt the interpretation more favorable to the defendant."]), it was clear to the Fourth District that the statute was to be read on its face. (*People v. Wagner, supra,* 170 Cal.App.4th at p. 888; c.f., *Wooten v. Superior Court* (2002) 93 Cal.App.4th 422, 432.) And, like the statute says, the crime of pandering occurs when

2 It is useful in this regard to consider the difference between crimes of solicitation, in which the articulated offer completes the crime, and crimes of encouragement, which contemplate some present ability to effect the target offense. Note there is no proscription against solicitation in section 266i, subdivision (a)(2). (*See generally, In re Ryan N.* (2002) 92 Cal.App.4th 1359, 1377-1378.)

3 "Take some more tea," the March Hare said to Alice, very earnestly. "I've had nothing yet," Alice replied in an offended tone, "so I can't take more." (Carroll, Lewis, *Alice in Wonderland*, ch. 7, available at http://www.cs.indiana.edu/metastuff/wonder/ch7.html.)

someone causes/induces/persuades/encourages someone else *"to become"* a prostitute, not by causing/inducing/persuading/encouraging someone to continue prostituting. (*People v. Wagner, supra,* 170 Cal.App.4th at p. 883; Pen. Code § 266i (a)(2).)

In petitioner's case, the Second District, relying on *Bradshaw,* maintained *Wagner* was inapplicable because the individual solicited was not actually a prostitute, but an undercover police officer. (Opn., at p. 6.) With all due respect, this is hair-splitting as jurisprudence: as plainly put by the plain words of the statute, the crime of pandering is the crime of encouraging someone *"to become a prostitute."* The anti-pandering statute, targets the specific evil of "turning" women to prostitution, not that of playing pimp: if someone is already a prostitute, the crime of pandering by encouraging cannot be committed.[4] By logical extension, this reasoning also extends to those situations where the person is not really a prostitute because the self-same illicit encouragement (trying to get someone "to become a prostitute") is present, though the intent is similarly unable to be effectuated. In short, trying to get someone to become a prostitute who can't or won't become a prostitute because she is either already a prostitute or a police officer is not enough to sustain a pandering conviction. (*People v. Wagner, supra,* 170 Cal.App.4th at p. 507 ["We can certainly sympathize with the *Bradshaw* court....[T]hey were groping for a solution without any precedential illumination."].)

But if the crime of pandering cannot be effected by the mere fact of soliciting someone to prostitute, the question becomes whether one is then guilty of attempted pandering? Again citing *People v. Bradshaw, supra,* 31 Cal.App.3d at p. 425, petitioner's court said no, because success is not a necessary element of the offense. (Opn., at p. 7.) However, this conclusion does not address the issue at issue in this case: *i.e.,* what, if any, crime is committed when a person attempts to pander, but cannot, because the object of his attentions is not a prostitute? (*People v. Wagner, supra,* 170 Cal.App.4th at p. 507.) And this is where the standard definition of attempt is most apropos. (Pen. Code § 21a ["An attempt to commit a crime consists of two elements: a specific intent to commit the crime, and a direct but ineffectual act done

4 The Second District footnoted that, although the Fourth District's holding was factually inapplicable, the "strong weight of authority" is contra *Wagner.* (opn., p. 6, fn. 3) As the *Wagner* decision makes explicit, there is no "strong weight of authority" in this matter—the *Bradshaw* "rule" being built on nothing but notions, and the cases subsequently relying on *Bradshaw,* like petitioner's case (and cited by petitioner's court), built on top of the airy that. (*People v. Wagner, supra,* 170 Cal. App.4th at pp. 507-508.)

towards its commission."]; *People v. Superior Court (Decker)* (2007) 41 Cal.4th 1, 7-8 [attempt to murder proved by retaining assassin].) By soliciting one to "become" a prostitute, who, by virtue or vice cannot "become" a prostitute, one has successfully attempted to pander—there has been, as there must be, "'some appreciable fragment of the crime committed, (and) it must be in such progress that it will be consummated unless interrupted by circumstances independent of the will of the attempter.'" (*People v. Camodeca* (1959) 52 Cal.2d 142, 145, quoting *People v. Buffum* (1953) 40 Cal.2d 709, 718; Pen. Code § 663 [a defendant may be found guilty of an attempt to commit any offense necessarily included in the offense for which he was charged].)

> Pandering is established when the evidence shows that the accused has succeeded in inducing his victim to become an inmate of a house of prostitution. [Citations.] Attempted pandering is proved by evidence of the acts of the accused which have failed to accomplish the actor's purpose by reason of its frustration by extraneous circumstances rather than by virtue of a change of heart on the part of the one who made the attempt.

(*People v. Charles* (1963) 218 Cal.App.2d 812, 819, quoting *People v. Mitchell* (1949) 91 Cal.App.2d 214, 217-218; *see also, People v. Grubb* (1914) 24 Cal. App. 604, 608; *People v. Matsicura* (1912) 19 Cal.App. 75, 78.) More precisely, that the woman in question is an undercover police officer is one such extrinsic circumstance, and a common one at that. (*People v. Mitchell, supra,* 91 Cal. App.2d at pp. 217-219.)

In *People v. Mitchell, supra,* 91 Cal.App.2d 214, police surveillance indicated the defendant was apparently keeping a house of prostitution. An undercover police officer was telephoned by the defendant, who inquired as to whether the officer had worked "in a house" before. During their subsequent in-person appointment, the defendant told the officer that she had been working for 12 years; had four girls working for her; her girls made $100 a night, halved with the defendant; she had been arrested many times, but done no time; and would take care of negotiating with customers. A customer arrived during the meeting, the defendant escorted him to another room, and then asked the officer to handle the trick; the officer declined. There was a follow-up telephone conversation, and a work start-date was set. The defendant was later convicted of attempted pandering. (*Id.*, at pp. 216-218.) Affirming the conviction, Division

Two found substantial evidence of overt acts, coupled with the impossibility of success, necessary to constitute an attempt.[5] (*Id.*, at p. 219; *In re Ryan N., supra,* 92 Cal.App.4th at pp. 1377-1378 [discussion of distinction between crimes of solicitation and attempts]; Pen. Code § 21a.)

Similarly, in *People v. Grubb, supra,* 24 Cal.App. 604, the defendant could be found properly guilty of attempted pandering because he put prosecutrix into house of prostitution, where she "was importuned to engage in sexual intercourse by visitors to the brothel, but refused all such importunities." (*Id.*, at p. 606; *see also, People v. Charles, supra,* 218 Cal.App.2d at p. 819.) And in *People v. Petros* (1914) 25 Cal.App. 236, the defendant's planned prostitution of the prosecutrix was thwarted when a known prostitute took the woman away and called the police. (*Id.*, at pp. 241-243.) That the prosecutrix did not become a prostitute was due to the timely and unexpected intervention of another:

> And it was this most commendable and humane intervention in the malodorous transaction by the fallen woman, Teddie Smith, that constituted the 'extraneous circumstances'—circumstances arising independently of the will of the accused—which frustrated or prevented the execution of his purpose to place her in a house of prostitution as an inmate thereof.

(Id., at p. 246; *People v. Matsicura, supra,* 19 Cal.App. at pp. 77-78 [defendant arranged for woman to prostitute in house, no evidence she ever did so]; *People v. Snyder* (1940) 36 Cal.App.2d 258, 533-534 [idem].)

In *People v. Bradshaw, supra,* 31 Cal.App.3d 421, Division Four distinguished *Matsicura* on grounds that the earlier opinion "does not mention the word 'encourage.'" However, the *Bradshaw* court did not consider whether a conviction for attempt would properly lie—nor did it need to, because the question before the court was whether a section 995 motion had been properly granted on a theory of entrapment when the defendant had "willingly and enthusiastically entered into negotiations for the [undercover] police woman's services." (*Id.*, at p. 423.) Too, the *Bradshaw* opinion did not address the fact that the version of section 266i subdivision (a)(2) applied in *People v. Mitchell, supra,* 91 Cal.App.2d at p. 216, fn. 1, *included* a proscription against pandering

5 In *People v. Frey* (1964) 228 Cal.App.3d 33, 44-45, 50, the defendants were convicted of a number of counts of pandering, some involving an undercover police officer; Division One did not consider the application of attempt principles relative to those counts.

by encouraging. Thus, contrary to the implication made by the opinion in this case, the *Bradshaw* opinion does not suggest that attempted pandering cannot be a lesser included offense to pandering, and numerous earlier cases held that convictions for attempted pandering were proper where unforseen circumstance thwarted the intended procurement. (*Accord, People v. Mitchell, supra,* 91 Cal.App.2d at pp. 217-219;) People *v.* Siu (1954) 126 Cal.App.2d 41, 43; People *v.* Petros, supra, 25 Cal.App. at p. 245; see generally, 1 Witkin, Cal. Crim.Law 3d (2000) Elements, § 61, p. 269.)

Given all the evidence indicated petitioner fully believed, as the police encouraged him to believe, that the undercover officer was currently a prostitute at the time he approached her, and that at most he approached her with an offer to "change management" (*Id.*, at p. 888), petitioner's conduct does not fall within the purview of the anti-pandering statute, and there is thus constitutionally insufficient evidence to sustain his conviction for pandering. (*People v. Wagner, supra,* 170 Cal.App.4th at p. 889; U.S. Const., Fourteenth Amend.; Cal. Const., art. I, § 15; *Jackson v. Virginia* (1979) 443 U.S. 307, 319; *People v. Johnson* (1980) 26 Cal.3d 557, 576-578.) Given, as attested to in this case, that law enforcement will continue to habitually use undercover officers as decoy prostitutes, and given that pimps will continue to solicit prostitutes to change management, this issue will continue to schism appellate courts, confuse trial courts, and invite arbitrary enforcement by prosecutors and police. (*Contra, People ex rel. Gallo v. Acuna* (1997) 14 Cal.4th 1090, 1144; U.S. Const. Fifth and Fourteenth Amends.) In order to clarify what constitutes the crime of pandering by encouragement, review should be granted. (Cal. Rules of Court, rules 8.500 (a)(b)(1).)

ARGUMENT

APPELLANT'S CONVICTIONS ON COUNTS TWO AND THREE MUST BE REVERSED AS THERE WAS INSUFFICIENT EVIDENCE OF FORCE OR DURESS

Appellant's conviction for two counts of violating Penal Code section 288, subdivision (b) must be reversed as there was insufficient evidence to support a finding that he used force or duress in either instance. (*Jackson v. Virginia* (1979) 443 U.S. 307, 318-319 [61 L.Ed.2d 560; 99 S.Ct. 2781]; *People v. Woffinden* (1993) 31 Cal.App.4th 1664, 1672; *People v. Cardenas* (1994) 21 Cal.App.4th 927, 939.)

The test to determine sufficiency of the evidence is "whether, on the entire record, a rational trier of fact could find appellant guilty beyond a reasonable doubt." (*People v. Johnson* (1980) 26 Cal.3d 557, 576-578.) As the Supreme Court said in *Johnson*, "our task... is twofold. First, we must resolve the issue in light of the *whole record*.... Second, we must judge whether the evidence of each of the essential elements... is *substantial*...." (*Id.*, at pp. 576-577, italics in the original]; *People v. Barnes* (1986) 42 Cal.3d 284, 303.) Substantial evidence must support each essential element underlying the verdict: "'it is not enough for the respondent simply to point to 'some' evidence supporting the finding.'" (*People v. Johnson, supra,* 26 Cal.3d at p. 577, quoting *People v. Bassett* (1968) 69 Cal.2d 122, 138.) Nor does a "50 percent probability" of an element constitute substantial evidence. If the facts as proven equally support two inconsistent interpretations, the judgment goes against the party bearing the burden of proof as a matter of law. (*People v. Allen* (1985) 165 Cal.App.3d 616, 626, citing *Pennsylvania R. Co v. Chamberlain* (1933) 288 U.S. 333, 339.) Evidence that fails to meet this substantive standard violates the Due Process Clause of the Fourteenth Amendment and article I, § 15 of the California Constitution. (*Jackson v. Virginia, supra,* 443 U.S. at p. 319; *People v. Johnson, supra,* 26 Cal.3d at pp. 575-578.)

To sustain a conviction of violating Penal Code section 288, subdivision (b), against a sufficiency challenge, the State must have proved both that the defendant touched a child with the proscribed sexual intent, and that he used force or duress to do so. Any qualifying force must be "'substantially different from or substantially greater than that necessary to accomplish the lewd act itself.'" (*People v. Pitmon* (1985) 170 Cal.App.3d 38, 46, quoting *People v.*

Cicero (1984) 157 Cal.App.3d 465, 474; *see also, People v. Cardenas, supra,* 21 Cal.App.4th at p. 939.) This force, however, is not that measure of physical control which frequently accompanies the acts complained of, for "a modicum of holding and even restraining" does not constitute substantially different or excessive force. (*People v. Senior* (1992) 3 Cal.App.4th 765, 744; see e.g., People v. Pitmon, supra, 170 Cal.App.3d at p. 48 [no force in grabbing/ holding victim's arm while fondling].)

Duress, in turn, is the:

> ... direct or implied threat of force, violence, danger, hardship or retribution sufficient to coerce a reasonable person of ordinary susceptibilities to (1) perform an act which otherwise would not have been performed or, (2) acquiesce in a act to which one otherwise would not have submitted.

(*People v. Pitmon, supra,* 170 Cal. App.3d at p. 50; *see also, People v. Cochran* (2002) 103 Cal.App.4th 8, 14.) Duress inherently "involves psychological coercion" and may be constructed from a number of externalities, including the relative ages and sizes of victim and defendant, and their social or familial relationship. (*People v. Superior Court (Kneip)* (1990) 219 Cal.App.3d 235, 238-239 ["the position of dominance and authority of the defendant and his continuous exploitation of the victim" relevant to duress finding]; *see e.g., People v. Schulz* (1992) 2 Cal.App.4th 999, 1005 [duress found where nine year old victim cried while restrained and fondled by adult uncle]; *People v. Sanchez* (1989) 208 Cal.App.3d 721, 747-748, cert. den. 493 U.S. 921 [eight year old victim viewed defendant grandfather as father, defendant repeatedly told her not to tell, mother would hit her if she did].) Though duress may involve physical control, it does not overlap with the level of physical engagement which constitutes force under the statute. (*People v. Schulz, supra,* 2 Cal.App.4th at p. 1105 ["'Duress' would be redundant... if its meaning were no different than 'force,' 'violence,' 'menace,' or 'fear of immediate and unlawful bodily injury.'"].)

In *People v. Cochran, supra,* 103 Cal.App.4th at p. 15, the victim was defendant's nine year old daughter. She was 4'3" tall, he was 5'9", he weighed approximately 100 pounds more than she; he molested her at home, videotaping some of their activities. During videotaping, defendant coached his daughter on how to perform, cajoling her compliance. In the videos, the victim could be seen gagging during oral copulation, curling away from defendant, complaining of pain, and worrying her mother will find them, all of which was

disregarded or discounted by her father. At trial, the victim testified she was mad/sad about the molestation, noting the defendant told her that if she told anyone, he would go to jail. The appellate court found sufficient evidence of duress given the "picture of a small, vulnerable and isolated child who engaged in sex acts only in response to her father's parental and physical authority. Her compliance was derived from intimidation and the psychological control he exercised over her and was not the result of freely given consent." (*Ibid.*) In its ruling, the Fourth District distanced itself from an earlier holding in *People v. Hecker* (1990) 219 Cal.App.3d 1238, 1250-1251, in which it found duress would not lie absent some "evidence [the defendant] was aware of and took advantage of" his victim's fear, for:

> Psychological coercion, without more does not establish duress. At a minimum there must be an implied threat of force, violence, danger, hardship or retribution.

(*Accord, People v. Wilkerson* (1992) 6 Cal.App.4th 1571, 1580 [implied threat of harm].)

In *People v. Woffinden, supra,* 31 Cal.App.4th 1664, and *People v. Cardenas, supra,* 21 Cal.App.4th 927, this Court aligned itself with the earlier concept of duress promulgated by the Fourth District in *Hecker:*[1] duress was determined by the "totality of the circumstances, including the age of the victim; the relationship between the victim and the defendant; the disparity in physical size between them; and the isolation of the location of the assault." (*People v. Woffinden, supra,* 31 Cal.App.4th at p. 1672.) Therefore, in *Woffinden,* duress was discerned where the defendant was 6'3" tall, weighed over 200 lbs., was the victim's teacher, a strict teacher who yelled at his students, a self-proclaimed "ogre" who shook his small charges, and who molested his seven year old student when she was alone in the class. (*Id.,* at p. 1673.) In *Cardenas,* which involved various sex offenses by a man posing as a *curandero* (faith healer), duress was derived from the defendant's position of trust with his female victims and his purposeful "trading on their fears that if they did no allow him to proceed with the 'cure' they would remain ill, or worse, risk imminent death to themselves or others.... appellant utilized this threat of divine intervention to coerce [his victims] into acquiescence." (*People v. Cardenas, supra,* 21 Cal. App.4th at p. 940 [defendant locked victims in an apartment, and told them bad

1 In *Woffinden,* this Court considered *Hecker* directly and approvingly on the concept of force, but not on the issue of duress. (*People v. Woffinden, supra,* 31 Cal.App.4th at pp. 1674-1675.)

spirits would kill them if they left or moved from room to room; he also told them what to eat, and choked them].)

In *People v. Espinoza* (2002) 95 Cal.App.4th 1287, the Sixth Appellate District, also employing the *Hecker* standard, found no duress where the defendant repeatedly molested his twelve year old daughter while she slept alone in her bedroom; the victim testified she was afraid to report because her father might "do something." (*Id.*, at p. 1292-1293.) Because there was no evidence the defendant "utilized any direct or implied threat" to molest his victim, and "[w]hile it was clear that L. was afraid of defendant," there was:

> ... no evidence was introduced to show that this fear was based on anything defendant had done other than to continue to molest her. It would be circular reasoning to find that her fear of molestation established that the molestation was accomplished by duress based on an implied threat of molestation.

(*Id.*, at p. 1321.) Similarly, there was no evidence in this case that Lita's fear was caused by any direct or implied threat made by appellant.

Appellant"s two section 288, subdivision (b) convictions were based on alternative theories of force and duress (RT 2742); during argument, the force/duress cited by the prosecutor in count 2 (the September 22nd incident) was appellant's pulling Lita's underwear down after she pulled them back up, and his telling her not to tell anyone. The prosecutor also alluded to appellant's "pull[ing] Lita back by the head. He pulls her hair to get her into place, in some position." (RT 2752-2754, 2813) The prosecutor argued the duress, while not as "clear as the force," inhered in an "indirect threat" based on the "relationship" between Lita and appellant:

> She was afraid to tell because he told her not to tell, which implies to a child something bad will happen if you tell. How did she interpret that? I'll get blamed. I'll get spanked. I'll get in trouble. I'll get hurt. Right? I might get physically hurt, or what else? The family will break up because he says "I'm going to go to jail if you tell." It's going to destroy the family. So these—this duress that she may lose people in her family, or she may have some harm herself, even though he didn't say it directly, if you find that that's

what's implied to her, and that's what she found,
that's another way to get to this count 2....

(RT 2755-2756)[2]

Relative to count 3 (the October 2nd episode), the State asserted:

He had to pick her up from one room and carry her
into the other room because she refused to just
come in there. So he picked her up and carried her,
used force to get her into the position to do what
he wanted to do to her. He also used force—I'm
sorry, he also overcame her resistance to get to her
bare skin because she kept her legs closed, and he
started touching her over her skin—I mean, over her
clothes, and she kept her legs closed tightly, and he
still was able to get to her skin and touch her skin
to skin... [&] And then as far as the duress, we've
already discussed the facts that make up the duress
that he would tell her, you know, over and over again
not to tell anybody, and that he'd be going to jail;
and if this kept her compliant up to the end...

(RT 2761; *see also*, RT 2813)

Contrary to the prosecutor's argument, Lita never testified appellant
pulled her head or hair during the September 22nd incident.[3] At the preliminary
hearing, Lita denied appellant pulled her hair, testifying instead that when she
pulled her underwear back up, appellant desisted. However, on other occasions,
appellant would take down her underwear and touch her. (RT 2249-2250) At
trial, Lita first testified appellant pulled her underwear down, she pulled it back
up, and after that she didn't remember what happened; she then amended
her account, testifying appellant pulled the underwear back down and began
touching her. (RT 1300- 1302) The point is, whatever force was used, it was that

2 More generally, the State characterized the duress in this case as emanating from Lita's
fear that she: "might get blamed for not telling soon enough, that she might get in trouble in the
family because it might be her fault. So she might get in trouble. She might get hurt; that the family
might get torn apart because obviously it's shown that these two families are close. ... [A]nd she
was told, warned by Mr. Diaz, 'If you tell... [&] I will go to jail. If you tell, I will go to jail,' and she took
that and had to live and carry that weight on her shoulders. Her aunt would lose her husband. Her
family would be torn if that happened. People she cared about." (RT 2734-2735) But if this was in
fact Lita's fear, it did not inhere in anything appellant did or said.

3 This detail was supplied exclusively by one of the officers who interviewed Lita, but was
not included in any of Lita's preliminary hearing or trial testimony, or in her statements to her mother,
her doctors, or in an earlier police interview. (RT 1943)

which commonly attends the sort of acts involved. (*Accord, People v. Schulz, supra,* 2 Cal.App.4th at p. 1004 [grabbing and holding victim's arm during fondling is not force].) As the Sixth District said in *People v. Senior, supra,* 3 Cal. App.4th at p. 774:

> Since ordinary oral copulation and digital penetration almost always involve some physical contact other than genital, a modicum of holding and even restraining cannot be regarded as substantially different or excessive "force."

So too, was the act of pulling Lita's underwear down no more than that modicum of contact necessary to touch her skin.

The duress in this case was purely conjured by the prosecutor, extracted and amplified from appellant telling Lita not to tell the authority figures around her what was going on, or he would go to jail. At the preliminary hearing, Lita testified this thought made her first sad, then "happy" (RT 2244), a reaction which as a preliminary matter belies the State's scenario of a girl impliedly threatened with being blamed, spanked, "physically hurt," or the imminent destruction of family. In fact, Lita told her doctor she didn't say anything because she was afraid no one would believe her, and her mother would be angry with her—neither of which has its genesis in anything appellant said to Lita, nor has anything particularly to do with appellant beyond the molestation. (RT 2126, 2151-2153, 2177) And Lita was apparently comfortable enough with the thought of the extended family falling apart to advise her aunt that she'd "better get another man." (RT 2155, 2165, 2173-2174) Again, the center does not hold: from appellant's list of who Lita should not tell, there is no direct or "implied threat" which had either the intention or effect of coercing her compliance. (See generally, *People v. Espinoza, supra,* 95 Cal.App.4th at p. 1321.)

The force relied upon by the prosecution in the October 2nd incident involved appellant calling Lita to the bedroom, her shaking her head and/or whispering "no,"[4] and him carrying her from living room to bed.[5] There was no additional evidence of duress tendered save appellant's earlier admonition not to tell. (RT 2761, 2813) And there is a problem with characterizing appellant's carrying Lita "like a baby" as "substantially different from or substantially greater

[4] At trial, Lita testified she shook her head (RT 1289); according to police, she "shook her head no, and she also made the motion that she moved her lips and said no, but somewhat verbalized it, but somewhat whispered it, no." (RT 1933)

[5] Contrary to the prosecutor's argument, there was no evidence appellant had to somehow "overcome" Lita's resistence to touch her skin.

than that necessary" to achieve the touching—given sex offenses are parsed into discreet conceptual events, the prefatory, non-forcible movement of a victim from one room to another, unjoined with any lewd touching, cannot constitute the force necessary to convert a molestation into forcible molestation. (Pen. Code § 667.6; *People v. Pitmon, supra,* 170 Cal.App.3d at p. 46.)

In the arena of sex crimes, courts routinely consider whether an offense against a single victim occurred on separate occasions under Penal Code section 667.6, subdivision (d):

> ... whether, between the commission of one sex crime and another, the defendant had a reasonable opportunity to reflect upon his or her actions and nevertheless resumed sexually assaultive behavior. Neither the duration of time between crimes, nor whether or not the defendant lost or abandoned his or her opportunity to attack, shall be, in and of itself, determinative on the issue of whether the crimes in question occurred on separate occasions.

(*See, People v. Irvin* (1995) 43 Cal.App.4th 1063, 1071; *People v. Plaza* (1995) 41 Cal.App.4th 377, 385; *accord, People v. Jones, supra,* 25 Cal.4th at pp. 100-101.) Conceptually, the "broad standard" of dividing events into occasions works in this instance to sever appellant's moving Lita from living room to bedroom from the subsequent touching. Inasmuch as appellant had a section 667.6, subdivision (d) "opportunity to reflect" between these events, they cannot be considered part and parcel of the same act for section 288, subdivision (b) purposes.[6] (*See generally, People v. Jones* (2001) 25 Cal.4th 98, 104-105; *c.f., People v. Diaz* (2000) 78 Cal.App.4th 243, 247-248 [separate kidnaping conviction may be based on slight movement to more isolated location for rape].)

Finally, as used too loosely in this prosecution, the concept of duress became a Promethean bag, designed to swell or shrink to fit whatever conduct the State presents—as evidenced by the prosecutor's rebuttal argument, which maintained Lita:

6 In this way the force which constitutes force in molestation cases is qualitatively different than force constituting force in rape cases: as the quantum of force necessary for molestation is lesser than that for rape (*e.g.,* the difference between pushing hands to one side, *People v. Bergschneider* (1989) 211 Cal.App.3d 144, 154, and "rearing back," or making a fist, *People v. Barnes, supra,* 42 Cal.3d at p. 304), so the carry-over effect of such a measure of force is equally diminished.

felt the threat to her own safety, as well as the safety of the family as far as the breakup of the family; and Dr. Eisen testified ad nauseam about how molesters position a power over the children, the relationship, especially when it's in the family.... You have all this relationship power, and you have the secrecy of , this is our secret. Don't tell anyone. All of that implies to the child many different things. It implies to children. We know that. A child of sexual abuse. Victims, that it does imply they talked to child sex victims long after when they're adults, and what they couldn't verbalize then they can verbalize now. I thought I would get in trouble if I told. I didn't think I could tell anybody. I didn't think anybody could keep me safe. I mean, these things are out there. They are implied threats. They can be made.

(RT 2812) But they weren't. As has been trenchantly put, "'[t]he very nature of duress is psychological coercion.'" (*People v. Minsky* (2003) 129 Cal.Rptr. 583, 588, 2003 Cal.App. LEXIS 92, quoting *People v. Cochran, supra,* 103 Cal.App.4th at p. 15.) Coercion is an effect, which implies a predicate cause. As appellant did nothing to cause Lita to believe her safety, or the safety of those she loved, was imperiled, appellant may not be liable for the hypothetical implications of telling Lita not to tell.

Because there is not substantial proof appellant used either force or duress during the incidents underlying counts 2 and 3, those counts must be reversed, and appellant may not be retried on those allegations. (U.S. Const., Fifth Amend.; *Lockhart v. Nelson* (1988) 488 U.S. 33, 34; *Burks v. United States* (1978) 437 U.S. 1, 10-11 [double jeopardy precludes retrial "for the purpose of affording the prosecution another opportunity to supply evidence which it failed to muster in the first proceeding"].)

ARGUMENT

APPELLANT'S CONVICTION FOR FAILURE TO REGISTER AS A SEX OFFENDER MUST BE REVERSED BECAUSE THE COURT MISINSTRUCTED THE JURY AND THERE IS INSUFFICIENT EVIDENCE TO SUSTAIN THE VERDICT

Introduction

Penal Code section 290 imposes a lifetime registration requirement on sex offenders; among other things, an offender must register his residential address within five working days of each birthday, and of each change of residence. (Pen. Code § 290(a)(1)(A), (D).) Appellant registered three times following his 1991 molestation conviction: his current conviction for failing to register was predicated on two specific lapses, neither of which constitute constitutionally tenable proof of violating the registration requirement. (See generally, *Jackson v. Virginia* (1979) 443 U.S. 307, 318-319; *People v. Virgil* (2001) 94 Cal.App.4th 485, 503-504.)

A. Insufficiency of evidence

As a general matter, the test to determine sufficiency of the evidence is "whether, on the entire record, a rational trier of fact could find appellant guilty beyond a reasonable doubt." (*People v. Johnson* (1980) 26 Cal.3d 557, 576-578.) As the Supreme Court said in *Johnson*, "our task... is twofold. First, we must resolve the issue in light of the *whole record*.... Second, we must judge whether the evidence of each of the essential elements... is *substantial*...." (*Id.*, at pp. 576-577, italics in the original]; see also, *People v. Barnes* (1986) 42 Cal.3d 284, 303.) Substantial evidence must support each essential element underlying the verdict: "'it is not enough for the respondent simply to point to 'some' evidence supporting the finding.'" (*People v. Johnson, supra*, 26 Cal.3d at p. 577, quoting *People v. Bassett* (1968) 69 Cal.2d 122, 138.) Nor does a "50 percent probability" of an element constitute substantial evidence. If the facts as proven equally support two inconsistent interpretations, the judgment goes against the party bearing the burden of proof as a matter of law. (*People v. Allen* (1985) 165 Cal.App.3d 616, 626, citing *Pennsylvania R. Co v. Chamberlain* (1933) 288 U.S. 333, 339.) Evidence that fails to meet this substantive standard violates the Due Process Clause of the Fourteenth Amendment and article I, § 15 of the California Constitution. (*Jackson v. Virginia, supra*, 443 U.S. at p. 319; *People v. Johnson, supra*, 26 Cal.3d at pp. 575-578.) If the State fails to prove

an allegation to constitutional satisfaction, the judgment must be reversed on that count, and the defendant may not be retried. (U.S. Const., Fifth Amend.; *Lockhart v. Nelson* (1988) 488 U.S. 33, 34; *Burks v. United States* (1978) 437 U.S. 1, 10-11 [double jeopardy precludes retrial "for the purpose of affording the prosecution another opportunity to supply evidence which it failed to muster in the first proceeding"].) In addition to its other constitutional defects, appellant's registration conviction is not supported by substantial evidence. (*People v. Jackson* (2003) 109 Cal.App.4th 1626, 1635.)

B. Section 290 registration: elements and requirements

Section 290 requires convicted sexual offenders register their residential address within five days of each birthday or relocation. If an individual has multiple residences, he must register all of them (Pen. Code § 290(B); *People v. Horn* (1998) 68 Cal.App.4th 408, 415-419); on the other hand, if an individual is homeless, he must update his registration every sixty days in the jurisdiction in which his is located. (Pen. Code § 290(C); *People v. North* (2003) 112 Cal.App.4th 621, 634). Actual knowledge of the registration requirement is mandated before one can be convicted of failing to register. (*People v. Garcia* (2001) 25 Cal.4th 744, 753.)

As noted, in *People v. Garcia, supra,* 25 Cal.4th 744, the Supreme Court held a defendant must have actual knowledge of the registration requirement; in so holding, the Court noted the "willfully violates" language of the section implied "a 'purpose or willingness' to make the omission. Logically one cannot purposefully fail to perform an act without knowing what act is to be performed." (*Id.,* at p. 752.) Instructing the jury only under CALJIC No. 1.20 on general principles of willfulness was inadequate to meet an actual knowledge standard, for the meaning of "'willfully' varies depending on the statutory context." (*People v. Garcia, supra,* 25 Cal.4th at p. 754 [instruction "correctly requires a showing of purpose or willingness to act.... [b]ut... the instruction was incomplete in failing clearly to require actual knowledge of the registration requirement."]; see, *People v. Jackson, supra,* 109 Cal.App.4th at p. 1634-1635.)

As modified by the trial court in this case, CALJIC No. 10.70.290 reads:

> The defendant is accussed [sic] in Count 12 of having violated section 290, subdivivision [sic] (g)(2), of the Penal Code, a crime.
>
> Every person with a prior felony conviction for Lewd act upon a child, a violation of section 288(a), of the Penal Code, and who knowingly fails to register as a

sex offender is guilty of a violation of section 290(g)
(2), of the Penal Code.

In order to prove this crime, each of the following
elements must be proved.

1. A person was previously convicted of the crime of
Lewd act upon a child, section 288(a) of the Penal
Code.

2. That person knew of their duty to register.

3. That person failed to provided [sic] their correct
name and or address to their local law enforcement
agency. (CT 176; RT 987)

With regard to count 12, the court also instructed under CALJIC Nos. 3.30
[Concurrence of Act and General Criminal Intent] (CT 161; RT 975) and 1.20
["Willfully"—Defined] (CT 144; RT 963). The court did not instruct as to the effect
of an admission (CALJIC Nos. 2.70 [Confession and Admission—Defined], 2.71
[Admission—Defined]), the corpus delecti rule (CALJIC No. 2.72 [Corpus Delecti
Must Be Proved Independent of Admission or Confession]), or the definition of
"knowingly" (CALJIC No. 1.21 ["Knowingly"—Defined]).

C. Failure to fully instruct

While the trial court instructed the jury under No. 10.70.290, which
includes the requirement appellant "knowingly fails to register," that "knowingly"
is directed in the syntax of the instruction to the knowledge of the duty to register,
not to a knowing failure to perform that duty. The applicable mens rea set forth
by the trial court was thus a combination of "willingly" as defined by No. 1.20[1]
and the No. 3.30 general intent instruction.[2] The jury was not instructed on the
definition of "knowingly."[3] Absent some guidance on the knowledge required to
violate section 290, the instructions as given improperly abrogate the mens rea
requirement contemplated by the statute.

1 CALJIC No. 1.20, as given to appellant's jury: "The word 'willfully' when applied to the
intent with which an act is done or omitted means with a purpose or willingness to commit the act
or to make the omission in question. The word 'willfully' does not require any intent to violate the
law, or to injure another, or to acquire any advantage." (CT 144)

2 As given: "In the crime charged in Count 12, there must exist a union or joint operation
of act or conduct and general criminal intent. General criminal intent does not require an intent
to violate the law. When a person intentionally does that which the law declares to be a crime,
he is acting with general criminal intent, even though he may not know that his act or conduct is
unlawful." (CT 161)

3 CALJIC No. 1.21: "The word 'knowingly' means with knowledge of the existence of
the facts in question. Knowledge of the unlawfulness of any act or omission is not required. [A
requirement of knowledge does not mean that the act must be done with any specific intent.]

Again, in *Garcia*, the Supreme Court ruled that instructing the jury only that the defendant "willfully" failed to register was insufficient, because it did not require finding the defendant was aware of his statutory obligation. While "willfully" suggests knowledge, and "knowledge has been held to be concomitant of willfulness," the further requirement of actual knowledge more fully satisfies the due process concern that a defendant subject to registration be cognizant of that duty and attendant liability. (*People v. Garcia, supra,* 25 Cal.4th at pp. 752-753.) If the defendant knows he is to register, his failure to register is willful. Similarly, the Comment to CALJIC No. 1.21 states "[a] requirement of knowledge in a penal statute imports only an awareness of the facts which bring the proscribed act within the terms of the statute and is not a requirement that the act be done with any specific intent." (*Citing People v. Calban* (1975) 65 Cal.App.3d 578, 585.)

And by this same token, the jury here needed to be told that if liability is contingent on knowing one has to register, it must also be linked to knowing one has failed to register. Under *Garcia*, the State must prove appellant "knowingly" did not register to be convicted of willfully failing to register. Without begging the question, if "willfully violates" means "fails to register knowing one has a duty to register," embedded within that failure is the knowledge of nonfeasance. Knowledge meaning awareness of the salient fact(s)—in appellant's case, that the address provided was incorrect.[4] To impose liability absent such knowledge converts section 290 from a general intent offense to a strict liability crime, as it would criminalize erroneous registration "regardless of wrongful intent or knowledge." (*People v. Valenzuela* (2001) 92 Cal.App.4th 768, 778; *see generally,* 1 Witkin & Epstein, Cal. Criminal Law (3d ed. 2000) Elements, § § 17, 18, pp. 220-223.)

4 It is worth underscoring this does not graft a specific intent requirement onto section 290, for the State would not have to prove a defendant intentionally attempted to dodge the registration obligation by providing a fictitious address, just that he was aware of the misrepresentation. (*C.f., In re Jorge M.* (2000) 23 Cal.4th 866, 869-870 [crime of possession of assault rifle not require proof defendant knew characteristics of assault rifles; sufficient if proof defendant knew or reasonably should have known].) In section 290 situations, the jury would only have to be instructed the defendant knew or should have known he failed to comply with the terms of his registration obligation.

The court also did not instruct on either the definition of confessions/ admissions[5] or the definition of an admission.[6] There is a sua sponte duty to so instruct when warranted. (*See generally, People v. Slaughter* (2002) 27 Cal.4th 1187, 1200, cert. den. 537 U.S. 1121; *People v. Beagle* (1972) 6 Cal.3d 441, 455; see also, Comment, CALJIC Nos. 2.70, 2.71 (CALJIC 6th ed.. 1996); *People v. Mendoza* (1987) 192 Cal.App.3d 667, 676, fn. 3.) The court also did not instruct the jury sua sponte on the corpus delecti rule,[7] as was also required. (See, People v. Beagle, supra, 6 Cal.3d at p. 455; see also, Comment, CALJIC No. 2.72 (CALJIC 6th ed.. 1996).) As to the effect of these instructional lacuna:

D. Appellant's failures to register: Lewis and Walnut Avenues

According to police, appellant had registered three times since his parole on October 2, 1998:[8] (1) November 5, 1999: 13990 Cherry Avenue, Long Beach; (2) March 6, 2002: 14734 Walnut Avenue, Apartment 2, Long Beach; (3) 14020 Lewis Avenue, Apartment A, Long Beach. (RT 388-389, 392) On May 17, 2002, police attempted to go to the 14734 Walnut Avenue address, but found no such location; additionally, there was no extent variation on the address, such as "14734 Walnut Way." (RT 396) On June 1, 2002, police went to 12346 Lewis Avenue and arrested appellant. The prosecutor asked the police witness, "Did the defendant tell you if he lived at that location?" The officer answered, "Yes." (RT 398)

5 CALJIC No. 2.70 [Confession and Admission—Defined], in part: "An admission is a statement made by [the] defendant which does not by itself acknowledge [his][her] guilt of the crime[s] for which the defendant is on trial, but which statement tends to prove [his][her] guilt when considered with the rest of the evidence. [&] You are the exclusive judges as to whether the defendant made a confession [or an admission], and if so, whether that statement is true in whole or in part. [&] [Evidence of [an oral confession] [or] [an oral admission] of the defendant not made in court should be viewed with caution."

6 CALJIC No. 2.71 [Admission—Defined]: "An admission is a statement made by [a] [the] defendant which does not by itself acknowledge [his][her] guilt of the crime[s] for which the defendant is on trial, but which statement tends to prove [his][her] guilt when considered with the rest of the evidence. [&] You are the exclusive judges as to whether the defendant made an admission, and if so, whether that statement is true in whole or in part. [&] [Evidence of an oral admission of [a][the] defendant not made in court should be viewed with caution."

7 CALJIC No. 2.72: "No person may be convicted of a criminal offense unless there is some proof of each element of the crime independent of any [confession][or][admission] made by [him][her] outside of this trial. [&] The identity of the person who is alleged to have committed a crime is not an element of the crime [nor is the degree of the crime]. The identity [or degree of the crime] may be established by [a][an][confession][or][admission]." (*People v. Jennings* (1991) 53 Cal.3d 334, 364, cert. den. 502 U.S. 969 ["The corpus delicti rule requires that the corpus delicti of a crime be proved independently from an accused's extrajudicial admissions."].)

8 Appellant testified he was released from custody in 1995, and spent from 1995 to 1999 "in immigration." He then moved to his mother's house on Cherry Avenue. (RT 631)

As argued by the prosecutor, appellant's section 290 conviction could be predicated on either of two separate registration failures: appellant's registering 14020 Lewis Avenue, Apartment A, on May 23, 2002, and his apparent residential arrest at 12396 Lewis Avenue on June 1, 2002; or appellant's registering 14734 Walnut Avenue, Apartment 2, on March 6, 2002, while actually residing at 14369 Walnut Avenue, Apartment 2. (RT 938-939) Appellant testified he "never missed" a registration, registering his mother's house at 13990 Cherry Avenue, then 14369 Walnut Avenue, Apartment 2, when he and Qui first moved together. Qui next relocated to 14020 Lewis Avenue; appellant didn't initially want to move,[9] but did after registering the new address, part of a multi-unit housing complex. Apartment A is a stand-alone house within the complex. (RT 627-628, 631, 633-634, 641-643)

1. Lewis Avenue

The Lewis Avenue theory of liability suffers a number of defects, legal and factual. Legally, there was no proof independent of appellant's arguable (see ante) admission that he lived at 13246 Lewis Avenue to render his registration of 14020 Lewis Avenue a failure to register. (People v. Cullen (1951) 37 Cal.2d 614, 624 [confession inadmissible until corpus established]; Jones v. Superior Court (1979) 96 Cal.App.3d 390, 396 [defendant's statements may not be used to establish corpus].) The test for instructional error is whether the error was harmless beyond a reasonable doubt. (Yates v. Evatt (1991) 500 U.S. 391, 405; Chapman v. California (1967) 386 U.S. 18, 24.) Given the flat fact appellant's jury was not told they could not find appellant failed to register a residence if the only proof of his residency came from appellant's out-of-court admission, the court's failure to instruct on the principles of the corpus delecti rule in this case cannot be considered harmless. (People v. Jackson, supra, 109 Cal.App.4th at p. 1635 [general sufficiency issues].)

That the trial court moreover failed to give a cautionary instruction on oral admissions only exacerbates the problem, particularly given appellant testified he did not live at 12346 Lewis Avenue, but rather at 14020 Lewis Avenue. An exacerbation further exacerbated by the State's argument:

> You have the statement by Officer Pirooz when Officer Pirooz arrested him that the defendant stated that he lived there, and though that sounds like that's hearsay that you can't take into consideration,

it actually isn't because it's called an admission by
a defendant when they make a statement saying
something that basically can be used against them
in court, which is that he lived at that address.

(RT 939) Left forever unsaid (and uncorrected) was that you actually can't use it against him unless you have other proof he lived at that address, and, plus, you have to view the statement with caution. Again, because the only proof appellant was in violation on the Lewis Avenue address was supplied by appellant's out-of-court admission, failing to properly instruct the jury as to how to treat that evidence was not harmless beyond reasonable doubt. (*Yates v. Evatt, supra,* 500 U.S. at p. 405.)

The factual errors are consequent, and threefold: First, leaving aside the corpus problem, there was no concrete evidence appellant lived at the 12346 address. According to the record, the prosecutor asked the officer if appellant said whether he lived at the location. The officer indicated that, "yes," appellant had said. However, the officer did not say what the content of this statement was. In other words, which there were not enough of here, this question and that answer are subject to alternative interpretation: either the prosecutor asked if appellant responded to the officer's question, and the officer said that he did respond, or the prosecutor asked if appellant admitted living at the arrest location, and the officer said appellant did so admit. Given the testimony does not specify which question was meant by the State or understood by the witness, and given this is the only proof (albeit improper proof) appellant resided at an unregistered location, it is not constitutionally sufficient to sustain his conviction for failure to register. (*People v. Johnson, supra,* 26 Cal.3d at pp. 576-578.)

Second, assuming appellant did live at the 12346 address, there was no evidence he had been there for more than the five days required to trigger the registration requirement. From May 23rd (the date he registered the 14020 Lewis Avenue address) to June 1st (when he was arrested) is a seven-day span: given there was no proof as to when appellant may have—if he had—moved to the 12346 address, it cannot be assumed that even his confession of residency would put him in violation of his statutory duty. (*C.f., People v. North, supra,* 112 Cal.App.4th at p. 632 [determination of when a location becomes a residence must account for "five day grace period allowed for registration."].) Appellant could have moved from 14020 Lewis Avenue to 12346 Lewis Avenue the day before his arrest—absent some indicia appellant had been residing at the 12346

address for more than five days (mail addressed to appellant, bills in his name at that location, lease agreement signed by him, etc.), there is no proof appellant was in *de jure* violation. Finally, there was no evidence the 14020 Lewis address was in fact factually improper, especially in the context of a knowing failure to register (*see ante*, at pp. 14-16): appellant testified the location was a multi-unit complex, composed of at least two separate structures containing a number of residences. *I.e.*, there's no telling what location was denoted by what address, and if 14020 is the number on the main or first building of the unit, but the actual structure inhabited by appellant was number 12346, due to the vagaries of municipal planning and address designations, then there is yet another debit in the thin sum total of proof appellant violated his registration obligation. (*People v. Virgil, supra,* 94 Cal.App.4th at pp. 503-504.)

2. Walnut Avenue

Appellant registered 1434 Walnut Avenue, Apartment 2. He lived at 1436 Walnut Avenue, Apartment 2. There is no evidence appellant knowingly put down the wrong address so as to escape the registration requirement. While testifying, appellant mistakenly referenced "Walnut Street, 1336" as his former residence. (*People v. Jackson, supra,* 109 Cal.App.4th at p. 1635.) As set forth *supra* at pp. 14-16, the trial court should have, but did not, instruct the jury on knowledge as an element of a section 290 violation. A trial court's failure to instruct a jury on an element of a crime requires reversal when "the defendant contested the omitted element and raised evidence sufficient to support a contrary finding." (*Neder v. United States* (1999) 527 U.S. 1, 19; *Pope v. Illinois* (1987) 481 U.S. 497, 503, fn. 7

Appellant so contested and so raised: he testified he knew of his duty to register, and dutifully registered as required. For the court not to instruct the jury that appellant actually knew or should have known that he put down the wrong address meant appellant could be convicted absent proof he was aware he was in violation of his statutory obligation. Particularly where, as here, the error is an error of a single digit—a 143*4* versus a 143*6*—an error which, unlike a more egregious misrepresentation, could be attributed to everything from intentional evasion to honest mistake to really bad handwriting. To borrow and bowdlerize from Justice Chin's majority opinion in *Garcia,* "a jury may infer from proof [of error] that the defendant did have actual knowledge...." (*People v. Garcia, supra,* 25 Cal.4th at p. 752.) The failure to fully instruct in this instance is not harmless beyond a reasonable doubt, and it is unfair. (*People v. Garcia, supra,* 25 Cal.4th at p. 755.)

Conclusion

The registration requirement requires an offender know both of his duty to register and of his failure to do so. Evidence of an admission must be viewed with caution, and is subject to the constraints of the corpus delecti rule. Appellant's jury was not so instructed, the evidence against him not so constitutionally circumscribed, and the State's proof factually inadequate— appellant's conviction on count 12 must be reversed. (*Rose v. Clark* (1986) 478 U.S. 570, 581-582; *People v. Garcia, supra,* 25 Cal.4th at p. 755; *People v. Jackson, supra,* 109 Cal.App.4th at p. 1635.)

ARGUMENT

APPELLANT'S GREAT BODILY INJURY FINDING MUST BE REVERSED AS NOT SUPPORTED BY CONSTITUTIONALLY SUFFICIENT EVIDENCE

Great bodily injury is "a significant or substantial physical injury." (Pen. Code § 12022.7(f); *People v. Escobar* (1992) 3 Cal.4th 740, 749-750.) "'A fine line can divide an injury from being significant or substantial from an injury that does not quite meet the description.'" (*Id.*, at p. 752, quoting *People v. Jaramillo* (179) 98 Cal.App.3d 830, 836.) Whether that line is crossed is necessarily fact-specific. (*People v. Cross* (2008) 45 Cal.4th 58, 65.) And the facts here do not sustain such a finding. (*Ibid.*)

In *People v. Cross, supra*, 45 Cal.4th at p. 60, the Supreme Court held that pregnancy without medical complications resulting from nonforcible intercourse "can" support a great bodily injury finding for sentencing purposes. The 13-year-old victim in Cross had been regularly sexually abused by her stepfather; when she was five and a half months pregnant, he took her to have an abortion. The 22 week-old fetus had to be surgically removed. There were no medical complications, and, after the abortion, the defendant resumed having sex with the girl until his arrest. The prosecutor argued at trial that *either* the pregnancy *or* the abortion constituted great bodily injury under the One Strike law. (*Id.*, at pp. 61-63.) Justice Kennard, writing for the Court, rejected the defense argument that only pregnancy resulting from a rape would support a finding of great bodily injury, the scenario supporting the finding in *People v. Sargent* (1978) 86 Cal.App.3d 148, 151-152. The Court also declined to hold that all pregnancies resulting from unlawful intercourse would constitute great bodily injury. (*People v. Cross, supra*, 45 Cal.4th at p. 66.)[1] Rather, the Court noted that *Sargent*, like the case before it, "was confined to the circumstances presented" (*id.*, at p. 65), *i.e.*, the facts at hand. And the facts—that the victim in *Cross* was 13, that the baby was 22 weeks old at the time of the abortion, that the fetus was then "'the size of two-and-a-half softballs'"—were enough to sustain the finding. (*Id.*, at p. 66.) The Court rejected the defendant's argument that the great bodily injury jury instruction as given (which stated that either the pregnancy or the abortion could constitute great bodily injury) was separate

[1] In his concurrence, Justice Corrigan maintained that pregnancy "will always impose on the victim a sufficient impact to meet the great bodily injury standard," and called upon the Legislature to amend Penal Code section 12022.7 accordingly. (*People v. Cross, supra*, 45 Cal.4th at pp. 73, 75.)

grounds for error, finding there was no reasonable likelihood the jury improperly understood the instruction to mean that the defendant personally inflicted the abortion. (*Id.*, at pp. 67-68.)

Here, the prosecutor erroneously and repeatedly argued both that pregnancy *per se* constituted great bodily injury and that appellant "caused" Elena's abortion. (RT 3:1536, 1553) As trenchantly put: "The law does not require anything more than the pregnancy. The pregnancy is the injury." "He caused the injury, the pregnancy, that led to the further injury of the abortion." (RT 3:1537, 3:1553) The prosecutor did briefly hypothesize about a woman who became pregnant but then miscarried early on, saying that this might be "arguable," which would then "be up to you to decide." This, according to the prosecutor, was apparently not that—though the prosecutor stopped slightly short of telling the jury it had nothing to decide. The prosecutor then, however, disavowed her hypothetical as well, reiterating the argument that the fact of pregnancy was the fact of injury ("Whether the defendant inflicted great bodily injury should not depend on what Elena's body decided to do with the pregnancy...."). (RT 3:1553-1554) For more case-specific poof, she cited Elena's weight gain, pallor and nausea, all commonplaces of pregnancy, even in its earliest stages, and, like the prosecutor in *Cross*, also cited the hazards and discomfort associated with her abortion, which, like the prosecutor in *Cross*, she argued were personally "caused" by appellant. (RT 1536-1537) But the risks referenced by the prosecutor were just that, risks, and appellant did not perform the abortion. (*People v. Cross, supra,* 45 Cal.4th at pp. 67-69 [improper to instruct that surgical abortion could be great bodily injury "personally inflicted" by defendant].)[2]

The fetus in appellant's case was 17 to 18 weeks old; there was no testimony as to its relative size at the time of the abortion. Compared to a "22 weeks and two days old"[3] fetus in *Cross*, which is typically between 7" and 10" long and weighs between 8 oz. and 1 lb. (usually closer to a pound), a 17 to 18-week old fetus is 5" to 5.5" long, weighing 5 to 5.5 oz.. In sum, a four-month old fetus is thus about two-thirds to half as long as and weighs roughly half to less than a third of a five-month old fetus. The movements of a 17 week old fetus may not yet be felt; an 18 week old fetus might be; a

2 The argument that the prosecutor improperly suggested the abortion was an adequate separate basis for the great bodily injury finding is not being raised because, like *Cross*, there seems to be no way the jury instructions, as given, would have supported such an interpretation/application of the evidence. (*People v. Cross, supra,* 45 Cal.4th at pp. 68-69.)

3 (*People v. Cross, supra,* 45 Cal.4th at p. 62.)

22 week old fetus can move freely, distinguish between light and dark, hear the maternal heartbeat, digestion, and voice. (*See e.g.*, http://www.drspock. com/article/0,1510,6238,00.html; http://www.whattoexpect.com/pregnancy/ week-by-week) These are not pleasant arguments, or considerations, but if a life sentence is to be imposed based on personal infliction of great bodily injury, then such arguments and considerations must be undertaken.

Simply put, the circumstances of Elena's pregnancy were insufficient to support the great bodily injury finding; that finding, and appellant's sentence on count 8, must therefore be reversed. (*People v. Cross, supra,* 45 Cal.4th at p. 66.)

ARGUMENT

APPELLANT'S DUE PROCESS RIGHTS WERE VIOLATED AS THERE WAS INSUFFICIENT EVIDENCE TO SUPPORT HIS CONVICTION BASED ON THE INHERENT IMPROBABILITY OF THE COMPLAINANT'S TESTIMONY

Courts once considered sex offense accusations "easily to be made and hard to be proved, and harder to be defended by the party accused, though never so innocent" (*People v. Huston* (1941) 45 Cal.App.2d 596, 597, quoting 1 Hale P. C. (1736) 635, 636); the pendulum has since swung to its other end-point, and such allegations are near-sacrosanct, free from the scrutiny given an ordinary charge of robbery. If a complaining robbery victim had falsely cried theft in other cases, if that victim had a pattern of so crying whenever crossed, and been proven a liar on several other points and occasions, and if, contrarily, the purported robber was shown to be a good man and citizen, there would be doubt sufficient to preclude his conviction. Taja was a troubled little girl from way back, one prone to accusing her caretakers of abuse and neglect. Her allegation of molestation against appellant was as baseless: appellant's conviction should be reversed as there was insufficient credible evidence to sustain the charge. (*See generally, Jackson v. Virginia* (1979) 443 U.S. 307, 318-319; *People v. Mayfield* (1997) 14 Cal.4th 668, 735, cert. den. 522 U.S. 839.)

The test to determine sufficiency of the evidence is "whether, on the entire record, a rational trier of fact could find appellant guilty beyond a reasonable doubt." (*People v. Johnson* (1980) 26 Cal.3d 557, 576-578 ["[O]ur task... is twofold. First, we must resolve the issue in light of the *whole record*.... Second, we must judge whether the evidence of each of the essential elements... is *substantial*...." at pp. 576-577, italics in the original]; *see also, People v. Barnes* (1986) 42 Cal.3d 284, 303.) Substantial evidence must support each essential element underlying the verdict: "'it is not enough for the respondent simply to point to 'some' evidence supporting the finding.'" (*People v. Johnson, supra,* 26 Cal.3d at p. 577, quoting *People v. Bassett* (1968) 69 Cal.2d 122, 138; *see generally, People v. Frye* (1998) 18 Cal.4th 894, 953, cert. den. 526 U.S. 1023.) Nor does a "50 percent probability" of an element constitute substantial evidence. If the facts as proven equally support two inconsistent interpretations, the judgment goes against the party bearing the burden of proof as a matter of law. (*People v. Allen* (1985) 165 Cal.App.3d 616, 626, citing, *Pennsylvania R. Co v. Chamberlain* (1933) 288 U.S. 333, 339.) Evidence that fails to meet

this substantive standard violates the Due Process Clause of the Fourteenth Amendment and article I, § 15 of the California Constitution.[1] (Jackson v. Virginia, supra, 443 U.S. at p. 319; People v. Johnson, supra, 26 Cal.3d at pp. 575-578.)

Though rare, there are cases in which convictions have been secured not just on legally insufficient evidence, but legally insupportable evidence. Bearing in mind the appellate court reviews the whole record in the light most favorable to the judgment (People v. Osband (1996) 13 Cal.4th 622, 690, cert. den. 519 U.S. 1061), and "[g]enerally, 'doubts about the credibility of [an] in-court witness should be left for the jury's resolution," (People v. Mayfield, supra, 14 Cal.4th a p. 735, quoting People v. Cudjo (1993) 6 Cal.4th 585, 609, cert. den. 513 U.S. 850 ["Except in these rare instances of demonstrable falsity, doubts about...."]), testimony may nonetheless be rejected:

... when it is inherently improbable or incredible,

i.e., "unbelievable per se," physically impossible, or

"wholly unacceptable to reasonable minds."

(Oldham v. Kizer (1991) 235 Cal.App.3d 1046, 1065, quoting Evjy v. City Title Ins. Co. (1953) 120 Cal.App.2d 488, 492; see also, People v. Huston (1943) 21 Cal.2d 690, 693; People v. Fremont (1941) 47 Cal.App.2d 341, 349-350.) The Supreme Court has specified the requisite quantum of proof in these cases as that evidence which asserts "something has occurred that it does not seem possible could have occurred under the circumstances disclosed." (People v. Headlee (1941) 18 Cal.2d 266, 267-268 [such deficit presents a question of law]; accord, People v. Mayberry (1975) 15 Cal.3d 143, 150; People v. Thorton (1974) 11 Cal.3d 738, 754, overruled on other grounds, People v. Flannel (1979) 25 Cal.3d 668, 684; see also, People v. Grant (1942) 53 Cal.App.2d 286, 287.) Under those circumstances, the appellate court "will assume that the verdict was the result of passion and prejudice." (People v. Headlee, supra, 18 Cal.2d at p. 267; People v. Nino (1920) 183 Cal. 126, 128 ["This court will not reverse a judgment given upon a verdict unless there is no evidence to support it, or when the evidence relied upon to uphold it is so inconsistent or improbable as to be incredible, or when it so clearly and unquestionably preponderates against the verdict as to convince the court that it was the result of passion or prejudice on the part of the jury."].)

1 "A state-court conviction that is not supported by sufficient evidence violates the due process clause of the Fourteenth Amendment and is invalid for that reason.... [A] California conviction without adequate support separately and independently offends, and falls under, the due process clause of article I, section 15." (People v. Thomas (1992) 2 Cal.4th 489, 545 (con. & dis. opn. of Mosk, J.), citation omitted.)

In *United States v. Chancey* (11th Cir., 1983) 715 F.2d 543, a conviction for kidnaping across state lines was reversed because the testimony of the purported victim, in the words of the court, "simply cannot pass muster...." (*Id.*, at p. 547.) Muster, in *Chancey*, being the complaining witness's failure to report her kidnaping, escape her kidnapper, or seek assistance in either case from a series of potential saviors, including a police officer. Because there was plenty of evidence the defendant and witness has engaged in a "transcontinental copulation spree," but only her testimony that the journey was nonconsensual, the court reviewed the credibility of this testimony. As the Eleventh Circuit put it, the rule that credibility issues are for the jury:

> ... does not address the problem, however, which arises when the testimony credited by the jury is so inherently incredible, so contrary to the teachings of basic human experience, so completely at odds with ordinary common sense, that no reasonable person would believe it beyond a reasonable doubt. The mere fact that the testimony is in the record is not enough. If a witness were to testify that he ran a mile in a minute, that could not be accepted, even if undisputed.[2] If one testified, without dispute, that he walked for an hour through a heavy rain but none of it fell on him, there would be no believers.

(*Id.*, at pp. 546-547.) Though the complaining witness in *Chancey* swore there was no consent, "her every *act* and *deed*" attested to her complicity, and thus the defendant's conviction could not stand. (*Id.*, at p. 547.)

In this case, Taja said that during the almost three years she lived with appellant and his wife, appellant repeatedly attempted to grab her breasts whenever they passed each other in the hall, tried to touch her breasts once while driving, and once, during a family camp-out in the living room, while lying next to his wife, appellant touched her breasts and put his hand in her vagina. More accurately, she initially testified she woke up first when she felt appellant's hand go into her underwear and vagina; she then pulled his hand out and yelled "you're sick." Later she testified she first felt appellant's hand touch her breast, threw his hand "out," and went back to sleep. (RT 635, 652) Brie first testified

2 The current indoor one-mile record is 3 minutes, 4.45 seconds for men (set by Hicham El Guerrouj on February 12, 1997), and 4 minutes, 17.14 seconds for women (set by Doina Melinte on February 9, 1990). (Http://www.guinessbookofworldrecords.com.)

she did not tell her grandmother during the year she lived with her grandmother, but told after moving back in with her grandmother, after leaving her mother's house. (RT 655-657)

Brie also testified she told her aunt about the camp-out incident right away, telling no one else until she told her grandmother. Brie moved to her grandmother's house after kicking the front door in and being asked to leave appellant's apartment; Brie lived with her grandmother for about a year before moving to her mother's house in Houston. Brie did not tell her grandmother about appellant's abuse during the first year she lived there after moving from appellant's apartment, rather, Brie told her grandmother about appellant's abuse and the abuse and neglect of Brie's mother only after moving out of her mother's house, where Brie had been living for five months to a year. In sum, Brie did not tell anyone appellant had molested her for somewhere between a year and a half to two years.

Brie's testimony does not describe the "physically impossible." Rather, Brie's testimony is "so inconsistent or improbable as to be incredible," and "so clearly and unquestionably preponderates against the verdict as to [be] the result of passion or prejudice on the part of the jury." (People v. Nino, supra, 183 Cal. at p. 128.) First, there are unsupported and spare allegations of random attempts at groping, which Brie, by her own testimony, thwarted as unwanted, just as she purportedly threw off appellant's hand in disgust during the camp-out. (RT 611-614, 616, 626-627, 642, 668-669) These attempts were supposedly reported by Brie to appellant's wife, who told her to "keep it in the house"; when Brie told appellant she was going to call the police, appellant told her not to tell as they would both get into trouble. (RT 615-616, 643) Leaving aside the fact the State did not call appellant's wife to corroborate any of this, the attitude of anger and revulsion represented by Brie's actions, as described by Brie—including threatening appellant with arrest—are belied by her mother's uncontradicted testimony that Brie was always jumping on appellant, wanting to play, and wanting his unadulterate attention. (RT 922, 926, 931-933) It's not that children who are abused never collude with their abuser,[3] but children who are "scared," who feel "really bad and uncomfortable about this touching"—as Brie said she did—do eschew or at least avoid their abuser. (RT 645) According to Brie, appellant's touches were "just disgusting,"[4] but Brie never made even

3 I.e., consent to the abuse. (C.f., People v. Lopez (1998) 19 Cal.4th 282, 293; People v. Cardenas (1994) 21 Cal.App.4th 927, 937, fn. 7.)

4 (RT 622)

minimal efforts to stay away from appellant, or tell anyone she did trust about the evils he was supposedly perpetrating even with 3,000 miles and 24 to 17 months between her and her alleged abuse and abuser. Despite, as in *Chancey*, the gross illogic of this failure and the number of "golden opportunities" to do so.[5]

Brie testified she didn't tell as a general matter because after "the first incident," she told appellant's wife, and appellant's wife told her not to tell anyone, they would just "forget about it and move on." But Brie could not remember what "the first incident" was. (RT 615-616, 643-644)

Brie saw her grandfather alone while she was living with appellant; her grandfather was her legal guardian, living in Southern California; Brie testified she knew her grandfather loved and would protect her. (RT 634-635, 646) Brie had a really good relationship with her grandfather, who helped raise her when she was living with her grandmother. During their day trips together, Brie's grandfather was "always telling her" she could stay with him any time. (RT 644-647) At trial, Brie testified she did not tell her grandfather about appellant's advances, or ask to stay with her grandfather, because she "didn't feel like talking about it." She didn't feel like talking about it because "I guess I didn't want to ruin the trip of spending time with him." (RT 646) Contrarily, Brie testified at the preliminary hearing she didn't tell her grandfather because she "didn't think about it." (CT 23)

Brie's mother also lived briefly at appellant's house; Brie testified she confided to her mother that appellant stared at Brie "every morning" while she slept. Her mother, according to Brie, said appellant also stared at her when she was sleeping. Brie testified she was "not really sure because I don't remember" why she didn't tell her mother about appellant's passes. (CT 20; RT 640-643, 655)

Brie's grandmother always made her feel comfortable: Brie testified she knew her grandmother loved her and would do anything to protect her. Brie's grandmother would never allow Brie to be mistreated or stay where she was being mistreated. (RT 644) Brie never felt uncomfortable talking

5 It will be argued that children are different, that they can never be held to an adult's cognitive standards, including the standard of reasonableness. (Inhelder, B., and Piaget, J., *The growth of logical thinking from childhood to adolescence: An essay on the construction of formal operational structures*, London: Routledge (1958).) But while children may not rationalize as an adult would, they do rationalize, and even a child does not embrace her abuser, unless the child (like the adult) perceives no other tenable alternative. (*See e.g., People v. Patino* (1994) 26 Cal.App.4th 1737, 1743-7144 [discussion of Child Sexual Abuse Accommodation Syndrome, noting its particulars are as consistent with false testimony as with true testimony].)

to her grandmother. Brie's grandmother called Brie almost every day while Brie was living with appellant and her aunt. At trial, Brie testified she did not tell her grandmother about appellant's advances while she was living with appellant because her aunt would lie and say Brie was not available when her grandmother called, though Brie was right there at the time. Brie also testified didn't know that her grandmother called her. Sometimes Brie would call her grandmother, but she didn't tell on those occasions because she has "a hard time sometimes expressing my feelings because ... I'm sensitive and ... really don't like talking about it." Brie "didn't think about" her grandmother protecting her from appellant. (RT 648-651) Contrarily, Brie testified at the preliminary hearing that she didn't tell her grandmother "because I just didn't want to talk about it." (CT 22)

Brie also testified she would walk home from school, staying alone at home until either appellant or her aunt got off work. Brie said she never called her grandmother, mother, or grandfather when she was alone because appellant and her aunt "got the long distance turned off." However, Brie did talk to her grandmother sometimes "like regular with long distance," and talked to her before the long distance was supposedly turned off. (RT 648-650)

Around the time Brie accused appellant of abuse, Brie also accused her mother of child abuse and neglect. After moving back in with her grandmother from her mother's house, Brie told her grandmother that Takecia walked around the house nude, and favored another daughter while abusing and neglecting the other. Brie said her mother beat her for half an hour on one occasion, that there were lots of photos of her mother naked, and that her stepfather took photos of her naked mother. Brie said she saw a photo of her mother nude with her father taking a picture of her. Brie's mother was investigated by the Texas authorities, and nothing came of Brie's allegations. (RT 656, 662-663) Unlike Brie's one- to two-year delay in reporting appellant, Brie reported her mother's alleged abuse within a week or two after moving out of her mother's house. (RT 657-659, 663)

With regard to the camp-out incident, Brie testified it occurred shortly before she was asked to move out of appellant's apartment, and that appellant was not only lying next to his wife when he decided to abuse Brie, but was under the same covers. Meanwhile, Brie was in a zippered sleeping bag, which came unzipped during the night. (RT 617-622, 667) At the preliminary hearing, Brie testified appellant had to unzip her bag because "it comes up and never comes down that much." (CT 12) At trial, Brie noted the bag came unzipped

when she moved, then swore on direct that she woke up because appellant was "unzipping my sleeping bag," but went back to sleep until she felt appellant's hand in her underwear. On cross-examination, Brie testified "to tell you the truth, I really don't know," how the bag came unzipped. She also testified she felt appellant touch her breast, "threw" his hand "out," and then turned and went back to sleep. Contrarily, she testified appellant "put his hand on her breast," but she was asleep during this touching, staying asleep until appellant touched her vagina. In her sleep-state, Brie said she was aware appellant touched the skin of her right breast with the skin of his hand. (RT 617-622, 626-627, 667, 669) At the preliminary hearing, Brie testified she felt nothing until appellant put his "finger" in her vagina. (CT 35, 37)

Brie also testified at the preliminary hearing that appellant put his hand down her panties and his finger in her vagina, and said he wanted to get on top of her, prompting her to yell "real loud," "you're sick." (CT 10, 12) According to Brie's initial testimony, her aunt woke up, and asked what was going on, but "I don't remember what happened then." A few minutes later, Brie did remember: her aunt told her if appellant had done what Brie said, Brie "should have caught his hand." (CT 11, 13) At trial, Brie testified her aunt told her to say she was making it up, so Brie agreed to say she was making it up. (RT 644)

Brie's mother, who initially believed her daughter and took her to the police to report appellant, soon decided Brie was lying. Brie's accusations didn't jibe with Takecia's own experience or opinion of appellant as a respectful man, or with her experience with children who are afraid of someone. Takecia testified Brie was not nervous around appellant, and, in fact, tried to command his ongoing attention. Takecia never told Brie appellant stared at her while she slept, and Brie had also lied about Takecia to her grandmother and the Texas authorities. (RT 905-911, 916, 922, 926, 931-935)

In sum, Brie's testimony was at best wildly inconsistent, and at least, highly improbable. Unlike other cases claiming insufficiency based on incredibility, there was no independent corroboration of Brie's accusations, and no telling admissions by appellant. (*Compare, People v. Byrnes* (1948) 84 Cal.App.2d 64, 69; *People v. Fremont, supra,* 47 Cal.App.2d at pp. 348, 350.) During their recorded conversation, Brie's indirect accusations of impropriety were met with appellant's confusion ("You know I've never disrespected you." "Did what?" "I told you years ago how wrong stuff like that were." (CT 65)), misunderstanding ("you used to pick at me all the time, so I used to pick back at you." "Whatever incidentally might have happened is—is past..." "If I owe

you an apology, or something, dear, I apologize." (CT 65)), and, as appellant began to understand what Brie was accusing him of, an absolute denial of guilt ("... there's nothing more, ever been more than just a regular relationship...." (CT 66)). To the extent appellant claimed culpability, he claimed culpability for "picking" on Brie, which he testified were those times he went to pinch her as she'd pinched him, knowing, as he put it on the tape, that he—as the adult— should not have done such things, but lost his temper because Brie "actually upset me to the degree for whereas I'm a grown adult, and you're a young girl, growing up." (CT 66) However inarticulate, appellant's response to his niece's allegations of "touching," first interpreted by him as referring to their mutual pinching and picking,[6] is not a sturdy enough hook upon which to hang a charge of child molestation. Not, that is, when added to Brie's irregular testimony, her inexplicable failure to report for a year and a half to two years, and her apparent fell-swoop penchant for accusing family members of abuse after she's worn out her welcome. (See also, People v. Franz (2001) 88 Cal.App.4th 1426, 1439, 1447; see generally, People v. Green (1980) 27 Cal.3d 1, 55 [evidence to be of "solid value" to sustain conviction].)

There was a time "... our courts [were] concerned about the vulnerability of children to suggestion or manipulation by adults who desired to use prosecution in this area for ulterior motives." (People v. Thomas (1978) 20 Cal.3d 457, 472, citing People v. Adams (1939) 14 Cal.2d 154, 166-167, quoting People v. Benson (1856) 6 Cal.221, 223 ["'There is no class of prosecutions attended with so much danger, or which afford so ample an opportunity for the free play of malice and private vengeance...'"].)[7] That time has passed, along with the skepticism that girded such concerns. In most cases, this is laudable. But appellant's case is not most cases. (See generally, People v. Breault (1990) 223 Cal.App.3d 125, 140-141; In re Paul C. (1990) 221 Cal.App. 3d 43, 54.) Because the evidence appellant molested Brie does not pass constitutional

6 In this regard, it appears the jury's verdict, as much as can be illuminated by its note, may have been based on these pinchings and pickings, as the "any lewd act" referenced by its note to the court. (See generally, People v. Markus (1978) 82 Cal.App.3d 477, 480.) And, not to put too fine a point on it, it's worth remembering the State dismissed count 2 on its own motion for insufficiency.

7 "It must be remembered, that it is an accusation easily to be made and hard to be proved, and harder to be defended by the party accused, though never so innocent; [and we should] be the more cautious upon trials of offenses of this nature, wherein the court and jury may with so much ease be imposed upon without great care and vigilance; the heinousness of the offense many times transporting the judge and jury with so much indignation that they are over hastily carried to the conviction of the person accused thereof by the confident testimony sometimes of malicious and false witnesses." (1 Hale P. C. (1736) 635, 636.)

muster, his conviction for violating Penal Code section 288, subdivision (a) must be reversed, and appellant may not be retried on that allegation. (U.S. Const., Fifth Amend.; *Lockhart v. Nelson* (1988) 488 U.S. 33, 34; *Burks v. United States* (1978) 437 U.S. 1, 10-11 [double jeopardy precludes retrial "for the purpose of affording the prosecution another opportunity to supply evidence which it failed to muster in the first proceeding"].)

VANESSA PLACE

ARGUMENT

Dear Clerk:

This supplemental letter brief is filed in response to the Court's March 26, 2009 request for additional briefing on the following issues: 1. Did the trial court commit prejudicial error in denying appellant's motion to sever counts 1 through 5 (Crista Mezo and Daniella C.) from counts 6 through 10 (Alicia A.); 2. Did the trial court commit prejudicial error in denying appellant's motion to exclude evidence of DNA on the ground that it was taken in violation of his due process and Fourth Amendment rights; 3. Did the trial court commit prejudicial error in admitting evidence of Crista Mezo' identification of appellant from the photographic lineup; 4. Did the trial court commit prejudicial error in refusing appellant's request to give CALCRIM 306 (untimely disclosure of evidence); 5. Did the trial court commit prejudice error in refusing appellant's request to give CALCRIM 1800 (theft by larceny); 6. Did the trial court commit prejudicial error in ruling that defendant could be separately punished for the burglary charged in count 1 and the robbery charged in count 4 (Crista Mezo); 7. Did the trial court commit prejudicial error in ruling that defendant could be separately punished for the burglary charged in count 6 and the robbery charged in count 7 (Alicia A.); 8. Did the trial court commit prejudicial error in doubling the sentence for the enhancements? (Cal. Rules of Court, rule 8.200(a)(4).) Appellant will respond to each request in the order presented by the Court.

1. With regard to the trial court's failure to sever, appellant would submit on the issue. (Pen. Code § 954; *People v. Soper* (2009) 45 Cal.4th 759, 773-776, 779 [discussion of cross-admissibility, presumption in favor of joinder and need for actual prejudice]; *compare, People v. Earle* (2009) 172 Cal.App.4th 372, 288-410 [detailing how failure to sever resulted in a deprivation of due process in that case].)

2. Appellant would submit on the Fourth Amendment/due process question posed by the police's collection of his DNA reference sample insofar as Det. Jose Espino testified appellant was unresponsive/unconscious at the time the first swab was collected (RT 8:5416) and was cooperative during the collection of the second sample, the sample subsequently transmitted to the crime lab for testing. (RT 8:5427-5428) (*Murray v. United States* (1988) 487 U.S.

533, 538-540; *Nix v. Williams* (1984) 467 U.S. 431, 443; *see also, Schmerber v. California* (1966) 384 U.S. 757, 767; *People v. Johnson* (2006) 139 Cal.App.4th 1135, 1158; *c.f., Skinner v. Railway Labor Executives' Ass'n* (1989) 489 U.S. 602, 617; *c.f. People v. Haendiges* (1983) 142 Cal.App.3d Supp. 9, 16.)

3. Subject to the following considerations, appellant would submit on the question whether the trial court committed prejudicial error in admitting evidence of Crista Mezo's identification of defendant from the photographic lineup. (*Manson v. Brathwaite* (1977) 432 U.S. 998, 114.) Mezo testified at the preliminary hearing that Det. Prince told her that police had a rape suspect in custody who might have been the perpetrator in her case. (RT 5:3661, 5:3665-3666) At trial, she testified that she went to the station to be interviewed a week after the robbery; while in the hallway, she ran into a deputy that she knew from another incident. The deputy told her there had been a rape in her area, and to be careful. Four hours later, Mezo met with Det. Prince; she asked the detective about the deputy's comment, and Prince said that it was true, but "separate." Prince said there was a rape in the other case. Mezo said that the detective did not say that there was a suspect in custody that he felt could be the perpetrator in her case. (RT 5:3636-3640, 5:3658-3660, 5:3672-3677, 5:3703-5705) At the preliminary hearing, Mezo said Prince had told her there was a rape suspect in custody who might be the suspect in her case, and he was going to show her the photo lineup to see if she recognized anyone. (RT 5:3668) At trial, Mezo testified that when she looked at the photo lineup, she immediately recognized appellant, and began crying and saying, "That's him." (RT 5:3642, 5:3675-3676, 5:3683) Prince did not respond. (RT 5:3706) Mezo was then taken to the tow yard, where jeans and a shirt matching her description of the robber's shirt was taken from the trunk of Alicia A.'s car. (RT 5:3609-3610, 5:3680) Mezo did not describe the robber as having tattoos, which are visible on appellant. (RT 5:3694, 5:3701-3702, 6:3904-3905, 6:3908-3910)

Prince testified he told Mezo about the rape suspect at some point near the end of the interview, before showing her the photo lineup. He gave Mezo the standard admonition before showing her the photo lineup, she looked at the pictures for several seconds, then identified appellant. Prince did not indicate to Mezo whether she had identified the rape suspect. (RT 6:3997-4006, 6:4017-4022) Factors to be considered in determining if a particular lineup was unduly suggestive are: the witness's opportunity to view the perpetrator at

the time of the offense; the witness's degree of attention; the accuracy of the witness's prior description of the perpetrator; the level of certainty demonstrated at the confrontation; the time between the crime and confrontation; and "the suggestiveness of the procedure employed." (*Manson v. Brathwaite, supra,* 432 U.S. at p. 114; *People v. Sanders* (1990) 51 C.3d 471, 508) Due process is violated if the procedure is "so impermissibly suggestive as to give rise to a very substantial likelihood of irreparable misidentification." (*Ibid.,* quoting *People v. Sequeria* (1981) 126 Cal.App.1, 12.)

4. Appellant would submit on the question whether the trial court committed prejudicial error in refusing appellant's request to give CALCRIM 306 on untimely disclosure of evidence (*see,* Pen. Code § 1054.5(b)), insofar as it appears the request was based upon the prosecutor's failure to disclose Alicia A.'s prior sexual history, to provide timely disclosure of the examining nurse's *c.v.* and the paramedic's report, and as there is no requirement that a party gain any tactical advantage or be "actually affected" by the belated disclosure in order for the instruction to be given. (*People v. Riggs* (2008) 44 Cal.4th 248, 307-308, 311; *People v. Bell* (200) 118 Cal.App.4th 254-255; *c.f., Kyles v. Whitley* (1995) 514 U.S. 419, 437; *Stickler v. Greene* (1999) 527 U.S. 263, 281-282; *In re Brown* (198) 17 Cal.4th 873, 879-881; *People v. Uribe* (2008) 162 Cal.App.4th 1457, 1482.)

5. Appellant would submit on the question whether the trial court committed prejudicial error in refusing to give CALCRIM 1800 (theft by larceny), insofar as theft by larceny (Pen. Code § 484) is a lesser included offense of robbery (Pen. Code § 211). (*See generally, People v. Miller* (1974) 43 Cal.App.3d 77, 81.)

6. With regard to whether the trial court erred in separately punishing the burglary charged in count 1 and the robbery of Crista Mezo charged in count 4, Penal Code section 654, subdivision (a) provides that "[a]n act or omission that is punishable in different ways by different provisions of law shall be punished under the provision that provides for the longest potential term of imprisonment, but in no case shall the act or omission be punished under more than one provision..." (*People v. Latimer* (1993) 5 Cal.4th1203, 1207-1212, 1216-1217.) There are three questions to be considered by the Court in determining the applicability of section 654 to counts 1 and 4. First, whether the evidence

supported a reasonable inference that appellant had any criminal objective independent of the intent to rob when he entered Mezo's apartment. (*Id.*, at p. 1208; *People v. Perry* (2007) 154 Cal.App.4th 1521, 1525; *see also, People v. Hughes* (2002) 27 Cal.4th 287, 348-349.) If a defendant has more than one independent criminal objective, he may properly be punished for each offense, "even though the crimes shared common acts or were parts of an otherwise indivisible course of conduct." (*Ibid.*; *People v. Harrison* (1989) 48 Cal.3d 321, 324-325.)

In this case, appellant's jury was instructed as to counts 1 and 6 that if it found appellant entered the building with the intent to commit "theft/or forcible rape or sodomy by force," appellant would be guilty of burglary, regardless whether the target crime was completed. (CT 3:553) It could be argued that substantial evidence supports the conclusion that appellant entered Mezo's home with the intent solely to commit a robbery, and that whatever intent he may have formed in terms of potentially assaulting Mezo, was formed only *after* he discovered that she had no money in the apartment. (*People v. Estrada* (1997) 57 Cal.App.4th 1270, 1276; *c.f., People v. Guiton* (1993) 4 Cal.4th 1116, 1127 ["if there are two possible grounds for the jury's verdict, one unreasonable and the other reasonable, we will assume, absent a contrary indication in the record, that the jury based its verdict on the reasonable ground."]; *People v. Russo* (2001) 25 Cal.4th 1124, 1132-1133 [jury need not unanimously decide or be certain, which felony burglary defendant intended].)

Second, the Supreme Court in *People v. Sparks* (2002) 28 Cal.4th 71, held that entry of a separate bedroom within a home with the requisite intent constitutes a burglary, even if the defendant had no such intent when he initially entered the home itself. (*Id.*, at p. 87.) Therefore, if appellant entered Mezo's daughter's bedroom with the intent to commit an assault therein, that could have provided an independent basis for the burglary conviction. (*Ibid.*) But again, the jury was instructed that a burglary would lie in counts 1 and 6 only if appellant entered "the building" with the requisite intent. The additional instructional language ("room within a building") was crossed out by the trial court: the jury affirmatively did not decide appellant's guilt on count 1 on those grounds. (CT 3:553) Thus, the burglary conviction in this case cannot be sustained based on the entry into the interior room: either the jury determined that appellant entered Mezo's home with a dual intent to rob and commit a sex offense, or section 654 proscribes multiple punishments on counts 1 and 4. (*People v. Beamon*

(1973) 8 Cal.3d 625, 637; *People v. Bauer* (1969) 1 Cal.3d 368, 376; *People v. Washington* (1996) 50 Cal.App.4th 568, 587.)

Third, assuming the Court finds that no reasonable inference could be drawn that appellant harbored a separate criminal objective other than robbery at the time he entered the apartment, and the entry into the bedroom is not proper basis for the burglary charge in count 1, the question becomes whether the ATM robbery was part of the robbery begun when appellant entered the apartment, or was a separate criminal venture. It could be argued that given a robbery is ongoing until the robber reaches a place of temporary safety (*People v. Carroll* (1970) 1 Cal.3d 581, 585; *People v. Chapman* (1968) 261 Cal.App.2d 149, 175), the ATM robbery was simply the terminus of appellant's robbery of Mezo. Thus, the sentence in count 1 should be stayed. (*People v Beamon*, supra, 8 Cal.3d at p. 637.)

7. With regard to whether the trial court erred in separately punishing the burglary charged in count 6 and the robbery of Alicia A. charged in count 7, it appears the court stayed the sentence in count 7 pursuant to section 654. (CT 3:655, 3:658)

8. The trial court should not have doubled the sentence for the enhancements. (Pen. Code § 1170.12(c)(1).)

Please be advised that I will be out of the country from April 27 until May 3rd, but will be available to respond to any additional requests the Court may have upon my return.

Very truly yours,

Vanessa Place

ARGUMENT

APPELLANT'S CONVICTIONS MUST BE REVERSED FOR PROSECUTORIAL MISCONDUCT

Prosecutorial misconduct has been characterized and condemned "thousands of times in cases issued in the courts of appeal throughout the land." (*People v. Zurinaga* (2007) 148 Cal.App.4th 1248, 1251.) The thesis is bedrock:

> The [prosecuting attorney] is the representative not of an ordinary party to a controversy, but of a sovereignty whose obligation to govern impartially is as compelling as its obligation to govern at all; and whose interest, therefore, in a criminal prosecution is not that it shall win a case, but that justice shall be done. As such he is in a peculiar and very definite sense the servant of the law, the twofold aim of which is that guilt shall not escape or innocence suffer. He may prosecute with earnestness and vigor—indeed, he should do so. But, while he may strike hard blows, he is not at liberty to strike foul ones. It is as much his duty to refrain from improper methods calculated to produce a wrongful conviction as it is to use every legitimate means to bring about a just one.

(*Berger v. United States* (1935) 295 U.S. 78, 88; *People v. Samayoa* (1997) 15 Cal.4th 795, 841.) But the abuse continues: in appellant's case, the prosecutor wept (or nearly wept) during closing argument, but wept (or nearly wept) in memory of police officers killed in the line of duty, all in apparent rebuttal to defense criticism of the actions of the officers in appellant's case.[1] The prosecutor also repeatedly and gratuitously disparaged defense counsel, casting aspersions on everything from his literary references to his trial tactics. "Prosecutors who engage in rude or intemperate behavior, even in response to provocation by opposing counsel, greatly demean the office they hold and the People in whose name they serve." (*People v. Hill* (1998) 17 Cal.4th 800, 819.)

1 It should be noted that the officers here were not harmed in the making of their case against appellant.

A prosecutor is given wide latitude during argument, but a prosecutor is not given *carte blanche*. The prosecutor may not, for example, express a personal opinion in guilt where there is a substantial danger that the jurors will think such an opinion is based on information other than that adduced at trial. (*People v. Bain* (1971) 5 Cal.3d 839, 848.) It is also improper for the prosecutor to accuse defense counsel of "fabricating a defense" (*People v. Bemore* (2000) 22 Cal.4th 809, 846), or "to otherwise denigrate" defense counsel (*People v. Woods* (2006) 146 Cal.App.4th 106, 117).

In *Woods*, the prosecutor said defense witnesses were "conjured up" just before trial, an argument that Division Eight found effectively charged counsel with suborning perjury. (*People v. Woods, supra,* 146 Cal.App.4th at p. 117.) The prosecutor also responded to a defense attack on the credibility of the police witness by stating that allegations of mispropriety were demonstrably false because counsel had not, as counsel was "obligated" to do, put on any witnesses to support them; that the officer in question simply had a job to do and did it; and that other officers would hardly endanger their livelihoods by rousting the defendant. The appellate court held these comments amounted to improper vouching for the prosecution witnesses, as well as an impermissible suggestion that the defense had an affirmative obligation to produce evidence. Moreover, given there were allegations of misconduct against one of the officers in question, the prosecutor was arguing a position the prosecutor knew to be false. (*Id.*, at pp. 113-114.) Similarly, in *People v. Alvarado* (2006) 141 Cal. App.4th 1577, 1583, the prosecutor impermissibly vouched for her office and the victim's credibility when she began her rebuttal argument by stating that: "I have a duty and I have taken an oath as a deputy District Attorney not to prosecute a case if I have any doubt that that crime occurred. [¶] The defendant charged is the person who did it."

In appellant's case, the prosecutor opened her rebuttal by drawing a cartoon of two animals, captioning them for the jury as a *dog and pony show*, then saying:

> I always get so angry when it's the attack-the-police strategy, because I've known five officers killed in the line of duty.
> Defense counsel objected; the objection was overruled, and the prosecutor continued:
> So when I hear experienced officers attacked in their integrity, it makes me very, very angry.

Defense counsel interrupted with a "running objection," duly noted by the court; the prosecutor went on:

So counsel can attack the police, because what he wants to do is distract you from the facts.

(RT 9: 4879)

Not only was this an outlandish play for the jury's sympathy, it was also "neither answered... nor were otherwise justified" by the defense argument. (*People v. Alvarado, supra,* 141 Cal.App.4th at p. 1585.) In *People v. Zurinaga, supra,* 148 Cal.App.4th 1248, 1255, the prosecutor, in response to a statement by defense counsel, drew an analogy between the victims on the September 11, 2001 airplanes and the victims of defendants' home invasion robbery. The analogy was not only drawn, it was literally illustrated with charts, passenger rosters, and an exhortation to the jurors to put themselves in the passengers' position, and, by inference, the robbery victims'. (*Id.,* at pp. 1255, 1260.) Division Six found clear prosecutorial misconduct in the inapt and "beyond the pale" analogy, but did not find prejudicial error given the evidence of guilt. (*Id.,* at p. 1260.)

In appellant's case, the prosecutor engaged in a variety of misconduct, from attesting to matters outside the record:

The prosecutor on DNA evidence:

Don't be misled by the defense arguing, "Oh, well, you know, this is technology that was developed in the '70s." Well, actually, I can remember as a child looking at LIFE magazine in the '50s, and I believe it was Watson and Crick who were the discoverers of the whole DNA molecule, who discovered it in the '50s, because it was on the cover of LIFE magazine. And I remember that quite well. So it's not brand new technology, it is 50 years old.[2]

(RT 9:4887)

And on the Arizona DNA study where unrelated inmates shared a number of alleles:

[2] There was no objection to this statement; counsel having unsuccessfully objected to the prosecutor tearing up at the beginning of her rebuttal, it may be said that on these later points "a timely objection and/or a request for admonition" would have been futile, and counsel's failure to further object is excused. (*People v. Hill, supra,* 17 Cal.4th at p. 820.)

> *Well, the word to remember is "apparently unrelated."*
> *Because I think we all know that Thomas Jefferson*
> *has both black and white offspring. That's pretty—I*
> *mean we've seen the movie, we've heard the*
> *television stuff. So just because one person appears*
> *black and one person appears white doesn't mean*
> *they can't be related.*

(RT 9:4889-4890)

The prosecution on the veracity of its police witnesses:

> *And you know what? It does make sense to me that*
> *Detective Prestwich would want to get it on tape,*
> *because there were so many incidents, so many*
> *people, so many facts to try and keep straight.*

(RT 9:4894)[3]

> *And remember, it's not just Detective Prestwich that*
> *testified there wasn't coercion or threats or any of*
> *that. Detective Sheppard also testified that there*
> *wasn't any such thing. And are you going to believe*
> *the testimony of two officers that have no reason to*
> *come in here and lie or that of a multiple-convicted*
> *felon?*

(RT 8:4635)[4]

The prosecution on defense tactics:

> *And, ladies and gentlemen, if the defense wanted*
> *to, they could have had their own DNA expert testify*
> *in this case. Could have had their own DNA expert*
> *testify in this case.*

(RT 8:4635)[5]

3 The prosecutor also argued that "[W]hether someone tapes or not is discretionary with the Sheriff's Department. The F.B.I. never tapes their interviews." The court partially sustained the defense objection, striking the comment about the FBI. (RT 9:4894)

4 This appears to fly in the face of the proffered testimony of Sam Trejo that officers searched his home without a warrant on four occasions: Trejo had the telephone number appellant dialed from Eddie's phone. It was suggested, though not established, that Sheppard participated in the illegal searches. The court refused to admit the testimony as insufficiently similar to the coercive tactics complained of by appellant. (RT 8:4504-4531)

5 Counsel objects; the court overrules the objection; the prosecutor continues. (RT 8:4635-4637)

*As I was saying, the defense could have called their
own defense expert on DNA if they had a problem
with the People's defense [sic] expert. They did not
call a DNA expert.*

(RT 8:4637)

Well, ladies and gentlemen, he was inferring that
we didn't do a live lineup. The defense has an equal
opportunity to ask for a live lineup if they thought that
that—the defendant would not be identified in the
lineup. [¶] But the defense chose not to. [¶] Just as
the defense chose not to call a DNA expert. Just as
the defense chose not to call any other witnesses. [¶]
And you know what's interesting? I don't think that
the defendant's mother was attacked by the People
in this case. Hasn't been attacked anywhere near
the attacking that's been done, personal attacks on
Detective Prestwich. [¶] But what's real interesting
is we have six incidents. The defendant's mother
came in to testify. And we know that they lived at the
same address. Not one person came in and gave
the defendant an alibi for any of the six incidents.

(RT 9:4903)

The prosecution on defense counsel:

*Okay. Then the defense talked about the confession
and said, it's like "A Tale of Two Cities." Well, he's
pretty much as bad at English literature as he is at
DNA, because "A Tale of Two Cities" had nothing
to do with two versions. It had to do with two cities,
Paris and London. That's what the two cities refers
to.*

(RT 9:4891)

The prosecutor thus went impermissibly outside the record to support
its argument (*People v. Benson* (1990) 52 Cal.3d 754, 794-795), vouched for
the credibility of its witnesses (*People v. Hall* (2000) 82 Cal.App.4th 813, 817),
improperly commented on defense tactics (*People v. Bemore, supra,* 22 Cal.4th
at p. 846), engaged in personal attacks on defense counsel (*People v. Bell*
(1989) 49 Cal.3d 502, 538), and, in its opening salvo, stood tearfully upon the

bodies of fallen police officers in a reprehensible bid for jury sympathy. (*People v. Zurinaga, supra,* 148 Cal.App.4th at p. 1260; *People v. Zambrano* (2004) 124 Cal.App.4th 228, 241.)

After the case was submitted, defense counsel moved for a mistrial based on prosecutorial misconduct, arguing the prosecutor had improperly shifted the burden to the defense, and citing the prosecutor's weeping. The trial court indicated that it had not actually seen tears during argument, but that the prosecutor "appeared emotional." The prosecutor denied crying, saying she was "more angry than anything" about the "attacks on the character [sic] of the officers in this case." In denying the motion, the court noted there was leeway in argument to "media events," and that, again, it did not see the prosecutor actually crying. (RT 9:4908-4910 ["I can't say that Ms. Cromer was crying in the sense of tears coming down."])

Counsel later presented testimony as part of the motion for new trial that the prosecutor was crying: a cousin of appellant's mother, sitting in the audience, testified the deputy district attorney's voice was cracking, her face was red, and she was in tears as she referred to officers who had lost their lives in the line of duty. (RT 10:6901-6907) The prosecutor again maintained she did not cry. (RT 10:6908-6909) In denying the motion, the court found that it did not think the witness could have seen "actual tears" during argument, that the court itself could not see the prosecutor's face during argument, but that it did detect emotion, and that "I do recall it certainly was not an outright crying." (RT 10:6914-6915)

But the impropriety here was not lachrymosity. The impropriety here was the interjection of irrelevant sentiment. It is tragic, and noble, when an officer falls in the line of duty, but neither tragedy nor nobility had anything to do with the officers in appellant's case. Th prosecutor in *Woods* comparably rebutted defense allegations of police misconduct by arguing the officers would not "risk their careers and their livelihood" for the case, not risk "pensions, house notes, car notes... bank accounts, children's tuition.."; Division Eight condemned this tactic as vouching for the witnesses' credibility, reversing the conviction for the cumulative effect of the misconduct at hand. (*People v. Woods, supra,* 146 Cal.App at pp. 114-115, 117 [significant that court overruled objections to argument]; *see also, People v. Hill, supra,* 17 Cal.4th at p. 845.) By overruling defense counsel's objection to the prosecutor's exploitation of the fallen officers, appellant's court ratified the prosecutor's suggestion that those who serve—as they may make the ultimate sacrifice – are somehow inherently

more honorable, more trustworthy than other witnesses,[6] and that defense counsel's "attack" on Detectives Prestwich and Sheppard was an insult to the memories of those who served.

For this, and the other instances of prosecutorial misconduct, appellant's convictions should be reversed. (*People v. Woods, supra,* 146 Cal. App.4th at p. 119.)

6 Nor did the standard instruction serve to cure the misconduct, particularly as the court had signaled to the jury that the remarks were not objectionable. (*People v. Woods, supra,* 146 Cal.App.4th at p. 118 [instruction that statements of attorneys are not evidence "not a magical incantation that erases" prosecutorial misconduct].)

ARGUMENT

APPELLANT'S CONVICTIONS MUST BE REVERSED AS THE CONSENT INSTRUCTION GIVEN IN RAPE CASES CONSTITUTES AN UNCONSTITUTIONAL SHIFT IN THE BURDEN OF PROOF

Introduction

The Sixth and Fourteenth Amendments require a defendant be convicted only on proof beyond a reasonable doubt of each element of every charged offense. (*In re Winship* (1970) 397 U.S. 358, 364.) To be convicted of rape, the State must prove the victim did not consent to sexual intercourse with the perpetrator.[1] CALJIC No. 1.23.1 defines consent in enumerated sex cases as an act or attitude of "positive cooperation."[2] As written, the consent definition requires affirmative proof of nothing: to prove the intent element in a rape case, the State simply has to show the absence of cooperation. In other words, the instruction creates a rebuttable mandatory presumption of lack of consent where there is not proof positive of assent. Because the defendant must then overcome this presumption by proving either actual cooperation or his reasonable, good-faith belief in such cooperation (*People v. Mayberry, supra,* 15 Cal.3d at pp. 155, 157), CALJIC No. 1.23.1 unconstitutionally shifts the burden of persuasion on that element to the defense. (*See, Francis v. Franklin* (1985) 471 U.S. 307, 317 [85 L.Ed.2d 344; 105 S.Ct. 1965].) Again, the court here failed to orally instruct the jury on the element of intent/lack of consent. However, insofar as appellant's jury could be deemed instructed under CALJIC No. 1.23.1;[3] appellant's convictions must be reversed. (*Rose v. Clark* (1986) 478 U.S. 570, 581-582.)

1 As defined for the jury in pertinent part by CALJIC No. 10.00 [Rape—Spouse and Non-Spouse—Force or Threats]: "... Every person who engages in an act of sexual intercourse with another person who is not the spouse of the perpetrator accomplished against that person's will by means of force, violence, duress, menace, or fear of immediate and unlawful bodily injury to that person is guilty of the crime of rape.... [&].... 'Against that person's will' means without the consent of the alleged victim." (CT 354; RT 1833-1834)

2 (Pen. Code § 261.6 ["In prosecutions under Section 261... in which consent is at issue, 'consent' shall be defined to mean positive cooperation in act or attitude pursuant to an exercise of free will. The person must act freely and voluntarily and have knowledge of the nature of the act or transaction involved. [&] A current or previous dating or marital relationship shall not be sufficient to constitute consent where consent is at issue in a prosecution under Section 261.... [&] Nothing in this section shall affect the admissibility of evidence or the burden of proof on the issue of consent."].)

3 (CT 355-356) There was no objection by trial counsel to the written instruction, and no waiver because of the failure to object. A trial court is under a duty to instruct the jury with No. 1.23.1

A. Presumptive jury instructions: overview.

Presumptive instructions are either mandatory or permissive. A permissive instruction "does not require... the trier of fact to infer the elemental fact from proof by the prosecutor of the basic one and ... places no burden of any kind on the defendant." (*Ulster County Court v. Allen* (1979) 442 U.S 140, 157.) Permissive presumptions are constitutional so long as the permitted inference is rational. (*Yates v. Evatt* (1991) 500 U.S. 391, 402, fn. 7; *Francis v. Franklin, supra,* 471 U.S. at pp. 314-315.) Mandatory presumptions instruct the jury "it must infer the presumed fact if the State proves certain predicate facts," on the other hand, mandatory presumptions are either conclusive or rebuttable. (*Id.,* at p. 314; *see also, Sandstrom v. Montana* (1979) 442 U.S. 510, 517-518; *Patterson v. New York* (1977) 432 U.S. 197, 210, 215.) A conclusive presumption removes an element from jury consideration after the State proves the predicate facts giving rise to the presumption. (*Francis v. Franklin, supra,* 471 U.S. at p. 314, fn. 2.) A rebuttable presumption does not entirely remove an element from consideration, but requires the jury find the presumed element "unless the defendant persuades the jury that such a finding is unwarranted." (*Ibid.*) Presumptive instructions are constitutionally "pernicious" insofar as they impermissibly shift the burden of proof to the defendant, thereby violating the Due Process clause. (*Yates v. Evatt, supra,* 500 U.S. at p. 401 [*Francis* instructions improperly "shifted the burden of proof on *intent* to the defendant."], emphasis added; U.S. Const. Fourteenth Amend.; Cal. Const., art. I, § 15; *Sandstrom v. Montana, supra,* 442 U.S. at p. 514.)

The Court in *Francis v. Franklin, supra,* 471 U.S. 307, delineated a two-step process for determining whether a jury instruction creates an improper presumption, prefatorially noting "[a]nalysis must focus initially on the specific language challenged," though

> ... the inquiry does not end there. If a specific
> portion of the jury charge, considered in isolation,
> could reasonably have been understood as creating
> a presumption that relieves the State of its burden
> of persuasion on an element of an offense, the

"in prosecutions under Penal Code sections 261, 262, 288a or 289." (Use Note, CALJIC No. 1.23.1, CALJIC (6th ed. 1996).) There is no obligation to object to instructions "not correct in law" on due process grounds. (*People v. Smithey* (1999) 20 Cal.4th 936, 976, fn. 7, cert. den. 529 U.S. 1026; *see also, People v. Flood* (1998) 18 Cal.4th 470, 482, fn. 2; *accord,* Pen. Code § 1259 ["The appellate court may also review any instruction given, refused or modified, even though no objection was made thereto in the lower court, if the substantial rights of the defendant were affected thereby."].)

> potentially offending words must be considered in the context of the charge as a whole. Other instructions might explain the particular infirm language to the extent that a reasonable juror could not have considered the charge to have created an unconstitutional presumption.

(Id., at p. 315.) If a specific instruction both "alone and in context of the overall charge, could have been understood by reasonable jurors to require them to find the presumed fact if the State proves certain predicate facts," the instruction is constitutionally noxious, and the reviewing court then determines whether the error was harmless in the case at hand. (*Carella v. California* (1989) 491 U.S. 263, 265; *Neder v. United States* (1999) 527 U.S. 1, 9-10.)

B. "Consent" as defined by CALJIC No. 1.23.1.

As argued, the intent element in a rape case is the negation of a lawful intent: to prove this negation according to the terms of No. 1.23.1, the State need only prove the victim did not assent to intercourse either pre- or post-penetration.[4] (*In re John Z.* (2003) 29 Cal.4th 756, 761-762; *People v. Roundtree* (1999) 75 Cal.App.4th 1158, 1163.) The requirement of assent has been strictly interpreted: submission is not enough, initial consent will not do, nor will "actual" as opposed to "legal" consent suffice, as in cases of statutory rape or rape by intoxication. (*People v. Hernandez, supra,* 61 Cal.2d at p. 536; *People v. Giardino* (2000) 82 Cal.App.4th 454, 460 ["By itself, the existence of actual consent is not sufficient to establish a defense to a charge of rape."].) Again, No. 1.23.1 defines consent as positive proof of cooperation in act or attitude so that consent as an element is lack of consent, the absence of ad hoc cooperation. (*C.f., People v. Dancy, supra,* 102 Cal.App.4th at pp. 36-37.) In sum, according to the standard consent instruction, without proof of the victim's *affirmative and continuous* cooperation, sexual intercourse is rape.[5] (*See, In re John Z., supra,* 29 Cal.4th at pp. 761-762.)

4 For purposes of this argument, "rape" refers to the conduct proscribed by section 261, subdivision (a)(2), as the consent analysis may be inapplicable to other subsections. (*See e.g., People v. Dancy* (2002) 102 Cal.App.4th 21, 36-37 [no "advance consent" defense to subsection (a) (4) rape of unconscious person as such consent would not negate "the wrongfulness of the man's conduct in knowingly depriving the woman of her freedom of choice both at the initiation of and during sexual intercourse."].)

5 In *People V. Williams, supra,* 4 Cal.4th at p. 367, Justice Mosk's concurrence addressed and disavowed this very conclusion, stating, "The intent to engage in an act of sexual intercourse in and of itself is not wrongful." In the ensuing intent analysis, Justice Mosk, joined by Justice Kennard, noted rape was a general intent crime because there was no further objective contemplated

Once the State has established this initial negative, the burden then shifts to the rape defendant, who must negate the negation by raising a reasonable doubt as to whether the victim actually consented, or whether "[the defendant] harbored a reasonable and good faith but mistaken belief of consent."[6] (*People v. Williams, supra,* 4 Cal.4th at p. 361; *People v. Mayberry, supra,* 15 Cal.3d at p. 155; *People v. Hernandez, supra,* 61 Cal.2d at p. 536; *accord, People v. Dancy, supra,* 102 Cal.App.4th at p. 37.) Because of this peculiar combination of first, the State's ability to prove an element of a criminal offense by virtue of the absence of a predicate fact and second, the subsequent shift to the accused to disprove that same element by establishing the affirmative existence of that same predicate fact,[7] the "positive cooperation" language of CALJIC No. 1.23.1 works to create an unconstitutional mandatory presumption in rape prosecutions. (*Francis v. Franklin, supra,* 471 U.S. at p. 314; *Patterson v. New York, supra,* 432 U.S. at p. 215.)

C. CALJIC No. 1.23.1 as improper rebuttable mandatory presumption.

As trenchantly put by the Court in *Pope v. Illinois* (1987) 481 U.S. 497, 503, fn. 7: "[t]he problem with the instruction[]... is that the jury could have been impermissibly aided or constrained in finding the relevant element of the crime...." (*Mullaney v. Wilbur* (1975) 421 U.S. 684, 701[condemning malice instruction requiring defendant "prove the critical fact in dispute..."].) And among the elements which instructions may not supplant or supplement, intent has been deemed particularly critical, and particularly vulnerable to compromise. (*Neder v. United States, supra,* 527 U.S. at p. 17; *Carella v. California, supra,* 491 U.S. at p. 265; *Sandstrom v. Montana, supra,* 442 U.S. at p. 518, fn. 7.)

beyond accomplishing the act itself: "the intent to engage in an act of sexual intercourse that is in fact unconsented and forcible..." (*Ibid.*) However, the cogent concurrence in *Williams* predated the current "expansive" concepts of rape, which have included such scenarios as postpenetration withdrawal of consent, more or less equivocally couched. (*In re John Z., supra,* 29 Cal.4th at p. 764-768, diss. opn. by Brown, J. [after consensually participating in "threesome," victim "never officially" told defendant she didn't want intercourse].)

6 The Court in *People v. Mayberry, supra,* 15 Cal.3d at p. 155, confirmed the affirmative defense of a good-faith, reasonable but mistaken belief in consent; in so doing, the Court underscored the intent here is rendered wrongful because of the victim's real or apparent lack of consent. (*See, People v. Williams, supra,* 4 Cal.4th at p. 365, conc. opn. by Mosk, J. ["A defendant's reasonable and honest belief in the complainant's consent... negatives the element of intent."].)

7 The predicate fact being the victim's "positive cooperation," as that element may be satisfied for jurisprudential purposes either by proof of actual cooperation or proof of the appearance of actual cooperation sufficient to establish such a good-faith, reasonable belief in cooperation. (*People v. Williams, supra,* 4 Cal.4th at pp. 360-361 [subjective and objective components to *Mayberry* defense].)

For example, in *People v. Lee* (1987) 43 Cal.3d 666, the California Supreme Court found conflicting instructions which required the jury find specific intent to kill while eliminating that intent requirement upon a finding of implied malice was an unconstitutional removal of the issue of intent from the jury. (*Id.*, at p. 674; *accord, People v. Odle* (1988) 45 Cal.3d 386, 414-415, cert. den. 534 U.S. 888.) Similarly, in *People v. Forrester* (1994) 30 Cal.App.4th 1697, 1701, the appellate court held unconstitutional an instruction which directed the jury to presume a defendant who wilfully failed to appear specifically intended to evade the court's process. And, again, in *Rose v. Clark, supra,* 478 U.S. 570, the Supreme Court left untouched the Sixth Circuit's determination that murder instructions were unconstitutional which stated all homicides were malicious absent evidence to the contrary, and that all proven killings were presumed to have been done maliciously. (*Id.*, at pp. 575-576.) In short, because intent is so often "the crux of the case," jury instructions which ameliorate the prosecution's burden are untenable, regardless if the alleviation comes in the form of a direct presumption, conflicting instructions, or simply by virtue of unduly shifting the burden of proof. (*Neder v. United States, supra,* 527 U.S. at p. 17)

As explicated, CALJIC No. 1.23.1 essentially states that absent evidence to the contrary, wrongful intent will be presumed in all rape cases where there is not proof of the complainant's positive cooperation. Like the malice instructions in *Rose*, the effect of this consent instruction shifts the burden of proving intent from the State to the defendant. (*Rose v. Clark, supra,* 478 U.S. at pp. 575-576.) Simply put, the problem here is that because the proof of intent adduced by the State is a lacuna, or factual absence, there are no "predicate facts" save the fact of intercourse which the State is required to prove.[8] Once intercourse is established, assuming no evidence of continuous "positive" cooperation, the defense must then affirmatively demonstrate, to the point of creating reasonable doubt, the complainant either gave her "legal"

8 This argument is perhaps the natural product of the wholesale metamorphosis of rape prosecutions from the time when the State had to prove a woman employed "utmost resistance" against the rape (*People v. Barnes* (1986) 42 Cal.3d 284, 297; *People v. Brown* (1934) 138 Cal. App. 748, 750 ["proof of resistance on the part of the female until overcome by force or violence is essential"]), to the need to show "some" resistence (*People v. Barnes, supra,* 42 Cal.3d at p. 297 [requiring "that which would reasonably manifest refusal to consent to the act of sexual intercourse"]; *see e.g., People v. Peckham* (1965) 232 Cal.App.2d 163, 165-168 [verbal protests enough]), to the present-day, when "positive cooperation" means the demonstrable on-going engagement in the sexual encounter. (*In re John Z., supra,* 29 Cal.4th at p. 766-767 [victim "never told" defendant she did not want to have intercourse].) In short, proof of consent has gone from utmost resistance which "must not have ceased throughout the assault" to utmost cooperation which may not similarly falter. (*People v. Barnes, supra,* 42 Cal.3d at p. 297.)

consent, or he thought she had.[9] (*People v. Mayberry, supra,* 15 Cal.3d at p. 154; *People v. Giardino, supra,* 82 Cal.App.4th at p. 460.)

D. Distinguishing Mayberry: the affirmative defense.

As noted, in *People v. Mayberry, supra,* 15 Cal.3d at p. 155, the California Supreme Court established an affirmative defense of good-faith, reasonable but mistaken belief in consent; in the context of the *Mayberry* defense, CALJIC No. 1.23.1 becomes a permissible presumptive instruction as it particularly implicates the defendant's subjective state. (*Patterson v. New York, supra,* 432 U.S. at p. 203, fn. 9.) The parameters of the permissible presumptive instruction were sketched by the United States Supreme Court in *Patterson v. New York, supra,* 432 U.S. 197:

> "... the state shall have proved enough to make it just for the defendant to be required to repel what has been proved with excuse or explanation, or at least that upon a balancing of convenience or of the opportunities for knowledge the shifting of the burden will be found to be an aid to the accuser without subjecting the accused to hardship or oppression."

(*Id.,* at p. 203, fn. 9, quoting *Morrison v. California* (1934) 291 U.S. 82, 88-89.)

In *Patterson,* the Court held a defendant may properly bear the burden of proving heat of passion as an affirmative defense, after the State has proved beyond a reasonable doubt that the defendant intentionally killed his victim. (*Patterson v. New York, supra,* 432 U.S. at p. 206.) In rejecting the argument that the government should have to disprove affirmative defenses, the High Court quoted the lower court: "'To require the prosecution to negative the 'element' of mitigating circumstances is generally unfair, especially since the conclusion that the negative of the circumstances is necessarily a product of definitional and therefore circular reasoning....'" (*Id.,* p. 211 fn. 13; *c.f., Martin v. Ohio* (1987) 480 U.S. 228, 2433-234.) By this token, in the earlier case of *Morrison v. California, supra,* 291 U.S. at pp. 90-91, the Court noted transfer of the burden was proper as it involved evidence which "has least a sinister significance," where there is no such significance, there must be "a manifest disparity in convenience of proof and opportunity for knowledge, as for instance, where a general prohibition is applicable to every one who is unable to bring himself within the

9 The complainant's lack of consent being in this sense a subjective fact.

range of an exception."[10] Applying this compensatory principle to the heat of passion "exception" in homicides, the Court in *Patterson* caveated:

> Of course if the *Morrison* cases are understood as approving shifting to the defendant the burden of disproving a fact necessary to constitute a crime, the result in the first *Morrison* case could not coexist with *In re Winship* [cite] and *Mullaney*.

(*Patterson v. New York, supra,* 432 U.S. at p. 203, fn. 9.)

Unlike homicide, or other assault offenses in which the conduct itself is presumptively unlawful, the *actus res* of rape does not necessarily implicate wrongful intent. To the extent *Mayberry* isolates a defendant's subjective apprehension[11] of a victim=s objective conduct, it falls within the Patterson purview of obligations rightly shouldered by the accused. To the extent CALJIC No. 1.23.1 shifts the burden to the defense in actual or legal consent cases to disprove a predicate fact B lack of consent B necessary for rape, it is improper under Winship and Mullaney. (Patterson v. New York, supra, 432 U.S. at p. 203, fn. 9.)

E. Prejudice.

Improperly presumptive jury instructions are to be reviewed for harmless error, defined as "whether the force of the evidence presumably considered by the jury in accordance with the instructions is so overwhelming as to leave it beyond a reasonable doubt that the verdict resting on that evidence would have been the same in the absence of the presumption. It is only when the effect of the presumption is relatively minimal... that the presumption did not contribute to the verdict rendered." (*Yates v. Evatt, supra,* 500 U.S. at p. 405; *Rose v. Clark, supra,* 478 U.S. at p. 582; *People v. Odle, supra,* 45 Cal.3d at p. 414; *People v. Dyer* (1988) 45 Cal.3d 26, 63-64, cert. den. 525 U.S. 1033.) In *Pope v. Illinois,* the Court noted the appellate inquiry is whether the predicate facts "'conclusively'" establish intent "'so that no rational jury could find that the defendant committed the relevant criminal act but did not *intend* to cause

10 (*See also, People v. Tewksbury* (1976) 15 Cal.3d 953, 963-964, cert. den. 429 U.S. 805 [proper to burden defense with defenses "which raise no challenge to the sufficiency of the prosecution's proof of any element of the crime charged but for reasons of public policy insulate the accused notwithstanding the question of his guilt."]; *accord, People v. Figueroa* (1986) 41 Cal.3d 714, 722; *see also, People v. Spry* (1997) 58 Cal.App.4th 1345, 1367-1368, overruled in part, *People v. Martin* (2001) 25 Cal.4th 1180, 1191-1192 [noting *Spry* still "good authority" on allocation of burden of proof *re:* the affirmative defense instruction].)

11 Leaving aside the concomitant issue of the defendant's objectively reasonable apprehension of that conduct. (*People v. Williams, supra,* 4 Cal.4th at pp. 360-361.)

injury.'" (*Pope v. Illinois, supra,* 481 U.S. at p. 503, quoting *Rose v. Clark, supra,* 478 U.S. at pp. 580-581; *c.f., People v. Forrester, supra,* 30 Cal.App.4th at pp. 1702-1703 [presumption harmless as defendant "explained" but did not negate presumed intent].)

In *Yates v. Evatt, supra,* 500 U.S. at pp. 394-395, petitioner was convicted of his coperpetrator's murder of the shopkeeper's mother, who emerged from a back room after the petitioner fled the scene. In its harmless-error analysis of "all the evidence on" the subject of the improper presumption, the Supreme Court noted the presence of "some evidence" rebutting malice, including petitioner's testimony that neither he nor his coperpetrator intended to kill anyone, and petitioner's having left the store before the murder occurred. (*Id.,* at pp. 408-409.) The Court concluded that as the evidentiary record "simply is not clear" on the issue of intent, the Court "could not infer beyond a reasonable doubt that the presumptions did not contribute to the jury's finding of [] intent...." (*Id.,* at p. 411.) Similarly, in *People v. Spry, supra,* 58 Cal.App.4th at p. 1371, the defendant was convicted of heroin possession; his defense was temporary possession for purpose of disposal. In reversing for prejudicial instructional error, the Fifth District noted that while the State's evidence was "strong" (admitted heroin addiction, use of heroin and PCP, heroin possession), the defense evidence was "equally strong," and the defendant's failure to tell police he possessed the heroin for purposes of destroying it presented an "evidentiary flaw," which created a credibility call for the jury. (*Compare, Neder v. United States, supra,* 527 U.S. at p. 17 [evidence of materiality "overwhelming"].)

Without belaboring facts already belabored, appellant's account of an initially consensual encounter that turned to extortion and then to panic was as strong, and, given the circumstances, as verifiable as De Vivero's story of sudden abduction and assault. Under *Yates,* it cannot be said that the evidence of lack of consent in this case was "so overwhelming" as to vitiate the makeweight effect of the improper presumption. (*Yates v. Evatt, supra,* 500 U.S. at p. 411.) Nor was the defect in No. 1.23.1 cured via other charges to appellant's jury. (*Accord, Yates v. Evatt, supra,* 500 U.S. at pp. 410-411.) General instructions on proof beyond a reasonable doubt and the presumption of innocence are not enough to cure the instructional ill, and there was nothing which would have ameliorated the presumptive burden on appellant to prove the De Vivero's ongoing cooperation. (*Francis v. Franklin, supra,* 471 U.S. at pp. 319-320.)

Conclusion

As nutshelled by the Court in *Neder*, intent in this case was "the crux of the case." (*Neder v. United States, supra,* 527 U.S. at p. 17; *United Brotherhood of Carpenters and Joiners of America v. United States* (1947) 330 U.S. 395, 411-412 ["The erroneous charge was on a vital phase of the case and affected the substantial rights of the defendants."].) Contrary to the court's characterization of the case as he said/she said, the jury here deadlocked on the issue of Zamudio's kidnaping, another consent-based offense, found the kidnaping for purposes of rape allegation not true, and acquitted on one of the counts of forcible oral copulation; the deliberations were relatively lengthy, the panel requesting a copy of Officer Carlyle's report, Dr. Lopez's medical report, the rape kit stipulation, and readback of Zamudio's testimony, all of which suggests something more nuanced than a wholesale belief in Zamudio's account that she was accosted, abducted, and assaulted, all without any provocation or cooperation on her part. (*See generally, In re Martin* (1987) 44 Cal.3d 1, 51, cert. den. 469 U.S. 930; *People v. Rucker* (1980) 26 Cal.3d 368, 391; *People v. Epps* (1981) 122 Cal.App.3d 691, 698; *People v. Allen* (1978) 77 Cal.App.3d 924, 935.) CALJIC No. 1.23.1 shifted the burden of proof in appellant's rape case by creating a presumption of unlawful intent absent evidence to the contrary; appellant's convictions must therefore be reversed. (*Patterson v. New York, supra,* 432 U.S. at p. 203, fn. 9; *Yates v. Evatt, supra,* 500 U.S. at p. 411.)

ARGUMENT

APPELLANT'S CONVICTIONS MUST BE REVERSED AS THE COURT ERRED IN DENYING APPELLANT'S MOTION FOR NEW TRIAL BASED ON NEWLY DISCOVERED EVIDENCE

Introduction

The standard for reviewing an order denying new trial based upon newly discovered evidence involves consideration of five factors: the evidence, not its materiality, must be newly discovered; the evidence cannot be "merely" cumulative; it must "be such as to render a different result probable on a retrial"; the party could not with reasonable diligence have discovered/produced the evidence trial; and the facts be shown "by the best evidence of which the case admits." (*People v. Martinez* (1984) 36 Cal.3d 816, 821.) Denial of a new trial motion is reviewed under an abuse-of-discretion standard (*People v. Navarette* (2003) 30 Cal.4th 458, 526, cert. den. 540 U.S. 1151; *People v. Clair* (1992) 2 Cal.4th 629, 667, cert. den. 506 U.S. 1063.); in determining whether there has been such an abuse, "'each case must be judged from its own factual background." (*People v. Delgado* (1993) 5 Cal.4th 312, 328.)

Here, the defense moved for a new trial on grounds of newly discovered evidence, improper admission of gang evidence, evidence of guilty pleas by former co-defendants, expert evidence by the forensic nurse supervisor, and ineffective assistance of trial counsel as to appellant. (CT 292-325; Supp. CT 108-126, 129-171; RT 2427-2432) Following hearing, the court denied the motion, finding no ineffective assistance of counsel, while finding no reasonable diligence in finding/presenting the testimony of the new witnesses. (RT 2810-2811, 2836-2837, 3043, 3123-3128)

A. The motion for new trial: evidence presented

1. Daniel Vasquez

Daniel Vasquez was the investigator for appellant's trial counsel, acting at counsel's direction; he testified he went to the housing project three or four times, and once to the motel. None of the people he spoke to at the motel identified anyone named Suzan Laynor. On his own initiative, he contacted Saldamando, another former co-defendant, who was then in-custody and subsequently deported. He did not locate Nina Rebuelta before trial because he did not have her last name at the time. He was unaware of Jesse Vallejo. He attempted to locate another hotel guest, "Shawl," who according to the police

report said he saw Antoinette being carried into the hotel, but was unable to do so. People at the housing project felt there'd been an injustice but were afraid to cooperate with the defense because they didn't want to get "rolled up" in a criminal case. There was another investigator, who located Alatea Orozco. Vasquez worked a total of forty-six hours on the case from the time he was retained in October 2003, to its completion. (RT 2440-2448, 2452-2470)

2. Jesse Vallejo

Jesse Vallejo was first interviewed post-trial; in June 2003, he was driving around with a friend, and met someone at a taco stand who said there was a "girl party" at the Motel 6. Vallejo and his friend followed the other driver to the motel, and the friend left, telling Vallejo he'd be right back. It was about 2:00 a.m.: the motel room door was open, and Vallejo saw three men laying on the bed, two other men walking around, about six men in all. Vallejo knew one man named Tommy, but it was not Tommy Guzman. There was an Asian woman there, 5'5" or 5'6", coming out of the bathroom with two men; she was wearing a towel wrapped around her. She got on the bed and took the towel off, looked at Vallejo and started touching him. He was kind of excited until another man started kissing her and laying her down. It did not seem the woman was being forced to have sex or that any force was used against her to hold her down or restrain her. Men would ask her to orally copulate them and she did, never saying no. She had intercourse with one man while Vallejo was there; she was moaning, and saying "give it more harder," "I like it." The woman also said "this is a real guy right here" and that man was "the one" or had a bigger penis because no one else was interested in having sex with her; she later swiped at some of the men, saying "you're a pussy, you can't perform, you can't get it up." The woman said some things about "who can get it up" and "who can give me pleasure," though not in those exact words. She invited Vallejo to have sex with her, but he declined; she touched his chest and upper thigh, asking Vallejo why he didn't want to have sex with her. He said he didn't find her attractive; she asked what was wrong with her, and if he was gay. Vallejo testified he didn't feel right, and couldn't perform well; "it just wasn't him," he guessed he was shy, and thought what she was doing was disgusting. The woman was conscious during the three hours Vallejo was there, consuming two lines of methamphetamine about thirty minutes after Vallejo arrived. She had been asking earlier, "Where's the white stuff?" She never slept, and never lost consciousness. Vallejo said he kind of enjoyed watching as it was "like porno." A couple of months later, Vallejo found out the men in the room had been arrested. (RT 2471-2490, 2499)

Vallejo had seen appellant in the housing project before, but never talked to him. Six years before the hearing, Vallejo associated with members of the Eastside Wilmas, but had never seen appellant or codefendant associate with them. (RT 2492-2495) He saw appellant and codefendant in the motel room that night: co-defendant was wearing boxers and a tank top. Vallejo told the investigator he saw the woman having sex with "one guy after another" and that the men were falling asleep. He told the investigator about the woman's multiple partners because he was guessing what had been going on before he arrived: Vallejo meant to say he saw one episode of intercourse and multiple episodes of oral copulation: the woman orally copulated or masturbated everyone but two or three men who were sleeping. By the time "Good Morning, L.A." came on television, Vallejo was bored, going in and out of the room to smoke and look for his friend. (RT 2496-2502)

When no one else wanted to have sex, the woman grew bored, and Vallejo and she talked. She asked, "Don't you think I'm cute? You don't like me?" When he said he didn't want to have sex with her, she looked at her legs and said, "Look at all these bruises on my legs. What am I going to tell my mom? These bruises, what am I going to tell my mom when she asks me about these bruises on my legs?" Vallejo suggested she tell her mother she fell down the stairs; the woman responded, "no, that's dumb," so Vallejo told her to make up her own damn excuse. (RT 2502-2504)

Vallejo was first approached to be a witness by Luz Prieto, appellant's sister, who told him appellant and co-defendant had been charged with rape. At the time Prieto contacted him, two or three months after the trial, Vallejo did not understand that appellant had already been convicted. (RT 2505-2509, 2521-2523) Two or three months after the incident, a motel employee told Vallejo some of the men at the party had been arrested for rape. Vallejo did not want to come forward because he didn't want to "get thrown in jail." (RT 2509-2521) After Prieto located him, the investigating detective called Vallejo, saying Vallejo would go to jail if the detective found any of Vallejo's DNA or belongings in the motel. (RT 2518-2520)[1]

1 Detective Scott Wolff testified he was present during the prosecutor's interview with Vallejo; Vallejo said appellant talked to him in the motel room, and Vallejo found out appellant was in Eastside Wilmas. Vallejo also said he spoke to co-defendant, who was introduced to him as Flaco; Vallejo was introduced to everyone in the room by Guzman. Vallejo was mostly associated with Westside Wilmas, but had some Eastside association when he was fourteen years old. According to Vallejo, appellant was lying down, drinking a beer, when Vallejo entered the room. The detective denied telling Vallejo he could get in trouble for being in that room, but did say if Vallejo's DNA was found on the victim or in the room, he might have "serious legal issues," and that he was going

3. Suzan Laynor

Suzan Laynor's mother worked at the Motel 6; on June 22nd, Laynor and her fiancé were guests at the motel. At the time, Laynor was eight-and-a-half months pregnant. It was hot, so about 11:30 p.m., Laynor went for a walk around the motel, to the back, in the area of Room 125. Laynor is "nosey," as she walked by one room, she noticed the blinds were open and the door wide open; she looked in, and saw a Filipino woman sitting on top of a man with her skirt up, wearing a tube top and no underwear. Other men were grabbing her, "feeling all over her" while she kissed the man beneath and gave him a "lap dance." (RT 2527-2529, 2535) Laynor immediately went back to her room. (RT 2529) Laynor knew Solano, but not appellant or co-defendant. She found out two to six months before the motion for new trial that Solano had been charged with rape: she was visiting her grandfather, and Solano's mother was there. As Laynor was telling her grandfather what she'd seen in the motel, Solano's mother asked her to describe the girl, Laynor did, and Solano's mother told Laynor that Solano had been accused of rape, and Laynor should contact appellant's sister.[2] (RT 2536-2539)

4. Tommy Guzman

According to his declaration, and the declaration of Vasquez, Tommy Guzman stated he pled guilty prior to the preliminary hearing in the current case, but felt the plea was a mistake. Guzman said that on June 23rd, Antoinette and "Edgar" came to his house; Antoinette asked if anyone else was home, and where Guzman's bedroom was. Guzman said upstairs, Antoinette said "come on" to Guzman and Edgar, and went upstairs. In the bedroom, Antoinette stripped and told Domiguez and Edgar that "who ever is hard come fuck me." Edgar had sex with Antoinette; Antoinette told Guzman it was his turn, and he had sex with her. Afterwards, Antoinette asked if she could use the telephone,

to come out and take a DNA sample from Vallejo. Vallejo told the detective to go ahead, he had nothing to hide. The detective never collected the sample, under instruction from the prosecutor. The detective interviewed a number of people in the course of his investigation, but had not discovered Vallejo before new trial counsel filed his affidavit. (RT 3080-3094)

2 The court struck evidence that Laynor saw the woman engaging in the same behavior on another date, rejecting defense counsel's argument that the proposed testimony impugned Antoinette's credibility, as well as her portrayal as having been meek and inexperienced, as irrelevant on the issue of consent in appellant's case. According to Laynor's declaration, on September 24, 2004, she saw Antoinette at a party next door, dressed in the same sort of outfit, acting very "slutty," rubbing up against and kissing "about ten different guys." (Supp. CT 134-135, 139-140) The court indicated counsel would have to establish a course of conduct for such evidence to be admissible. (RT 2529-2533) This is a tangible example of the untenable corner created by No. 1.23.2, and the general due process problem lurking in sex cases, emblematized by the tension between Evidence Code sections 1103 and 1108.

and made three or four calls, but no one was home. Antoinette said she needed to reach the guy with the truck because her stuff was inside; Edgar said he would try to get her things back. During this time, Zach Hidalgo came over; Antoinette said "hey you guys ready" and returned upstairs to have serial sex with the three men. Guzman said Antoinette would orally copulate them to erection, followed by intercourse. No one forced Antoinette to have sex. Afterwards, they went outside, and dispersed. Guzman said he heard Antoinette had gone home in a blue pick-up truck, but did not know whose truck that was. (Supp. CT 117-119, 136-138)

5. Nina Rebuelta

At the hearing, Nina Rebuelta testified she saw the party; two or three weeks later, someone told her codefendant, a neighbor of hers, had been arrested. There was a young Korean or Chinese woman at the gathering, not with codefendant. Codefendant asked Rebuelta if she would take the girl home, and she agreed. The police arrived, and everyone ran. Rebuelta did not know appellant, though thought she had seen him once before. She had not been subpoenaed before the hearing. (RT 2540-2549) According to her declaration and interview with Vasquez, Rebuelta used to be part of the party group, but had been in recovery for three years and was no longer involved in that life. Rebuelta saw the girl at the party lifting her dress and "letting guys touch her." Rebuelta knew the crowd "to be rowdy," and thought the girl might get herself in a situation she didn't want; when the girl lifted her skirt and started "climbing on top" some of the men. Rebuelta told her that maybe it was time she left, and offered her a ride home. The girl told Rebuelta she did not need a ride, and wanted to stay; Rebuelta took her arm and tried to walk her away from the men; the girl pulled away from Rebuelta and said to leave her alone, she wanted to stay. The girl also said that she was "going to do all these guys," that she was "partying." Rebuelta took this to mean she was going to have sex with the men, and returned to her house. Rebuelta thought the girl was under the influence, but not drunk or unable to take care of herself: "she seemed to know what she was doing and what she wanted." Later, codefendant approached Rebuelta and asked her to drive the girl home; Rebuelta said she'd already offered, but if he could convince her to leave, she would take her home. Neither codefendant or the girl returned to Rebuelta's house. Shortly afterwards, the police arrived, and everyone scattered; when Rebuelta next went outside, everyone was gone. (Supp. CT 119-121, 143-145)

6. Luz Prieto

Luz Prieto testified that after appellant was found guilty, she spoke to his former trial counsel, who did not want to file a motion for new trial because the court would deny such a motion. Prieto contacted other attorneys, eventually retaining the attorney who represented her brother at the preliminary hearing. Prieto then began her own investigation of the allegations: she started by trying to find Queiro, who testified the day Prieto came to court. She spent seven days "going around" asking people where he was and following those leads until she was directed to a park where he supposedly hung out; at the park, some youngsters told her where he lived. Prieto snuck into that gated community, and asked around, but didn't find Queiro the first couple of times she was there. At some point, she was told he hung out in an alley. She started checking all the alleys, asking people in the neighborhood where people gathered. After three more days, she found Queiro. She asked him if he could tell her where Antoinette lived. Queiro didn't know for sure, but said it was on 220th. (RT 2708-2721, 2766-2769)

Prieto spent the next five days driving up and down 220th Street, unsuccessfully searching for Antoinette. She talked to the mailman, but he gave her no information. She would approach groups of people in the neighborhood; one day, she talked to some young guys at a corner near a hamburger stand, and after she told them what had happened, one person said "Jesse" might be able to help her, and Jesse lived near Pacific Coast Highway and Ronan. (RT 2723-2730) Prieto went to that area and started asking for Jesse; after nine days of approaching people on the street, someone said he knew Jesse, and pointed out his house. (RT 2730-2731)

Jesse was Jesse Vallejo. Prieto talked to him, told him what happened, but did not get his full name at the time; Vallejo said "it wasn't rape." It took approximately 26 full days to find Vallejo. (RT 2732, 2772-2773) Prieto also contacted the various trial investigators, spoke to codefendant's brother and sister, and eventually found Nina Rebuelta. She told Rebuelta what had happened; Rebuelta said the convictions weren't right because the girl wanted to be there. Prieto asked Rebuelta if she'd be willing to testify, and Rebuelta said she was. The two met, Rebuelta told Prieto what she'd seen, including that she'd asked the girl if she wanted a ride home. Rebuelta told Prieto she should have put the girl in the car because she was misbehaving, there were a lot of

guys, and the girl was going from guy to guy. The investigator had been unable to find Rebuelta because Rebuelta had moved.[3] (RT 2732-2745, 2549-2951)

Prieto talked to one of the women from codefendant's family about Jesse Solano's family, spoke to Solano, then went looking for his mother, Connie. She located Connie, Connie told her Solano "got a deal" but was innocent. Connie also told Prieto about Suzan Laynor, and took Prieto to Laynor's grandfather's house. They tried calling Laynor, but Laynor wasn't home; a couple of days later, Prieto returned and asked the grandfather to call again, he did, and Laynor came to meet Prieto. Laynor told Prieto she didn't understand why no one contacted her. Connie told Prieto she was ignored when she would try to tell her son's attorney and/or investigator about Laynor. (RT 2751-2759) Prieto got Santos's name as a trial witness; she knocked at Santos's door to ask her about the case, but Santos refused to talk to her. (RT 2760-2761) Prieto also attempted to talk to Shirley Earles. (RT 2777)

Prieto contacted counsel after locating each potential witness. The entire investigation took two-and-a-half to three months. (RT 2748, 2951, 2754) Prieto had nothing to do with trial preparation. One of Prieto's other brothers had retained appellant's trial attorney; during trial, she would call and ask that brother what was happening, and be told "everything's okay." (RT 2734, 2762-2765)

B. The motion for new trial: the courts' rulings.

The court found no ineffective assistance of counsel in appellant's trial counsel's opening the door to admission of Solano's rape conviction, or in trial counsel's failure to preclude Antoinette from repeatedly using the legal conclusion of "rape" to characterize her encounters. (RT 2780-2781, 2785, 2810-2811) The court found no violation of the right to counsel in counsel's failure to object to admission of unauthenticated photographs of Antoinette taken during her sexual assault examination, the failure to call the examining nurse or attending officers as witnesses. (RT 2787-2807, 2812, 2820-2821, 3006-3043, 3046-3049) Nor was there a problem with counsel's failure to locate the new witnesses presented at the hearing, given the lengths to which appellant's sister went to find them. (RT 2808-2822, 2827, 2829, 2836-2839)

3 Prieto went to Rebuelta's address, was told Rebuelta no longer lived there, asked for the owner, was told the owner was in Mexico, and to return in two weeks, returned in two weeks, the owner wasn't there, returned a week later, got the owner's telephone number, spoke to the owner, asked for any application information, the owner told her to call back the next day, called back the next day, got a number, called the number, and Rebuelta answered. (RT 2739-2742)

The court then denied the motion based on newly discovered evidence, finding no reasonable diligence in failing to locate Jesse Vallejo based on his statement that he talked to appellant in the motel room: the court did not believe Vallejo was unknown to appellant and/or codefendant, and thus, Vallejo was not "newly discovered." The court also found Vallejo's failure to come forward or be found earlier "seriously attacks [his] credibility," given Vallejo's status as innocent bystander. Similarly, the court felt Suzan Laynor could have been found with a reasonable effort, given her mother was the motel manager; though "more important," according to the court, "she didn't tell us anything." The court rejected counsel's argument that Danny Guzman was unavailable at the time of trial because he had admitted to raping Antoinette the next day. According to the court, as Guzman did not admit to being in the motel room, he had no Fifth Amendment concerns in this area. The court found Rebuelta's testimony merely cumulative, and not newly discovered because codefendant was her friend. In no event did the court feel any of the proffered evidence would lead to a different result at retrial.[4] (RT 3123-3128)

It is flatly paradoxical to find no ineffective assistance of counsel in failing to locate the missing witnesses, while finding no reasonable diligence in failing to locate the missing witnesses: either the witnesses were available, given a reasonable search, or they were not—either appellant's trial counsel's performance fell within the realm of reasonableness, or it did not. (*Strickland v. Washington, supra,* 466 U.S. at p. 668.) Moreover, the court's analysis here impermissibly elevated the diligence requirement beyond the rock-bottom purpose it serves: that the trial itself is "the determination of guilt and innocence." It is unfair to penalize a criminal defendant for his counsel's failure to produce a witness, and it was through no discernible fault of appellant's that Guzman, Laynor, Rebuelta, and even Vallejo were not called to testify. (*People v. Martinez, supra,* 36 Cal.3d at p. 825.)

With regard to Vallejo, the court's finding there was not reasonable diligence in locating this witness was not a sufficient basis in itself for denying the motion, and its credibility determination likewise mooted as it was inexorably linked to its diligence finding. For although the court thought appellant had willfully failed to tell trial counsel Vallejo was in the motel room, there was no factual basis for this conclusion: leaving aside the commonplace that many street acquaintances may or many not know one another's given first name, let

4 Counsel noted Queiro and Vasquez were presented at the hearing not as newly discovered witnesses, but as part of the calculus for considering the motion. (RT 3098-3100)

alone a surname or address, there was nothing to indicate the logical converse: that Vallejo knew appellant, which would have supported the court's supposition that appellant knew Vallejo. Vallejo testified he talked to appellant's sister about the general scene in the motel room, not about particulars concerning appellant, and this account was reiterated by Prieto, whom the court found credible. By this same token, appellant did not tell either the defense investigator or his sister that he spoke to Vallejo at the motel,[5] and appellant's sister only happened upon Vallejo as a potential witness after canvassing several neighborhoods, asking if anyone knew anything about the motel incident. This smacks less of ball-hiding and more of not knowing or remembering the name of the guy who was one of the guys who showed up for the girl party, a guy who arrived after the party started, and was introduced once when he walked into the room, and then mostly played bench. And although the State at the hearing also speculated that appellant should have told counsel about Vallejo, the State as well conceded no investigator could be expected to conduct the sort of investigation appellant's sister undertook. (RT 2843-2844)

By the same token, Laynor was a surprise to both parties: despite Detective Wolff's presumptively thorough investigation, which included (at minimum) interviews with the motel clerk, housekeeper, and other guests, and Vasquez's testimony that he interviewed people at the motel, and despite the court's investigative model ("And you go to the manager and say, look, we're looking for the people around the hotel that night."), the manager's daughter was only found by Prieto, and only by accident. And again, either it was within the bounds of reasonable representation to conclude Guzman was unavailable because of his Fifth Amendment interest in not exposing himself to further liability (*California v. Green* (1970) 399 U.S. 149, 167, fn. 17; *In re Paul P.* (1985) 170 Cal.App.3d 397, 401; see also, *People v. Fonseca* (1995) 36 Cal.App.4th 631 633-634]), or it was not. (*People v. Pope, supra,* 23 Cal.3d at pp. 419-420.)

The baseline problem here is the court simply discounted all witnesses atomistically, though it was to consider the evidence as a whole. (*People v. Delgado, supra,* 5 Cal.4th at p. 328.) For example, to find Laynor's testimony

5 In its analysis, the trial court indicated Vallejo said he saw appellant sitting around in his boxers; what Vallejo testified to was that he saw codefendant sitting in his boxers. (RT 2850) When counsel for the hearing noted that appellant didn't know Vallejo, the court said, "I haven't heard that. And he hasn't told me that." (RT 3112) This put appellant in the position of either asserting his Fifth Amendment privilege against self-incrimination at the motion for new trial or foregoing his right not to testify in hopes of establishing due diligence, which would, if successful, lead to a retrial in which his motion for new trial testimony could be used against him—a constitutionally offensive Hobson's choice. (*Compare, Ohio Adult Parole Auth. v. Woodward* (1997) 523 U.S. 272, 278.)

VANESSA PLACE

lightweight, based on a five or ten-second scan of Antoinette apparently enjoying herself in the motel room, while considering Vallejo's testimony on this same matter suspect, and the witness in the parking lot's equally brief observation credible, makes no sense. Moreover, Rebuelta's testimony was not cumulative, for she was the only neutral witness to testify to Antoinette's demeanor/behavior before the police patrol cruised the party. Divinia Allen's testimony on this, and on everything else, as the trial court emphatically noted at trial, was obliterated by her relationship to Guzman. (*Compare, People v. Ochoa* (1998) 19 Cal.4th 353, 473, cert. den. 528 U.S. 862 [new evidence only corroborated defendant's confession].) Further, the trial court misapprehended its role as assessed the credibility of the proposed witnesses, and found them wanting:

In *People v. Martinez, supra,* 36 Cal.3d 816, the Supreme Court reversed for the failure to grant a new trial where a potential defense witness would have testified that a drill press, sporting defendant's palm print, had not been painted the night before the burglary as the prosecution witnesses testified. Rejecting the argument that the potential defense witness was not as credible as the testifying prosecution witness, the Court admonished the state:

> The problem with this reasoning, like that of the trial court, is that it overlooks the burden of proof. To acquit the defendant, the jury need not find [potential defense witness's] recollection accurate and [prosecution witnesses'] inaccurate. It need only decide that [potential defense witness's] testimony [would] raise a reasonable doubt as to the time when the drill press was repainted, and thus a reasonable doubt as to defendant's guilt.

(*Id.,* at p. 823-824.) Similarly, the trial court here should not have isolated its assessment of Vallejo's credibility as the makeweight for denying the motion for new trial based on that witness's newly discovered evidence. Given Antoinette was the only person—as underscored by the State at argument—to testify as to the events in the motel, the question should have been whether Vallejo's testimony, essentially unimpeached, would have meant "a reasonable doubt would remain" concerning Antoinette's state of intoxication: was she, in fact, passing in and out of consciousness, being physically manipulated by the men in the room, or did she seem alert and in apparent control of herself and her

desires. (*People v. Ault* (2004) 33 Cal.4th 1250, 1261-1262 [affirming need for independent review of entire proceedings].)

In *People v. Drake* (1992) 6 Cal.App.4th 92, defense counsel did not call an expert who would have testified that defendant's passenger pulled the emergency brake, causing his own death. In affirming in part and reversing in part the trial court's grant of a new trial,[6] the Court of Appeal noted, "one of the most prolific causes of miscarriages of justice is the reluctance of trial judges to exercise the discretion with which they are clothed to grant a new trial when the circumstances show that justice would thereby be served." (*Id.*, at p. 97; *c.f., People v. Earp* (1999) 20 Cal.4th 826, 870, cert. den. 529 U.S. 1005 [purpose of ineffective assistance of counsel claim is to make sure trial can "be relied on as having produced a just result."].) For though a trial court must reweigh the evidence in ruling on new trial motions, keeping in mind the general rule favoring verdicts, it must always do so with an eye on the fair trial rights of the accused and the ongoing application of the standard of proof. (Cal. Const., art. VI, § 13; *People v. Drake, supra,* 6 Cal.App.4th at p. 98.) This the court did not do.

As in *People v. Martinez, supra,* 36 Cal.3d at pp. 822-823, the prosecution's case here was not quite the dead-bang cinch the court described, and evidence of Antoinette's intoxication relative to her consent, and her consent itself, critical to a fair determination of appellant's intent, and thus of his guilt. It is no answer here that some of this evidence was presented at trial: as in the case of Scott, that evidence was worthless to appellant; as to the other proposed witnesses, there were no other sources.

Conclusion

In *People v. Sherrod* (1997) 59 Cal.App.4th 1168, 1174-1175, the appellate court succinctly stated:

> [C]riminal defendants, regardless of their guilt or innocence are entitled to a fair trial..., and the trial court is obligated to grant a new trial if it finds the result of the first trial to have been unfair.

People v. Martinez, supra, 36 Cal.3d at p. 822, ftn.2, quoting Witkin Cal. Criminal Procedure (1963) pp. 568-569 ["'fair consideration of competent ... evidence tending to negative guilt is essential to any enlightened system of criminal justice.'"].) The California Supreme Court wrote in *People v. Fosselman* (1983) 33

6 Division Six of the Second District affirmed the court's decision to grant a new trial on certain counts based on newly discovered evidence, but reversed the new trial order on others as based only on the trial court's mistaken belief that "there's no such thing... as a partial motion for a new trial." (*People v. Drake, supra,* 6 Cal.App.4th at pp. 96, 99-100.)

Cal.3d 572, 582, quoting the United States Supreme Court in *Glasser v. United States* (1942) 315 U.S. 60, 71: "'Upon the trial judge rests the duty of seeing that the trial is conducted with solicitude for the essential rights of the accused." By its ruling, the trail court here abrogated that duty; appellant's convictions must be reversed, and a new trial ordered. (*People v. Martinez, supra,* 36 Cal.3d at pp. 823-824.)

ARGUMENT

APPELLANT JOINS IN ALL ISSUES RAISED BY CODEFENDANT WHICH MAY ACCRUE TO APPELLANT'S BENEFIT

Appellant joins in all issues raised by codefendant Guadiana which may accrue to appellant's behalf. (Cal. Rules of Court, rule 13; *People v. Stone* (1981) 117 Cal.App.3d 15, 19, fn. 5; *People v. Smith* (1970) 4 Cal.App.3d 41, 44.)

ARGUMENT

APPELLANT'S SENTENCE VIOLATED THE SEPARATION OF POWERS DOCTRINE AS A JUDICIAL ENCROACHMENT UPON AN EXECUTIVE FUNCTION

The court's sentencing appellant to 1,002 years plus thirty-nine life terms also violated the separation of powers doctrine as the court specifically imposed such an excessive sentence to "make sure that Mr. Flores never steps foot into society again, that he spend the rest of his life in prison period." (RT 2418) To this end, the court designed the punishment to preclude all possibility of parole, asiding that the mandatory sex offender registration requirement would only apply "should some governor ever suffer a brain aneurism to the point where they release the defendant." (RT 2424) But it is the province of the executive, not the judiciary, to determine who is eligible for parole: by orchestrating a sentence of 1,002 years plus thirty-nine life terms, the court impermissibly poached upon that province. (*Obrien v. Jones* (2000) 23 Cal.4th 40, 48.)

Article III, section 3 of the California Constitution states "The powers of state government are legislative, executive, and judicial. Persons charged with the exercise of one power may not exercise either of the others except as permitted by the Constitution." The purpose of this proscription is to "protect any one branch against the overreaching of any other branch" (*In re Attorney Discipline System* (1998) 19 Cal.4th 582, 595-596), overreaching which becomes constitutionally noxious when a branch "defeat or materially impair the inherent functions of another branch." (*In re Rosenkrantz* (2002) 29 Cal.4th 616, 662, cert. den. 538 U.S. 980.) In proactively precluding the executive branch from making any meaningful decisions about appellant's eligibility for parole, the trial court "arrogate[d] to itself the core functions of another branch," in violation of the separation of powers doctrine. (*Carmel Valley Fire Protection Dist. v. State of California* (2001) 25 Cal.4th 287, 297.)

Penal Code section 3000, subdivision (a)(1) requires any sentence pursuant to section 1170 include a period of parole; subdivision (b)(7) establishes the Board of Prison Terms as the parole authority. Section 3040 grants the Board of Prison Terms the power to parole, and section 3041, subdivision (a) authorizes the Board to set appropriate parole release dates. Subdivision (b) states such a release date is obligatory unless the Board "determines that the

gravity of the current convicted offense or offences, or the timing and gravity of current or past convicted offense or offences, is such that consideration of the public safety requires a more lengthy period of incarceration for this individual...." (*See also*, Cal. Code Regs., tit. 15 § 2401.) Under section 3041.1, the Governor has the power to request further review of parole decisions by the full Board; sections 3041.7 and 3042 set forth the procedures for parole release dates and hearing for prisoners serving life terms. (*See also*, Cal.Const., art. V, § 8(b).)

In *In re Rosenkrantz, supra,* 29 Cal.4th at pp. 654-658, the Supreme Court acknowledged the broad discretion invested by the Legislature in the Board of Prison Terms in setting and determining parole release dates, while simultaneously concluding the judiciary had the authority to review the factual basis of those decisions based on the liberty interests involved. The Court then considered whether the Governor's authority to reverse a decision of the Board under article V, section 8(b) was similarly subject to judicial review, and similarly concluded it was, for the same reasons, and by the same measure. (*In re Rosenkrantz, supra,* 29 Cal.4th at p. 660-661, 664.) The Court rejected a separation of powers argument by the Governor's office, finding that courts are obliged to ensure individuals are not deprived of liberty interests without due process of law: *i.e.*, the judiciary must be able to preclude "arbitrary and capricious" denials of parole. (*Id.*, at pp. 664-665.) By this same token, the judiciary may not leapfrog over the executive and decide an individual otherwise eligible for parole may not be considered for parole by the Board of Prison terms come what may post-conviction. (*C.f., Manduley v. Superior Court* (2002) 27 Cal.4th 537, 553 [separation of powers doctrine prohibits Legislature from granting prosecutors post-fling authority to control legislatively-specified sentencing decisions of a court].)

Just as the Legislature has the authority to control parole eligibility, but "cannot abort the judicial process by subjecting a judge to the control of the district attorney," neither can a judge obviate the executive function by eliminating its ability to determine whether parole should be granted to a life prisoner. (*People v. Sidener* (1962) 58 Cal.2d 645, 654 (dis. opn. by Schauer, J.),[1] cert. den. 374 U.S. 491; *People v. Belton* (1978) 84 Cal.App.3d Supp. 23, 34 [mandatory 90-day minimum not usurp judicial function of granting probation].) As embedded in the Code sections cited above and the deferential standard of review set forth in *Rosenkrantz*, it is the executive who has custody of a man

1 Overruled by *People v. Tenorio* (1970) 3 Cal.3d 89, 91, in which the Court agreed with Justice Schauer's dissent.

post-conviction, and it is the executive who is best able to determine whether that man—as he proves himself post-conviction—ought ever be released into society. (*Marbury v. Madison* (1803) 5 U.S. (1 Cranch) 137, 170 [2 L.Ed.60] ["It is not by the office of the person to whom the writ is directed, but the nature of the thing to be done, that the propriety or impropriety of issuing a mandamus is to be determined."].) Appellant's sentence must therefore be reversed. (*In re Rosenkrantz, supra,* 29 Cal.4th at p. 666-667.)

ARGUMENT

THE MANDATORY REGISTRATION AND SPECIAL PROBATIONARY RESIDENCY/TRAVEL/VISITATION REQUIREMENTS IMPOSED ON APPELLANT CONSTITUTE CRUEL AND UNUSUAL PUNISHMENT

As noted, the trial court imposed the mandatory sex offender registration on appellant; the court also imposed a special residency restriction as a condition of probation: appellant may not be within 100 yards "of places where minors frequent, congregate, including, but not limited to school yards, parks, amusement parks, concerts, theaters, playgrounds, beaches, swimming pools, arcades, except as approved by your probation officer and supervised by approved chaperone." (RT 2:318-319) Though the California Supreme Court has previously upheld sex offender registration as not violating either federal and state prohibitions against cruel and unusual punishment (*In re Alva* (2004) 33 Cal.4th 254, 268), registration requirements have since been radically expanded. (Pen. Code § 3003.5.) The constitutional legitimacy of the new requirements is currently before the Court in *In re J.(E.)*, Supreme Court Case No. S156933 [rev. gtd. October 4, 2007] and *People v. Mosely*, Supreme Court Case No. S169411 [rev. gtd. ; 86 Cal.Rptr.3d 23, formerly 168 Cal.App.4th 512].[1] Both appellant's mandatory sex offender registration, as presently constituted, and as it includes a residency restriction under section 3003.5, and the special 100-yard residency restriction imposed by the sentencing court, constitue cruel and unusual punishment in violation of the state and federal constitutions. (U.S. Const. Eighth Amend.; Cal. Const. art. I, § 17; *see generally, Smith v. Doe* (2002) 538 U.S. 84, 101; *contra, In re Alva, supra,* 33 Cal.4th at p. 268.)

As has been outlined by the United States Supreme Court, the determinative question in terms of whether a particular law constitutes punishment or regulation is whether the legislature meant to establish "civil proceedings." (*Kansas v. Hendricks* (1997) 521 U.S. 346, 361.) To this end,

[1] The specific issues before the Court in *In re E.J.*, Sup. Ct. Case No. S156933, are whether the residency requirements violate ex post facto clauses, constitute an unreasonable parole condition, impinges on substantive due process rights, and is unconstitutionally vague. These issues obviously include a determination of whether the new registration requirements are penal in nature. (http://appellatecases.courtinfo.ca.gov/search/case/mainCaseScreen.cfm?dist=0&doc_id=1888611&doc_no=S156933.) Consideration of these issues will include consideration of the penal, or punitive, nature of registration under Proposition 83. (http://www.aclunc.org/cases/active_cases/asset_upload_file371_8060.pdf.) The Court has deferred briefing in *Mosely* pending decision in *re E.J.* (http://appellatecases.courtinfo.ca.gov/search/case/mainCaseScreen.cfm?dist=0&doc_id=1901089&doc_no=S169411.)

a reviewing court will consider the law's statutory construction (text and structure); the legislative goal served by the statute; its manner of codification and enforcement; and its actual affect upon the individual. (*Smith v. Doe, supra,* 538 U.S. at pp. 93-97, citing *Kennedy v. Mendoza-Martinez* (1963) 372 U.S. 144, 168-169.) In *Kennedy v. Mendoza-Martin,* the Court set forth seven factors to be considered in determining if the effect of a regulation is punishment for due process considerations under the Fifth and Sixth Amendments:

> Whether the sanction involves an affirmative disability or restraint, whether it has historically been regarded as a punishment, whether it comes into play only on a finding of scienter, whether its operation will promote the traditional aims of punishment—retribution and deterrence, whether the behavior to which it applies is already a crime, whether an alternative purpose to which it may rationally be connected is assignable for it, and whether it appears excessive in relation to the alternative purpose assigned....

(*Kennedy v. Mendoza-Martinez, supra,* 372 U.S. at pp. 168-169.)[2] In Smith, a plurality of the Court upheld the Alaska Sex Offender Registration Act, finding there was no affirmative disability/restraint inherent in registration, denying that Internet notification was the putative equivalent of the historical punishment of shaming ("Our system does not treat dissemination of truthful information in furtherance of a legitimate governmental objective as punishment."), and finding ample nonpunitive legislative purpose in alerting the public to the risk of sex offenders in the community, given the special risks of sex offender recidivism.[3] (*Smith v. Doe, supra,* 538 U.S. at pp. 98-103.)

2 In *Smith,* Justice Kennedy noted the factors have their origins in Sixth and Eighth Amendment jurisprudence. (*Smith v. Doe, supra,* 538 U.S. at p. 97.)

3 In his concurrence, Justice Thomas stated that any ex post facto challenge should be confined to an analysis of the obligations actually created by the statute, not their factual affect (*Smith v. Doe, supra,* 538 U.S. at p. 106); Justice Souter's concurrence demonstrated his belief that the Alaska act was a close call in terms of punitive effect, saved only by the presumption of constitutionality (*id.,* at p. 110). Justice Stevens dissented, concluding that the registration requirement was part of the punishment for sex offenders, as it severely impaired their liberty interests and was imposed on no other class of offenders (*id.,* at pp 111-113.) Justice Ginsburg separately dissented, also finding an "affirmative disability or restraint" in the registration requirements, as well as an unconstitutional excessiveness in relation to the Act's nonpunitive purpose. Justice Breyer joined. (*Id.,* at pp. 115-118.)

In *People v. Castellanos* (1999) 21 Cal.4th 785, 792, the California Supreme Court held sex offender registration was not punishment for purposes of ex post facto analysis,[4] noting such laws were uniformly considered regulatory in nature. (*See also, People v. McVickers* (1992) 4 Cal.4th 81, 87.) The purpose of having sex offenders register was to "'"facilitat[e] the location of ... sex offenders by law enforcement personnel,' a purpose unrelated to punishment.'" (*People v. Castellanos, supra,* 21 Cal.4th at p. 792, quoting *People v. McVickers, supra,* 4 Cal.4th at pp. 81, 87, 89, quoting *State v. Noble* (1992) 171 Ariz. 171 [829 P.2d 1217]; *see also, People v. Fioretti* (1997) 54 Cal. App.4th 1209, 1214.) The underlying statutory assumption was that registration deters those most "likely to repeat their offenses" (*In re Luisa Z.* (2000) 78 Cal. App.4th 978, 982) by "facilitating the apprehension of past offenders" (*People v. Villela* (1994) 25 Cal.App.4th 54, 60). Moreover, absent these registration requirements, law enforcement would have no other means of identifying or monitoring those particular types of perpetrators. (*See, Wright v. Superior Court* (1997) 15 Cal.4th 521, 527 [purpose of section 290 "to assure that persons convicted of the crimes enumerated therein shall be readily available for police surveillance at all times because the Legislature deemed them likely to commit similar offenses in the future.") In its ex post facto analysis, the Court relied upon these legislative presumptions in applying selected elements of the *Kennedy v. Mendoza-Martinez* multifactor test, indicating the two "crucial elements"— legislative intent and punitive effect—demonstrated that section 290 was essentially regulatory in nature, and the ex post facto proscription inapplicable. (*People v. Castellanos, supra,* 21 Cal.4th at pp. 796-797.)

Subsequently, in *In re Alva, supra,* 33 Cal.4th 254, the Court held that "mere registration" for those convicted of misdemeanor possession of child pornography did not constitute cruel and unusual punishment under either the state or federal constitutions. (*In re Alva, supra,* 33 Cal.4th at pp. 261, 268, overruling *In re Reed, supra,* 33 Cal.3d 914, [sex offender registration for misdemeanor public lewd/dissolute conduct]; *People v. Noriega* (2004) 124 Cal. App.4th 1334, 1343.) The Court relied upon the United States Supreme Court's

4 Earlier, in *In re Reed* (1983) 33 Cal.3d 914, the Court deemed section 290 registration punishment for Eighth Amendment purposes. The Court in *Castellanos* found the section was not punishment under the double jeopardy clause of the Fifth Amendment and the ex post facto prohibition of article I, section 10, clause 1, and disapproved *Reed* to the extent it suggested sex offender registration was punishment in an ex post facto analysis. (*People v. Castellanos, supra,* 21 Cal.4th at pp. 798-799.) However, as Justice Kennard amplified in her dissent, "punishment has a different and broader meaning" in the Eighth Amendment context. (*Id.,* at pp. 800-801, citing *Austin v. United States* (1993) 509 U.S. 602.)

decision in *Smith* as well as its own reading of *Austin v. United States, supra,* 509 U.S. 602, in which civil forfeiture of property used in illegal drug distribution was found subject to Eighth Amendment strictures. In *Austin,* the Supreme Court explained that a civil sanction "that cannot fairly be said solely to serve a remedial purpose, but rather can only be explained as *also* serving either a retributive or deterrent purpose, is punishment as we have come to understand the term." (*Id.,* at p. 602, emphasis added.) Forfeiture was historically a punishment: its purported remedial purposes were not sufficient to change its essentially punitive nature because the social remedies of government compensation and community protection were not "solely" the purpose served. (*Id.,* at pp. 602, 621.) The *Alva* Court interpreted this as meaning the protections of the Eighth Amendment do not apply "'unless the *only* explanation for that [punitive] impact is a punitive purpose: an intent to punish.'" (*In re Alva, supra,* 33 Cal.4th at pp. 286-287, emphasis added, quoting *Doe v. Portiz* (1995) 142 N.J. 1, 662 A.2d 367, 388.)

Leaving aside whether a determination of "punishment" turns on whether the "only" explanation for a punitive impact is punitive purpose (*Alva*), or on whether the remedial impact's "only" explanation is that it "also" serves a punitive purpose (*Austin*), the sex offender residency strictures as codified in Penal Code section 3003.5 are no civil regulation. Unlike previous registration requirements, the restrictions passed in November 2006 as part of Proposition 83 were meant to be—and are—punitive.[5] As a prefatory matter, the residency constraints of Proposition 83 are codified in the Penal Code, and its administration left entirely to law enforcement. (Pen. Code § 290, et. seq.; *compare,* Welf. & Instit. Code §§ 6600, et. seq. [setting forth Sexually Violent Predator (SVP) provisions; Department of Mental Health responsible for operation of SVP facilities].) By comparison, while Alaska's sex offender registration requirement itself is part of the state's Code of Criminal Procedure, the notification provisions are in the Health, Safety, and Housing Code, and it is implemented by the Department of Public Safety. (*Smith v. Doe, supra,* 538 U.S. at pp. 85-86, 96 [codification not dispositive, but indicative, of legislative intent].)

Moreover, the proposition was presented to California voters as a "Sexual Predator Punishment and Control Act." (Prop. 83 § 1.) Section 2 further stated that "adequate penalties must be enacted," the state must "provide adequate penalties for and safeguards against sex offenders," and "existing

5 These arguments also apply to the more restrictive residency/travel limitations imposed on appellant as part of his probation.

laws that punish aggravated sexual assault, habitual sexual offenders, and child molesters must be strengthened and improved." (*Id.* § 2(d)(b).) Section 31 reiterates that the voters' intent is to "strengthen and improve the laws that punish and control sex offenders." Most of the proposition's substantive provisions were in kind, enacting new criminal prohibitions and increasing the penalties for existing crimes. (*See e.g., Id.*, §§ 3-18.) This preference for punishment not only contrasts with the regulatory provisions previously approved, but demonstrates that what the voters believed they were getting was "the toughest law against predators in the nation." (http://www.signonsandiego.com/uniontrib/20080214/news_1n14jessica.html.) Or, as put by the *Sacramento Bee* on October 24, 2006: "California's worst sex criminals would be in line for more prison time, lifetime satellite monitoring and virtual banishment from urban society under a crackdown measure set for the Nov. 7 ballot." Or the *Los Angeles Times* on September 18, 2006: "A national movement to restrict where released sex offenders may live has swept into California this election season, with voters set to approve or reject a far-reaching crackdown on society's most loathed ex-convicts." (http://www.calvoter.org/voter/elections/2006/general/props/news.html#83.)[6] Or, put another way, "[t]he object of punishment is to exact retribution for past misconduct, and to deter future transgressions *by imposing painful consequences for violations already committed.*" (*In re Alva, supra*, 33 Cal.4th at pp 287-288, emphasis in the original.)

Registration generally is considered an affirmative disability/restraint as it creates a proactive duty, failure of which to perform constitutes a criminal offense. (*See, Wright v. Superior Court, supra*, 15 Cal.4th at p. 526 [section 290 is "an affirmative, mandatory duty."].) By the same token, though sex offender registration imposed "a substantial burden on the convicted offender," stated the Court's plurality opinion in *Castellanos*, "this burden is no more onerous than necessary to achieve the purpose of the statute." (*People v. Castellanos, supra*, 21 Cal.4th at p. 792, 796.) Justice Kennard's concurrence and dissent (joined by Justices Werdegar and Brown) stated that registration "does not seem" to involve an affirmative disability/restraint as the registrant is "not prevent[ed] from doing anything he could otherwise do." (*Id.*, at p. 804.) Similarly, as footnoted by the Court in *In re Alva*, the addition of Internet notification did not appear to change this rubric, as notification provisions per se do not unduly burden the

6 Proposition 83 passed with 70% voter approval. (http://www.latimes.com/news/local/politics/cal/la-110806jessicaslaw,0,7781880.story?coll=la-home-headlines.)

registrant.[7] (*In re Alva, supra,* 33 Cal.4th at p. 317, fn. 9 [declining to reach issue while noting such disclosure generally upheld as "legitimate means of assisting the public to protect itself against dangerous recidivist sex offenders."].)

Furthermore, the traditional aims of punishment—retribution and deterrence—are manifestly served by section 3003.5. (*Kennedy v. Mendoza-Martinez, supra,* 372 U.S. at p. 168].) On its face, the statute promised to deter sex offenders from reoffending by keeping them physically segregated from children. (*See e.g.,* Calif. Secty. of State, "Proposition 83: Sex Offenders, Sexually Violent Predators, Punishment Residence Restrictions and Monitoring. Initiative Statute" [Argument in Favor of Proposition 83: "Create PREDATOR FREE ZONES around schools and parks to prevent sex offenders from living near where our children learn and play…WE CANNOT WAIT ANOTHER DAY TO PROTECT OUR KIDS."] [http://www.sos.ca.gov/elections/vig_06/general_06/pdf/proposition_83/entire_prop83.pdf].)

Though, like other forms of undifferentiated strictures (*i.e.,* punishments), the statutory prohibition applies without regard to whether the offender's offense had anything to do with children. (*United States v. Brown* (1965) 381 U.S. 437, 458 ["One of the reasons society imprisons those convicted of crimes is to keep them from inflicting future harm, but that does not make imprisonment any the less punishment."]; *accord, Ewing v. California* (2003) 538 U.S. 11, 26-27.) In terms of retribution, the law has historically sanctioned undesirable individuals and groups by telling them where they can and cannot live—the punishment for transgressing the community's ethical and/or juridical boundaries is to be placed outside the community.[8] (*Smith v. Doe,* 538 U.S. at p. 98.) Banishment is punishment, and is punishment for ex post facto and Eighth Amendment purposes. (*Stogner v. California* (2003) 539 U.S. 607, 614; *Trop v. Dulles* (1958) 356 U.S. 86, 102 ["He may be subject to banishment, a fate universally decried

7 A conclusion affirmatively disapproved by Justices Souter, Stevens, Ginsberg and Breyer in *Smith v. Doe, supra,* 538 U.S. at pp. 107, 110, 111, 115-116.

8 Exile can be either internal (resettlement within the country of residence) or external (deportation outside the country of residence. Historical figures who were banished include Ovid, Seneca the Younger, the Dalai Lama, Pablo Neruda, Michel Bakunin, St. Thomas Becket, Napoleon I, Bertolt Brecht, Frédéric Chopin, El Cid, Gutave Courbet, Heinrich Heine, Victor Hugo, Aleksandr Solzhenitsyn, Leon Trotsky, Xiao Qiang, and Benazir Bhutto. (http://dic.academic.ru/dic.nsf/enwiki/5777.)

Dante described banishment in *The Divine Comedy* thus:

Tu lascerai ogne cosa diletta/più caramente; e questo è quello strale/che l'arco de lo essilio pria saetta./Tu proverai sì come sa di sale/lo pane altrui, e come è duro calle/lo scendere e 'l salir per l'altrui scale // You will leave everything you love most:/this is the arrow that the bow of exile/shoots first. You will know how salty/another's bread tastes and how hard it/is to ascend and descend/another's stairs (Paradiso XVII: 55-60.)

by civilized people."]; *but see, Korematsu v. United States* (9th Cir. 1943) 140 F.2d 289, 290 [evacuation law prohibiting all persons of Japanese ancestry from remaining in city upheld against Eighth Amendment challenge].)

Practically speaking, sex offenders, including appellant, cannot now live anywhere in the three largest cities in the state. (Jennifer Dacey, *Sex Offender Residency Restrictions: California's Failure to Learn from Iowa's Mistakes*, 28 J. Juv. L. 11, 19-21 (2007; *accord, Doe v. Miller* (8th Cir. 2005) 405 F.3d 700, 724 (conc. dis. opn. of Melloy, J.) [Iowa residency restriction "cover[s]" virtually the entire city area" of Des Moines and Iowa City and "[i]n smaller towns that have a school or childcare facility, the entire town is often engulfed by the excluded area."].) The current residency restrictions—and the even more Draconian restrictions imposed here—impinge on the registrant's right to travel, his right to own property (*Nixon v. Administrator of General Services* (1977) 433 U.S. 425, 474; *Mann v. Georgia Dept. of Corrections* (2007) 282 Ga. 754-755, 760 [653 S.E.2d 740] ["there is no place [in the state] where a registered sex offender can live without being continually at risk of being ejected]), his ability to seek employment, and his various freedoms of personal and expressive association (*People v. Beach* (1983) 147 CalApp.3d 612, 618). Unlike the Alaska registrant, the California sex offender is manifestly *not* "free to move where they wish and to live and work as other citizens...." (*Smith v. Doe, supra,* 538 U.S. at p. 87.)

As noted, section 3003.5 is thus an unconstitutionally excessive stricture: aside from being applied to all sex offenders, including those who victimized only adults, the residency requirements ignore any distinction between violent and non-violent offenders, between those on parole for sex offenses, and those on parole for non-sex offenses who have a previous sex offense conviction, even if a misdemeanor, even if suffered years earlier. (Pen. Code § 290.46(e)(2)(C).) It ignores, in effect, anything like an individual assessment of risk that would indicate a legitimate civil regulation. (*Compare,* Welf. & Inst. Code § 6600, et. seq. [requiring individual determination of recidivist risk/future dangerousness].)

Under the terms of Penal Code section 3003.5, appellant's mandatory registration and the special 100-yard residency/travel/visitation restriction imposed as a condition of his probation violate the federal and state prohibitions against cruel and unusual punishment, and must be stricken.[9] (U.S. Const. Eighth Amend; Cal. Const. art. I, § 17.)

9 Normally, failure to object to a condition of probation forfeits that issue on appeal. However, no objection is required where the question at issue involves a pure question of law and

VANESSA PLACE

one implicating a fundamental constitutional interest, and in which there is no need for the reviewing court to refer to factual findings or to remand for further factual findings. (*In re Sheena K.* (2007) 40 Cal.4th 875, 879, 887.) Given that appellant's mandatory registration requirement and residency/ travel restrictions pose a pure question of law, the issue is not waived by counsel's failure to object. (*Id.*, at p. 888.) To the extent an objection was required, it was ineffective assistance of trial counsel to fail to object to appellant's registration and the special 100-yard residency/travel/vsitation restriction as constituting cruel and unusual punishment. (*See generally, Strickland v. Washington* (1984) 466 U.S. 668, 687; *People v. Jones* (2003) 29 Cal.4th 1229, 1254.)

ARGUMENT

APPELLANT'S 1040-YEARS AND TEN LIFE TERMS
CONSTITUTES CRUEL AND UNUSUAL PUNISHMENT

Medieval justice included putting a man in a hanging cage, keeping him there til he died, and, after birds of prey picked clean the skeleton, keeping the skeleton on as warning to other miscreants: perhaps this is something like what the trial court had in mind in sentencing appellant to 1,040 years in state prison, in addition to ten life terms. A sentence of 1,040 years plus ten lives is barbaric on its face, and constitutes cruel and unusual punishment in contravention of the Eighth and Fourteenth Amendments and article I, section 17 of the California Constitution. (*Enmund v. Florida* (1982) 458 U.S. 782, 801; *Robinson v. California* (1962) 370 U.S. 660; *People v. Dillon* (1983) 34 Cal.3d 441, 479-482.)

A punishment is constitutionally offensive if it is "grossly out of proportion to the severity of the crime" (*Gregg v. Georgia* (1976) 428 U.S. 153, 173), disproportionate to a defendant's "personal responsibility and moral guilt" (*Enmund v. Florida, supra,* 458 U.S. at p. 801), or "so disproportionate to the crime for which it is inflicted that it shocks the conscience and offends the fundamental notions of human dignity" (*In re Lynch* (1972) 8 Cal.3d 410, 424.) Though the Legislature has "the broadest discretion possible in enacting penal statutes and in specifying punishment for crime, ... the final judgment as to whether the punishment it decrees exceeds constitutional limits is a judicial function." (*People v. Anderson* (1972) 6 Cal.3d 628, 640, cert. den. 405 U.S. 958.) Both trial and appellate courts have authority to deem a sentence cruel and unusual. (*People v. Cromer* (2001) 24 Cal.4th 889, 990-901; *People v. Meeks* (2004) 117 Cal.App.4th 891, 900.) Though Eighth Amendment jurisprudence has been most recently focused on affixing the perimeters of proportion, the fixed mark remains: a punishment "must not be so sever as to be degrading to the dignity of human beings." (*Furman v. Georgia* (1972) 408 U.S. 238, 271 (conc. opn. by Brennan, J.).)

In *Rummel v. Estelle* (1980) 445 U.S. 263, 278, the United States Supreme Court upheld a life sentence for a non-violent third-time felony offender. The Court found that the Texas recidivist statute, while stringent, was not so untoward as to justify judicial intervention in "the complexities confronting any court that would attempt" to "evaluate the position of any particular recidivist

scheme...." (*Id.*, at pp. 280, 281.) In *Solem v. Helm* (1983) 463 U.S. 277, 289-290, the Court nonetheless reversed a sentence of life without the possibility of parole for a non-violent seven-time felon as "significantly disproportionate to his crime." (*Id.*, at p. 303.) Justice Powell, writing for the Court, set forth a tripartite Eighth Amendment analysis, requiring consideration of:

> (I) the gravity of the offense and the harshness of the penalty; (ii) the sentences imposed on other criminals in the same jurisdiction; and (iii) the sentences imposed for commission of the same crime in other jurisdictions.

(*Id.*, at p. 292.) The life term in *Solem* was deemed "far more severe" than that in *Rummel* in main because the defendant in *Rummel* would be eligible for parole in 12 years, while there was no possibility for the *Solem* defendant's release. (*Solem v. Helm, supra,* 463 U.S. at p. 292.)[1]

In *Harmelin v. Michigan* (1991) 501 U.S. 957, 1001, Justice Kennedy's concurrence harmonized *Rummel* and *Solem* by suggesting:

> the Eighth Amendment does not require strict proportionality between crime and sentence. Rather, it forbids only extreme sentences that are 'grossly disproportionate' to the crime.

(*See also, Henderson v. Norris* (8th Cir. 2001) 258 F.3d 706, 709; *United States v. Jones* (10th Cir. 2000) 213 F.3d 1253, 1261; *United States v. Bland* (9th Cir. 1992) 961 F.2d. 123, 128-129, cert. den. 506 U.S. 858.) In *Harmelin*, the Court upheld a life without possibility of parole term for drug offenders convicted of possessing more than 650 grams of cocaine. (*Harmelin v. Michigan, supra,* 501 U.S. at pp. 996-1001.) Though *Harmelin* betrayed a split among the justices, two of whom[2] argued the proposition that the Eighth Amendment mandated proportionality in sentencing was "simply wrong" (*Id.*, at p. 965), four who would

1 The Court noted that the possibility of commutation did not mitigate the punishment, as it was "nothing more than a hope for 'an ad hoc exercise of clemency'.... Recognition of such a bare possibility would make judicial review under the Eighth Amendment meaningless." (*Id.*, at p. 303.)

2 Justice Scalia, who delivered the opinion of the Court only with regards to the merits of petitioner's Eighth Amendment claim, and Chief Justice Rehnquist, who joined the entirety of Justice Scalia's opinion. (*Id.*, at p. 961.) Under Justice Scalia's analysis, proportionality was only an "aspect of our death penalty jurisprudence, rather than a generalizable aspect of Eighth Amendment law." (*Id.*, at p. 994.)

have found the sentence disproportionate under the *Solem* test,[3] and three,[4] including Justice Kennedy, who averred that a non-capital sentence could be unconstitutionally, *i.e.*, grossly, disproportionate (though the defendant there did not meet the standard). (*Id.*, at p. 996-1001.)

After considering these factors, the second and third tiers of the *Solem* analysis might be excused unless "a threshold comparison of the crime committed and the sentence imposed leads to an inference of gross disproportionality." (*Harmelin v. Michigan, supra,* 501 U.S. at p. 1005.) As drugs are scourge of society, and Harmelin was convicted of possession between 32,500 and 65,000 doses, his punishment did not so ill-fit his crime. (*Id.*, at p. 1002; *accord, People v. Mantanez* (2002) 98 Cal.App.4th 354, 366 [25-to-life term for heroin possession and receiving stolen property not cruel and unusual given defendant's recidivism].)

In *Ewing*, the Court revisited the proportionality debate, again, resulting in a plurality opinion: the Court's opinion, written by Justice O'Connor, was joined by Justice Kennedy and the Chief Justice, adopted Justice Kennedy's approach in *Harmelin*,[5] finding the Eighth Amendment contains a "'narrow proportionality principle'" when applied to noncapital sentences. (*Ewing v. California* (2003) 538 U.S. 11, 20, quoting *Harmelin v. Michigan, supra,* 501 U.S. at p. 996-997 (conc. opn. by Kennedy, J.).) Under the plurality's analysis,

3 Justices White, Blackmun and Stevens. (*Id.*, at p. 1009.) Justice Marshall filed a separate dissent concurring with Justice White's dissent while asserting Justice Marshall's continuing opposition to the death penalty. (*Harmelin v. Michigan, supra,* 501 U.S. at p. 1027.) Justices Stevens, with Justice Blackmun joining, filed an additional dissenting opinion underscoring that the penalty involved was "'cruel and unusual in the same way that being struck by lightning is cruel and unusual.'" (*Id.*, at p. 1028-1029, quoting *Furman v. Georgia* (1972) 408 U.S. 238, 309 (conc. opn. of Stewart, J.).)

4 Justices Kennedy, O'Connor and Souter.

5 Justices Scalia and Thomas concurred; in his concurrence, Justice Scalia reiterated his belief the Eighth Amendment cannot apply to non-capital offenses as the prohibition is only applicable to "'certain *modes* of punishment....'" If the peneological purpose of the strike statute is incapacitation, and incapacitation is a legitimate peneological purpose, any further consideration of the State's interest in imposing such a severe sentence was irrelevant on the question of proportionality: in other words, if a State wants to lock someone up for life for stealing a set of golf clubs, "[p]erhaps the plurality should revise its terminology, so that what it reads into the Eighth Amendment is not the unstated proposition that all punishment should be reasonably proportionate to the gravity of the offence, but rather the unstated preposition that all punishment should reasonably pursue the multiple purposes of the criminal law." (*Ewing v. California, supra,* 538 U.S. at pp. 31-32, quoting *Harmelin v. Michigan, supra,* 501 U.S. at p. 985.) Justice Thomas simply stated the Eighth Amendment has no proportionality guarantee. (*Ewing v. California, supra,* 538 U.S. at p. 32.)

proportionality review is finally principled[6] by the above disclaimer—that only "extreme sentences that are 'grossly disproportionate' to the crime" are proscribed. Further, Solem did not mandate either inter- or intra-jurisdictional comparisons between offenses and punishments. (*Ewing v. California, supra*, 538 U.S. at p. 23, quoting *Harmelin v. Michigan, supra*, 501 U.S. at p. 1001.) The Eighth Amendment does not prohibit California from exercising its authority to incapacitate repeat offenders, and a sentence of 25-years-to-life for stealing $1,200 worth of merchandise after having two prior violent/serious felony convictions was not grossly disproportionate given that interest. (*Id.*, at pp. 25, 28-30.) Justice Breyer, writing for the dissent—Justices Stevens, Breyer, Souter and Ginsberg—argued the facts of *Ewing* were not substantially different than those of *Solem*, and dictated the same "grossly disproportionate" finding.[7] (*Id.*, at p. 35.) In a separate dissent, Justice Stevens quoted *Atkins v. Virginia* (2002) 536 U.S. 311: "'The Eighth Amendment succinctly prohibits 'excessive sanctions.'" (*Ewing v. California, supra*, 538 U.S. at p. 33.) This prohibition covers everything from bails and fines to the death penalty; as sentences were one commonly indeterminate, judges historically had to exercise wide discretion in affixing punishment, discretion cabined by "a broad and basic proportionality principle" constitutionally secured. (*Id.*, at p. 35; *see also, Lockyer v. Andrade, supra*, 538 U.S. at p. 83 (dis. opn. by Souter, J. ["If Andrade's sentence is not grossly disproportionate, the principle has no meaning."].)

The question whether a sentence is grossly disproportionate to the crime is not confined to lengthy sentences for relatively minor offenses, nor is it mooted by the constringed reading of the prohibition under *Ewing*, for the bedrock still holds:

> The basic concept underlying the Eighth Amendment
> is nothing less than the dignity of man. While the

6 It is prefatorially principled by the following four tenets: "'the primacy of the legislature, the variety of legitimate peneological schemes, the nature of our federal system, and the requirement that proportionality review be guided by objective factors.'" (*Ewing v. California, supra*, 538 U.S. at p. 23, quoting *Harmelin v. Michigan, supra*, 501 U.S. at p. 1001.)

7 While acknowledging the plurality's emphasis on the "rarity" of such a finding, the dissent found this to be one of those rare instances based on "three-kinds of sentence-related characteristics," specifically, the length of the term "in real time, *i.e.*, the time that the offender is likely actually to spend in prison"; the criminal conduct involved in the current offense, and the offender's criminal history. Here, the term was at least 25 years, the conduct nonviolent, and the history nondeterminitive: "'no penalty is *per se* constitutional.'" (*Ewing v. California, supra*, 538 U.S. at pp. 38-41, quoting *Harmelin v. Michigan, supra*, 501 U.S. at p. 1001; *c.f., Lockyer v. Andrade* (2003) 538 U.S. 63, 77 [plurality opinion upholding 25-year-to-life strikes term for shoplifting: "The gross disproportionality principle reserves a constitutional violation for only the extraordinary case."].)

> State has the power to punish, the Amendment
> stands to assure that this power be exercised within
> the limits of civilized standards.

(*Trop v. Dulles* (1958) 356 U.S. 86, 100.) A sentence that makes mock of a man's lifespan, that deals with a man as if he were, in fact, a monster, so preternatural that he must be locked away for a millennium and thirty-nine lifetimes to guarantee his being kept from society, degrades the dignity of all humanity. (*Contra, id.*, at p. 101 ["The Amendment must draw its meaning from the evolving standards of decency that mark the progress of a maturing society."].)

In *People v. Deloza* (1998) 18 Cal.4th 585, 600, the Supreme Court held the Three Strikes law required a specialized "separate occasion" determination by the trial court in the decision to impose consecutive or concurrent terms; the Court reversed and remanded for resentencing, never addressing the Eighth Amendment issue posed by the 111-year to (four) life sentence. Justice Mosk's concurrence was devoted to the issue, as:

> Regrettably, multicentury sentences are becoming
> commonplace and generally remain unchallenged.
> Certainly there is understandable revulsion
> directed towards a defendant who has committed
> numerous counts of illegal conduct. Not infrequently
> the charges are sexual in nature; that conduct
> appears to draw the monstrous sentences.

(*Id.*, at p. 601.) Justice Mosk referenced an unpublished Oklahoma opinion in which a sentence of 30,000 years was upheld without comment; the dissent objected, calling the sentence "'shocking and absurd'," and calling for appellate courts to implement "'an honest system of imprisonment. If we don't, sentence 'inflation' will make a mockery of us all.'" (*Ibid.*, quoting *Robinson v. State* (Oka.Crim.App. Apr. 1, 1996) F94-1377.) For his part, Justice Mosk advised the maximum sentence ought be life imprisonment, a sentence "a defendant is able to serve." In those egregious cases where there are "exceptionally numerous victims," the maximum might be life without possibility of parole. (*Id.*, at p. 602; *c.f., O'Neil v. Vermont* (1892) 144 U.S. 323, 340 (dis. opn. by Field, J.) ["The State may, indeed, make the drinking of one drop of liquor an offence to be punished by imprisonment, but it would be an unheard-of cruelty if it should count the drops in a single glass and make thereby a thousand offences, and thus extend the punishment for drinking the single glass of liquor to an imprisonment of almost infinite duration."].)

There are other cases where defendants have been sentenced to millennia, but not very many, and not very logically: In *People v. Byrd* (2001) 89 Cal.App.4th 1373, the defendant was sentenced to 115 years, plus 444-years-to-life; citing its previous decision in *People v. Cartwright* (1995) 39 Cal.App.4th 1123, 1134-1137 [375-years-to-life plus 53 years affirmed], the Third District upheld the sentence, finding it "immaterial" that the defendant could not serve the sentence, for "in practical effect, he is no different position that a defendant who has received a sentence of life without possibility of parole." According to the court, as life without possibility of parole is not cruel and usual punishment, neither does multi-century sentencing; moreover, such a sentence "serves valid peneological purposes: it unmistakably reflects society's condemnation of defendant's conduct and it provides a strong psychological deterrent to those who would consider engaging in that sort of conduct in the future." (*Id.*, at p. 1383.)

The defendant in *Callins v. State* (Okla. 1972) 500 P.2d 1333, was convicted of first degree rape; under the indeterminate sentencing scheme then in place,[8] the jury sentenced him to 1,500 years imprisonment. The Court of Appeal upheld the sentence, citing the imposition of a 1,000 year term for rape in *Fields v. Phillips* (Okla. 1972) 501 P.2d 1390, cert. den. 532 U.S. 969; in Fields, the majority rejected an Eighth Amendment challenge and a separation of powers challenge, stating "the practicalities of life compel us to observe that a sentence of 1,000 years is, for all intents and purposes, a life sentence," such a sentence did not violate the province of the executive branch by mooting the possibility of parole as the sentence was within the jury's authority to give, and "it could be argued that a jury panel could assess a term of 25,000 or a million years, if they choose to do so." (*Id.*, at p. 1393; compare, *Sills v. Texas* (1971) 472 S.W.2d 119, 120 ["It is suggested that a jury could give a sentence of 25,000 or 1,000,000 years if they chose to do so. It is further suggested that 1,000 years or a million years is an impossible punishment and should not be assessed. It does not change the rule that a person can be considered for parole when he has received credit for 20 years or one-third of his sentence, whichever is the less."].)[9] In the majority's opinion, the aggravated term must have been due to "some additional consideration... such as an attempt to indicate outrage at the

8 There was a five-year minimum, but no fixed maximum term for first degree rape. (*Fields v. Phillips, supra,* 501 P.2d at p. 1393, citing 21 O.S. 1971, § 1115.)

9 By way of comparison, it appears appellant would have to serve 751 years before being eligible for parole. (Pen. Code § 1170.12(a)(7); *In re Cervera* (2001) 24 Cal.4th 1073, 1076; compare, *Rummel v. Estelle, supra,* 445 U.S. at p. 267 [defendant eligible for parole in 12 years]; *Solem v.*

facts and circumstances of the case and in some way to serve as a deterrent."
(*Fields v. Phillips, supra,* 501 P.2d at p. 1394.) The victim in *Fields* was "raped
successively by [] three Negroes," including the two defendants. (*Id.,* at p.
1391.) One justice had concurred in *Fields,* simply noting the sentence should
be modified to life imprisonment. (*Id.,* at pp. 1395.)

 This concurring justice subsequently dissented in *Callins,* preliminarily
noting he "did not see the relevancy of affirming a sentence of either 1,000
years, or one of 1,500 years," and that if the practicalities of life mean that a
1,000 year sentence is a life sentence, then "this Court should act within its
wisdom and cause the sentence to reflect 'life imprisonment.'" (*Callins v. State,
supra,* 500 P.2d at p. 1336, opn. of Brett, J..) Though the dissent agreed with
the jury the facts of the case would provoke anyone to wish the defendant
permanently removed from society, "it is the duty of the appellate courts to
apply the law with reason, and not to be guided by emotions, as the jury was."
(*Ibid.*) Finally:

> [W]hen trial courts permit and accept jury verdicts
> of excessive punishment... it makes a mockery of
> the jury system... and, further, when appellate courts
> approve such ridiculous verdicts they only magnify
> that mockery and perpetuate the travesty of justice.
> It should be remembered, a just society is not judged
> by how it treats its best citizens, but instead, how
> it treats its worst citizens. In the instant case there
> is no possible way for the sentence to be satisfied,
> unless upon defendant's death his embalmed body
> is placed upon the cell bunk for the balance of the
> 1,500 years.

(*Callins v. State, supra,* 500 P.2d at p. 1337.)

 Rather than revisit the standard comparison between a sentence for
murder and an unusually lengthy sentence, which seems to have lost whatever
cache it once had, it is perhaps more useful to consider the minimizing effect
of millennial sentencing. For what Justice Mosk presaged has come to pass:
as sentences of hundreds of years become commonplace, the thousand year
sentence is born: as the thousand year sentence makes its advent, the life term
(or the 25-to-life term) once considered a serious penalty, reserved for the worst

Helm, supra, 463 U.S. at pp. 282-283 [defendant not eligible for parole]; *Harmelin v. Michigan,*
supra, 501 U.S. at p. 961 [defendant not eligible for parole].)

offenders, becomes an average sentence, an existential midterm. (*Compare, People v. Lewis* (2004) 120 Cal.App.4th 837, 856-857 [25-year-to-life term for section 273(a)(b) violation not cruel and usual given amount of force and anger required to produce four-month old's fatal head injuries].) The State's legitimate peneological purpose of wanting to incapacitate recidivists does not, in turn, legitimize a thousand-year sentence, or end-stop the question whether that sentence is cruel and unusual.[10] The grossly inflated sentence in this case cannot be reconciled with any concept of real time or real humanity, and thus, *this* is the exceptional sentence. (*Lockyer v. Andrade, supra,* 538 U.S. at p. 77; c.f., *United States v. Bajakjian* (1998) 524 U.S. 321, 342-343.) And this sentence is absurd:

If, for all practical purposes, a millennial sentence is life imprisonment, then it is no more practically incapacitating than life imprisonment. If, for all practical purposes, a millennial sentence "unmistakably reflects society's condemnation" of the conduct punished, then it is no greater condemnation than life imprisonment. If, for all practical purposes, it provides a "strong psychological deterrent" to those who would commit similar offenses, it can provide no more or less a deterrent than life imprisonment—unless one is willing to hang the skeleton.

Again, "the primary principle is that a punishment must not be so severe as to be degrading to the dignity of human beings." (*Furman v. Georgia, supra,* 408 U.S. at p. 271 (conc. opn. by Brennan, J.).) The extreme severity of a punishment "may reflect the attitude that the person punished is not entitled to recognition as a fellow human being," such as found in torture, wherein the man is refused human status, and in criminalizing disease, where the man is treated as "a diseased thing rather than as a sick human being," and, "of course, a punishment may be degrading simply by reason of its enormity. A prime example is expatriation, 'a punishment more primitive than torture,' for it necessarily involves denial by society of the individual's existence as a member of the human community." (*Id.*, at pp. 273-274, quoting *Trop v. Dulles, supra,* 356 U.S. at 101, emphasis added.) The court here frankly characterized appellant as

10 As put by the Court: "The very purpose of a Bill of Rights was to withdraw certain subjects from the vicissitudes of political controversy, to place them beyond the reach of majorities and officials and to establish them as legal principles to be applied by the courts." Judicial enforcement of the Clause, then, cannot be evaded by invoking the obvious truth that legislatures have the power to proscribe punishments for crimes. That is precisely the reason the Clause appears in the Bill of Rights..... we must not, in the guise of 'judicial restraint,' abdicate our fundamental responsibility to enforce the Bill of Rights. Were we to do so... [t]he Cruel and Unusual Punishments Clause would become, in short, "little more than good advice." (*Trop v. Dulles, supra,* 356 U.S. at 104.)

"inhuman," "a monster." (RT 2386-2387) But appellant is a human being, with a human being's susceptibility to the limits of mortality. Just as you can only kill a man once, you can only imprison him for life: to fain imprison him for the ages is grossly disproportionate to any offense and grossly disproportionate to any civilized sense of inalienable human worth. (*People v. Cox* (2003) 30 Cal.4th 916, 970; *People v. Dillon, supra,* 34 Cal.3d at p. 487, fn. 38.) Appellant's sentence should be modified to life imprisonment. (U.S. Const., Eighth Amend.)

ARGUMENT

APPELLANT REQUESTS THAT THIS COURT INDEPENDENTLY EXAMINE THE ENTIRE RECORD ON APPEAL

Pursuant to *People v. Wende* (1979) 25 Cal.3d 436, counsel requests that this Court independently review the entire record on appeal for arguable issues.

Present counsel has advised appellant that he may file a supplemental brief with the court within 30 days and may request the court to relieve present counsel. Present counsel remains available to brief any issue(s) upon invitation of the court. (See Declaration attached hereto.)

Dated: September 10, 2008

Respectfully submitted,

VANESSA PLACE
Attorney for Appellant

CPSIA information can be obtained at www.ICGtesting.com
Printed in the USA
LVOW05s0254300414

383829LV00003B/111/P